American Indian Art Series

HOPI-TEWA POTTERY

500 Artist Biographies

First Edition
Published by CIAC Press
(Center for Indigenous Arts & Cultures Press)

Printed in U.S.A. by Gardner Lithograph
8332 Commonwealth
Buena Park, CA 90621-2591

CENTER FOR INDIGENOUS ARTS & CULTURES
A division of Southwest Learning Centers, Inc.
a non-profit, educational organization est. 1972
P.O. Box 8627
Santa Fe, NM 87504-8627
(505) 473-5375
Fax 505-424-1025
email - Indians@nets.com

ISBN 0-9666948-0-5

Library of Congress Catalog Card Number 98-87933

Schaaf, Gregory
Hopi-Tewa Pottery: 500 Artist Biographies
by Gregory Schaaf, Ph, D
edited by Richard M. Howard
designed by Angie Yan
computer graphics for color pages by Dr.Neil Chapman
p. cm.
Incudes 500 illustrations, bibliographical references and biographical index.
ISBN 0-9666948-0-5
1. Indians of North America – Art –Pottery
2. Indians of North America – Biography
3. Hopi Indians – Pottery
4. Pueblo Indians – Pottery
5. Tewa Indians – Pottery
6. Hopi Indians – Biography
7. Pueblo Indians – Biography
8. Tewa Indians – Biography
9. Indian Pottery – Collectors and Collecting – Southwest
I. Schaaf, Gregory. II. Howard, Richard M.
III. Center for Indigenous Arts & Cultures. IV. Title.

American Indian Art Series

HOPI-TEWA POTTERY

500 Artist Biographies

ca. 1800-present

with Value/Price Guide

featuring over 20 years of auction records

Gregory Schaaf

by Gregory Schaaf, Ph.D.

edited by Dick Howard
designed by Angie Yan

First Edition

CIAC Press
Santa Fe, New Mexico

Special Thanks to:

Museum of Northern Arizona, Flagstaff, AZ
Museum of Indian Arts & Culture, Santa Fe, NM
Heard Museum, Phoenix, AZ
SWAIA, Santa Fe, NM
Eight Northern Indian Pueblos, NM
Gardner Lithograph, Buena Park, CA

— A Tewa Educator's Perspective —

This is the first time that a comprehensive survey and databases for Indian artists have been done. It has been a long time in coming and its impact will be significant for Indian artists and collectors of Indian art for decades to come!

Greg Cajete
Santa Clara Pueblo
Assistant Professor, UNM
Arts Education

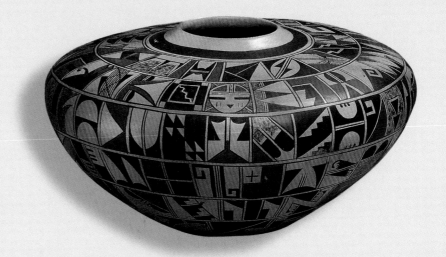

Rachel Sahmie
Mosaic of 124 Symbols

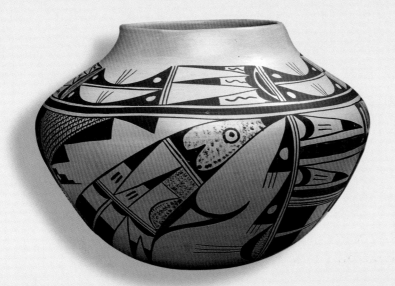

Frog Woman Style
Spirit Bird Design

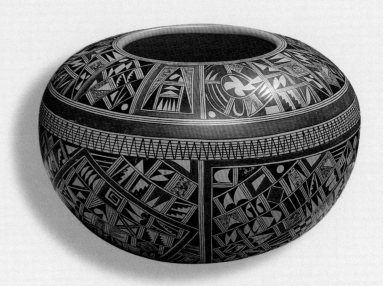

Digital Photography by Jeff Visone

Rondina Huma
Mosaic of 280 Symbols

Stella Huma
Sikyatki Bird Design

Nampeyo Pot Painted by Fannie
Mythic Bird Design

Hattie Carl
Feather and Cloud Design

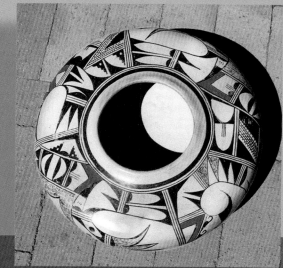

Nampeyo Family
photograph by Michelle Van Vliet

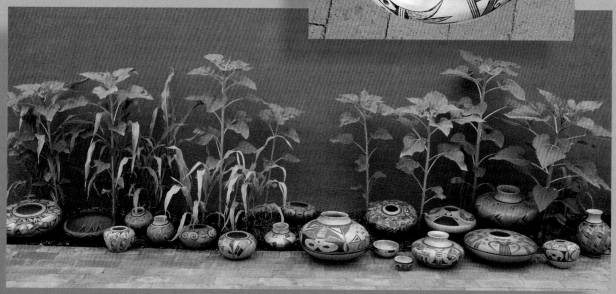

Rainy Naha
Migration Design

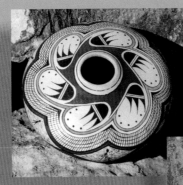

Dolly Joe Navasie (White Swann)
Mythic Bird and Sky Band Design

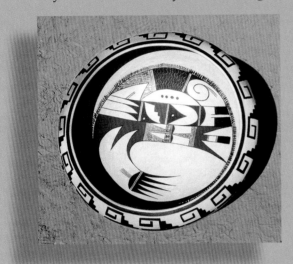

Feather Woman
Bat Wing Design

Frog Woman and Feather Woman Families
photograph by Michelle Van Vliet

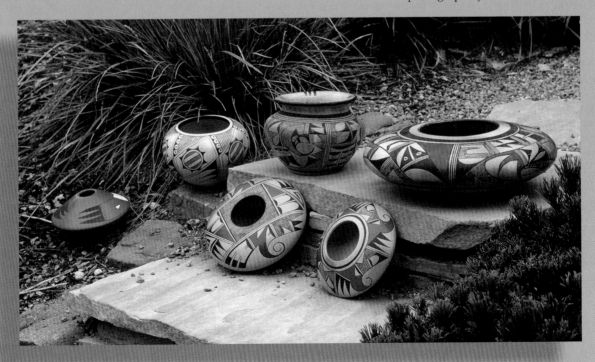

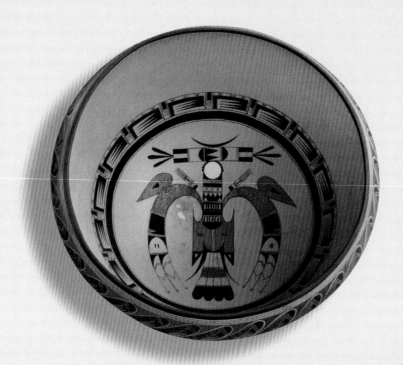

Jacob Koopee
Sikyatki Bird Design

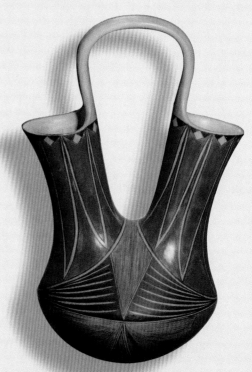

Dextra Quotskuyva
Wedding Vase

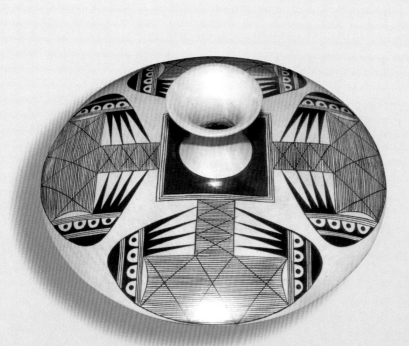

Nona Naha
Bat Wing Design

Contents

Introduction

"Tewa offering to the Sun," ca. 1926, by Edward Curtis. Courtesy of Rainbow Man, Bob & Marianne Kapoun.

The Center for Indigenous Arts & Cultures, a non-profit, educational organization, is coordinating a new "American Indian Art Series." Our goal is to compile American Indian artist biographies. Artists may freely use and copy the text of their biographies as a brochure for people interested in their art. This project's main purpose is to provide helpful guides to American Indian artists.

Please consider our invitation for your direct participation. We are calling on Indian artists, educators, curators, collectors, traders, gallery owners, auction houses and others to unite in this good work. Together, we will expand our extensive archives focused on the history of American Indian artists.

Indian artists are invited to participate in the writing and development of their personal biographies. A questionnaire is available to help focus on key questions. These simple surveys also may be used by curators, collectors and others to document items from public and private collections. All Indian artists - youth & elders - are invited to participate.

Educators also are invited to participate in the writing and development of educational curriculum materials. An Indian education website is in development to freely distribute these materials to students and teachers. See our web design at: www.studiox.com/indians.

The "American Indian Art Series" will profile the lives, cultures and arts of American Indian and other indigenous peoples. I believe we are all "indigenous" to somewhere. We need only to rediscover our tribal roots. With this awareness often comes a desire to revive and support traditional arts.

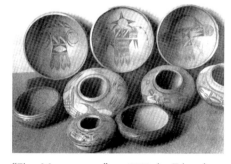

"First Mesa pottery," ca. 1922, by Edward Curtis. Courtesy of Rainbow Man, Bob and Marianne Kapoun.

The value of this book — from statements collected from the artists and their families — was best explained by master potter Dextra Quotskuyva. She is the great-granddaughter of Nampeyo, the most famous Hopi-Tewa potter in history. "The potters and their families will have something to feel proud of, looking back at these people and their work. It gives a lot of credit to them." We honor the artists with respect for their remarkable artistic achievements.

Millions around the world are experiencing a growing appreciation for the arts and cultures of native peoples. In the American

"Walpi Village," ca. 1923, by Edward Curtis. Courtesy of Rainbow Man, Bob and Marianne Kapoun.

Southwest, Indian artists continue to create beautiful objects with loving care. Their creations may be seen as six main types of art forms: paintings, jewelry, baskets, textiles, carvings and pottery. This book addresses two major questions: Who? & Valuation?

Brief biographies of almost 500 Hopi-Tewa potters over the past 200 years are featured in this volume.

The artists include people of Hopi and/or Tewa ancestry. The largest group of Tewa clans arrived from New Mexico ca. 1700. They retained their Tewa language and traditions, centered at Tewa Village on First Mesa.

The history of pottery in the Southwest stretches back more than two thousand years. While pottery making is much older in Mexico, Central and South America, perhaps the oldest pottery in the Southwest has been found in southern Arizona and New Mexico, dating 300 B.C.

Legends take pottery making back to the dawn of creation. Some perceive the world in the beginning as being first soft, like moistened clay. In a sense, this land was molded, shaped by wind, water and the forces of nature.

Clay is said to come from the "body of Mother Earth" and to be "alive." Clay breathes. Different clays have different feelings, qualities and strengths. Hopi-Tewa potters speak respectfully of the spirit of Clay, asking her for help in this good work. Following this time honored tradition, we ask that the biographies of these potters be received in a good way.

Our plan for the future is to continue the "American Indian Art Series":

The Southwest

Featuring artists from the following
Pueblos and other Indian communities:
San Ildefonso, Santa Clara, Acoma, Tesuque, Pojoaque, San Juan, Taos,
Nambe, Picuris, Jemez, Laguna, Isleta, Sandia, Santo Domingo,
San Felipe, Santa Ana, Cochiti, Zia, Zuni, Navajo & Apache

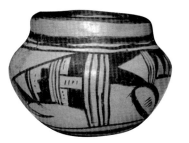

Gregory Schaaf Collection

The Discovery of Two Nampeyo Pots

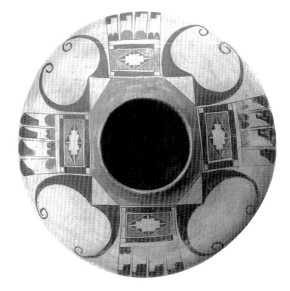

Nampeyo, Polychrome Seed Jar,
"Eagle Tail Feather Skirt" design.

"June 1906, made by
Nampeyo, potter at Hano.
J. Walter Fewkes" written
on the bottom of the pot.
Complete history of past
ownership.

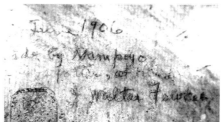

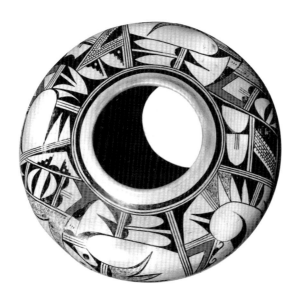

Made by Nampeyo & painted by Fannie.
Polychrome Seed Jar, ca. 1930.
"Mythic Bird" design.

"This pot originally was
bought directly from Fannie,
Nampeyo's daughter, by
Caroline Tawangyama, a
Hopi woman from Hotevilla
on Third Mesa."

4

Acknowledgments

As Director of the Center of Indigenous Arts & Cultures, I wish to thank the many people who have helped make this book possible. First, in a traditional way, let us give thanks for gift of clay and ask for gentle rains to continue to bring fertility and good life to the Southwest. This book is intended to honor the Hopi-Tewa potters who come from many clans with long histories. We recognize native people's unique contributions to this land and life. We extend our respect to the Hopi elders and their families who first invited me to visit in 1981 for the purpose of contributing my knowledge on treaties and international law. Their requests that I begin collecting "original documents related to Hopi history and culture" inspired years of dedicated research. This book is one of the fruits born from seeds planted long ago by Hopi elders.

I also recognize and honor the many Pueblo people whose kindness and hospitality have made me feel welcome as a guest in their homes. Thank you for inviting me and my family to your ceremonies and the good food we have enjoyed during your Feast Days. I will continue to try my best to live up to the trust you have placed in me. May our friendships grow forever.

Other friends of the Pueblo people have been most helpful. Dick Howard, a respected Indian Market pottery judge and collector extraordinaire, is widely recognized as one of the foremost specialists in the field. He agreed early on to edit the text for accuracy and to offer additional information. Thank you, Dick, for sharing your wealth of knowledge, personal experiences and access to your remarkable collection. You deserve credit for helping me to stay on the right path.

This book was designed by Angie Yan, a fine arts graduate of California State University, Los Angeles. She has enjoyed a distinguished career as a painter, best noted for her colorful landscapes. Her oil paintings and delicate pastels of the Great Southwest and California are recognized for their subtle beauty. Ms. Yan did much of the photography for this book. She scanned both her photographs and historic photographs. The beauty of her graphic design, in my opinion, compliments nicely the artistry of the potters. Her artistic touch is found on every page. We honor her unique contribution.

The "circle of advisors" included Dr. John and Jill Anderson, who reviewed the manuscript from its early stages. Their editorial suggestions were invaluable. Dr. Anderson's

Photograph by
Steve Elmore

Jeff Hammond
Collection

writings on American Indian history and cultures are at the cutting edge of scholarship. Rethema Youvella and Clarenda Lomayestewa from Iskasokpu Gallery at Second Mesa were especially helpful, carefully recording clan identity and distinguishing between Hopis and Tewas. Blanche Brody, Elizabeth Baekeland, Robert and Dixie Fisher, Alph and Pauline Sekakuku reviewed the manuscript in the editing process. Thanks to Sue Kuyvaya at the Cultural Preservation Office who received our survey and project description.

Members of the Indian Art Collector's Circle in Santa Fe were the first to see early drafts of the manuscript: Bill Hawn, Bo Hunter, Susan Latham, Arch & Challis Thiessen, Dr. Bennett & Fabrizia Marcus, Christopher Selser, Blanche & Jack Brody, Barbara London, Ellen Kemper and others. The group meets the first Wednesday of every month, free of charge, dedicated to learning more about Indian art. The Circle was co-founded by Jan Duggan, past president of the Antique Tribal Art Dealers Association, and by myself.

The Museum of Indian Arts and Cultures in Santa Fe deserves special recognition. Director Patricia House is to be commended for networking so well with Indian arts educators and Indian nations. Librarian Laura Holt was especially helpful. For over two decades, she has organized and computerized a state-of-the-art facility. She and I agreed to unite our research efforts, sharing biographical information, database designs, merging the best of our ideas. Louise Stiver, Curator of Collections, made available their inventory of signed and attributed Hopi-Tewa pottery. Curators Joyce Begay-Foss, Lillie Lane, and Jane Sinclair offered ideas in the development of biographical information for the benefit of Indian artists, as well as educational curricula for children. Volunteers Marlene Dallo and Hope Marrin made significant contributions by inputting biographical information into the museum's Indian Artist database. Thanks to the museum staff who helped provide access to MIAC's remarkable collection.

Gregory Schaaf
Collection

The Museum of Northern Arizona also deserves special recognition for amassing and preserving a vast collection of Hopi pottery, as well as other art forms. MNA has been a primary repository of information on Hopi potters and other artists. Photo Archivist Tony Marinella was especially helpful.

At the Heard Museum in Phoenix, Associate Archivist James T. Reynolds provided computer print-outs of their inventories and artist database. The Heard's Photo Archivist also compiled special lists of artist portraits and other historic photographs.

Bob and Marianne Kapoun, owners of Santa Fe's Rainbow Man, provided illustrations

Frank Kinsel Collection

from the historic photographer Edward Curtis.

The fine printing of this book is the work of award-winning printer David Gardner of Gardner Lithograph, Buena Park, CA. David flew to Santa Fe, embraced our vision and shared our commitment to achieve the highest quality. It was a joy to work with their professional team, especially John Visone, Jim Black, Franz Dreikorn & Kevin Broady.

Thanks to Dawna and Dr. Neil Chapman, our computer and photographic advisor, and his Photoshop class at Mt. San Antonio College: Claudia, Luis, Marcial, Raul, Ramon, Ray, and Sunny. Tom Tallant, a gifted photographer and webmaster of www.canyonlands.com, provided portraits of several potters. Jill Giller and Bill Bonebrake contributed photographs, as did Frank Kinsel, Steve Elmore, Ed Samuels, and Michelle Van Vliet. Ellen Napiura Taubman of Sotheby's was helpful as their Indian art specialist. Robert Gallegos and Ron Munn Auctions, Col. Doug and Steve Allard, and Will Channing gave permission to use sales records from their auctions. These auction records provide a wealth of information about artists, dates, types of art forms, as well as sales results. Their auctions are advertised in *Indian Art Magazine, Indian Trader* and other publications. Bob Orndorf, an excellent researcher, helped locate auction records. Thomas B. Cavaliere shared with good humor his experiences at Hopi.

Support came from the School of American Research, Wheelwright Museum, Heard Museum, Institute of American Indian Arts, National Museum of the American Indian, Smithsonian Institution, and more. Rare book dealers worked as historical detectives, especially Bob Craner, Bob Fein, Books Unlimited, Dumont Maps & Books, Books and More Books, Collected Works Bookshop, Margolis & Moss Books.

The directors of Southwest Learning Centers deserve recognition: Seth Roffman, Radford Quamahongnewa, Dane Reese, Gail Russell, James Berenholtz, Mazatl Galindo and Fidel Moreno. Jeffrey Bronfman's vision and support inspires us all.

Others offered editorial suggestions, including Luella Schaaf, Kim, David and Tony Moore, Charlotte and John Alexander. Wayne Lawrence, Mindy Paul, Lewis Kemper and Dick Roth offered photographic suggestions. Mr. & Mrs. Charlie Strong loaned a rare copy of Alexander Stephen's journal.

Terry Schurmeier of Cowboys & Indians in Albuquerque ordered the first case of books, pre-publication. Thank you for your good faith. We hope your lead inspires others to call and order the books. Public support is needed for the series to continue. If you would like to contribute names and information for the "American Indian Art Series," please contact Dr. Gregory Schaaf, Director, Center for Indigenous Arts & Cultures, P.O. Box 8627, Santa Fe, NM 87504-8627 or call (505) 473-5375, FAX (505) 424-1025, email - Indians@nets.com

Future website address: Indians.edu. We are collecting information on all art forms in each region of the continent. Many Thanks.

Courtesy of Steve Elmore

CHAPTER ONE:
"Who are the Hopi-Tewa potters?"

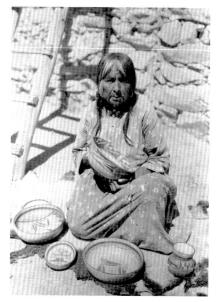

"Who is this potter?" ca. 1900-1920.
Photograph by Bryce Elliot, neg.#140781.
Courtesy of Museum of New Mexico.

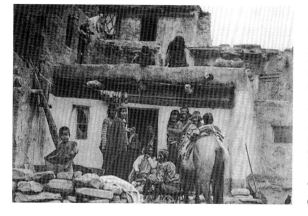

"Tewa Village Plaza," ca. 1880s.
Courtesy of National Anthropological Archives.

The Hopi-Tewa potters are a group of native artists from various clans living about a hundred miles southeast of the Grand Canyon in Arizona. Hopi clans speak a Uto-Aztecan language, while the Tewa clans speak a Tanoan dialect from New Mexico. Long ago the two groups of clans came together, centered around First Mesa, a flat-topped mountain with a panoramic view for hundreds of miles. They continue to speak their respective languages, while living side-by-side, sharing many cultural arts traditions. One of those traditions is the ceramic art of pottery making.

This book presents biographical information on almost 500 Hopi-Tewa potters. New editions will appear as new artists arise and as more request to participate in the development of their biographies. Many artists kindly sat down with us and enjoyed wonderful conversations, usually around their kitchen tables. The artists shared much information never before recorded. They have offered their knowledge of the lives of their people and the beauty of their unique artistic expressions. They have welcomed us into their homes, treated us with hospitality and shared a very personal part of their lives. For this, we are thankful.

Hopi and Tewa clans share in common a tradition that they were "born" or "emerged" from the body of Mother Earth. The place of emergence, the *Sipapu,* is considered the navel of the earthly female spirit. For some Hopi clans, this place is located in the bottom of the Grand Canyon, while the Tewa place of emergence, *Siibopay,* is said to be beneath a lake in southern Colorado.

Tewa elders Albert Yava and Alfonso Ortiz recorded their oral history, recounting great migrations down from present day Colorado into New Mexico. Tewa clans followed the Rio Grande, establishing pueblos including: San Ildefonso, Santa Clara, San Juan, Nambe, Pojoaque and more. Clan histories are the subject of my book, *Ancient Ancestors of the Southwest.*

"A Visitor," ca. 1922, by Edward Curtis.
Courtesy of Rainbow Man, Bob and Marianne Kapoun.

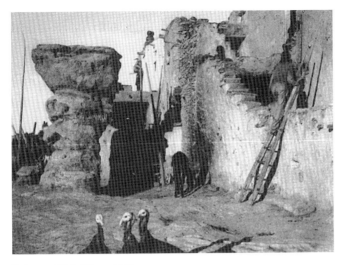

"Plaza at Walpi," ca. 1923, by Edward Curtis. Courtesy of Rainbow Man, Bob and Marianne Kapoun.

Around 1300 to 1350, many clans migrated throughout the Southwest. As these groups of extended families migrated, they carried their traditions, including styles and techniques in making pottery. Their clan symbols, found in rock art and designs on pottery shards, mark their trails.

Today, most of the Hopi-Tewa potters make a style of ceramics variously called "Hano Polychrome" or "Sikyatki Revival" ware. "Hano" is the Hopi name of Tewa Village on First Mesa. The word "Sikyatki" means "yellow earth" and also is the name of a former village at Hopiland located two miles north of First Mesa. Polychrome means multi-colored. Revival implies an earlier style has returned to popularity.

Who originally created Sikyatki Polychrome, the multi-colored style of pottery popular at Hopi today? Two groups of clans. The *Kokop* "Firewood" people, including the Coyote Clan, came from present day New Mexico. They were influenced by *Patki*, Water Clan people from southern Arizona and Mexico. Southern Hohokam groups came from the Gila River and Salt River valleys, and the Verde Valley. The Eastern groups of Tewa and Keresan speakers from New Mexico introduced new and refined techniques. The southern groups contributed more designs. Later arrivals of Kachina and Tewa clans further expanded the body of design symbolism and range of techniques. Here we find the roots of what is generally known today as "Hopi pottery."

Sikyatki, ca. 1375-1625. Photographs by Richard M. Howard.

With the uniting of these clans around 1375, an "artistic movement" grew and spread outward from Hopiland, influencing groups of potters throughout the Southwest. Black-on-white pottery generally fell out of style, being replaced with brilliant black-on-orange, followed by black-on-yellow pottery. The color red soon was added. Fantastic pictorial designs flourished — butterflies, parrots, feathers, and the unfolding of seeds into plants became important symbols. These designs reflect a philosophy and spirituality based on the study of life, germination, plant genetics, the transformation and growth of plant, animal and insect life. The potters observed nature closely, with respect for the spirit of Earth. Among the people were star gazers, observing the cycles of the cosmos to time their ceremonies. Hopi-Tewa pottery reflects world views related to the past, present and future of over a hundred clans.

"Woman's eagle tail skirt" design, ca. 1900 Photograph by Richard M. Howard.

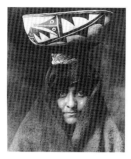

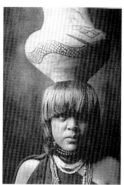

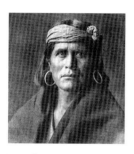

Top: "A Zuni woman with feast bowl," ca. 1926.
Middle: "Tewa woman from San Ildefonso," ca. 1926.
Bottom: "A Walpi man," ca. 1922.
Photos by Edward Curtis.
Courtesy of Rainbow Man, Bob & Marianne Kapoun.

The *Kokop,* "Firewood" people, came from New Mexico. Their related clans include: the *Isauu* Coyote, *Kwewu* Wolf, *Sikyataiyo* Yellow-fox, *Letaiyo* Gray-fox, Masi Maasaw Earth Spirit, *Tuvou* Pinion, *Hoko* Juniper, *Awata* Bow, *Sikyatci* Yellow-bird, and *Tuvatci* bird, as well as the *Zrohono* and *Eototo,* for which we have no translation.

Alexander Stephen recorded in the 1890s that the *Isauu* Coyote Clan was involved in the development of Sikyatki Polychrome. The clan settled in the village of Sikyatki and brought with them a beautiful pottery tradition later revived by Nampeyo.

"A Hopi mother," ca. 1922, by Edward Curtis, Courtesy of Rainbow Man, Bob and Marianne Kapoun.

Katci, chief of the Kokop Clan at Walpi at the time of Nampeyo, ca. 1890, said his people originally had come from Jemez Pueblo in New Mexico or from related villages on the Jemez Plateau. They lived in temporary villages near present day Keams Canyon and Eighteen-Mile Spring, before settling permanently at Sikyatki during the fourteenth century. The ruins of Sikyatki can still be seen about two miles north of Polacca.

What happened to the village of Sikyatki? Why was it abandoned? According to Chief Katci, when Sikyatki was at the height of its importance, a Walpi man brutally hacked off the hair of one of a group of Sikyatki Runner Kachinas who were at Walpi for a ceremonial race. The Sikyatki man was so furiously angry at this indignity to a Kachina that he vowed vengeance on the man from Walpi.

"Soon thereafter, visiting Walpi men challenged the men of Sikyatki to a race. The vengeful Sikyatki man emerged as Runner Kachina in search of his Walpi rival. He could not find him. In a state of revengeful rage, he spotted his foe's sister, "seized her and, with his sharp stone knife, cut off her head." The Walpi people returned horrified back to their own village.

Thus began a feud between Walpi and Sikyatki. The conflict grew worse over time. Some accounts claim the chief of Sikyatki himself grew concerned that his own people were losing sight of their humble philosophy of living respectfully, close to the Earth. The climax of the story came when the Walpi people attacked and burned Sikyatki sometime during the 15th century. Walpi men reportedly smeared the Sikyatki houses with pine sap, set them on fire and destroyed the village.

Some claim that all the Sikyatki people were killed. Others point out that Kokop clans and societies are integrated today at Walpi and other Hopi villages. Tewa elder Albert Yava explained simply, "The people of Sikyatki had to go away because of evil things..."

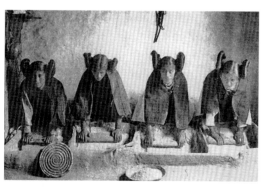

"Grinding corn meal," ca. 1921, by Edward Curtis.
Courtesy of Rainbow Man, Bob & Marianne Kapoun.

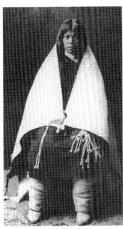

"Hopi bride," ca. 1922, by Edward Curtis. Courtesy of Rainbow Man, Bob and Marianne Kapoun.

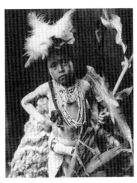

"Awaiting the return of the snake racers," ca. 1922, by Edward Curtis. Courtesy of Rainbow Man, Bob & Marianne Kapoun.

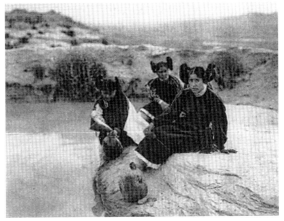

"Evening in Hopiland," ca. 1921, by Edward Curtis. Courtesy of Rainbow Man, Bob and Marianne Kapoun.

The Tewa ancestors of Nampeyo did not move from New Mexico to Hopiland until after the Pueblo Revolt of 1680, when the Pueblo people united to regain their freedom from Spanish rule. Around this time, the Hopi sent three delegations to New Mexico to ask some of the Tewa to move to Hopiland. Their purpose was to attract the famed Tewa warriors to become the defenders of First Mesa against groups of Utes, Paiutes and Navajo who were raiding Hopiland. The Tewa won a famous battle against the Utes and eventually settled atop First Mesa, founding the village of Hano, also known as Tewa Village.

Twelve years later the Spanish returned for the "reconquest" of the Southwest. Spanish soldiers arrived at Hopi and sought their revenge against participants in the Pueblo Revolt of 1680. Over a hundred Hopis were executed by Spanish soldiers. However, the Spanish never gained a permanent foothold at Hopi.

Around 1700, the Catholic village of Awatovi was destroyed in a manner similar to the earlier destruction of Sikyatki. The survivors were said to have been integrated into villages at Hopi.

Early in 1700's, another group of people from Jemez moved to Hopi to escape the Spanish reconquest in New Mexico. Toward the end of the century, the Wild Mustard Clan, Roadrunner Clan and others, who had moved from the area east of Santa Fe to Hopiland, founded a new pueblo, Sichomovi, next to Tewa Village on First Mesa. Sichomovi, Walpi, and Hano or Tewa Village are the pueblos now atop First Mesa.

Awatovi, black-on-yellow bowl, ca. 1350 with naktci or cloud design. Photograph by Richard M. Howard.

In the late 19th century, the village of Sikyatki was excavated by Jesse Walter Fewkes. Beautiful Sikyatki Polychrome pottery was unearthed. Nampeyo and potters from her Corn Clan were among those who were inspired by the remarkable designs and shapes of the old pots. These potters created a revival of Sikyatki Polychrome, the style of pottery most popular at Hopi today.

CHAPTER TWO:
"How do we evaluate Hopi-Tewa pottery?"

Photographs by
Steve Elmore

The original price of every Hopi-Tewa pottery is set by the artists themselves. They say, "This one is $____." When we, the collectors, say yes, then an initial value has been set. Traders may try to negotiate a group price for a large number of pots purchased at one time. Sometimes, especially in the old days, trade goods were offered and exchanged. Among the favored trade items are parrot feathers, jewelry, turquoise, coral, and hand-woven textiles. The spirit of old time trading is still alive today.

When pottery or any other artwork is resold a "market value" is determined. The "wholesale price" is an amount a dealer is willing to pay. The "retail price" is the amount a collector is willing to pay. The difference between wholesale and retail prices ranges from 10% for very desirable items to double the purchase price — called "keystone" — for more general items.

"Auction value" is determined when a group of collectors and dealers compete for a collection of items. For the purpose of this book, we have collected over 20 years of auction results and have compiled them under each artist's name. We include detailed descriptions of each item, the pre-auction estimate, and the auction results. By analyzing auction results for comparable pots sold over the years, one can estimate the average yearly appreciation rate.

The value of Hopi-Tewa pottery has risen steadily over the past century. Seventy-five years ago, Nampeyo used to charge 50 cents for a twelve inch seed jar. Today, the same pot might bring $20,000 - 30,000. Some contemporary potters, who a few years ago received a hundred dollars for a twelve inch seed jar, today receive thousands of dollars per pot. Demand often exceeds limited supplies. The result? Prices are going up steadily.

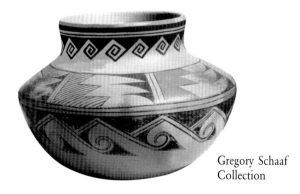

Gregory Schaaf
Collection

Top Ten Points in Evaluating Hopi-Tewa Pottery

People often ask, "What should I consider when buying Indian art?" My first advise is, "Buy what brings you joy. What is valuable to you, in your heart, is most important." Indian art appraisers also consider the following 10 points:

1. Who? An authentic Rembrandt painting probably is worth much more than a painting that just looks like a Rembrandt painting. The same is true for Hopi-Tewa pottery. We first consider, is this an authentic, handmade Hopi-Tewa pottery? Some artists in Mexico, especially from Mata Ortiz near Casas Grandes, paint Hopi-Tewa designs on some of their pottery. Some non-Indians traditionally fire "Hopi style" pottery. Some companies manufacture unfired "green-ware" ceramics with assembly lines of minimum wage workers who paint Hopi-Tewa or Southwest style designs. Other companies use stencils or photo-mechanical methods to transfer Hopi-Tewa designs onto mass market ceramics. This brings into question the issue of intellectual property rights.

Casas Grandes pot
signed Hopi

In addressing the question of authenticity, the signature or hallmark painted on the bottom is important. Look up the names of the artists in this book. Learn about their lives and artistic achievements. You may wish to go to Hopiland and personally meet the artists. Hopi potters generally love to re-examine their earlier pots. For some potters, it is like a family reunion. "Oh, look at my babies," one grandmother exclaimed, cradling each pot, one at a time, in her hands. The artists themselves can help determine authenticity.

Most Hopi-Tewa pots before 1950 do not bear signatures. Nampeyo rarely signed her pots. In later years (1930s), a family member sometimes applied Nampeyo's name to the bottom of a pot, because Nampeyo herself was blind and could not paint. Some early collectors signed pots to remember the names of the artists. Some unscrupulous, early traders wrote Nampeyo on the bottom of unsigned Hopi-Tewa pottery, hoping the name of the famous artist would bring a higher price. Fortunately, we have not seen many outright forgeries, as is common among old style Kachina dolls.

Learn the terms for unsigned pottery. "Documented by" means there is documentary evidence as to its authenticity and proper attribution. "Attributed to" means someone, possibly a recognized authority, has given his opinion as to who made the piece. "Probably by" means someone thinks it is by a particular artist. "In the style of" means that the piece is similar to, but probably not by the artist.

"Southwest style" means it is a reproduction, probably by non-Indian craftsmen or machine made. Most Indian art collectors steer clear of "Southwest style" reproductions. The American Indian Arts & Crafts Act is intended to prevent misrepresentation of Indian art.

Signatures and hallmarks on original Hopi-Tewa pots have been digitally scanned with a computer and included in this book as a aid to authenticity. Compare these pictures with the signatures on the bottoms of your pots, though signatures do vary over time. Eventually, we hope to include signatures from early, middle and late periods from an artist's career to help provide keys to dating.

2. Artistic Design and Aesthetic Quality? When certain qualities come together for you personally, you have found a work of art that will bring you much pleasure and real value. Some collectors ask, "Does this art work "sing" to you?"

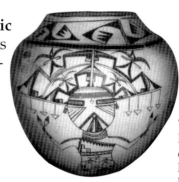

"Butterfly Maiden," Polacca Polychrome, ca. 1890. Photograph by Richard M. Howard

3. Size? Size is a an important determinant in valuing Hopi-Tewa pottery. Larger pots are generally worth much more than smaller ones, not only because they are harder to make, but because the risk of loss to the potter is much greater. Pots larger than fourteen inches are considered huge and very valuable, because fewer large pots survive the firing process unbroken.

4. Where? Buying directly from the artist provides a unique experience. Visitors to Hopiland may stay at the Hopi Cultural Center Motel, Keams Canyon Motel or the Campgrounds on Second Mesa. Some artists participate in annual Indian art shows and sales. These include Santa Fe Indian Market, Eight Northern Indian Pueblos Artist & Craftsman Show, the Heard Museum Show and the "Hopi Show" at the Museum of Northern Arizona.

Hopi-Tewa pottery is distributed through shops and galleries in Hopiland, and throughout the Southwest, and elsewhere. Many museums have quality shops.

Schedules of events, museum and gallery listings are available in several magazines, including *American Indian Art*

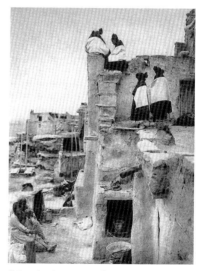

"On the house top," ca. 1922, by Edward Curtis. Courtesy of Rainbow Man, Bob and Marianne Kapoun.

Magazine, Indian Artist Magazine, Native Peoples Magazine, New Mexican Magazine, Arizona Highways, Santa Fean, Indian Trader and others.

5. Condition? Pottery specialist Dick Howard recently commented at a meeting of Santa Fe's Indian Art Collector's Circle: "If you want a perfect pot, buy machine-made. Handmade pots are never perfect."

FORMS: Consider the balance and symmetry of the pot. The most difficult are low shouldered seed jars and outward flaring rims.

DAMAGE: An uncracked pot often will "ring" when tapped lightly. A cracked pot will not. Small cracks are called "hairline." Damage lowers the value.

PAINT: Traditional paints are fragile. The surface may flake off or be scratched. Older pots almost always have some paint loss. The older the pot, the more paint loss is expected. Each collector makes a decision as to how much paint loss is acceptable.

FIRE CLOUDS: When too much smoke is formed by gusts of wind, darkened areas can appear on the surface. Some color variations are desirable and can add to the beauty of a pot. However, if the fire cloud obscures the design, the value can be lowered. Fire clouds are usually the result of traditional firing and are generally not found on kiln fired pottery. Traditional potters discourage kiln firing which may devalue their pottery.

RESTORATIONS: Two philosophies exist. Archaeologists often prefer restorations that are clearly visible. Collectors often prefer restorations which match the original design and appearance of the pot. Some collectors prefer not to restore at all.

6. When? The age of a Hopi-Tewa pot often is not the most important variable to value, as in other art forms. One could group pottery into two categories: signed and unsigned. Most pre-1950 Hopi-Tewa pottery is unsigned. Some contemporary potters still do not sign their pots, although most do sign.

An artist's recent works may be their finest achievements and most valuable, especially the pots of contemporary masters. Rare early works also are prized. The question is: when did artists develop to a level of true excellence? And how long did they sustain the high quality of their pottery? Some of the greatest artists, including Nampeyo, still made pots when their eyesight failed, but turned over the painting of the pots to family members.

Sikyatki Jar, ca. 1375-1625.
Photograph by Richard M. Howard

7. Popularity? Museum exhibitions, gallery showings, exhibit catalogs, magazine articles, books and other media add to popularity. Collectors gather at sunrise on the first day of Indian Market to buy

their favorite artworks by their favorite artists. Indian art galleries and dealers promote their artists' popularity through advertising in magazines and exhibits. Artists sometime appear at openings; others do demonstrations. One of the purposes of this book is to promote the popularity of all the artists.

8. Awards? Competition to win awards is keen, especially Indian Market ribbons. But don't be too swayed by the presence of a ribbon, since it represents the esthetic judgment of one or two people. Try to understand why that piece was judged superior, but, in the end, make your own esthetic judgment on what you would enjoy.

9. Technical Fineness? Evaluate the overall fineness of technical execution. Was each step successful in the techniques used to produce pottery? Was the clay good and well prepared? Were the coils laid down in a well balanced manner? How thin is the pot? Is the design well painted? The quality of polish is important in pottery. Just how fine is this pot in relationship to the best of Hopi-Tewa pottery?

10. Rarity? Some artists produce few artworks. When the supply is low, demand may grow. Values rise with competition among collectors.

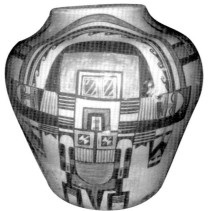

Large Polychrome Jar, ca. 1920.
Photograph by Richard M. Howard

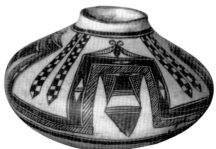

Polacca Jar, sold by Thomas Keams in 1892.
Photograph by Richard M. Howard

CHAPTER THREE:
"How is Hopi-Tewa Pottery made?"

Shortly after the turn of the century, Nampeyo was visited by two anthropologists — Jesse Walter Fewkes and Walter Hough. Both men represented the United States National Museum, part of the Smithsonian Institution. A six-page account of Nampeyo's pottery making techniques was recorded and later published by Hough in 1915. His book, *The Hopi Indians,* is one of the first full-length texts devoted exclusively to the Hopi and Tewa people.

The following introduction to Hopi-Tewa pottery making techniques and materials incorporates Hough's writings. A later contribution to this subject was made in 1977 by Kathleen E. Gratz in cooperation with the Museum of Northern Arizona. Contemporary Hopi-Tewa potters, especially Priscilla Nampeyo, helped us better understand the tradition of Hopi pottery making. This section encourages discussion of those techniques today considered "traditional." The importance of maintaining traditional techniques is encouraged by many elder potters. We respect their teachings.

Our approach to Hopi-Tewa pottery techniques is organized under the following ten topics:

1. Gathering & Preparing the Clay
2. Starting the Pot
3. Coiling
4. Smoothing
5. Drying
6. Sanding
7. First Polishing
8. Painting
9. Second Polishing
10. Firing

 GATHERING & PREPARING THE CLAY

Walter Hough recorded: "Nampeyo was prepared to instruct. Samples of the various clays were at hand and the novice was initiated into the qualities of the *hisat chuoka,* or ancient clay, white, unctuous and fragrant, to which the ancient Sikyatki potters owed the perfection of their ware;

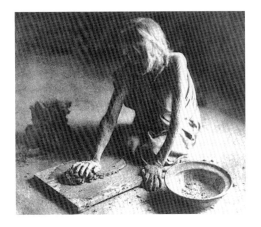

"Potter mixing clay," ca. 1922. Courtesy of Rainbow Man, Bob and Marianne Kapoun.

the reddish clay, *siwu chuoka,* also from Sikyatki; the iron-stained clay, *choku chuoka,* a white clay with which vessels are coated for finishing and decoration, coming from about miles southeast of Walpi. In contrast with Nampeyo's four clays the Hopi women use only two, a gray body clay, *chaka-butska,* and a white slip clay, *kutsatsuka.*"

"Continuing her instructions Nampeyo transferred a handful of well-soaked ancient clay from a bowl on the floor by her side to a smooth, flat stone, like those found in the ruined pueblos. The clay was thrust forward by the base of the right hand and brought back by the hooked fingers, the stones, sticks and hairs being carefully removed. After sufficient working the clay was daubed on a board, which was carried out, slanted against the house, and submitted to the all-drying Tusayan sun and air. In a short time the clay was transferred from the board to a slab of stone and applied in the same way, the reason being a minor one known to Nampeyo, — perhaps because the clay after drying to a certain degree may adhere better to stone than to wood. Sooner than anyone merely acquainted with the desiccating properties of the moisture-laden air of the East might imagine, the clay was ready to work and the plastic mass was ductile under the fingers of the potter."

 STARTING THE POT

In ancient times, baskets were sometimes used as a form to start the bottom of a pottery. This technique probably is over a thousand years old. Baskets are a much older art form, dating back over 10,000 years in the Southwest.

Walter Hough recorded from Nampeyo: "The concave dish called *tabipi,* in which she began the coiled vessel and which turns easily on its curved bottom, seems to be the nearest approach of the Pueblos to the potter's wheel."

In 1977, Kathleen E. Gratz discussed a technique that did not use a tabipi.

 COILING

Walter Hough recorded: "Nampeyo set out first to show the process of coiling a vessel. The even "ropes" of clay were rolled out from her smooth palms in a marvelous way, and the efforts to rival excited a smile

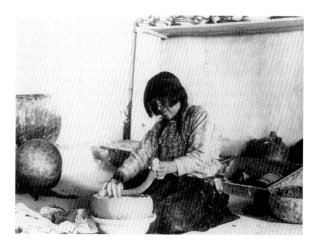

"Nampeyo coiling a clay jar," by Adam Clark Vroman, 1901. Smithsonian Institution Photo #32357-F

from the family sitting around as spectators.

"The seeming traces of unobliterated coiling of the bases of some vessels may be the imprints from the coils of the *tabipi.* As the vessel was a small one, the coiling proceeded to the finish and the interims of drying as observed in the manufacture of large jars were not necessary."

In 1977, Kathleen E. Gratz illustrated a "Production Sequence" with photographs of Garnet Pavatea. This respected potter demonstrated at the Museum of Northern Arizona. The first photo shows her making coils by rolling the clay between her palms. Gratz noted the size of the coil was about 3/4 inch in diameter and long enough to fit once around the rim of the pottery being made. The coils are built one atop the next.

Forming a Canteen:

Walter Hough recorded from his visit with Nampeyo: "Then a toy canteen was begun by taking a lump of clay which, by modeling, soon assumed the shape of the low vase. With a small stick, a hole was punched through each side, a roll of clay was doubled for the handles, the ends thrust through the holes and smoothed down inside the vase, through the opening. The neck of the canteen was inserted in a similar way. Now the problem was to close the opening in this soft vessel from the outside. Nampeyo threw a coil around the edge of the opening, pressing the layers together, gradually drawing in, making the orifices smaller until it presented a funnel shape. Then the funnel was pressed toward the body of the canteen, the edges closed together, soldered, smoothed, and presto! it was done and all traces of handling hidden. Anyone knowing the difficulties will appreciate this surprisingly dexterous piece of manipulation. Afterward, Nampeyo made a small vase-shaped vessel, by modeling alone, without the addition of coiling as in the shaping of the canteen."

 SMOOTHING

Walter Hough recorded from Nampeyo: "Then gourd smoothers, *tuhupbi,* were employed to close up the coiling grooves, and were always backed from the outside or inside by the fingers."

Kathleen Gratz noted the continuation of the tradition of using gourd smoothers in the 1970's. In 1998, the author observed Dextra Quotskuyva's husband making gourd smoothers. He shaped them to Dextra's specifications. She examined them closely. They were about 3 to 4 inches in length, shaped similar to a cake frosting smoother. The edges were fine and well sanded.

 DRYING

Walter Hough recorded from Nampeyo: "Finally the smooth "green" vessel was set aside to dry." Gratz indicated that pots were

allowed to partly dry until "leather hard." Then the pots are scraped with a piece of pottery sherd, butter knife or similar tool.

SANDING

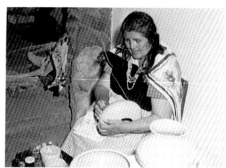

In the 1970s, Gratz recorded the continued use of sandstone. Some potters still use sandstone, but sandpaper being wrapped around a small block of wood is commonly used.

"Garnet Pavatea sanding her pot." Courtesy of the Museum of Northern Arizona. (MNA #C-100.34)

FIRST POLISHING

For a fine polish, river stones traditionally are used. Some are made of quartzite. These polishing stones sometimes are passed down from generation to generation. A personal relationship often is formed between potters and their polishing stones. Today, some use stones polished in a rock tumbler. Polishing pottery gives a smooth and shiny surface.

PAINTING

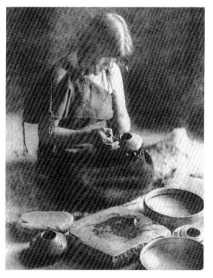

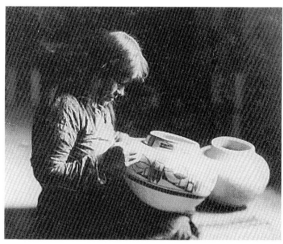

"Nampeyo painting designs," ca. 1900, by Edward Curtis. Courtesy of Rainbow Man, Bob and Marianne Kapoun.

Walter Hough recorded from Nampeyo: "Nampeyo exhibited samples of her paints, of which she knows only red and dark brown [and white]. The red paint is yellow ochre, called *sikyatho*, turning red on firing. It was mixed on a concave stone with water. The dark brown paint is made from *toho*, an iron stone brought from a distant mesa. It was ground on a slab with a medium made from the seed of the tansy mustard *(Sisymbrium canescens)*.

"The brushes were two strips of yucca, *mohu,* one for each color. With these slender means, without measurement, Nampeyo rapidly covered the vessels with designs, either geometrical [more abstract symbols] or conventionalized [more pictorial symbols], human or cult [spiritual], — figures or symbols. The narrow brush, held like a painter's striper, is effective for fine lines. In broad lines or wide portions of the decoration, the outlines are sharply defined and the spaces are filled in. No mistakes are made, for emendations and corrections are impossible.

"[In the early 1900s and before] The ware when it becomes sufficiently dry must receive a wash of the white clay called *hopi chuoka or kutsatsuka,* which burns white...The use of the glaring white slip clay as a ground for decoration was probably brought from the Rio Grande by the Tewa, ancient Hopi ware [Sikyatki clans also migrated from New Mexico] is more artistic, being polished on the body or paste, which usually blends in harmony with the decoration."

SECOND POLISHING

Walter Hough recorded from Nampeyo: "Thereupon it is carefully polished with a smooth pebble, shining from long use, and is ready for decoration."

Although Gratz indicated only polishing before painting, I have observed potters polishing on top of the freshly painted red designs. Jake Koopee paints small areas, then polishes them soon after the surface dries a little. This may be one reason why his painted designs firmly adhere to the surface of his pots without flaking off.

FIRING

Right: "Nampeyo firing pottery," ca. 1900. Courtesy of Rainbow Man, Bob and Marianne Kapoun.
Below: "Nampeyo building a wall of fuel," by Adam Clark Vroman, 1901. Smithsonian Institution Photo #34188-A.

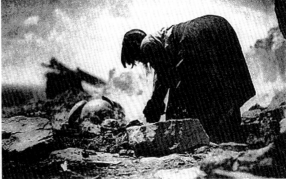

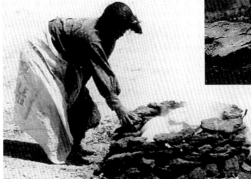

Before firing, the pots are warmed. Priscilla Nampeyo showed me the cast iron oven used by her, her mother Rachel Nampeyo and grandmother Annie Healing. The pots are placed inside to warm them a little. This lowers the amount of breakage. Gratz indicated in

the 1970s, pots also were simply warmed next to the fire.

Walter Hough recorded from an unnamed Hopi woman: "The Hopi have an odd superstition that if any one speaks above a whisper during the burning of pottery, the spirit inhabiting the vessel will cause it to break. No doubt the potter had this in mind while she was whispering and was using all her blandishments to induce the small spirits to be good.

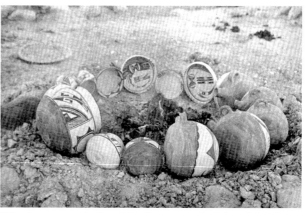

"Heating up pots before firing," ca. 1900, by Edward Curtis. Courtesy of Rainbow Man, Bob and Marianne Kapoun.

"Quite opportunely the next day, an invitation to see the burning of pottery came from an aged potter who resides at the Sun Spring. When the great Hopi clock reached the appointed place in the heavens, the bowed yet active potter was found getting ready for the important work of firing the ware. In the heap of cinders, ashes, and bits of rock left from former firings, the little old woman scooped out a concave ring. Nearby was a heap of slabs of dry sheep's droppings, quarried from the floor of a fold perched on a ledge high up the mesa and brought down in the indispensable blanket. In the center of the concave kiln floor a heap of fuel was ignited by the aid of some frayed cedar bark and a borrowed match from the opportune *Pahana*, "people of the far water," the name by which white men are known. When the fire was well established, it was gradually spread over the floor to near the margin and the decorated bowls brought from the house were set up around the concave sides toward the fire, while the potter brought, in her blanket, a back load of friable sandstone from a neighboring hillock.

"Under the first heat the ware turned from white to purple gray or lavender, gradually assuming a lead color. They were soon heated enough and were ready for the kiln. Guarding her hand by the interposition of a fold of the blanket, the potter set the vessels, now quite unattractive, aside, proceeded to rake the fire flat and laid theron fragments of stone at intervals to serve as rests or stilts for the ware. Larger vessels were set over smaller and all were arranged as compactly as possible. Piece by piece, dexterously as a mason, the potter built around the vessels a wall of fuel, narrowing at the top, till a few slabs completed the dome of the structure, itself kiln and fuel.

"Care was taken not to allow the fuel to touch the vessels, as a discoloration of the ware would result, which might subject the potter to the shafts of ridicule. Gradually the fire from below creeps up the walls till the interior is aglow and the ware becomes red hot. Little attention is now needed except closing burned out apertures with new

pieces of fuel; the potter, who before, during the careful and exact dispositions, has been giving little ejaculations as though talking to a small child, visits the kiln intermittently from the nearby house. Here she seeks refuge from the penetrating, unaromatic smoke and the blazing sun.

"She remarked that when the sun should hang over the brow of the mesa at the height indicated by her laborious fingers, the ware would be baked, the kiln a heap of ashes, the yellow decoration a lively red and the black a dark brown on a rich cream color ground. Next day, the true foresight, she brought her quaint wares to the camp and made a good bargain for them, incidentally asking, "Matches all gone?"

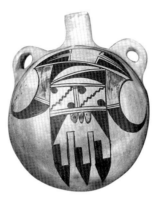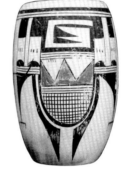

Frank Kinsel Collection

A Note from the Author _____

Please recognize that this is only the first edition, a text that will be revised and expanded as new artists emerge and more information comes forth. We encourage your direct participation by offering suggestions, photographs and oral history traditions. Our intention is to personalize Indian artists, to let people get to know them better. Friendships I have developed in the Indian art world have brought deeper meaning to my life. I wish to thank each and everyone of them for enriching my existence and beautifying the world.

Value Guides to living artists are not included out of respect to the wishes of the potters. Please forgive any errors in this regard.

ARTIST SURVEY
AMERICAN INDIAN ART SERIES

If you have additional names, further information or corrections to offer, please contact:

Gregory Schaaf, Ph.D., Director, Center for Indigenous Arts & Cultures
A division of Southwest Learning Centers, Inc.
a non-profit, educational organization est. 1972
P.O. Box 8627, Santa Fe, NM 87504-8627
or call (505) 473-5375, FAX 505-424-1025, email - Indians@nets.com

OPTIONAL: Please submit photographs of artists and artwork.

Artist's Name(s) _____ Tribe/Nation _____

Language _____ Village _____ Clan _____

Active Years _____

Types of artwork _____

Lifespan/Birth Date & Place _____

Address/Phone # _____

Father _____ Mother _____ Spouse _____

Children _____

Education _____

Teacher(s) of artform _____

Student(s) you have taught artform _____

Career _____

Honors/Awards _____

Demonstrations _____

Exhibitions _____

Collections _____

Techniques _____

Materials _____

Favorite Designs _____

Values/Prices _____

Publications _____

Galleries _____

I enjoy creating artwork, because _____

Yes, I give permission for the information & photos to be published in the *American Indian Art Series.*

Signed _____ Date _____

(Please write additional thoughts and feelings on another page.)

The Artists

Karen Abeita holds her jar
with pottery sherd design.
Photo by and courtesy of Jill
Giller, Native American
Collections, Denver, CO

Karen Lynne Abeita-Daw

(Tewa/Isleta, Kachina/Parrot Clan, Tewa Village: active 1984-present: black
and red on yellow seed jars, piki bowls)
BORN: September 23, 1960 at Albuquerque
FAMILY: Granddaughter of Mamie Nahoodyce; wife of Darryl Daw. See Tewa
Kachina/Parrot Clan-Extended Family Tree.
AWARDS: Best of Show, "Invitational," Lawrence, KA, 1995; numerous other awards.
DEMONSTRATIONS: University of Pennsylvania, Philadelphia, PA.
EXHIBITIONS: 1992-98 "Indian Market," Santa Fe; Gallup Ceremonial, Crow
Canyon, Chicago, San Diego
FAVORITE DESIGNS: Polik Mana - Butterfly Maiden, pottery sherds, feathers,
eagle tail feather skirt, Nachwach - clan handshake, clouds, song birds

*"*I enjoy creating pottery, because it's me! You put your heart into
your work, and in the end, it'll reward you also. And never for-
get to pray! Thanks to the earth for letting me be who I am."

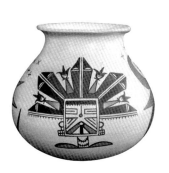
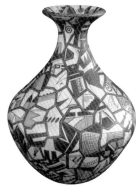
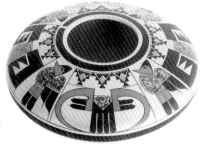

Photographs by Bill Bonebrake.
Courtesy of Jill Giller,
Native American Collections, Denver, CO

Alberta Adams

(active 1980-present: polychrome wedding vases, bowls)

Alice Adams

(Tewa, Tewa Village, active 1950-1985+: bowls)
VALUES: On March 18, 1988, bowl, parrot design, ca. 1965 (2.5 x 9"), est. $100-200,
sold for $155 at Allard, #483.
On March 15, 1991, signed, bowl, ca. 1950 (4 x 11"), est. $200-400, sold for $80 at
Allard, #722
On December 5, 1991, 8 Hopi pots by Alice Adams, V. Dewakuku, B. Monongye,
Loretta Huma, including a seed jar, bean pot, ladle, mug and bowls with feather
designs, the largest (5 1/2 x 5"), est. $200-300 sold for $192.50 at Butterfield &
Butterfield, sale #4664E, #883.

Dolly Ann Adams

(active 1940: miniature pots)
VALUES: On October 14, 1988, signed, 2 miniature pots, ca. 1940 (2 x 3"), sold for
$17.50 at Munn, #134.

Donna Adams
(active 1980s)

Emma Adams
(Hopi, Butterfly Clan, Sichomovi, active 1950-1960: piki bowls)
FAMILY: Grandmother of Emma Naha; Mother of Marcella Kahe, Pansy Ovah, Marty Adams, Burke Adams, Laverne Chaca, and Ramona Ami.
COLLECTIONS: Museum of Northern Arizona, piki bowl, #E5759, 1957.
PHOTOGRAPHS: Portrait (1960), neg. # 3076, Museum of Northern Arizona
VALUES: On March 18, 1988, bowl, bird design (4 x 14"), est. $200-400, sold for $455 at Allard, #535.
PUBLICATIONS: Allen 1984:116

Photograph by Marc Gaede
Courtesy of the Museum of
Northern Arizona.
(neg. #77.0276)

Sadie Adams
(Flower Woman, signs with Flower symbol/
5 petals, some with red dot in the center)
(Tewa, Kachina/Parrot Clan, Tewa Village: active 1930-1981: black and red on yellow jars, bowls, lamps, tiles, red cookie jars, redware bowls, plates, cups and saucers)
LIFESPAN: November 28, 1905-December 25, 1995
FAMILY: See Tewa Kachina/Parrot Clan-Extended Family.
AWARDS: Honorable Mention, "Hopi Show," Museum of Northern Arizona, 1942; Honorable Mention, "Third Scottsdale National Indian Arts Exhibition," Executive House, Scottsdale, AZ. Section C - Crafts, Classification I - Pottery, Division I - Traditional, 1964.

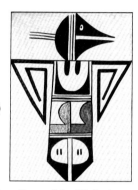

Gregory Schaaf Collection

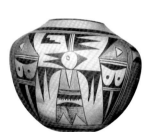

Attrib. to Sadie Adams
Photograph by Steve Elmore

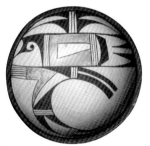

Attrib. by Richard M. Howard
Gregory Schaaf Collection

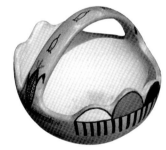

Richard M. Howard
Collection

EXHIBITIONS:
 1942 "Hopi Show," Museum of Northern Arizona
 1964 "Third Scottsdale National Indian Arts Exhibition," Executive House, Scottsdale, AZ
 1995-1997 "Following the Sun and Moon - Hopi Katsina Dolls," Heard Museum
 1997 "Hopi Traditions in Pottery and Painting Honoring Grace Chapella, Potter (1874-)," NU Masters Gallery, Alhambra, CA
COLLECTIONS: Museum of Northern Arizona, black and red on yellow jar, #OC2781, 1930; tile, E188a, 1933; tile, E188b, 1933; tile, E426, 1936; black and red on yellow jar, #E431, 1936; tile, ; black and red on yellow bowl, E516, 1939; #E1407, 1930-1945; tile, #E1408, 1930-1945; tile, #E1409, 1930-1945; red cookie jar, #1467, 1958; tile, #E1933, 1933-43; redware bowl, #E2221, 1961; 4 tiles, #E2582-2583, 2590-2591, 1930; tile, #E2995, 1955; 2 black on red jars, #E3542-3543, 1967; black and red on yellow jar, #E7437, 1930-1970; black and red on yellow jar, #E7863, 1930-1940; black and red on yellow jar, #E7864, 1930-1940; 8 tiles, #E8563-8570, 1930-1935; Dr. Gregory

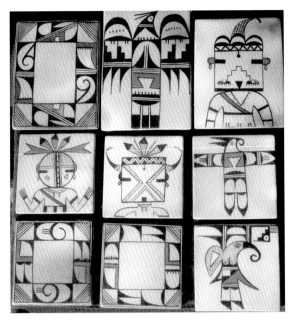

Photograph by and collection
of Richard M. Howard

Schaaf Collection, Santa Fe; Heard Museum , Phoenix, AZ, bowl, #NA-SW-HO-A3-7; pot with lid, #NA-SW-HO-A7-76; jar, #NA-SW-HO-A7-72; 2 ceramic tiles, #NA-SW-HO-A7-155, #NA-SW-HO-A7-156, ca 1985; jar, #NA-SW-HO-A7-51.
FAVORITE DESIGNS: Thunderbirds, clouds, and feathers.
VALUES: On February 6, 1998, black on cream lidded sugar jar & creamer with loop handles, ca. 1970, est. $200-300, sold for $247.50 at Munn, #131.

On October 17, 1996, a black & red on yellow jar with a feather design, signed Sadie Adams with Flower Hallmark (10 1/2" h.), est. $2,000-3,000, sold for $1,380 at Sotheby's, sale #6898, #251.

In 1996, a pair of cylindrical jars made into lamp bases with stylized bird designs, ca. 1940-50, (8.5 x 5"), est. $750-1,000, sold for $550 at Munn February 1996:78, #776.

On March 25, 1994, a polychrome ashtray (7.25"), ca. 1940, est. $125-250, sold for $137.50, at Allard, #400K.

On May 19, 1995, a pair of jars made into lamp bases, feathers, tail feathers & wave designs, signed with Flower Hallmark (9 x 8"), est. $600-1,000, sold for $1,100 at Munn, #953.

On October 16, 1992, a black on white bowl with two handles, tail feathers & wave designs, signed with Flower Hallmark (3 x 6"), est. $50-100, sold for $35 at Munn, #73.

On March 16, 1990, signed Flower Woman, unusual oval bowl with circular handles, spiral rain design, ca. 1935 (6 X 12"), est. $250-500, sold for $267.50 at Allard, #79.

On March 17, 1989, signed, polychrome bowl, bird in profile design, ca. 1950 (2.5 x 4"), est. $50-00, sold for $110 at Allard, #711.

On March 22, 1985, signed, polychrome jar, bird design (7 x 8"), sold for $175 at Allard, #202.

On March 22, 1985, signed, polychrome jar, bird design (6 x 8"), sold for $35 at Allard, #256.

On March 22, 1985, signed, polychrome jar, germination, tail feather and cloud design (7 x7"), sold for $95 at Allard, #551.

On March 23, 1984, signed, black & red on yellow bowl, germination and rain design, ca. 1940 (4 x 7"), sold for $95 at Allard, #557.

In July, 1942, a set of 5 black and red on yellow tiles (7 x 5"), with an Honorable Mention ribbon, "Hopi Show," Museum of Northern Arizona, Flagstaff, sold for $2.50 @ 50 cents each.
PHOTOGRAPHS: Portrait (1957), neg. # 9536, Museum of Northern Arizona
PUBLICATIONS: Allen 1984:105-107; Collins 1977:11; Dedera 1985:27; Gaede 1977:18-21; Gault 1991:15; Hayes & Blom 1996:66-75; Mather 1990:37; Trimble 1987:101; Wilson 1974:40.
BIOGRAPHICAL DATABASES: "Hopi-Tewa Potters," Native American Resource Collection, Heard Museum, Phoenix.

In a March 1998 interview, master potter Dextra Quotsquyva admired her work, "Sadie was a really good potter. She did those ones with the flaring rim and flat ones. They're the hardest."

Daughter Lorna Lomakema said, "My mother was the greatest person. After our father died when I was seven, she raised us all by herself, supporting us with her pottery. She did everything for us kids. To help me go to nursing school, she took her pots, went to Lorenzo Hubbel and asked for a loan. She made him pots for years. She was a great mother."

B. Addington
(Snake hallmark)
(Incised redware)

Gregory Schaaf
Collection

Linda Addington
(active 1990-present)
PUBLICATIONS: Dillingham 1994:60-61

Cedric Albert
(Dawavendewa, Dawa Gui Va, "Beauty of the Sunrise")
(Hopi, Corn Clan, Moencopi, active 1980-present)
BORN: 1960

Florine Allison
(Hopi, Fire/Coyote Clan, Polacca, black on yellow)

Gregory Schaaf
Collection

Eleanor Ami
(Tewa, Tewa Village, active 1960-1980: canteens, pottery rattles)
COLLECTIONS: Museum of Northern Arizona, rattle, #E5484, 1971; canteen, #E7872, 1977.
PUBLICATIONS: Allen 1984:116, 121

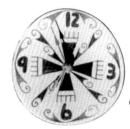

Lloyd Ami
(1990-present: clock faces)

Gregory Schaaf Collection

Photograph by Tom Tallant.
Courtesy of
Canyon Country Originals,
http://www.canyonart.com/

Loren Ami
(Tewa/Hopi, active 1990-present: polychrome jars, bowls, canteens)
FAMILY: Grandmother - Eleanor Ami, Companion - Hisi Nampeyo/Camille Quotskuyva
POTTERY TEACHER: Dextra Quotskuyva
EXHIBITIONS:
 1991 Roy Boyd Gallery, Chicago, Ill.
 1995 Lovena Ohl Gallery, Scottsdale, AZ
 1996 Bill Foust Gallery, Scottsdale, AZ
 Adobe East Gallery, Summit, NJ
 "The Nampeyo Legacy Continues," Martha Hopkins Struever, Santa Fe
 1997 Adobe East Gallery, Summit NJ
 Otowi Trading Co., Santa Fe, NM
 "Succeeding Generations," Faust Gallery, Scottsdale, AZ
BIOGRAPHICAL DATABASES: "Hopi-Tewa Potters," Native American Resource Collection, Heard Museum, Phoenix.

L oren Ami was raised away from Hopiland. He grew up in Santa Fe, where his mother worked for the Indian Health Service. Loren took a ceramic class in high school, beginning his interest in pottery. "He did exceptional work that was recognized

by his teachers."

For his senior year, Loren and his mother moved home to Hopi. He was reunited with his grandmother, Eleanor Ami, a fine potter. He reconnected with other family members who were potters, including Sadie Adams. Loren then met one of the top young potters, Camille Quotskuyva, who signs her pots "Hisi Nampeyo." Loren began assisting Camille in her pottery production. Camille's mother, Dextra Quotskuyva, "saw his talent and encouraged him to do his own work. Loren is an excellent student, taking her advice to heart...He continues to work with her as he progresses in his career."

Photograph by Bill Bonebrake. Courtesy of Jill Giller, Native American Collections, Denver, CO

"Loren paints his pottery with old, Sikyatki designs. He is especially known for his fine polychrome canteens... He is grateful for the talent he has been blessed with."

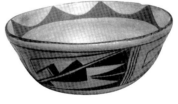

Mary Ami
(Buffalo Maiden)
(Tewa, Bear Clan, Tewa Village, active 1940-1980: polychrome seed jars)
BORN: 1919, adopted by Grace Chapella.
FAMILY: See Tewa Bear, Sand and Spider Clan Family Tree Chart.
FAVORITE DESIGNS: butterflies, rain
VALUES: On February 1, 1991, polychrome seed jar, butterfly & rain designs, ca. 1960 (3 x 8"), sold for $200 at Munn, #713.
PUBLICATIONS: Dillingham 1994:10-11
BIOGRAPHICAL DATABASES: "Hopi-Tewa Potters," Native American Resource Collection, Heard Museum

Gregory Schaaf Collection

Mettie Ami

Nettie Ami
(Hopi, Sichomovi, active 1940-1983: yellowware jars, black on red bowls, black and red on yellow jar, ladles)
COLLECTIONS: Museum of Northern Arizona, yellowware jar, #E3313, 1966; black on red bowl, #E3695, 1968; 2 black and red on yellow jars, #E5898a,b, 1972; ladle, #E7211, 1975.
PUBLICATIONS: Allen 1984:113-114, 116, 119

Norma Ami
(Hopi, Roadrunner Clan, Sichomovi, active 1950-1977+: black on yellow bowls, canteens)
COLLECTIONS: Museum of Northern Arizona, canteen, #E2241, 1961; black on yellow bowl, #E8562, 1950-1960.
VALUES: On September 27, 1985, signed, ladle, bird design, ca. 1975 (6.5 x 6.5"), est. $25-45, sold for $15 at Allard, #676.
PUBLICATIONS: Allen 1984:112, 121

Photograph by Angie Yan.

*Ramona Ami
Hopi*

Ramona Ami

(Hopi, Butterfly Clan, Sichomovi, active 1980s-present)
BORN: February 15, 1929
FAMILY: Daughter of Hale & Emma Adams; wife of
Alexander Ami; mother of Nadine Ami, Glenda Ami,
Barbara Ami & Carletta Josheama
FAVORITE DESIGNS: birds, butterflies and moths
AWARDS: Best of Division
EXHIBITIONS: Heard Museum, Phoenix, AZ; Sedona
Hopi Gathering, Sedona, AZ; Pueblo Grande; 1996-98 Eight
Northern Pueblos Artist & Craftsman Show, NM
GALLERIES: Agape, Heard Museum, McGee's Indian Art,
Huyanki, Sekakuku Trading Post.
PUBLICATIONS: Jacka & Jacka, 1998

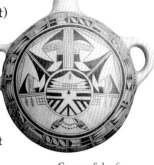

Gregory Schaaf
Collection

//It gives me pleasure to create pieces that I usually was not planning
on in the beginning. Working with clay gives me a good feeling."

Reva Polacca Ami

(Reva Ami Nampeyo)
(Pima/Tewa, active 1980-present: polychrome jars, vases)
BORN: 1964
FAMILY: Mother: Alice (Pima), Father - Harold Polacca Nampeyo, Sr. (Tewa), Son
- Clinton Polacca Nampeyo.
POTTERY TEACHER: Harold Polacca
PUBLICATIONS: Dillingham 1994:14-15
BIOGRAPHICAL DATABASES: "Hopi-Tewa Potters," Native American Resource
Collection, Heard Museum, Phoenix.

Rita Andrews

(Hopi, Asa/Chakwina, Sichomovi, active 1990-present: polychrome jars)
BORN: March 13, 1957 at Keams Canyon, AZ
FAMILY: Granddaughter of Erma Tawyesva; daughter of Heber and Revenna
Andrews; mother of Louvette, Curtis, and Po-Vee.
TEACHER: Erma Tawyesva
FAVORITE DESIGNS: hummingbirds, butterflies, swirls.

Animal with Spots hallmark

(black and red on yellow seed jars)
VALUES: On September 25, 1990, a black & red on yellow seed jar (11 1/4" dia.),
$2,500-4,000, sold for $1,925 at Sotheby's, sale #6061, #193.

Ant Woman

(see Marcia Rickey)

Antelope hallmark

(see Zella Cheeda)

Lela Augah

(Tewa, Sand Clan, Tewa Village)
FAMILY: See Tewa Bear, Sand & Spider Clan Family Tree Chart.

Andrea Auguh
(Tewa, Stick Clan, Tewa Village, active 1970s & 1980s)
FAMILY: Daughter of Chloris Auguh

Chloris Auguh or Anah
(also Pinni)
(Tewa, Stick Clan, Tewa Village, active 1960-1982: pottery)
LIFESPAN: (-1983)
FAMILY: Mother of Andrea Auguh; half sister of Albert Yava in *Big Falling Snow*, pp. 19, 68, ill.

Faye Avatchoya
(Tewa, Corn Clan, Tewa Village, active 1930-1960: black and white on red bowls, redware bowls)
EXHIBITIONS:
> 1995-1997 "Following the Sun and Moon - Hopi Katsina Dolls," Heard Museum, Phoenix, AZ
COLLECTIONS: Museum of Northern Arizona, black & white on red bowl, #E1311, 1956; redware bowl, #E5758, 1957; black & white on red bowl, #E7454, 1930-1950; Heard Museum, Phoenix, AZ, pot, #NA-SW-HO-A1-25; bowl, #NA-SW-HO-A7-66.
PHOTOGRAPHS: Portrait (1957), neg. # 9532, Museum of Northern Arizona, Flagstaff
PUBLICATIONS: Allen 1984:111, 116, 119
BIOGRAPHICAL DATABASES: "Hopi-Tewa Potters," Native American Resource Collection, Heard Museum, Phoenix.

Badger Paw hallmark
(active 1940: white ware effigies)
VALUES: On March 22, 1985, signed, white ware effigy of a bear's head, ca. 1940 (6 x 7"), sold for $25 at Allard, #783.

Susie Bacon
(Tewa, Sichomovi, active 1930-1940: black and red on yellow bowls)
COLLECTIONS: Museum of Northern Arizona, black and red on yellow bowl, #E157, 1935.
PUBLICATIONS: Allen 1984:106

Nathan Begaye
(Navajo/Hopi, active ca 1970-present: variety of natural colors on white, buff, yellow, orange, red, and green jars, bowls and other forms.)
FAMILY: Lives in Santa Fe.
COLLECTIONS: Richard M. Howard Collection; Letta Wofford Collection.
FAVORITE DESIGNS: parrots, serpents, human faces, feathers, rain clouds
PUBLICATIONS: Gault 1991:15; Jerry and Lois Essary Jacka, *Beyond Tradition: Contemporary Indian Art and Its Evolution* (Flagstaff, AZ: Northland Publishing Co., 1988); Dawn Reno, *Contemporary Native American Artists* (Brooklyn, NY: Alliance Publishing, Inc., 1995)

Photographs by Richard M. Howard

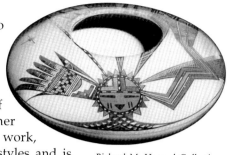

Nathan Begaye's ancestry draws from two major Southwest cultures: Hopi and Navajo. He devotes long hours researching both tribal traditions, especially their wealth of designs element. Biographer Dawn Reno summarized his work, "Begaye creates a variety of styles and is influenced by both modern and traditional designs."

Jerry and Lois Essary Jacka illustrated three of Nathan's pots in *Beyond Tradition: Contemporary Indian Art and Its Evolution*, p. 86. Their selections illustrate design symbolism from Navajo and Hopi, as well as 700 year old pottery traditions. "Navajo/Hopi potter Nathan Begaye creates an extraordinary variety of pottery styles...water jar with Navajo deities and a corn-husk stopper; small jar with the shape and design of Hopi Sikyatki polychrome pottery; seed jar with influences from thirteenth century Anasazi black-on-white pottery." Much may be gained by carefully analyzing these three works, because they characterize long traditions Begaye has inherited.

The first pot features a rare design of Navajo Yeis, spiritual deities called the "Holy Ones." Only recently has this subject matter been introduced in Navajo pottery by Lucy Leuppe McKelvey. She led the way, inspiring some Navajo potters toward a new direction. Traditional Navajo wares often are thick utility jars fired in solid dark colors ranging from black, dark grey and dark brown to dark brownish green. Decoration is limited to minimal incising, with the exception of occasional zoomorfic sculptural forms, mostly horned toads and lizards. Begaye's piece follows the path of McKelvey's innovations in fine line painting of spiritual and natural symbols on orange and buff clay backgrounds. McKelvey's favorite forms include low shouldered ollas and tall flaring jars. In comparison, Begaye's Navajo pot is a taller olla with a small base curving gently upward, until turning back inward near the top. She uses solid black paint, while Begaye employs a dark brown, as well as various shades of dark orange and brick red. Both use white paint for highlights. McKelvey's backgrounds are unpainted, while Begaye paints fine line hatching, like diagonal twill textiles. McKelvey's compositions are standing figures and swirling forms. Begaye's transforms horizontal zig-zags on a shoulder line into triangular abstracted heads, suggesting Yei characteristics. Their faces are bisected with a Picasso-like flair. Hanging feathers and lightning bolts strike downward. Atop the pot, Begaye added a corn-husk stopper, like on an old water jar. Around the neck he tied a white braided deerskin carrying strap with fringe. Although ancient in conception, the effect is quite modern.

Begaye's second type of pottery is in the Sikyatki Revival or Hano Polychrome style of Hopi ceramics. This low shouldered olla is a form revived by Nampeyo (1860-1942) and her descendants. According to family tradition, Nampeyo departed from Hopi Polacca Polychrome to Sikyatki by collecting pottery shards east of her First Mesa home and studying the designs. Sikyatki style pottery originated around A.D. 1300, using a clay that fired yellow or orange and polychrome painted designs favoring parrot, eagle and prayer feather images. Begaye probably is acquainted with the classic book by

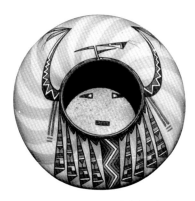

Jesse Walter Fewkes, *Designs on Prehistoric Hopi Pottery*, based on his 1895 excavation of the village of Sikyatki. Some of his design elements may have been inspired by those illustrated in Fewkes or simply by his acquaintance with pottery by Nampeyo descendants. However, Begaye's creativity shines through in his depiction of the Hopi Sun Spirit, Tawa, featuring unique angular feathers radiating from his head.

Begaye's third type of pottery is in a thirteenth century style known as Anasazi Black-on-White. His design symbolizes connected scroll as Muingwa-generative force of nature. The design elements also are similar to those found in ancient textile fragments in the Southwest. The history of these symbols may be traced from the South, especially in the Hohokam region of Southern Arizona. The Tewa potter most noted for the revival of Anasazi Black-on-White style is Helen Naha, also known as Feather Woman.

Perhaps Nathan Begaye's mixed Navajo and Hopi ancestry freed him from maintaining family stylistic traditions. This may account for his diversity of styles. His pottery stands on its own, refined in form and noted for high quality in fine line painting.

Cheryl Benn

BIOGRAPHICAL DATABASES: "Hopi-Tewa Potters," Native American Resource Collection, Heard Museum, Phoenix.
PUBLICATIONS: Dillingham 1994:43

Shirley Benn

(see Shirley Benn Nampeyo)

John Biggs

(active 1990-present)
LIFESPAN: (1970-)
FAMILY: Adopted son of Loretta Navasie Koshiway; brother of Charles Navasie and Lana Yvonne David
PUBLICATIONS: Dillingham 1994:61, 65
BIOGRAPHICAL DATABASES: "Hopi-Tewa Potters," Native American Resource Collection, Heard Museum, Phoenix.

Brooks

(active 1930-1940: unfired bowls)
COLLECTIONS: Museum of Northern Arizona, unfired bowl, #E29, 1930-1940.
PUBLICATIONS: Allen 1984:106

Buffalo Maiden

(see Mary Ami)

Treva James Burton

(signs T. Burton)
(Old Oraibi, active 1950-present: black & red on yellow, black on red jars, plainware bowls, vases, pottery shoes)
COLLECTIONS: Museum of Northern Arizona, pottery shoe, #E1298, 1954; plainware bowl, #E1299, 1954, plainware bowl, #E1300, 1954; black on red jar, #E6259, 1973.
PUBLICATIONS: Allen 1984:110

Butterfly hallmark

A.C.C. hallmark
(active 1970-1980: miniature pots)
VALUES: On June 5, 1992, 2 miniature pots signed A.C.C. & Z.A.C., ca. 1975 (2 x 2"), est. $40-80, sold for $25 at Munn, #514.

S.C.C. hallmark
(possibly Sara Collateta)
(active 1960-1990: bird effigy bowls)
VALUES: On June 3, 1994, two bird effigy bowls (3 x 6"), est. $40-80, sold for $33, at Munn, #288.

On June 5, 1992, signed S.C.C., bird effigy bowl, ca. 1979 (6 x 3"), est. $25-50, sold for $40 at Munn, #226.

On June 5, 1992, signed S.C.C., bird effigy bowl, ca. 1960 est. $30-60, sold for $20 at Munn, #454.

On October 4, 1991, signed S.C.C., bird effigy bowl, feather, germination & triangular spiral designs, ca. 1970 (7 x 5"), est. $25-50, sold for $40 at Munn, #770.

Z.A.C. hallmark
(possibly Zella Cheeda)
(active 1970-1980: miniature pots)
VALUES: On June 5, 1992, 2 miniature pots signed A.C.C. & Z.A.C., ca. 1975 (2 x 2"), est. $40-80, sold for $25 at Munn, #514.

Sylvia Calton
(see Sylvia Dalton)

Juanita H. Calvin
(active 1960: polychrome canteens)
VALUES: On May 17, 1991, signed Juanita H. Calvin, polychrome canteen, ca. 1960 (4 x 4"), sold for $30 at Munn, #574.

Hattie Carl
(Hopi, active 1900-1951)

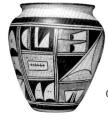

Gregory Schaaf Collection

Doyle A. Chapella
(Hopi)

Grace Chapella
(Tewa, Bear Clan, Tewa Village, active 1900-1980: black on yellow jars)
LIFESPAN: (1874-1980)
FAVORITE DESIGNS: butterflies, moths, germination, gourds
FAMILY: Daughter of Poui & Toby White; sister of Mihpi Toby, Laura Tomosie, Dalee & Bert Youvella. Wife of Tom Pavatea; 2nd marriage to John Mahkewa; mother of Alma

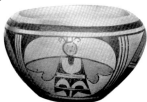

Photograph by Steve Elmore

36

Photograph by Marc Gaede
Courtesy of the Museum of
Northern Arizona.
(neg. #77.0266)

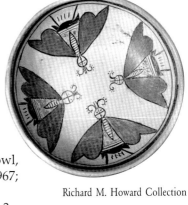

Tahbo (1915-1993), Dorothy Addington and Donald
Mahkeva; grandmother of Ramon Tahbo, Deanna
Tahbo, Gabriel Tahbo, Miriam Louise, adopted
Larson Addington; great-grandmother of Olson
Lomaquahu, Colleen Lomaquahu & Althea
Lomaquahu, Mark Tahbo. See Tewa Bear, Sand
and Spider Clan Family Tree Chart.
TEACHER: Nampeyo
COLLECTIONS: Museum of Northern Arizona,
black on yellow jar, #OC2782, 1930-1940; Heard
Museum, Phoenix, AZ, pot, #NA-SW-HO-A7-131; bowl,
#NA-SW-HO-A7-173; olla, #NA-SW-HO-A7-62, ca 1967;
olla, #NA-SW-HO-A7-63.
PUBLICATIONS: Allen 1984:105; Dillingham 1994:2-3;
Gaede 1977:18-21
BIOGRAPHICAL DATABASES: "Hopi-Tewa Potters," Native American Resource
Collection, Heard Museum, Phoenix; "Artist Database," Museum of Indian Arts &
Cultures, Santa Fe.

Richard M. Howard Collection

She is said to be one of the first Tewa-Hopi potters to individualize
her work by signature.

Helen Chapella
VALUES: On March 15, 1991, signed, large seed jar with flaring rim, water and rain
design, ca. 1920 (8 x1 6"), est. $1,500-3,000, sold for $1,005 at Allard, #847.

Karen Kahe Charley
(signs KKC and a Butterfly Hallmark)

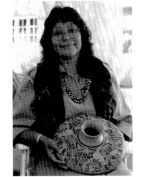

Photograph by Angie Yan

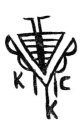

(Hopi, Butterfly/Badger Clan, Sichomovi, active 1980-present: jars, bowls,
stew bowls, wedding vases, canteens)
FAMILY: Daughter of Marcella and Val
Jean Kahe. Three children: Lisa (b. 1971),
Anson (b. 1972), Kyle (b. 1977)
EDUCATION: Polacca Day School,
Phoenix Indian School
POTTERY TEACHER: Her mother,
Marcella Kahe, who also taught Emmaline
Naha and Ramona Ami.
EXHIBITIONS: Hopi Show, Museum of
Northern Arizona, 1996?, Santa Fe Indian Market,
Indian Arts Alliance, Mesa Arizona; Peabody
Museum, Harvard University, Yale University,
Philbrook Museum, Tulsa, OK.

Gregory Schaaf Collection

AWARDS: Best of Show, Best of Division, Best Traditional Pottery, Hopi Show,
Museum of Northern Arizona, 1996?, Best of Show, Best of Division, Best Traditional
Pottery, Santa Fe Indian Market, SWAIA, Fred Kabotie Award.
COLLECTIONS: Museum of Northern Arizona, Flagstaff
PUBLICATIONS: *Indian Art Magazine, Indian Trader, Indian Market Magazine*

On a cold snowy day in February, 1998, young Jake Koopee
took me over to meet one of his neighbors, Karen Charley, a
top prize winner. She was forming a pottery bowl, as we
arrived. The smell of roasting lamb was in the air.

We sat down across from Karen, a vibrant mother of three. She continued to form her pottery, as we spoke casually. Karen gracefully rolled a coil of clay, rubbing her hands together with rhythm. She delicately placed it atop the rim of her bowl, joining the ends together.

Photograph by Angie Yan

Karen commented, "We always join them in a different spot each time." She began massaging the clay, smoothing the inside with rocking strokes. When her pot grew to about a foot in diameter, she suddenly coiled it back, like a wave rolling over. This was not to be a bowl, but rather a seed jar. Coil by coil, she formed the shoulder, working her way inward until the mouth was less than two inches wide. She formed the top half of the pot while we were talking, in maybe 30 minutes. Her artistry was impressive.

Mostly we talked about Karen's mother, Marcella Kahe. "My mother taught me how to make pottery. She also taught Emoline Naha and Ramona Ami. My mother is a good teacher. She makes us do it right, in the traditional way. She points out if we don't prepare our clay right, missed a spot sanding or didn't polish long enough." Karen proudly acknowledged her mother's award in 1993, "Arizona Indian Living Treasure."

Karen then showed me one of her mother's black and red on orange bowls, about nine inches in diameter, gracefully formed. The design layout began with a solid black line near the lip, followed by a one inch band featuring 16 rectangles. A sequence of four symbols was repeated four times. A two inch band followed, composed of 8 larger rectangles. A sequence of two designs was repeated four times. Her symbols featured parrot tail feathers, eagle tail feathers, feathers, rain clouds and other Sikyatki designs. Karen told me the price of the pot and added, "We tell her that she could get higher prices for her pottery. But she just says that she wants to stick with the old-time prices."

Karen said she had some pottery, but they were at her house in Keams Canyon. We jumped in my car, drove down the mesa and westward to Keams. On the way we talked about their recent Bean Dance, the spring purification ceremony. We also talked about her career as a potter. I asked her how her career as an artist changed after winning the Best of Show at the Second Mesa "Hopi Show" and the Museum of Northern Arizona, "Hopi Show." She said humbly, "Oh, well, I guess they helped. More people started to come around asking for my pottery."

We finally turned off the pavement, fish-tailing down a muddy road to their house. Her two granddaughters were playing on the couch. In a tall glass cabinet, Karen displayed her collection. She proudly showed me one of her mother's pots, saying softly, "This one's by my mother. It's not for sale."

She showed one of her polychrome pottery, a black and red on orange stew bowl (5 x 10"), the one for me. She decided to give it to me for an "old time price." I was grateful.

Her double banded design layout bears Marcella's influence. Karen's bottom band is twice as large as the top, like her mother's

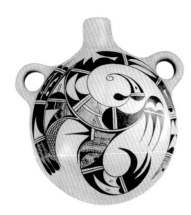

Photograph by Angie Yan

bowls. Karen's top design was recorded as "Bear Paw" by Alexander Stephen in the 1890s. Her bottom designs are alternating rain cloud and terraced step motifs.

When I took Karen back to her house atop First Mesa, we both started sniffing as soon as we walked in. "Oh no! The lamb is burning."

She ran to the stove, opened the oven and poured water into the baking pan. "Whew! Just in time." She gave me some fresh piki bread before I departed. A winter snow storm was rolling in, and snow flakes were beginning to swirl down. As I drove down the mesa, I remember thinking about the Spring purification ceremony. Part of the ancient ritual was a prayer for snows to help saturate the gardens with lots of moisture. The ceremonies were successful this year and the gardens would flourish.

As I descended 800 feet to the lower village, Polacca, I thought about how First Mesa is kind of double banded, with a smaller population living on top of the mesa and twice as many down below. From a distance, First Mesa is laid out similar to Karen and Marcella's double banded design layout...probably just an interesting coincidence. Karen said she preferred making her pottery in the old house, up on top of the mesa. She explained, "It's quiet here. Everything is familiar. It's a good place to make pottery."

Lena Chio Charley
(may be the same as Lena Charlie)

Cora P. Charlie
(black and red on yellow bowls)
VALUES: On December 3, 1986, a black & red on yellow bowl with pictorial eagle design, signed Cora P. Charlie (10 1/2" dia..), $800-1,200, sold for $1,210 at Sotheby's, sale #5522, #53.

Attrib. to Lena Charlie

Lena Charlie
(Corn hallmark, Corn Woman)
(Tewa, Tewa Village, active 1930-1960: black and red on yellow jars, canteens; black and white on red bowls)
FAMILY: See Tewa Kachina/Parrot Clan - Extended Family Tree Chart.
EXHIBITIONS: 1989-1990 Eiteljorg Museum, Indianapolis
COLLECTIONS: Museum of Northern Arizona, canteen, #E614, 1940; black and red on yellow jar, #E2207, 1960; Heard Museum, Phoenix, AZ, canteen, #702P, c. 1950-1960.
FAVORITE DESIGNS: parrots, birds, moths, rain clouds, feathers, Nachwach-clan handshake and black dots around the rim spaced 1/4" apart .
VALUES: On June 4, 1997, a black and red on yellow jar, signed with Corn Hallmark (9 1/4" dia..), est. $1,200-1,800 sold for $1,092 at Sotheby's, sale #7002, #339.

On May 21, 1996, a black and red on yellow jar, signed with Corn Hallmark (12" dia..), along with a smaller jar signed Fannie Nampeyo (5 3/4" dia..), est. $2,000-3,000, sold for $1,725 at Sotheby's, sale #6853, #280.

On October 15, 1995, a black & red on yellow bowl, feathers and Nachwach-clan handshake designs, signed with Corn Hallmark, ca. 1930 (3 x 11"), est. $350-500, sold for $247.50 at Munn, #1144.

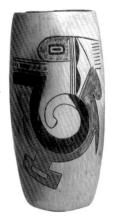

Attrib. to Lena Charlie.
Gregory Schaaf Collection

On October 13, 1995, a polychrome plate with parrot tail feathers, rectangular water waves, prayer feather designs, signed with a Corn Hallmark (10″ d.), est. $200-300, sold for $159.50 at Munn, #292A.

On March 25, 1994, signed with a Corn Hallmark, black and white on red bowl, Thunderbird design, ca. 1944 (3 x 9″), est. $225-450, sold for $192.50 at Allard, #1371.

On March 25, 1994, signed with a Corn Hallmark, black and red on yellow cylinder vase, bird design, ca. 1946 (9 x 4″), est. $300-600, sold for $247.50 at Allard, #1372.

On March 16, 1990, signed Corn Woman, polychrome bowl, bird design, ca. 1950 (3 x 11″), est. $350-700, sold for $477.50 at Allard, #200.

On March 18, 1988, signed, cylinder vase, twin parrot design (8 x 4.5″), est. $125-250, at Allard, #42

On March 18, 1988, bowl, germination and parrot tail feather design (3 x 7″), est. $150-300, sold for $80 at Allard, #823

On December 2, 1987, a black and red on yellow jar, signed with Corn Hallmark (8 1/2″ dia..), est. $1,200-1,800 [need sales result] at Sotheby's, sale #5643, #94. (*NOTE - This is the same pot as item #339 that sold on June 4, 1997 at Sotheby's sale #7002 for $1,092.)

On March 22, 1985, signed, cylinder vase, parrot design (9 x 5″), sold for $150 at Allard, #36.

On March 22, 1985, signed, polychrome jar, ca. 1948, moth design (Fewkes 1911-1912:254, fig. 83) with black dots around the rim spaced 1/4″ apart (4.5 x 7″), sold for $135 at Allard, #158.

On March 22, 1985, signed, cylinder vase, Thunderbird design (9 x 4″), sold for $120 at Allard, #187.

On March 22, 1985, signed, cylinder vase, parrot design (10 x 5″), sold for $150 at Allard, #540.

On March 22, 1985, signed, shallow bowl, Thunderbird design, ca. 1944 (3 x 9″), sold for $115 at Allard, #576.

PHOTOGRAPHS: Portrait (1960), neg. # 3085, Museum of Northern Arizona
PUBLICATIONS: Allen 1984:108, 111; Fewkes 1911-1912:254, fig. 83.
BIOGRAPHICAL DATABASES: "Hopi-Tewa Potters," Native American Resource Collection, Heard Museum, Phoenix; "Artist Database," Museum of Indian Arts & Cultures, Santa Fe.

Lena Charlie's pottery is admired for its high quality and fine line painting. Her clay fires to a warm, cream orange. Her designs are well balanced, often in four quadrants. She uses diagonal hatching and stippling for added tonality. She is respected as a master potter.

Zella Cheeda

(Antelope Woman, Antelope Girl, Antelope hallmark)

(Hopi, Sichomovi, active 1950-1980: redware bowls and wedding vases, black, white & red on red cookie jars, pottery forks & spoons)
FAVORITE DESIGNS: rainbirds, parrots
COLLECTIONS: Museum of Northern Arizona, fork & spoon, #E6308a,b, 1973; 6 redware bowls, #E6309a-f, 1973; bowl, #E7210, 1975.
VALUES: On July 8, 1994, a black, white & red on red cookie jar with lid, ca. 1950-1960 (9.5 x 7.5″), est. $600-900, sold for $440 at Munn, #803.

On January 31, 1992, signed Zella Cheeda, bowl, ca. 1960, Provenance: Joan Drackert Estate (4 x 10″), est. $150-300, [need sales result] at Munn, #18.
PUBLICATIONS: Allen 1984:117

Gregory Schaaf Collection

Chorosie
(Tewa, Tewa Village, active 1930-1940: black and red on yellow jars)
COLLECTIONS: Museum of Northern Arizona, black & red on yellow jar, #E496, 1937.
PUBLICATIONS: Allen 1984:108

Lorraine Choyou
(Hopi, Flute Clan, Sichomovi, active 1980-present: black and red on yellow bowls, jars, vases, cylinder vases)
BORN: July 17, 1964
FAMILY: Daughter of Robert Choyou and Kathleen Dewakuku; related to Jacob Koopee; mother of George, Coran, Yanaka Pewo, Dwight, Robin and Marlene.
POTTERY TEACHERS: Marie Koopee, Kathleen Dewakuku
STUDENTS: Yanaka Pewo
EXHIBITIONS: Pueblo Grande, Phoenix

Lorraine Choyou is one of the most honest people I ever met. She once returned to me a bag of jewelry, worth thousands of dollars, that I had left by mistake in her living room. Her pottery is quite beautiful and graceful.

I visited Lorraine in March of 1998. She was kind and hospitable. She then had no pottery available, as she had been busy taking care of her children. We talked about her relative, Jacob Koopee, who was away on a trip.

After our visit, when I was driving back to Santa Fe, I thought to myself, "Lorraine Choyou is a nice and honorable person."

Carla Claw
(see Carla Claw Nampeyo)

Charlene Clark
(see Charlene Youvella)

Lucy Cochise
(Hopi, Sichomovi, active 1920-1940: white jars)
COLLECTIONS: Museum of Northern Arizona, white jar, #E442, 1931.
PUBLICATIONS: Allen 1984:107

A. Collateta
(also signs Collateta)
(active 1990-present: black & red on yellow cylinder vases)
FAVORITE DESIGNS: parrot, prayer feather

Charlene Collateta
(Shoshone/Paiute)
FAMILY: Married into Hopi.

Christopher Collateta
FAMILY: Son of Nyla Sahmie

Kathleen Collateta
(Kathleen Collateta Sandia, also signs K. Collateta)
(active 1975-present: black & red on yellow seed jars & vases; black & red on white jars, wedding vases, bowls)
FAMILY: Grand-daughter-in-law of Sara Collateta
FAVORITE DESIGNS: birds, rain, clouds, Mudheads, feathers, parrot, Polik Mana-Butterfly Maiden, Dawa-Sun Kachina

Michael Collateta
(active 1990-present)
BORN: 1981
FAMILY: Son of Nyla Sahmie, brother of Seth Collateta
PUBLICATIONS: Dillingham 1994:2-3
BIOGRAPHICAL DATABASES: "Hopi-Tewa Potters," Native American Resource Collection, Heard Museum, Phoenix; "Artist Database," Museum of Indian Arts & Cultures, Santa Fe.

Sara or Sarah Collateta
(Navajo, Polacca, active 1990s)
FAMILY: Wife of Taft Collateta, Sr.; mother of Taft, Jr.

Seth Collateta
BORN: 1985
FAMILY: Son of Nyla Sahmie; brother of Michael Collateta

Al Colton
(see Al Qoyawayma)

Matilda Coochycima
(active 1950-1960)
EXHIBITIONS: 1960 "Hopi Show," Museum of Northern Arizona, Flagstaff
PHOTOGRAPHS: Portrait (1960), neg. # 3074, Museum of Northern Arizona

Tim Cordero
(Hopi/Cochiti)

Corn hallmark
(see Lena Charlie and many Nampeyos)

Corn hallmark with "M.K."
(See Marie Koopee)

Corn Leaves hallmark

Frank Kinsel Collection

Rachel Cuva or Cuya
(Hopi, Walpi, active 1950-1960: ladles)
COLLECTIONS: Museum of Northern Arizona, stew bowl, ladle, #E5226, 1954.
PUBLICATIONS: Allen 1984:115

Cyashongka
(Hopi, Hotevilla, active 1930-1940: plainware jars-pitched)
COLLECTIONS: Museum of Northern Arizona, plainware jar-pitched, #E155, 1935.
PUBLICATIONS: Allen 1984:106

Dahlee, Dalee or Da Tse
(Tewa, Bear Clan, Tewa Village, active 1900-1921)
LIFESPAN: (-1921)
FAMILY: Daughter of Poui & Toby White; sister of Mihpi Toby, Laura Tomosie, Grace Chapella & Bert Youvella. See Tewa Bear, Sand and Spider Clan Family Tree Chart.
PUBLICATIONS: Dillingham 1994:2-3
BIOGRAPHICAL DATABASES: "Hopi-Tewa Potters," Native American Resource Collection, Heard Museum, Phoenix; "Artist Database," Museum of Indian Arts & Cultures, Santa Fe.

Dalewepi
(see Ergil Vallo)

Tony Dallas
(Hopi)

Sylvia Dalton
(Sylvia Calton)
(Hopi)

Myra Daniels
(active 1945-75: large, shallow polychrome bowls)
LIFESPAN: (-June 1975)

Richard M. Howard Collection

Alice Dashee
(active 1970-present: black & red on yellow jars, vases, tiles, ladles)

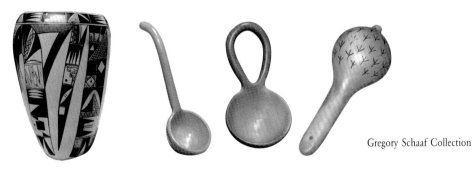

Gregory Schaaf Collection

Laura Dashee
(also signs L. Dashee)
(active 1970-present: red and black on white jars, wedding vases, tiles)
FAVORITE DESIGNS: Mudheads, clouds, parrots

Mabel Dashee
(Hopi, Walpi, active 1930-1940: black& red on yellow jars, piki bowls, canteens)
COLLECTIONS: Museum of Northern Arizona, piki bowl, #E452, 1938.
VALUES: On October 15, 1994, black and red on yellow canteen, parrot design (11 x 9"), est. $700-1,100, sold for $450 at Munn, #933.
 On December 2, 1992, a black & red on yellow jar (6 3/4 x 8 3/4"), along with two other pots by Lucy Nahee, est. $350-450, sold for $330 at Butterfield & Butterfield, sale #5235E, #3451
PUBLICATIONS: Allen 1984:107

Edith David
(active 1950-1960)
EXHIBITIONS: 1958 "Hopi Show," Museum of Northern Arizona, Flagstaff
PHOTOGRAPHS: Portrait (1958), neg. # 9568, Museum of Northern Arizona

Irma David
(active 1970: black on red seed jars)
FAVORITE DESIGNS: bear claws, feathers, clouds
VALUES: On January 31, 1997, a bowl signed Rena Leslie (3.5 x 5.5), together with a seed jar and a bowl signed B. Polacca, est. 150-250, sold for $132 at Munn, #46.
 On June 3, 1994, black on red seed jar, bear claws, feathers, clouds designs (5 x 6.5"), est. $75-150, sold for $44, at Munn, #878.

Lana Yvonne David
(Tadpole Hallmark)
(Tewa, active 1990-present: black and red on white bowls)
LIFESPAN: (1971-)
PUBLICATIONS: Dillingham 1994:60-61; Hayes & Blom 1996:72-

Lana Yvonne David is noted for her unique design layout. Some bowls feature the entire design enclosed in an off-centered circle at the bottom of the bowl.

S. C. David
(Hopi, active 1990)

Sunbeam David
(Tewa, active 1980s: polychrome jars, bowls, lamps)
FAMILY: Wife of Randolph David; daughter of Lena and Victor Charlie; mother of Neil David, Sr., a major artist in paintings and Kachina dolls.
VALUES: One piece among six sold as one lot, est. $200-300, at Butterfield & Butterfield, sale #4582A, #2675.
 On August 24, 1984, signed, bowl, ca. 1983 (4 x 7"), sold for $35 at Allard, #674.

William David
(Tewa, active 1990-present: polychrome seed jars)
FAVORITE DESIGNS: rain cloud, rainbird, germination

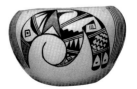

Gregory Schaaf Collection

Dawamana
(Sun Woman)
(see Ada Fredericks)

44

Cedric V. Dawavendewa
(see Cedric Albert)

Maryan Denet
(Sun Clan Hallmark)
(black and red on yellow jars)
Value: On October 14, 1994, black and red on yellow jar, feather design (5 x 3.5"), est. $60-100, sold for $65 at Munn, #658.

Susanna Denet
(Hopi, active 1975-1990)

A. Dewakuku
(active 1970: jars)
VALUES: On March 22, 1985, signed, polychrome jar, ca. 1970 (7 x 10"), sold for $105 at Allard, #416.

Georgia Dewakuku
(see Georgia Dewakuku Koopee)

Kathleen Dewakuku
(Hopi, Flute Clan, Sichomovi, active 1960-present: black and red on yellow bowls, jars, vases, cylinder vases)
BORN: ca. 1945
FAMILY: Wife of Robert Choyou; mother of Lorraine Choyou; grandmother of George, Coran, Yanaka Pewo, Dwight, Robin and Marlene.

Verla Dewakuku

Verla Dewakuku
(also signed V. Dewakuku)
(active 1970-present: polychrome bowls, jars, plates)
FAVORITE DESIGNS: Sikyatki designs, rain clouds, parrot tail feathers, Twin War Gods footprints
PUBLICATIONS: Barry 1984:81-88

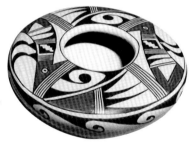

Richard M. Howard
Collection

Nellie Nampeyo Douma
(see Nellie Nampeyo)

Carol or Caroline Duwyenie
(Hopi, active 1981-present)
FAMILY: Previously married to Preston Duwyenie. Mother of Mary and Megan Duwyenie.

Mary Duwyenie
(Hopi, active 1990-present)
FAMILY: Great-granddaughter of Belle Kuyiyesva and Sarah Duwyenie. Granddaughter of Lorenzo "Hubbel" Duwyenie and Edith Kuyiyesva; daughter of Preston and Caroline Duwyenie; sister of Megan Duwyenie.

Preston Duwyenie
(Lomaiquilvaa - "carried in beauty")
(Hopi, Reed Clan, Hotevilla, later Santa Clara
Pueblo, active 1979-present: micaceous clay
white, orange and blackware seed jars, high
shoulder jars, storage jars, plates, bowls, some
with inlayed sterling medallions; earlier type -
black and red on yellow, orange and redware seed
jars and bowls)

Photograph by
Bill Bonebrake.
Courtesy of Jill Giller,
Native American
Collections, Denver, CO

BORN: September 6, 1951
FAMILY: His mother's mother
was Belle Kuyiyesva. His father's
mother was Sarah Duwyenie.
He is the son of Lorenzo
"Hubbel" Duwyenie (kachina
carver) and Edith Kuyiyesva
(basket weaver); husband of
Debra Gutierrez (Santa Clara,
Winter Clan) - 3 children: Kateri
(who has two children: John Dee
and Christopher), David and
Stephanie. Father of Mary and Megan
Duwyenie.
EDUCATION: Hotevilla Day School (grades 1-4); Kiva Elementary; Scottsdale High;
Institute of American Indian Arts (AA); Colorado State University (BFA)
TEACHERS: Otellie Loloma & Ralph Pardington (IAIA); Ken Hendrey and Richard
Devore (CSU)
STUDENTS: Preston taught for 6 years at IAIA and 2 years as a graduate teaching
assistant at CSU
HONORS: List of awards, being compiled by the artist, to appear in the next edition.
DEMONSTRATIONS: Museum of Indian Arts & Cultures, Santa Fe; Wheelwright
Museum, Santa Fe; Gardener Museum, Toronto, Ontario, Canada; University of
British Columbia.
EXHIBITIONS:

1979-present	Indian Market, (SWAIA), Santa Fe
1981-present	Eight Northern Pueblos Indian Artists & Craftsmen Show
1983-present	Heard Museum Show, Phoenix
1985-1988	"Hopi Show, "Museum of Northern Arizona, Flagstaff
1992	"Fireworks," Edmonton, Canada
1998	"Micaceous Clay Show," Museum of Indian Arts & Cultures, Santa Fe

Preston Duwyenie's present pottery is unique in three main
ways: the use of micaceous clay, the smoldering technique used
to create blackware and the addition of silver medallion insets.
As a student of Otellie Loloma at IAIA, he was encouraged to exper-
iment with different techniques and materials. The result is the
development of a different and elegant style.

Preston is very likable. He expresses himself in a thoughtful
manner. While his voice may be soft, his ideas are deep and philo-
sophical. His gentle humility balances well with his profound
thought and expression.

When asked about his personal views on pottery, Preston
responded: "Pottery is part of creation. My pots are like my little
children."

Recounting his early childhood at Hotevilla on Third Mesa, Preston reminisced, "As children, our swimming pools were the clay beds that filled and softened from the rains. We picked up the clay and made little Katsinas and other forms."

"In my work, I focus on a part of nature, which to me is a living entity," Duwyenie said. "Each part has a purpose. Different aspects teach us different things about ourselves and the world."

I like Preston Duwyenie, and I like his pottery. Both are "one of a kind."

Emma's Grandmother
(Hopi, Oraibi, active 1885-1915: piki bowls)
COLLECTIONS: Museum of Northern Arizona, piki bowl, #OC1085, 1885-1915
PUBLICATIONS: Allen 1984:104

Ethel
(see Ethel Salyah)

Fawn
(see Eunice Navasie and Fawn Navasie Garcia)

Feather hallmark
(see Helen Naha)

Feather & L hallmark
(see Loretta Naha)

Feather & Longhair Kachina hallmark
(see Burel Naha)

Feather & Rainy hallmark
(see Rainy Naha)

Feather & S hallmark
(see Sylvia Naha)

Flower Girl
(see Garnet Pavatea)

Flower hallmark with dots on five petals
(see Sadie Adams)

Flower hallmark with five petals, only one dot in center & "L.L."
(see Lorna Lomakema)

Flower hallmark with a line on three petals or Flower with no center lines, four petals, small circle in center, Peach Flower
(see Irene Gilbert Shupla)

Flower hallmark with no petals and two leaves
(see Joy Navasie - she later used her mother's frog symbol with webbed toes)

Flower & Rain Cloud hallmark
(active 1940-1950: bowls)
VALUES: On June 5, 1992, bowl, ca. 1940 (3 x 6"), est. $50-100, sold for $55 at Munn, #381.

Flute Girl
(see Lenmana Namoki)

Ada Fredericks
(Dawamana, meaning "Sun Mother")
(Hopi, Kykotsmovi, active 1950-present: plainware bowls, also embroidered plaques - see Gregory Schaaf, *Who's Who in Pueblo Weaving* (Santa Fe: CIAC Press, scheduled 1999))
COLLECTIONS: Museum of Northern Arizona, plainware bowl, #E1468, 1958; plainware bowl, #E1469, 1958.
PUBLICATIONS: Allen 1984:111

Barbara Fredericks
(Pahongsi)
(Hopi, Kykotsmovi, active 1960-1980: plainware bowls, turtle effigies, bell clappers, ladles)
COLLECTIONS: Museum of Northern Arizona, 5 plainware bowls, #E2485a-e, 1962; plainware bowl, #E3319, 1966; turtle, #E3852, 1968; bell clapper, #E3892, 1968; ladle, #E7878, 1968.
PUBLICATIONS: Allen 1984:112, 121

Claude or Claudie Fredericks
(Hopi, Kykotsmovi, active 1970-1980: miniature dogs, whistles)
COLLECTIONS: Museum of Northern Arizona, miniature dog, #E5097, 1970; whistle, #E5780, 1972.
PUBLICATIONS: Allen 1984:115, 116

Eugene Fredericks
(Hopi, Kykotsmovi, active 1960-1970: turtle effigies)
COLLECTIONS: Museum of Northern Arizona, turtle, #E3852, 1968; 3 effigies, #E5491a-c, 1971.
PUBLICATIONS: Allen 1984:114

Marcia Fritz
(see Marcia Rickey)

Frog & Gail hallmark
(see Gail Navasie Robertson)

Frog & L.
(see Loretta Navasie)

Frog & L.N.
(see Leona Navasie)

Frog & M.N. & V.N. hallmark
(see Maynard & Veronica Navasie)

Frog & Tadpole hallmark
(see Marianne Navasie)

Frog & Tadpole & D.R. hallmark
(See Donna Navasie Robertson)

Frog Woman
(frog with short toes hallmark)
(see Paqua Naha)

Frog Woman
(frog with webbed toes hallmark)
(see Joy Navasie)

Fawn Garcia
(see Fawn Navasie Garcia)

James Garcia
(see James Garcia Nampeyo)

Melda Garcia
(see Melda Nampeyo)

A. Gasper
VALUES: On December 5, 1991, 4 Hopi pots by Veronica Polacca, A. Gasper, Nyla Sahmie, Colleen Poleahla, including two wedding vases, each with painted stylized birds; a jar with migration design, and a small black on red jar, the largest (9 1/4 x 6"), est. $250-350 sold for $220 at Butterfield & Butterfield, sale #4664E, #869.

Idelle George
(Hopi, Old Oraibi, active 1960-1970: wind chimes)
COLLECTIONS: Museum of Northern Arizona, wind chime, #E4162, 1969.
PUBLICATIONS: Allen 1984:110, 113-14

A. Gila
(active 1950-1960: black & red on yellow bowls)
FAVORITE DESIGNS: classic Sikyatki birds, eagle wings & tail feathers
VALUES: On July 8, 1994, a red & black on yellow bowl in Sikyatki style, ca. 1950-1960 (3 x 9"), est. $300-500, sold for $165 at Munn, #501.

Irene Gilbert
(see Irene Gilbert Shupla)

Larson Goldtooth
(Tewa/Hopi-Navajo, Tobacco? Clan, active 1990s)
FAMILY: Son of Ernestine (Tewa/Hopi) and ___ Goldtooth (Navajo)

Lillian Gonzales
(see Lillian Gonzales Nampeyo)

Daisy Goshquapinima's Grandmother
(Hopi, Oraibi, active 1880: plainware jars)
COLLECTIONS: Museum of Northern Arizona, plainware jar, #OC1100, 1880;
plainware jar, #OC1102, 1880
PUBLICATIONS: Allen 1984:104

Claudia Grover
(also Claudia Grover James)
(Tewa, Kachina/Parrot Clan, Polacca, active 1980-present)
FAMILY: Granddaughter of Beth Sakeva

Eugene Hamilton
(Tewa, Kachina/Parrot Clan, Tewa Village, active 1990)
FAMILY: Father of Loren, husband of Tonita Nampeyo Hamilton

Loren D. Hamilton
(Loren Hamilton Nampeyo)
Tewa, Corn Clan, Tewa Village, active 1980-present: canteens)
LIFESPAN: (1961-)
FAMILY: Grandson of Fannie Polacca Nampeyo; son of Eugene and Tonita
Nampeyo Hamilton.
PUBLICATIONS: Dillingham 1994:14-15
BIOGRAPHICAL DATABASES: "Hopi-Tewa Potters," Native American Resource
Collection, Heard Museum, Phoenix; "Artist Database," Museum of Indian Arts &
Cultures, Santa Fe.

Roselda Hamilton
(Hopi, Sichomovi, active 1980-present)
FAVORITE DESIGNS: birds, rain, clouds
PUBLICATIONS: Bassman 1997:81

Betty Harvey
(Tewa, Tewa Village, active 1930-1940: black and red on yellow bowls)
COLLECTIONS: Museum of Northern Arizona, black and red on yellow bowl,
#E610, 1940.
PUBLICATIONS: Allen 1984:108
BIOGRAPHICAL DATABASES: "Hopi-Tewa Potters," Native American Resource
Collection, Heard Museum, Phoenix; "Artist Database," Museum of Indian Arts &
Cultures, Santa Fe.

Theresa Harvey
(Hopi, Walpi, active 1930-75: black and red on yellow jars,
black on red bowls)
FAVORITE DESIGNS: parrot, eagle tail feathers, rain clouds
COLLECTIONS: Museum of Northern Arizona, black on red
bowl, #E187, 1931; black and red on yellow jar, #E4165, 1969; black
and red on yellow jar, #E8666, 1974.
PUBLICATIONS: Allen 1984:106, 114

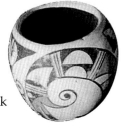

Gregory Schaaf Collection

Vina Harvey
(active 1970-present)
PUBLICATIONS: Barry 1984:81-88

Annie Healing
(see Annie Healing Nampeyo)

Juanita Healing
(active 1940-present)
BORN: ca. 1910
FAMILY: Daughter-in-law of Annie Healing; wife
of Dewey Healing; sister of Patricia Honie.
PUBLICATIONS: Dillingham 1994:14-15.

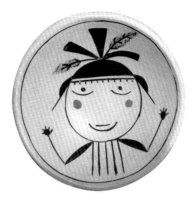

Richard M. Howard Collection

Emma Heyah
(Hopi, Walpi, active 1930-1950: black and red on yellow bowls)
COLLECTIONS: Museum of Northern Arizona, black and red on yellow bowl,
#E5225, 1930-1950.
PUBLICATIONS: Allen 1984:115

Lenora Holmes
(Hopi, active 1990)

Robert Allen Homer
(Hopi/Zia, active 1990-present)
PUBLICATIONS: Hayes & Blom 1996:74-75

Audrey or Audry Honie
(Tewa, Tewa Village, active 1935-1981: black and red on yellow jar, stew
bowls)
COLLECTIONS: Museum of Northern Arizona, stew bowl, #E414, 1938; black and
red on yellow, #1418, 1945-1955.
PUBLICATIONS: Allen 1984:107

Agnes Honie
(Hopi, active 1980-1990)

Patricia Honie
(Hopi, Sichomovi/Polacca, active 1960-1987+: black and red on yellow
bowls, black on red bowls, effigies, tiles)
FAMILY: Sister of Juanita Healing
FAVORITE DESIGNS: parrots, rain, feathers
COLLECTIONS: Museum of Northern Arizona, black and red on yellow bowl,
#E5778, 1972; effigy, #6306, 1973.
VALUES: On March 25, 1994, a black on red bowl (4.75 x 8.25"), ca. 1960, est. $150-

300, sold for $165, at Allard, #378.

On February 4, 1994, black & red on yellow bowl, ca. 1960s, rain & prayer feather designs (4 x 8"), est. $150-275, sold for $150, at Munn, #492.

On March 20, 1992, signed, tile, parrot design, ca. 1960 (5 x 4"), est. $475-150, sold for $55 at Allard, #298.

On February 1, 1991, signed, polychrome jar, rain, prayer feather & parrot designs, ca. 1950 (3 x 6"), sold for $150 at Munn, #678.

On August 24, 1984, signed, black & red on yellow seed jar, Rainbird design, ca. 1983 (4.5 x 6.5"), sold for $40 at Allard, #671.

Richard M. Howard Collection

On August 24, 1984, signed, black & red on yellow bowl, geometric design, ca. 1983 (3 x 4"), sold for $15 at Allard, #672.

On August 24, 1984, signed, black & red on yellow seed bowl, ca. 1983 (4 x 6"), sold for $35 at Allard, #675.
PUBLICATIONS: Allen 1984:116-117.

Daisy Hooee
(see Daisy Hooee Nampeyo)

Dianne Tahbo Howato
(see Dianna Tahbo)

Viola Howto
(Hopi, Sichomovi, active 1940-1950: black and red on yellow jars, black on red jars)
COLLECTIONS: Museum of Northern Arizona, black on red jar, #E1002, 1950; black and red on yellow jar, #E2640, 1963.
Photographs: Portrait (1957), neg. # 9539, Museum of Northern Arizona, Flagstaff
PUBLICATIONS: Allen 1984:110

Loretta Huma
(Hopi, Sichomovi)
VALUES: On December 5, 1991, 8 Hopi pots by Alice Adams, V. Dewakuku, B. Monongye, Loretta Huma, including a seed jar, bean pot, ladle, mug and bowls with feather designs, the largest (5 1/2 x 5"), est. $200-300 sold for $192.50 at Butterfield & Butterfield, sale #4664E, #883.

Roberta Huma
VALUES: On October 14, 1994, black and red on yellow jar, parrot design (7 x 8"), est. $75-150, sold for $330 at Allard, #1500.

RONDINA HUMA
TEWA VILLAGE
POLACCA, ARIZ.

Rondina Huma
(Tewa, Kachina-Parrot Clan, Tewa Village, active 1973-present: black and red on yellow jars, bowls and miniature bowls)
BORN: March 30, 1947 at Keams Canyon
FAMILY: Daughter of Perry L. and Nellie Kinale; mother of Viola Lopez, Margene and Gerald Huma; former wife of Wilfred Huma; former daughter-in-law of Rosetta Huma.

Gregory Schaaf Collection

AWARDS: Best of Show, Best of Division, Best Traditional Pottery, Santa Fe Indian Market, SWAIA, 1996.
EXHIBITIONS: Santa Fe Indian Market, SWAIA, Santa Fe; "Hopi Show," Museum of Northern Arizona, Flagstaff.
COLLECTIONS: Heard Museum, Phoenix
PUBLICATIONS: Barry 1984:81-88; Gaede 1977:18-21; Gault 1991:15
BIOGRAPHICAL DATABASES: "Hopi-Tewa Potters," Native American Resource Collection, Heard Museum, Phoenix; "Artist Database," Museum of Indian Arts & Cultures, Santa Fe.

Rondina Huma is a top prize winning potter. Her most noted style are black and red on yellow jars with bands of Sikyatki designs. She is praised for her fine, detailed designs covered with hundreds of symbols. The shape and polish on her pots are exceptional.

Rondina strongly voices support for cultural preservation, "I don't want this craft to die out. I want to keep up the pottery making, so it will keep the culture of my tribe alive."

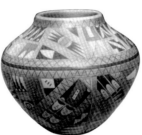
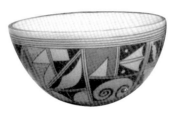
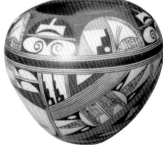

Photographs by Richard M. Howard

Rosetta Huma

(Hopi, Sichomovi, active 1950-1987+: black and red on yellow vases, wedding vases, bowls, canteens, ladles, rattles)
FAMILY: Mother of Wilfred Huma; former mother-in-law of Rondina Huma
COLLECTIONS: Museum of Northern Arizona, ladle, #E5368, 1974.
FAVORITE DESIGNS: 4 directions, Nachwach-clan handshake, connected scroll as Muingwa-generative force of nature, eagles, butterflies
VALUES: On May 19, 1995, two black and red on yellow pottery items: 1 vase (4 x 4"), and 1 bowl (2 x 4"), est. $60-100, sold for $80 at Munn, #96.

On May 19, 1995, pottery rattle with 4 directions design & ladle with Nachwach-clan handshake design (7 x 2"), est. $75-150, sold for $70 at Munn, #651.

On October 14, 1994, black and red on yellow canteen with eagle design, ca. 1950 (8 x 9"), est. $275-400, sold for $450 at Munn, #67.

On May 17, 1991, signed, polychrome wedding vase, butterfly design, ca. 1950 (10 x 6"), sold for $130 at Munn, #321.
PUBLICATIONS: Allen 1984:115

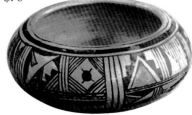

Gregory Schaaf Collection

Stella Huma
(Poivee)

(Tewa, Tewa Village, Kachina-Parrot Clan, active 1960-1996: black and red on yellow jars, black on red canteens)
LIFESPAN: (- 1996)
COLLECTIONS: Philbrook Art Center, Tulsa, OK
FAVORITE DESIGNS: parrot, rain, cloud
VALUES: On May 12, 1996, a black on red canteen, parrot & rain cloud design, ca. 1960 (8 x 9"), est. $350-500, sold for $220 at Munn, #872.

On February 5, 1993, black & red on yellow seed jar, ca. 1970, clouds, tail feathers & connected scroll as Muingwa-generative force of nature (3 x 10"), est. $700-1,400, sold for $500 at Munn, #1010
PUBLICATIONS: Bassman 1997:79; Gault 1991:15; Strickland 1986:288

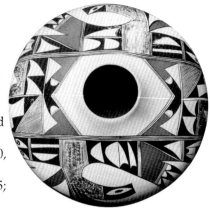

Richard M. Howard Collection

Rennard Stickland, in his 1986 article, illustrated one of Stella's black and red on yellow seed jars with feather and cloud designs. He commented on her style: "The potter Stella Huma has refined the early-twentieth-century ellipsoidal form of Hopi vessels, while retaining and mastering the historic design repertoire, and adapting it to accentuate the sculptural traits of her jars."(Strickland 1986:288)

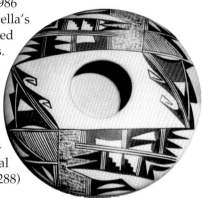

Violet Huma

(Hopi, Sichomovi, active 1930-1982+: redware jars, piki bowls, black & red on yellow chicken effigy bowls, plates with holes for hanging)
FAMILY: Mother of Anita Polacca
COLLECTIONS: Museum of Northern Arizona, 2 redware jars, #E2638a,b, 1963; piki bowl, #E6206, 1973.
VALUES: On October 14, 1995, a black & red on yellow chicken effigy bowl, ca. 1970 (5 x 10"), est. $175-250, sold for $99 at Munn, #562.

On July 8, 1994, a polychrome bowl, ca. 1940-1950 (3.5 x 5"), est. $75-150, sold for $77 at Munn, #538.

On March 22, 1985, signed, plate with holes for hanging, ca. 1950 (1 x 8"), sold for $45 at Allard, #744.
PUBLICATIONS: Allen 1984:113, 117; Gaede 1977:18-21.

Photograph by Marc Gaede Courtesy of the Museum of Northern Arizona. (neg. #77.0264)

VIOLET HUMA

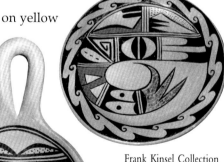

Frank Kinsel Collection

Richard M. Howard Collection

Sylvia Naha Humphrey
(see Sylvia Naha)

Hunimimka

(Hopi, Oraibi/Hotevilla, active 1850-1928: plainware jars and bowls, canteens)
COLLECTIONS: Museum of Northern Arizona, plainware jar, #OC1090, 1850-1910; plainware jar, #OC1092, 1928; canteen, #OC1096, 1908-1910; plainware jar, #OC1103, 1923; plainware bowl, #OC1107, 1908.
PUBLICATIONS: Allen 1984:104

Earl Jackson

(active ca. 1970: bowls with unusual pottery ring stands)
FAVORITE DESIGNS: feathers, triangular spirals
VALUES: On October 14, 1995, a bowl & ring stand: feather and triangular spiral design (6 x 6"), est. $200-300, sold for $93.50 at Munn, #570.

Alice James

(Hopi, Oraibi, active 1940-1981: black on yellow bowls, plainware bowls and jars, miniature canteens)
COLLECTIONS: Museum of Northern Arizona, plainware bowl, #E1072, 1952; black on yellow bowl, #E1922, 1964; plainware jar, #E5788, 1972; bowl, #E6247, 1973; miniature canteen, #E8573, 1981.
PUBLICATIONS: Allen 1984:110, 116

Claudia Grover James

(see Claudia Grover)

Darlene James

(see Darlene James Nampeyo)

Don James

(Tewa, Corn Clan, Polacca, active 1990-present)

Harrison Jim

(active 1975-present: black and red on white)
FAMILY: He makes pottery with wife Marianne Navasie.
PUBLICATIONS: Hayes & Blom 1996:72-75

Dolly Joe

(see White Swann)

Jofern

(see Jofern Silas Puffer)

Emily K.

(active 1940-1950: bowls)
VALUES: On March 22, 1985, signed, bowl, geometric design, ca. 1942 (3 x 8.5"), sold for $60 at Allard, #935.

Hannah K.

(Hopi, Shungopavi, active 1900-1930: plainware jars)
COLLECTIONS: Museum of Northern Arizona, plainware jar, #E1519, 1900-1930.
PUBLICATIONS: Allen 1984:111

Ka'chi

(Foxglove)

(Hopi, Sichomovi, Cedarwood Clan, Kachina Society, Two Horn Society
priest, chief of Koyemsi, active 1870-1900: clay figurines for ceremonies)
PUBLICATIONS: Stephen 1936:1118

> **"**On the evening of December 22, 1891 — winter solstice — Pü'che
> and Ka'chi were in the Goat Kiva at Walpi, making clay effigies of
> oxen. They attached prayer feathers to the effigies' necks and set
> them on the altar in the Goat Kiva."
>
> He was Eo'toto at Sha'lako and participated in Niman, the
> Kachina Home Dance. (Stephen 1936:12, 1099-1100)

J. Kachiwmana

(active 1970-1980: black on red bowls)
VALUES: On October 14, 1994, black on red bowl (3 x 5"), together with a bowl by
F. Lalo, est. $80-120, sold for $75 at Munn, #660.

Gloria Kahe

(Navajo, Polacca, active 1970-present: black and red on yellow jars, bowls,
cylinder vases, lidded cookie jars)
FAMILY: Spouse of Samuel Kahe; daughter-in-law of Marcella Kahe; sister-in-law
of Karen Charlie; mother of Valerie Kahe.
PUBLICATIONS: Barry 1984:81-88

Gloria Kahe is a Dené or Navajo woman who married into a
Hopi family of potters. She learned from one of the respect-
ed masters, Marcella Kahe. As a result of her excellent train-
ing, Gloria's pottery is made in the traditional way. Her pottery is
beautiful, well formed and designed. She has branched away from
Hopi-style Sikyatki designs by incorporating symbols and imagery
from her Dené culture. Some of her pottery displays Dené spirit fig-
ures called "Yeis." These Yei or "Holy People" figures are found in
Navajo sand paintings and on Navajo rugs mostly from the Four
Corners region. Gloria also has created some new designs that are
bold and well balanced.

Although her heritage is Dené, she is included here because
her pottery is so closely related to Hopi in terms of materials, tech-
niques and appearance. Her cross cultural influences add to our
interest in her pottery. She resides in Polacca, the lower village,
where many cross cultural families live. She could not inherit a house
in the village atop the Mesa, because these houses are passed down
through the women in the matrilineal tradition.

Marcella Kahe

Marcella Kahe
Hopi

(signs Marcella or M. Kahe)
(Hopi, Sichomovi, Butterfly/Badger Clan, active 1940-present: black and red
on yellow and red on yellow jars, bowls, plates, stew bowls, double spouted
water vases)
FAMILY: Mother of Karen Charlie and Samuel Kahe; mother-in-law of Gloria Kahe
(Navajo); wife of Val Jean Kahe; daughter of Emma and Hale Adams; sister of
Ramona Ami, Laverne Chaca, Burke Adams.
AWARDS: 1993 - Arizona Indian Living Treasure award; Curator's Award,

Heritage Program, Museum of Northern Arizona
COLLECTIONS: Museum of Northern Arizona, Stew Bowl, #E8599, 1982; black and red on yellow bowl.
PUBLICATIONS: Barry 1984:81-88

Gregory Schaaf Collection

Marcella Kahe is a respected elder woman of the Butterfly Clan. She lives atop First Mesa in the village of Sichomovi, the guards of Walpi Village.

Marcella makes traditional pottery. She is one of the few potters who makes double spouted water vases. These were made in ancient times to water young plants. Her vase sold at Munn on June 3, 1994 featured an old Sikyatki design, Cotyledon, that represents a young plant sprouting. Her design is appropriate for the type of vessel. In planting and nurturing plants, the Hopi recognize the power of germination and the principles of plant genetics.

As stated earlier, I visited with Marcella's daughter, Karen Charlie, in their home at Sichomovi. She said, "My mother taught me how to make pottery. She also taught Emmaline Naha and Ramona Ami. My mother is a good teacher. She makes us do it right, in the traditional way. She pointed it out if we didn't prepare our clay right, missed a spot sanding or didn't polish long enough." Karen proudly acknowledged her mother's award in 1993, "Arizona Indian Living Treasure."

Karen then showed me one of her mother's gracefully formed bowls. The pot was black and red on orangeware and about nine inches in diameter. The design layout began with a solid black line near the lip, followed by a one inch band featuring 16 rectangles. A sequence of four symbols was repeated four times. A two inch band followed, composed of 8 larger rectangles. A sequence of two designs was repeated four times. Her symbols featured parrot tail feathers, eagle tail feathers, prayer feathers, rain clouds and other Sikyatki designs mostly from the 13th-14th century. Karen told me the price of her mother's pot, a most reasonable amount. I bought it. Karen added, "We tell her that she could get higher prices for her potteries. But she just says that she wants to stick with the old time prices."

Samuel Kahe
(Hopi, active 1990)

Valerie Kahe
(Hopi, active 1990)

Bertha Kanaele
(see Bertha Kinale)

Juanita Kavena
(active 1980s)

Photograph by Marc Gaede
Courtesy of the Museum of
Northern Arizona.
(neg. #77.0275)

Rena Kavena
(Hopi, Hotevilla/Sichomovi, active 1920-1980: black and red on yellow
bowls, stew bowls, redware jars and bowls, ladles)
LIFESPAN: (ca. 1900-after 1979)
COLLECTIONS: Museum of Northern Arizona, stew bowl, #E2641, 1963, black and
red on yellow bowl, #E3312, 1966; redware jar, #E8009, 1961; ladle, #E8387, 1979;
stew bowl, #E8423, 1977; black on red bowl, #E8559, 1967-1975.
PUBLICATIONS: Gaede 1977:18-21; Allen 1984:113

Rena was born at Oraibi and witnessed the 1906 split. She moved later to Hotevilla, then to Sichomovi.

Tracey Kavena
(Hopi, active 1980s-1990)

I. Kaye
(active 1970-1989: polychrome stew bowls)
VALUES: On June 3, 1994, a red & black on yellow stew bowl, Sikyatki designs (3 x
6"), est. $100-200, sold for $60.50 at Munn, #79.

Rosalie Kaye
(Hopi, Flute-Deer Clan, Walpi/Polacca, active 1950-1980?: black on yellow
wedding vases, seed jars)
FAMILY: Wife of Maxwell Namoki; Mother of Rollie Namoki (Kachina carver),
Hyram Namoki (Kachina carver) and Lawrence Namoki (Kachina carver and potter)

Mrs. Keely
(Tewa, Tewa Village, active 1930-1940: black and red on yellow jars)
COLLECTIONS: Museum of Northern Arizona, black and red on yellow jar, #E440,
1930-1940.
PUBLICATIONS: Allen 1984:107

Bertha Kinale
(Hopi, Coyote Clan, Walpi, active 1970: black and red on yellow jars)
COLLECTIONS: Museum of Northern Arizona, black and red on yellow jar,
#E5094, 1970.
PUBLICATIONS: Allen 1984:115

Nellie Kinale
(Tewa, Kachina/Parrot Clan, Tewa Village, active 1950-1980s)
FAMILY: Mother of Rondina Huma

Rondina Kinale Huma
(see Rondina Huma)

King's Mother-in-law
(Hopi, Shungopavi, active 1860: plainware jars)
COLLECTIONS: Museum of Northern Arizona, plainware jar, #OC1153, 1860
PUBLICATIONS: Allen 1984:105

Kochahonawe

(Hopi, Walpi, active 1930-1940: black and white on red jars, plainware jars)
COLLECTIONS: Museum of Northern Arizona, plainware jar, #E197, 1935; black and white on red jar, #E459, 1936.
PUBLICATIONS: Allen 1984:106

Kokopelli hallmark

(see Jacob Koopee)

Alton Komalestewa

(Tewa, Kachina/Parrot Clan, Polacca, active 1970: redware and brownware)
FAMILY: Former son-in-law of Helen Shupla (Santa Clara) & Kenneth Shupla (Tewa)
PUBLICATIONS: Bassman 1997:77

Cynthia Sequi Komalestewa

(Hopi/Tewa, Sichomovi, active 1970-present: Christmas ornaments)
FAMILY: Father - Hugh Sequi (Tewa); mother - from Adams family (Hopi); sister - Miltona Naha; aunt-in-law - Helen Naha (Feather Woman)
COLLECTIONS: Museum of Northern Arizona, Christmas ornament, #E8575, 1981
LIFESPAN: (1954-)
PUBLICATIONS: Allen, 1984:122; Dillingham 1994:60-61
BIOGRAPHICAL DATABASES: "Hopi-Tewa Potters," Native American Resource Collection, Heard Museum, Phoenix; "Artist Database," Museum of Indian Arts & Cultures, Santa Fe.

Betsy Koopee

(see Betsy Koopee Nampeyo)

Emma Lou Koopee

(Tewa, Corn Clan, active 1990)

Georgia Dewakuku Koopee

(signs G. Koopee)
(Hopi, Walpi/Sichomovi, Deer/Flute Clan, active 1980-present: black & red on white wedding vases)
FAMILY: Daughter of George and Angelisa Dewakuku; paternal niece of Garnet Pavatea & Myrtle Young; sister of Kathleen Dewakuku, Delores and Lucinda; wife of Jacob Koopee, Sr.; mother of Jacob Koopee, Jr.

Jake or Jacob Myron Koopee

(signs Koopee with a Kokopelli hallmark)
(Hopi-Tewa, Sichomovi, Deer/Flute Clan, active 1990-present: black and red on yellow jars, bowls and plates)
BORN: March 31, 1970
FAMILY: Great-great grandson of Nampeyo; great-grandson of Nellie Nampeyo Douma; grandson of Marie Koopee; son of Jacob Koopee, Sr.(Tewa) and Georgia Dewakuku Koopee (Hopi)
POTTERY TEACHERS: Marie Koopee, Kathleen Dewakuku, Nancy Lewis, Zella Cheeda, Dextra Quotskuyva
AWARDS: 1996-Best of Show, Committee's Choice, Best Traditional Pottery, "Hopi

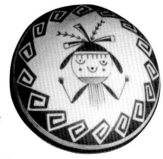

Gregory Schaaf Collection

Photograph by Tom Tallant.
Courtesy of
Canyon Country Originals,
http://www.canyonart.com/

Show," Museum of Northern Arizona; 1997-Best of Show, Best of Division, 1st &
2nd, "Hopi Show," Museum of Northern Arizona; 1997-Alkus Memorial Award (for
best young artist), Gallup Ceremonial.
EXHIBITIONS:
 1996 "Hopi Show," Museum of Northern Arizona
 1997 "Hopi Show," Museum of Northern Arizona
 Heard Museum Show
 Gallup Ceremonial
COLLECTIONS: Paul Harvey Collection
FAVORITE DESIGNS: He draws from old
Sikyatki designs, adding roundels with innova-
tive clown and Kachina faces.
GALLERIES: Gallery 10, Scottsdale; Blue Rain
Gallery, Taos; McGee's Trading Post, Hollbrook;
Steve Gowgill, Richard Heards
PUBLICATIONS: Bassman 1997:81; Paul Harvey,
"Documentary Film."

Gregory Schaaf Collection

Jake Koopee is a young potter of extra-
ordinary talent. He is already a top prize
winner. His academic performance also has
been exceptional, being accepted in a pre-dental college program.
Jake and his family display warm hospitality to visitors to their home,
perched on the west side of the mesa. Jake is known for creating
some of the largest pots made today at Hopi.

I first met young Jake in 1995 during a visit to First Mesa. He
was so friendly and outgoing, our friendship formed during that day.
He introduced me to his father and mother who invited me to eat din-
ner with them. The view from their kitchen window overlooks the
edge of the west side of the mesa. I recall the sunset was magnificent,
similar to the colors in Hopi pottery. At least twelve of Jake's pots, in
various stages of completion, were placed around the edge of one liv-
ing room wall. I saw his palette with traditional paints and a tiny
yucca brush. There were several small polishing stones.

The following year, I stopped to visit and was told Jake was
in the back. I found him preparing to fire some pots. I felt fortunate
to watch the whole process. He carefully placed his pots, forming a
little pyramid over them with large pottery sherds. Jake said, "You
have to place everything just right. The pots must get some air, but
not too much. Gusts of wind can make the smoke grow too thick,
leaving black fire clouds on the pots."

He was equally careful in the way he stacked the sheep
manure, used for centuries as fuel for the fire. Jake began to move
faster, "The sun's going down. The wind's going to start kicking up."
He used stick matches to start the fire. He kept working at it, blowing
the first coals. Finally, the fire began to roar. It was dark by the time
the fire burned down. Inside the ashes were Jake's beautiful pots,
swirls of orange and yellow hues with intricately painted designs.

On my next visit, Jake took me and my friends on a tour of
Walpi, the old village on the tip of First Mesa. We walked by the
home of Olive Toney, the Eagle Clan Mother, and across the narrow
road where the mesa drops 800 feet down on both sides. The village
was constructed of sandstone blocks, shaped by master stone masons
centuries ago. Some of the houses are two or three stories, nestled
together, sharing common walls. Wooden ladders jutted upward
from the kivas. A visit to Walpi is memorable, like stepping back in

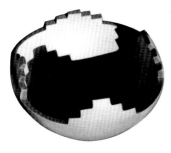

Gregory Schaaf Collection

time a thousand years.

The next day we returned, accepting an invitation to attend ceremonies at Walpi. The plaza was filled with people. I positioned myself behind one grandmother in a wheelchair. Soon the Kachinas arrived, dancing only a few feet away. I recalled years earlier when I had sat at this spot surrounded by children. A Kachina filled the yucca sifter basket resting in my lap with fresh roasted popped blue corn. The children clustered around me all afternoon, feasting from my basket which was refilled several times.

Later in the afternoon, I saw Jake and other family members carrying many large boxes up to the highest home overlooking the plaza. As part of a traditional "give-away" ceremony, Jake and the others began throwing gifts down to the people gathered in the plaza. At first, they threw candy, fresh corn, and other foods. The crowd roared with laughter, when they started to throw watermelons. One woman stayed in there side-by-side with the men, wrestling for position to try to catch them. When they missed one, the sound of smashing melons made the crowd roar even louder. Next they threw boxes and boxes of Tupperware that grew in size to plastic trash cans. Finally, they began throwing fine Hopi pottery plates like frizbees, each valued at hundreds of dollars. As each was caught, the person jumped for joy, holding his prize in the air. Then the winds began to gust, sending some of the precious pots flying over the edge of the mesa. A group of enterprising young boys scrambled to collect the broken pieces down at the bottom.

My next visit with Jake and his family came in February, 1998. Jake called out to me, "Hello Gregory! Good to see you again." We sat down in the living room to talk. He told me how he hadn't worked for about six months after the death of his father. I offered my condolences and shared my similar remorse over the departure of my own father years earlier.

After a while, he asked me to come with him over to his brother's house. Here he showed me a pottery masterpiece that he was working on for the Heard Museum show. It was about 18 inches high featuring a pottery sculpture of a Long Hair Kachina that topped a large gourd-shaped pottery base. "My Aunt Dextra [Quotskuyva] inspired me to do this "pottery sherd" design." The surface looked like it had been broken into hundreds of sherds and glued back together like a jigsaw puzzle. In reality, the sherd-forms were painted on and filled with different designs. I watched him paint some solid yellow. "These areas will fire red," he explained. After the yellow clay pigment dried, Jake used a polishing stone to smooth the surface. I returned several days in a row, and found young Jake painting and polishing for hours on end on his masterpiece.

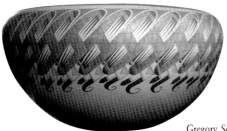

Gregory Schaaf Collection

61

Marie Nampeyo Koopee
(Corn Clan Hallmark with "M.K.; sometimes signs Marie Nampeyo)
(Tewa, Corn Clan, Tewa Village, active 1970-90: black and red on yellow jars)
FAMILY: Granddaughter of Nampeyo; daughter of Nellie Nampeyo Douma; wife
of Logan Koopee; mother of Jacob Koopee, Sr. (Tewa) and Emma Lou; grandmother
of Jacob "Jake" Myron Koopee Nampeyo; sister of Augusta Poocha Nampeyo and
Zella Kooyquattewa.
COLLECTIONS: Museum of Northern Arizona, black and red on yellow jar,
#E6366, 1973.
VALUES: On May 19, 1995, 3 small pots: 1 signed Marie Nampeyo [Koopee], 1
signed Verla Dewakuka, 1 unsigned, est. $100-150, sold for $110 at Munn, #161.
PUBLICATIONS: Dillingham 1994:14-15
BIOGRAPHICAL DATABASES: "Hopi-Tewa Potters," Native American Resource
Collection, Heard Museum, Phoenix; "Artist Database," Museum of Indian Arts &
Cultures, Santa Fe.

Zella Kooyaquaptewa
(see Zella Nampeyo)

Loretta Navasie Koshiway
(see Loretta Navasie)

Koyemsi
(See Steve Lucas)

Rachel Koyiesva
(see Rachel Koyiesva Loloma)

David Lalo

Laura
(active 1930)
PUBLICATIONS: Dillingham 1994:2-3

Natelle Lee
(active 1960-present)
LIFESPAN: (1941-)
PUBLICATIONS: Dillingham 1994:60-61

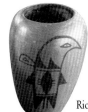

Della Leslie
(active 1980s)
FAMILY: Daughter of Rena Leslie

Richard M. Howard Collection

Lois Leslie
(Hopi, Rabbit-Tobacco Clan, Sichomovi, active 1960: black & red on yellow jars)
VALUES: On February 2, 1996, a black & red on yellow jar with a flaring rim (9 x
9"), est. $300-450, sold for $275 at Munn, #776.

Rena Leslie
(hallmark)
(Hopi, active 1950-1980: large cylinder vases,
jars & bowls))

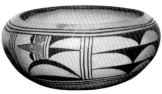

VALUES: On January 31, 1997, a bowl signed Rena
Leslie (3.5 x 5.5), together with a seed jar signed Irma
David and a bowl signed B. Polacca, est. 150-250, sold
for $132 at Munn, #46.

 On March 25, 1994, a polychrome jar with bird and butterfly designs (7 x 7.25"),
est. $150-300, sold for $175, at Allard, #73.

 On March 18, 1988, bowl (3 x 95"), est. $100-200, sold for $205 at Allard, #534.

Lesou or Lesso
(see Nampeyo)

Cecilia Lesso
(Pima, active 1970s)
FAMILY: Wife of Wesley Lesso; mother of Lynette

Lynette Lesso
(Tewa, active 1970s)
FAMILY: Daughter of Cecilia & Wesley Lesso

Lorrain Gala Lewis
(Hopi, active 1990)

Nancy Lewis
(Hopi, Sichomovi, active 1960-1980: redware bowls, wedding vases, piki
bowls, canteens)
COLLECTIONS: Museum of Northern Arizona, redware bowl, #E3313, 1966; wed-
ding vase, #E7804, 1977; wedding vase, #E7871, 1971; black and red on yellow jar,
#E8560, 1979; piki bowl, #E8665, 1969.
VALUES: On March 22, 1985, signed, polychrome canteen, bird design, ca. 1974 (4
x 4.5"), sold for $110 at Allard, #992.
PUBLICATIONS: Allen 1984:121

Charles Loloma
(Hopi, Hotevilla, active 1950-1981: wheel thrown glazed ceramics, carved
stoneware jars, jewelry, paintings)
LIFESPAN: b. January 7, 1921 at Hotevilla Pueblo, Hopi; d. 1991
FAMILY: Husband of Otellie Loloma, 1942. Divorced in 1965.
EDUCATION: Phoenix Indian School; Fort Sill Indian School; Lawton, OK; School
of American Craftsmen; Alfred University, New York.
TEACHERS: Fred Kabotie, Lloyd Kiva New
STUDENTS: Elizabeth White. He taught classes at Flagstaff, Sedona and Santa Fe
at the Institute for American Indian Arts.
EXHIBITIONS:
1958	Tom Bahti Gallery, Tuscon, AZ
1959-62	Fifth Avenue Crafts Center, Scottsdale AZ
1963	Paris, France
1966-90	Loloma Gallery, Hotevilla, Hopi

1970	Objects USA, American Craft Museum, New York (traveling)
1974	Museum of Contemporary Art, New York
1978	Museum of Contemporary Art, New York
1980	California Academy for the Living Arts, San Francisco, CA
1981	Turtle Museum of the Living Arts, Niagara Fall, NY
	Native American Arts '81, Philbrook Art Center, Tulsa, OK
1982	Grand Palais, Salon d'Automne, Paris
1984	San Diego Museum of Man, CA
1986	When the Rainbow Touches Down, Heard Museum, Phoenix, AZ (traveling)
	American Craft Museum, New York
1996	Museum of Anthropology, Wake Forest University
1996-97	San Diego Museum of Man, CA

COLLECTIONS: Arizona State Museum; University of Arizona, Tuscon; California Academy of Sciences; Elkus Collection, San Francisco; Children's Museum of Indianapolis; Heard Museum, Phoenix; Indian arts and Crafts Board, U.S. Department of the Interior, Washington, D.C.; Millicent Rogers Museum, Taos, NM; Museum of Anthropology, Wake Forest University; Museum of Northern Arizona, Flagstaff; San Diego Museum of Man; Wheelwright Museum of the American Indian, Santa Fe.

VALUES: On December 2, 1992, carved stoneware jar in creamy clay with dark brown glazed interior, incised pueblo village scene with kiva ladders and Spider Woman's crosses, (3 x 3 7/8"), est. $800-1,200, sold for $1,045 at Butterfield & Butterfield, sale #5235E, #3430.

On December 5, 1991, a wheel thrown ceramic with yellow-green glazed interior, the ridged exterior unglazed and carrying a pair of painted hands, scrolls upon the palms (5 1/4 x 4 1/4"), est. $1,000-1,500 sold for $1,210 at Butterfield & Butterfield, sale #4664E, #887.

On December 5, 1991, signed "Loloma '53," a wheel thrown ceramic with brown glazed interior, the ridged exterior lightly incised design of a woman holding corn, animals, rain clouds, stars, mountains and more (4 3/4 x 7"), est. $2,000-4,000 sold for $4,125 at Butterfield & Butterfield, sale #4664E, #888.

On December 5, 1991, signed "Loloma," a wheel thrown ceramic with yellow speckled olive green glazed interior, the ridged exterior lightly incised design of rain clouds (3 1/2 x 8 1/2"), est. $1,500-3,000 sold for $1,980 at Butterfield & Butterfield, sale #4664E, #889.

On December 5, 1991, signed "Loloma," a wheel thrown ceramic with brown glazed interior, the ridged exterior with alternating glazed and unglazed bands (4 1/2 x 5"), est. $800-1,200 sold for $880 at Butterfield & Butterfield, sale #4664E, #890.

On December 5, 1991, signed "Loloma," a wheel thrown ceramic with brown glazed interior, the ridged exterior with single dark glazed band below the rim (4 x 6 3/4"), est. $1,000-1,500 sold for $1,100 at Butterfield & Butterfield, sale #4664E, #891.

PUBLICATIONS: Bassman 1997:77; Jacka and Jacka 1988; Mather 1990; Monthan and Monthan 1975; New 1981; Nordness 1970; Seymour 1988; Tanner 1973; Wade and Strickland 1981; Washburn 1984.

Charles Loloma is best known for his award-winning jewelry. He also created, with his wife Otellie, a style of wheel-thrown ceramics called, "Lolomaware." His unique contribution was the creation of a bridge between traditional Hopi art and the world of modern art. His jewelry and ceramics utilized ancient materials, yet are modern in design, winning respect and patronage worldwide.

Charles grew up in the village of Hotevilla, a pueblo on Third Mesa, formed when Yukiuma and his traditional followers split from the village of Oraibi in 1906. They were united behind an ancient philosophy of peace based on Maasaw, the Spirit of the Earth. They chose

a humble way of life, relying on ancient seeds, dry farming and powerful ceremonies to bring gentle rains. Because they proclaimed their independence and refused to swear allegiance to the United States government, their survival was threatened when United States authorities arrested most of the men in the village and sent them to Alcatraz Prison. Federal officers also took children from their mothers' arms and sent them away to government boarding schools.

By the year of his birth, 1921, the Hopi men returned from Alcatraz and the village was trying to knit itself back together. Charles grew up in a community where almost all were artists. They maintained a tradition where they made almost everything they used. Each person, family and clan inherited certain symbols used in designs that decorated their handmade items. Four main spiritual societies regulated the ceremonial cycle of annual dances, which strongly influenced Charles and other Hopi children.

During the Great Depression of the 1930s, Charles was sent to Phoenix Indian School. Fortunately, he became a student of Fred Kabotie, one of the most famous painters in Hopi history. In 1939, Loloma assisted in painting murals at the Golden Gate International Exposition in San Francisco. The following year, he joined his art teacher, Fred Kabotie, in painting murals at the Museum of Modern Art. Their murals were based on kiva paintings from the ancient village of Awatovi.

Loloma was in the Army during World War II. He served in the cold Aleutian Islands off the coast of Alaska. The native Aleutian people, famous for producing some of the finest twined basketry on earth, were evacuated from these islands. The military established a presence to protect the United States from feared invasions from the north.

After the war in 1947, Loloma received a scholarship under the G.I. Bill. He studied ceramics at the School for American Craftsmen at Alfred University in New York. He was joined by Hopi woman artist, Otellie Pasiyava, who would become his wife in 1952. While at Alfred University, Charles won a Whitney Foundation fellowship, a prestigious art grant. He took the opportunity to study Hopi clays and natural pigments, assisted by the lovely Otellie.

In 1954, Charles and Otellie Loloma moved back to Arizona. They started their own gallery in Scottsdale, producing wheel-thrown Lolomaware ceramics. The Lolomas were painters and potters before they became jewelers. Their inlaid jewelry brought great fame and fortune.

Charles Loloma did not start making jewelry until 1955. He experimented with lost wax, sand casting, and tufa casting techniques. He worked on refining his soldering process. He looked at the mosaic jewelry tradition of the ancient Hohokam area around Southern Arizona. Loloma also experimented with a variety of both traditional and innovative materials. He began creating gold and silver rings, bracelets and pins featuring rows of different materials — turquoise, coral, shell, jet, ebony and ironwood. His trademark style of mosaic jewelry was composed of rows of diverse materials. His bracelets then cost a few hundred dollars and became quite popular. Today, the same bracelets sell for between $5,000 - 10,000.

In the late 1950s and early 1960s, Charles taught ceramics at the University of Arizona and Arizona State University. He taught summer classes for the Southwest Indian Art Project. In 1962, Charles, Otellie and Cherokee designer Lloyd Kiva New moved to

Santa Fe to help start the Institute for American Indian Art. The following year, 1963, Charles enjoyed his first successful one-man-show in Paris, France. Unfortunately, in 1965 he and Otellie divorced. From 1966-1990, Charles worked partly out of a studio and home that he built back home in Hotevilla.

The popularity of Indian jewelry, pottery and other Indian arts grew in the 70s and 80s. Charles exhibited at the American Craft Museum, Museum of Contemporary Art, Museum of Contemporary Crafts and other centers for contemporary art. People around the world began recognizing his unique contribution. In 1982, his art was showcased at the Grand Palais, Salon d'Automne in Paris, France.

Charles enjoyed a fast lifestyle in the 80s. He drove around the reservation in a new Jaguar. He flew his own private plane. The now famous Loloma enjoyed entertaining guests from around the world. In 1986 he survived a terrible accident, but never completely recovered. His nieces, Verma Nequatewa and Sherian Honhongva, continued producing Loloma style jewelry under the name Sonwai. Charles Loloma died in 1991. Five years later, he was honored posthumously with a Lifetime Achievement Award by the Southwestern Association for Indian Affairs, organizers of the Santa Fe Indian Market.

Otellie Pasiyava Loloma
(Sequafnehma, "The-place-in-the-valley-where-the-squash-blossoms-bloom")
(Hopi, Sipaulovi/Hotevilla/Scottsdale/Santa Fe, active 1950-1990: fine art ceramics, pottery, jewelry, paintings)
LIFESPAN: b. 1922 in Sipaulovi Village, Second Mesa, AZ.; d. January 30, 1993.
EDUCATION: Oraibi High School, special classes in ceramics, AZ; Alfred, 1947-1949; University of Arizona, 1958-1959; University of Northern Arizona, 1960-1961; CSF/SF, 1962.
FAMILY: Married to Charles Loloma 1942. Divorced in 1965.
CAREER: Co-operator of arts and crafts shops, IAIA educator, head of Ceramics Department IAIA, jeweler, painter, and ceramist.
HONORS:: Alfred University, NY, scholarship; National Women's Caucus for Art, Honor Award, 1991. Honor Awards for Outstanding Achievement in Visual Arts. She danced in traditional groups at the 1968 Mexican Olympics and a special invitational program at the White House. Partial listing for ceramics awards includes: Arizona State Fair, Phoenix, AZ ('60, 1st); Philbrook Art Center, Tulsa, OK ('63, 1st); Scottsdale National Indian Art Exhibition in Scottsdale, AZ ('62, 1st; '65, 1st); Southwestern Association for Indian Arts, Indian Market, Santa Fe, NM ('83). First Award, Ceramic Sculpture, Phoenix State Fair, 1960; First Award, Scottsdale National Indian Arts Exhibition, 1962; First Award, Philbrook Annual American Indian Exhibition, 1963; First Award, Ceramic Pottery, Scottsdale National Indian Arts Exhibition, 1965; Second Award, Ceramic Pottery, Scottsdale National Indian Arts Exhibition, 1966; First Award, Contemporary Pottery, Scottsdale National Indian Arts Exhibition, 1968.
EXHIBITIONS:
 1958 Tom Bahti Gallery, Tucson, AZ
 1959-6 Fifth Avenue Crafts Center, Scottsdale, AZ
 1963 Heard Museum, Phoenix, AZ
 1965 Blair House, Washington, D.C.
 1966 Edinburgh Art Festival, Scotland
 Berlin Festival, Germany
 1967 Museo de Belles Artes, Buenos Artes, Argentina
 Biblioteca Nacional, Santiago, Chile

1967-68 Center for Arts of Indian America, Washington, D.C.
1968 Philbrook Art Center, Tulsa, OK
1969 Alaskan Centennial, Anchorage, Alaska
1970 Marjorie Weiss Gallery, Bellevue, WA
 Princeton University, NJ
1973 Museum of Fine Arts, Santa Fe
1977 Judith Sern Gallery, Minneapolis, MN
1984 Turtle Museum of the Living Arts, Niagara
 Falls, NY
1985 American Indian Community House Gallery,
 New York, NY
 University of Michigan Art Museum, Ann Arbor
 Brazos Gallery, Richland College, Dallas, TX
 Carl N. Gorman Museum, University of
 California, Davis
 American Indian Art Center Gallery, Minneapolis, MN
1985-88 Women of Sweetgrass, Cedar & Sage (traveling exhibit)
1986 Oregon Institute of Art, Portland
 Wheelwright Museum, Santa Fe
 Evergreen Galleries, Evergreen College, Olympia, WA
 Gardiner Art Gallery, Oklahoma State University, Stillwater
 Southwest Museum, Los Angeles

Challis & Arch Thiessen Collection

COLLECTIONS: Indian Arts & Crafts Board, United States Department of the Interior, Washington, D.C., Heard Museum, Phoenix, AZ, Institute of American Indian Arts, Santa Fe, NM/M, National Museum of the American Indian, Washington, D.C., Philbrook Art Center, Tulsa, OK; Mr. and Mrs. Harold Price, Bartlesville, Oklahoma; Mrs. D. Elkus, San Francisco; Mr. and Mrs. Stewart L. Udall, Washington, D.C.; Arch and Challis Thiessen.
PUBLICATIONS: Bassman 1997:77; Brody 1971; Hammond and Jane Quick-to-See Smith 1985; Lippard 1985; Monthan and Monthan 1975; New 1981; Nordness 1970; Snodgrass 1968; *Southwest Profile* August/September/October 1992:116-125; Younger, et al. 1985.

Otellie Loloma devoted her life to creative artistic pursuits and the passing of Hopi and American Indian traditions through her hundreds of students. She recognized pottery as an ancient tradition. Otellie worked faithfully in clay, while teaching Hopi values and traditional techniques. She was loved by her students and many who collected her artworks.

Otellie worked for over three decades, studying the fine points of ancient pottery making techniques. She also was an innovator, exploring the techniques of Asian, European and other cultures. She taught these techniques for handmade pottery and ceramics, while developing and sharing what she learned.

Otellie was the wife of Charles Loloma, the most famous Hopi jeweler. She influenced his experimentation in ceramics. They both served together as teachers at the Institute for American Indian Arts in Santa Fe, New Mexico. In this rich, artistic community, the Lolomas met artists from across the country and around the world. This international exchange of creative ideas not only launched them into international acclaim, but also inspired countless, young Indian art students so that they too could enjoy professional careers as artists.

Otellie's family survived severe hardships through a strong will to be free and to continue their traditional way of life. As a child, Otellie Loloma learned traditional cooking from her mother and aunts. She baked breads, using a process similar to firing pottery.

Her grandmother helped her form her first pots, small clay dolls. She cared for her clay dolls like a young mother, wrapping them carefully onto small wicker cradleboards.

As a young woman, Otellie expanded her pottery making experience in 1949 to 1951, while she studied at Alfred University under a BIA scholarship. Here she was exposed to a broad range of pottery clays, pigments, styles and techniques.

After college, she taught clay activities at Shungopovy Day School on Second Mesa. Otellie and Charles experimented with local clays and natural paints. They set up a studio at Shungopovy Village and taught classes. Although she had mastered wheel thrown pottery techniques in college, she returned to traditional hand coiling.

In 1958, Otellie and Charles experienced their first art exhibition at Tom Bahti Gallery in Tucson. Their next invitation came from Lloyd Kiva New, Cherokee textile-fashion designer and art teacher. The Lolomas joined New in developing the Fifth Avenue Crafts Center in Scottsdale. They worked here in a studio for four years.

In the autumn of 1962, they moved to Santa Fe and helped develop the Institute of American Indian Arts. New became the first Indian president at IAIA. Otellie and Charles became art teachers at the school. For over a quarter of a century, she taught ceramics, sculpture, painting, basic design and traditional Indian dance until her retirement in 1988.

Otellie's influence is widely-known in the work of her students: Pete Jones (Onondaga), Jacquie Stevens (Winnebago), Robert Tenorio, Manuelita Lovato (Santo Domingo), Preston Duwyenie (Hopi) and Tony Abeyta (Navajo). She expressed her philosophy of teaching: "When I teach, which is so important to me and my own clay work, I try to instill belief in my students whether Indian or non-Indian. When that belief is alive, their work is alive. This belief and aliveness gives the student their strength in what they do in any art form or life work. This belief and aliveness is what makes me the artist I am...it is what I am all about."

Otellie explained her own ideas about her work: "Most of my ideas come from the stories told to me at home by uncles and my father and neighbors when I was growing up at Hopi. Winter at Hopi is cold and we stay inside a lot, and this is storytelling time. These are the stories of Soyoko, the Kachinas and Yaya times; these stories are of Hopi men and women, animals and birds and Spider Woman. Many of my paintings, clay figures and portraits on my pots are real characters at Hopi. Some of them are from my imagination and feelings about how I think they might look. Many are dressed in traditional Hopi fashion and are memories of early days. I want to show the young people the way things were before. When I work with figures in clay, I think of them as part of my life and visualize them as I work. When I make a bowl, I think of how it will be used, what will go in it like food or water, and I know it must be beautiful to hold such precious things like food or water."

Indian art educator James McGrath commented, "Otellie does not bring a college degree nor names of famous teachers to her world of self-expression. She brings that long root of Hopi tradition that was recorded on rock cliffs of the Southwest long before the Europeans came. She brings the passion and beauty of her land, her spiritual life, her love of the earth and the life of the clay which is the blood of her world to you, the viewer. Otellie Loloma shares freely with you her expression of beauty."

Rachel Koyiesva Loloma

(Hopi, Badger Clan, Hotevilla, active years 1940-1980: piki bowls, plainware, some with crenelated rims)
FAMILY: Daughter of Tom Poyesva; wife of Rex Loloma, mother of Charles Loloma, Ramona Loloma Poleyma, Mary Lou Loloma, Peggy Loloma Kaye and Willard Loloma
EDUCATION: Hotevilla Day School
POTTERY STUDENTS: Ramona Loloma
GALLERIES: Museum of Northern Arizona Gift Shop

Deanna Lomahquahu

(see Dianna Tahbo)

Grace Navasie Lomahquahu or Lomaquahu

(Tewa, Kachina/Parrot Clan active 1960-present)
LIFESPAN: (1953-)
FAMILY: Granddaughter of Paqua Naha/1st Frog Woman and Deanna Lomaquahu; daughter of Perry Navasie (Hopi) and Joy Navasie, Frog Woman, (Tewa); wife of Olson Lomaquahu; sister of Leona Navasie, Maynard Navasie, Mary Ann Navasie, Natelle Navasie, Loretta Navasie Koshiway.
PUBLICATIONS: Dillingham 1994:60-61
BIOGRAPHICAL DATABASES: "Hopi-Tewa Potters," Native American Resource Collection, Heard Museum, Phoenix; "Artist Database," Museum of Indian Arts & Cultures, Santa Fe.

CLAUDINA LOMAKEMA

Claudina Lomakema

(Hopi, Sichomovi, active 1970-1982: black and red on yellow jars)
COLLECTIONS: Museum of Northern Arizona, black and red on yellow jar, #8163, 1978
PUBLICATIONS: Allen 1984, 1921; Gault 1991:15

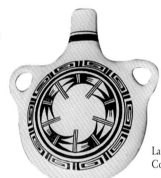

Laura & Sandy Clark Collection

Emogene Lomakema

Emogene Lomakema

(Hopi, Walpi, active 1950-present: jars, bowls, canteens, cookie jars, plainware jars, cylinder vases in the following styles: black on red & black on white, black and red on yellow)
COLLECTIONS: Museum of Northern Arizona, plainware jar, #E2016, 1960s; black on red & black on white bowl, #E3694, 1968; black and red on yellow jar, #E4157, 1969; 2 black and red on yellow jars, #E5773a,b, 1972.
FAVORITE DESIGNS: birds, parrots
PUBLICATIONS: Allen 1984:112, 114

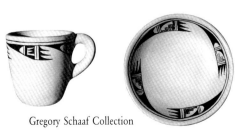

Gregory Schaaf Collection

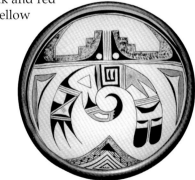

Challis & Arch Thiessen Collection

Lorna Lomakema

(Flower Hallmark with 5 petals, one dot on each petal & L.L.)
(Tewa, Kachina/Parrot Clan, Tewa Village, active 1970-present: black and red on yellow jars, wedding vases, bowls, and tiles)
BORN: September 16, 1930.
FAMILY: Daughter of Sadie Adams; wife of Stetson Lomakema; see Tewa Kachina/Parrot Clan - Extended Family Chart.
EDUCATION: Polacca Day School, Ganado Mission School
FAVORITE DESIGNS: Polik Mana/Butterfly Maiden Kachina
COLLECTIONS: Museum of Northern Arizona, black and red on yellow jar, #E5370, 1974.
PUBLICATIONS: Allen 1984:115

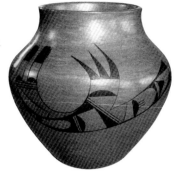

Richard M. Howard Collection

Pottery takes my mind off of everything. I go into our little shack, not knowing what I'm going to make. I start molding, and then I know what will come. I feel close to what I'm doing making pottery.

Wallace Lomakema

(Hopi, active 1990)

Percy Lomaquahu

Hopi, Hotevilla, active 1990)
LIFESPAN: (- post 1990)

Gregory Lomayesva

(Santa Fe, active 1990-present: clay masks)
GALLERIES: Museum of Northern Arizona Gift Shop

Cash Longka

(Hopi, Hotevilla, active 1920-1940: canteens)
COLLECTIONS: Museum of Northern Arizona, canteen, #OC2783, 1930.
PUBLICATIONS: Allen 1984:105

Emma Lou

PUBLICATIONS: Dillingham 1994:2-3

Eleanor Lucas

(see Eleanor Lucas Nampeyo)

Janelle Lucas

(Tewa, Corn Clan, active 1980s)
FAMILY: Daughter of Eleanor Lucas Nampeyo, sister of Karen & Steve Lucas

Richard M. Howard Collection

Karen Lucas

(Tewa, Corn Clan, active 1982-present)
LIFESPAN: (1959-)
FAMILY: Granddaughter of Rachel Namingha
Nampeyo, daughter of Eleanor Lucas; and sister of
Stephen Lucas and Janelle Lucas
EXHIBITIONS: Hopi Indian Market Show, Martha
Struever
GALLERIES: Museum of Northern Arizona Gift Shop
PUBLICATIONS: Dillingham 1994:14-15
BIOGRAPHICAL DATABASES: "Hopi-Tewa Potters," Native
American Resource Collection, Heard Museum, Phoenix; "Artist Database,"
Museum of Indian Arts & Cultures, Santa Fe.

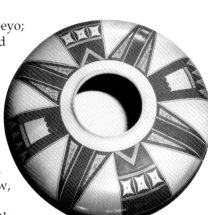

Frank Kinsel Collection

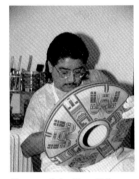

Photograph by Tom Tallant.
Courtesy of
Canyon Country Originals,
http://www.canyonart.com/

Steve or Steven Lucas

(signs Koyemsi, Mudhead & Corn Clan Hallmarks)

(Tewa, Corn Clan, Polacca, 1985-present)
FAMILY: Grandson of Rachel Namingha Nampeyo;
son of Eleanor Lucas, brother of Karen Lucas and
Janelle Lucas; nephew of Priscilla Namingha
Nampeyo.
AWARDS: Second Places, SWAIA, Indian
Market, Santa Fe, NM, 1993; First and Second
Place, SWAIA, Indian Market, Santa Fe, NM.,
1994; First, Second and Third Place, SWAIA,
Indian Market, 1995; Best of Division, 39th
Annual Heard Museum Indian Fair and Market,
Heard Museum, Phoenix, Az., 1997; Best of Show,
SWAIA, Indian Market, Santa Fe, NM., 1998.
EXHIBITIONS: Hopi Indian Market Show, Martha
Struever

Richard M. Howard
Collection

> 1997 14th Annual Phoenix Indian Center Bola Tie Dinner and
> Awards Banquet, Phoenix, AZ
> "Succeeding Generations," Faust Gallery, Scottsdale, AZ

GALLERIES: Museum of Northern Arizona Gift Shop, Flagstaff; Adobe East;
Gallery 10, Faust Gallery, Southwest Trading Company, Robert F. Nichols and
Martha Hopkins Struever.
PUBLICATIONS: Dillingham 1994:14-15
BIOGRAPHICAL DATABASES: "Hopi-Tewa Potters," Native American Resource
Collection, Heard Museum, Phoenix; "Artist Database," Museum of Indian Arts &
Cultures, Santa Fe.

At www.koyemsi.com, biographical information is recorded on the internet for
this artist:

*"*Steve Lucas, Hopi potter, has emerged as one of the premier
artists from the Nampeyo family. He has consistently won blue
ribbons at the most prestigious shows in the pottery field—Santa
Fe Indian Market, Gallup Ceremonial, just to name two of the most
illustrious shows. This is his page. You will find his work at the finest
galleries such as Gallery 10, Faust Gallery, Southwest Trading
Company, Nichols Gallery and Martha Hopkins Struever. Or, you
may buy direct through this web site. The pottery selection within
Steve's website is certainly not all that is available, and, may not cur-
rently be available since his work sells very quickly. However, the

pottery featured on his site will show you his style and quality. If you'd like to order or find out more information, you may contact Steve by e-mail or by calling 520-721-8757.

"Steve Lucas has the Hopi name of Koyemsi, Hopi-Tewa for the mudhead clown, the clan to which he belongs on Hopi First Mesa. This name and the mudhead logo appear on the base of each of Steve's pots. You will find, simultaneously, the corn logo, symbol of the Corn clan, the clan of Nampeyo, Steve's great, great-grandmother.

e-mail: stevel@koyemsi.com

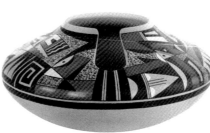

Photograph by Bill Bonebrake..
Courtesy of Jill Giller,
Native American Collections,
Denver, CO

Lucy's Mother
(active 1920-1930)
PUBLICATIONS: Walker & Wyckoff 1983:116

Myrtle Luke
(see Myrtle Luke Young)

Kenneth A. Lynch
(Hopi, active 1981-1990)
BORN: 1974
FAMILY: Son of Nyla Sahmie. See Nampeyo Family Tree

B. Maha
(active 1970: cylinder vases)
FAVORITE DESIGNS: parrots
VALUES: On October 4, 1991, signed, cylinder vase, parrot design, ca. 1970 (4 x 3"), est. $35-70, sold for $50 at Munn, #861.

Donald Mahkewa, Jr.
(Hopi/Tewa, Sun Clan, Polacca: polychrome bowls and jars)
BORN: December 8, 1948 in Parker, AZ
FAMILY: Son of Donald, Sr. & Corrine Mahkewa; husband of Dawn Navasie; father of Julian & Starlie Mahkewa. See Tewa Bear, Sand & Spider Clan Family Tree Chart.
TEACHER: Fawn and Dawn Navasie
DEMONSTRATIONS: Elder Hostel; Prescott College, Prescott, AZ

Gloria Mahle
(Hopi, Sichomovi, active 1980-present)
FAVORITE DESIGNS: bird, rain, clouds
PUBLICATIONS: Bassman 1997:81

Juanita Maho
(active 1980s)

Photograph by Marc Gaede
Courtesy of the Museum of
Northern Arizona.
(neg. #77.013)

Patty Maho

(Tewa, Kachina/Parrot Clan, Tewa Village, active 1930-1979: black and red
on yellow bowls, redware bowls)
LIFESPAN: (ca. 1903-Oct. 1993)
FAMILY: She made pots with her sister, Mamie
Nahoodyce. See Tewa Kachina/Parrot Clan Family Tree.
FAVORITE DESIGNS: parrots, feathers
COLLECTIONS: Museum of Northern Arizona, black & red
on yellow bowl, #E3697, 1968; redware bowl, #E8559, 1969.
VALUES: On February 6, 1998, a black on red bowl, ca. 1960,
eagle designs (3.5 x 10″), est. $300-500, sold for $385 at Munn, #91.

Gregory Schaaf Collection

On June 3, 1994, black on red jar, parrot designs (5 x 6″), est. $200-400, sold for
$302.50, at Munn, #759.

On October 4, 1991, signed, polychrome bowl, parrot design, ca. 1960 (3 x 10″),
est. $200-400, sold for $175 at Munn, #683.

On August 1, 1991, a black and red on yellow jar with prayer feather designs (10″
dia.), est. $250-350, [need sale result], at Butterfield & Butterfield, sale #4582A, #2717.
PUBLICATIONS: Gaede 1977:18-21; Allen 1984:114

Priscilla Maho

(active 1980s)

Ma-Kai-Yah

(active 1980: polychrome jars)
VALUES: On March 26, 1982, signed, polychrome jar, bird and cloud design, ca.
1975 (7 x 5″), sold for $150 at Allard, #909.

Saquaoh Mou Mann

(active 1940: unusual gourd shaped pots)
VALUES: On October 4, 1991, signed, unusual gourd shaped bowl, germination,
rain designs, ca. 1940 (4 x 4″), est. $75-150, sold for $45 at Munn, #393.

Mashongisic

(active 1950: black & red on yellow bowls)
VALUES: In 1981, signed, a black & red on yellow bowl, ca. 1950 (2 3/4 x 5 1/4),
was offered for sale at $75 by T.N. Luther, "American Indian Art," catalog #A2-1981,
item #P40, p. 86.

Bessie Monongya or Monongye

(Hopi, Old Oraibi, active 1950-73: white jars, redware jars, black on yellow
jars, plainware jars, piki bowls, ladles, cups)
COLLECTIONS: Museum of Northern Arizona, ladle, #E1937, 1964; white jars,
#E2639a,b, 1963; plainware jar, #E2994, 1962; plainware
jar, #E3123, 1965, plainware jar, #E3854, 1968; cup,
#E4160. 1969; redware jar, #E5897, 1972; black on
yellow jar, #E6248, 1973.
VALUES: On December 5, 1991, 8 Hopi pots by
Alice Adams, V. Dewakuku, B. Monongye, Loretta
Huma, including a seed jar, bean pot, ladle, mug
and bowls with feather designs, the largest (5 1/2 x
5″), est. $200-300 sold for $192.50 at Butterfield &
Butterfield, sale #4664E, #883.
PUBLICATIONS: Allen 1984:111, 113-114, 116

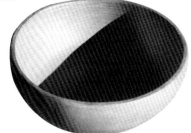

Piki Bowl
Gregory Schaaf Collection

Jessie Monongye

(Snow Chief)

(Hopi, Hotevilla, active 1950-present: pottery, jewelry, painting graphics)

BORN: 1927 in Los Angeles, CA.

EDUCATION: Haskell; Occidental College, Los Angeles, CA.

FAMILY: Son of jeweler Preston Monongye; grandson of Hopi Wuchim Society priest, the late David Monongye..

CAREER: U.S. Army, WWII. BIA juvenile officer; assistant Chief of Police on his reservation; silversmith, potter, sculptor, Katsina carver, and painter; primarily a silversmith.

AWARDS: Inter-Tribal Indian Ceremonial, Gallup, NM ('70, 1st; '71, 1st), Scottsdale Nationals; Gallup Inter-Tribal Ceremonial, Gallup, NM; Museum of Northern Arizona Annual Hopi Show, Flagstaff, AZ; New Mexico and Arizona state fairs; Santa Monica All Indian Ceremonial Show, Santa Monica, CA.

EXHIBITIONS:

 1970 Inter-Tribal Indian Ceremonial, Gallup, NM

 1971 Inter-Tribal Indian Ceremonial, Gallup, NM

 Inter-Tribal Indian Ceremonial, Gallup, NM, Scottsdale National Indian Art Exhibition, Scottsdale, AZ, Margaret Kilgore Gallery, Scottsdale, AZ.

COLLECTIONS: Margaret Kilgore Gallery, Scottsdale, AZ; Smithsonian Institution; The Heard Museum; Museum of Northern Arizona.

PUBLICATIONS: Jacka & Jacka 1988; Lester 1995; Mateuz 1997; Monthan and Monthan 1975; Tanner 1973; Wright 1972, 1989.

Jessie was born in 1927 to a Hopi father and a mother from a California Mission Indian nation. Raised in Hopi tradition, he began an apprenticeship with his uncle, Gene Pooyouma, in the art of silversmithing when he was only nine. When he wasn't operating the bellows to melt down silver Mexican and American coins, he tended livestock.

Regarding the roots of his jewelry, Jessie Monongye's father, Preston, taught him how to make tufa-cast jewelry. Jessie is especially noted for his use of gold.

However, Jessie also credits his mother with inspiring his jewelry work. He conceded that he was "slightly bored and only 'playing' at silver work" when his mother came to him in a dream. Her spirit told him that he would be a "famous artist." He accepted fine jewelry tools from her and devoted himself to refining his style and techniques.

He was raised on the Hopi Reservation at Hotevilla, Arizona, where his art reflected traditional elements in a contemporary setting. When viewing his work one is "filled with a strong spiritual sense, an anticipation that something magical is about to happen."

Monongye's inspiration was in his deep spiritual beliefs. "We Hopis are tapped into the Ultimate Source - maybe you want to call it Supreme Being or God - this gives us the power to become anything the Creator is. We believe the heavens are the father and the earth is the mother. This is what my art is trying to say. It is for my people, for now and forever."

Monongye left Arizona to enter the armed forces in World War II. On the GI bill he pursued a career in law at Occidental College in Eagle Rock, California. Upon returning to Arizona, he became a BIA juvenile officer and assistant Chief of Police on his reservation, eventually leaving these positions to devote all his time to his art.

He once wrote to fellow artist Barbara Bovee: "When I began

producing artwork, before World War II, there was no commercial outlet. What was produced was for the Indian and perhaps the occasional visitor under the portal at the railroad station. It is important to me that Indian Art be preserved as such. We make up an era much as the Ming Artists of China comprised. . . I'm just interested in survival for my art, my family and myself. When I do leave this life it will be as I entered, with nothing."

Monongye continued silversmithing and crafted jewelry for the crowned Prince of the Philippines and other noted dignitaries. Under the auspices of the State Department, he toured European countries displaying his works. His jewelry-making expanded to sculptures in silver and wood, but in recent years his interests turned to painting, etching and lithography.

There was often some young artist taking a lesson in the studio, for Monongye was an accomplished teacher. "I feel the only way to perpetuate art is through teaching it. There are too many times when Indian artists are totally assimilated into the art world, not giving any tribal identity to their art. I feel this is a great injustice to the American Indian. In my feeling, true Americana is American Indian art. Indian art is just now finding its niche in the art world. This has come about through the efforts of Charles Loloma, Otellie Loloma, the Institute of American Indian Arts at Santa Fe, and through many fine Indian Teachers."

Jessie Monongye displays an enormous talent and a multitude of achievements. In 1988, Jerry and Lois Essary Jacka illustrated Monongye's jewelry in *Beyond Tradition: Contemporary Indian Art and Its Evolution.* They commended the artist's work as "masterfully executed inlay jewelry...Incorporating a myriad of stones set in silver and gold. Monongye draws upon the galaxies as well as his Navajo and Hopi cultures for inspiration."

One of his last lithographs entitled "Spirit of the Flute Player" is deeply symbolic. The artist explained: "The figure depicted is a Flute Playing Kachina - the Kachina is our key to the Creator. We pray though the Kachina, not to the Kachina, and our prayers are carried to the Creator through the Kachina's spirit. The flute dance ceremonial alternates with the famous Hopi Snake Dance and is part of a harvest ritual and blessing."

Vivian Muchmo
Polacca, Ariz.
Tewa

Vivian Muchmo
(Vivian Shula)
(Tewa, Polacca, active 1980: black & red on yellow bowls
FAVORITE DESIGNS: parrot, cloud

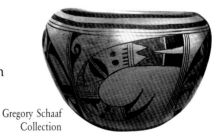

Gregory Schaaf
Collection

Ethel Muchmoul
(Hopi, active 1980-1990)

Mudhead & Corn Clan hallmark
(see Steve Lucas)

Vivian Mumzewa

(Numzewia)
(Hopi, Sichomovi, active 1960-1980: redware bowls, ladles)
COLLECTIONS: Museum of Northern Arizona, redware bowl, #E7423a, 1976; 4 ladles, #E7423b-e, 1976
PUBLICATIONS: Allen, 1984:119

Arlene Mutz

(signs A. L. Mutz)
(active 1980s)

Leila Mutz

(Hopi, Sichomovi, active 1960-1983: vases, bowls, plates, miniatures)
VALUES: On June 3, 1994, bowl, parrots, eagle tail feathers, rain cloud designs, ca. 1960 (4 x 4"), est. $60-120, sold for $55 at Munn, #968.
 On November 10, 1989, signed miniature plate, ca. 1970 (1 x 3.5"), est. $25-50, sold for $20 at Allard, #1502.

Mae Mutz

(Hopi, Sichomovi, active 1960-1983: bowls)
VALUES: On June 5, 1992, signed, black & red on yellow seed jar, wing & bands of Sikyatki designs, ca. 1985 (5 x 5"), est. $200-400, sold for $175 at Munn, #1176.
 On June 3, 1994, redware bowl, incised ^^^^ design, ca. 1960 (3.5 x 4.5"), est. $30-60, sold for $50 at Munn, #970.

Fannie Myron

(see Fannie L. Polacca)

Beatrice Nampeyo Naha

(see Beatrice Naha Nampeyo)

Burel Naha

(Feather & Longhair Kachina Hallmark)
(Tewa, Spider Clan, active 1960-present)
LIFESPAN: (1944-)
FAMILY: Son of Helen Naha; brother of Rainy Naha, Sylvia Naha Humphrey and Rechenda Hill. See Frog Woman-Feather Woman Extended Family Tree Chart.
PUBLICATIONS: Dillingham 1994:60-61; Hayes & Blom 1996:72-75
BIOGRAPHICAL DATABASES: "Hopi-Tewa Potters," Native American Resource Collection, Heard Museum, Phoenix; "Artist Database," Museum of Indian Arts & Cultures, Santa Fe.

Cheryl Naha

PUBLICATIONS: Hayes & Blom 1996:68-75

Elvira Polacca Naha

(see Elvira Nampeyo)

Emma Naha

(active 1970-present: black & red on orange seed jars, wedding vases)
FAVORITE DESIGNS: parrots
PUBLICATIONS: Bassman 1997:81

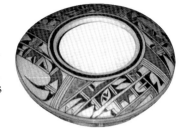

Emma Naha is noted for making fine small seed jars with Sikyatki designs. Her clay fires to a warm orange hue.

Luella Schaaf Collection, Oxnard, CA

Helen Naha

(Feather Woman, Feather Hallmark, H. Naha)

(Tewa, Spider Clan, Tewa Village/Polacca, active 1940-1993: jars, wedding vases, vases, bowls, cylinder vases, miniatures, tiles in the following styles: black on white, black and red on white, black on black, black and red on yellow, black on yellow)
LIFESPAN: (1922-1993)
FAMILY: Wife of Archie Naha; mother of Burel Naha, Rainy Naha, Sylvia Naha Humphrey, and Rechenda Hill. See Frog Woman-Feather Woman Extended Family Tree Chart.
AWARDS: First Place, New Mexico State Fair, 1973
COLLECTIONS: Museum of Northern Arizona, black on black jar, #E3179, 1964; wedding vase, #E3317, 1966; black on yellow bowl, #E3356, 1967; wedding vase, #E8756, 1983; Heard Museum, Phoenix, AZ, jar, #NA-SW-HO-A7-77; jar, #NA-SW-HO-A10-1; seed bowl, #NA-SW-HO-A2-4; jar, #NA-SW-HO-A2-5.

Gregory Schaaf Collection

FAVORITE DESIGNS: feathers, water, connected scroll as Muingwa-generative force of nature, sun, rain, spirals, Nachwach-clan handshake, Anasazi black on white and Tularosa designs.
VALUES: On February 6, 1998, black & red on white seed jar, ca. 1970s, 4 wings design (3.5 x 6"), est. $350-550, sold for $715 at Munn, #501.

On December 4, 1997, a polychrome jar (8 " h.), acquired in 1984, est. $800-1,200, sold for $1,495 at Sotheby's, Sale #7066, #257.

On January 31, 1997, a black and red on white bowl, migration design (3.5 x 5.5), est. $250-450, sold for $385 at Munn, #183.

On January 31, 1997, a round polychrome tile, bird design (7.5 dia.), est. $250-375, sold for $220 at Munn, #572.

In 1996, a polychrome jar (6 x 8"), est. $600-900, sold for $522.50 at Munn, February 1996:78, #776.

On October 15, 1995, a black on white jar, connected scroll as Muingwa-generative force of nature and Nachwach-clan handshake designs (4 x 4.5"), est. $450-750, sold for $687.50 at Munn, #1124.

On March 24, 1995, a polychrome jar with diagonal star and feather Sikyatki designs (4.5 x 5.5"), ca. 1970, est. $400-800, sold for $467.50, at Allard, #179.

On October 15, 1994, black and red on yellow jar, sun and rain designs (4.5 x 6"), est. $450-750, sold for $220 at Munn, #715.

On October 16, 1994, black on white seed jar, Tularosa spiral and Nachwach clan handshake designs (5 x 8 1/2"), est. $600-900, sold for $625 at Munn, #935.

On August 14, 1994, a polychrome jar with eagle tail designs (7.5 x 6"), ca. 1960, est. $800-1600, sold for $687.50, at Allard, #99.

On February 4, 1994, miniature polychrome bowl, ca. 1970 (1 x 3"), est. $100-200, sold for $125, at Munn, #326.

On March 26, 1993, signed, wedding vase, bird design, ca. 1973 (14 x 7.5"), est. $1,000-2,000, sold for $1045 at Allard, #333.

On February 5, 1993, black on white seed jar, ca. 1990, Tularosa style spiral, Nachwach-clan handshake designs (2 x 4"), est. $200-400, sold for $325 at Munn, #460.

On February 5, 1993, black on white seed jar, ca. 1980, Tularosa style spiral, Nachwach-clan handshake designs (5 x 7"), est. $600-1,200, sold for $900 at Munn, #791A.

Richard M. Howard Collection

On February 5, 1993, black & red on yellow seed jar, ca. 1990, stars & cloud designs (3 x 6"), est. $600-1,200, sold for $600, at Munn, #839.

On February 5, 1993, black & red on white jar, ca. 1990, clouds, feathers, parrot designs (4 x 6"), est. $900-1,800, sold for $400 at Munn, #1203.

On March 20, 1992, signed, wedding vase, unusual feather and diamond design, ca. 1960 (5 x 3"), est. $125-250, sold for $330 at Allard, #419.

On January 31, 1992, signed, bowl, ca. 1970, Provenance: Joan Drackert Estate (3 x 6"), est. $100-200, [need sales result] at Munn, #664.

On November 26, 1991, a black on white bowl with migration design, signed with a feather hallmark (9 1/4" dia), $1,500-2,000, sold for $1,210 at Sotheby's, sale #6181, #242.

On October 4, 1991, signed H. Naha, polychrome chicken effigy bowl, ca. 1950, wing feather designs (4 x 7"), est. $100-200, sold for $110 at Munn, #631.

On April 25, 1991, a black and red on white seed jar with three bands of inter-locking frets, scrolls and hatched triangles design (3 3/4 x 7 1/4"), est. $200-300, sold for $660, at Butterfield & Butterfield, sale #4541E, #4096.

On February 1, 1991, polychrome jar, geometric designs, abrasion on side, ca. 1970 (8" h.), sold for $150 at Munn, #335.

On February 1, 1991, signed, red, orange & black on white cylinder vase, parrot designs, ca. 1960 (8 x 3"), sold for $450 at Munn, #620A.

On March 22, 1985, signed, polychrome bean pot with handles, parrot design, ca. 1945 (8 x 8"), sold for $150 at Allard, #317.

PUBLICATIONS: Staff 1974:8-9. [Features the firing techniques of Helen Naha, "Feather Woman."]; Allen, 1984:113; Barry 1984:81-88; Dillingham 1994:61-62; Gault 1991:15; Hayes & Blom 1996:72-75.

BIOGRAPHICAL DATABASES: "Hopi-Tewa Potters," Native American Resource Collection, Heard Museum, Phoenix; "Artist Database," Museum of Indian Arts & Cultures, Santa Fe.

//Wife of Archie Naha, (the son of Paqua Naha). Helen was a self taught potter originally using the techniques of her sister-in-law, Joy Navasie, and later developed her own vocabulary based on prehistoric pot shards from the Awatovi ruins." Sotheby's, December 4, 1997, sale #7066, back pages.

Courtesy of Victor and Tommy Ochoa

Loretta Naha
(Feather & L Hallmark)
(Tewa, active 1980-present: black and red on white)
PUBLICATIONS: Hayes & Blom 1996:72-75

Marty Naha
(see Marty Nampeyo)

Miltona Naha
(active 1980-present)
LIFESPAN: (1962-)
FAMILY: Daughter of Hugh Sequi and sister of Cynthia Sequi Komalestewa.
PUBLICATIONS: Dillingham 1994:60-61
BIOGRAPHICAL DATABASES: "Hopi-Tewa Potters," Native American Resource Collection, Heard Museum, Phoenix; "Artist Database," Museum of Indian Arts & Cultures, Santa Fe.

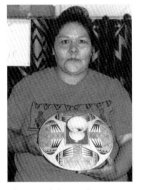

Photograph by Angie Yan

Nona Naha
(Tewa-Hopi, Corn Clan,Tewa Village, active 1988-present: jars, bowls, vases)
BORN: December 27, 1958 at Keams Canyon, AZ
FAMILY: Daughter of Sylvan and Edith Nash; wife of Terry Naha; mother of Terran Naha. See Frog Woman-Feather Woman Extended Family Tree Chart.
TEACHERS: "Feather Woman" Helen Naha, Rainy Naha and Sylvia Naha
AWARDS: 2nd, 3rd & Honorable Mention, "Hopi Show," Museum of N. Arizona
FAVORITE DESIGNS: bat wing, pottery shard, other Nampeyo designs
BIOGRAPHICAL DATABASES: "Hopi-Tewa Potters," Native American Resource Collection, Heard Museum, Phoenix; "Artist Database," Museum of Indian Arts & Cultures, Santa Fe.

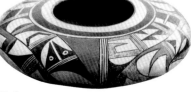

Photograph by Angie Yan

Nona Naha produces some of the thinnest pottery at Hopi. She said, "I love the feeling of relief and satisfaction when the pot is completed. The process for me is long, since I take time to do my best. I also appreciate the reaction of the buyers who acknowledge art and the work behind it."

Paqua Naha
(first Frog Woman, Frog with short toes Hallmark)
(Tewa, Kachina/Parrot Clan, Tewa Village, active 1910-1955: jars, bowls, oval bowls, cylinder vases in the following styles: black and red on yellow, black and red on white; black and white on red, black on red, redware mugs)
LIFESPAN: (1890?-1955)
FAMILY: Mother of Joy Navasie, who used her mother's "Frog Woman" name, and Archie Naha; grandmother of Marianne Navasie, Leona Navasie, Natelle Lee, Maynard Navasie, Loretta Navasie, Grace Navasie Lomahquaha, Burel Naha, Rainy Naha, and Sylvia Naha Humhrey; cousin of Sadie Adams. See Frog Woman-Feather Woman Extended Family Tree Chart.

Gregory Schaaf Collection

FAVORITE DESIGNS: Mythic bird hanging from the sky band, parrot, clouds, rain, feathers, birds, water, Zuni style scrolls

COLLECTIONS: Museum of Northern Arizona, black on red jar, #E523, 1939; black and white on red bowl, #E6584, 1920-1950; by Paqua or Joy Navasie black and red on yellow bowl, #E6982, 1950s; black and red on yellow jar, #E8796, 1930-1950; Heard Museum, Phoenix, AZ, wedding vase, #NA-SW-HO-A7-109; jar, #NA-SW-HO-A7-168, ca 1980; Dr. Gregory Schaaf Collection, Santa Fe.

Gregory Schaaf
Collection

VALUES: On February 6, 1998, black & red on yellow plate, ca. 1950, mythic bird hanging from the sky band design (10 x 1"), damage-paint loss, est. $350-550,sold for $357.50 at Munn, #376.

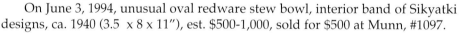

On June 4, 1997, a black and red on yellow jar, signed Frog Hallmark (17 3/4" h.), est. $4,000-6.000 sold for $4,600 at Sotheby's, sale #7002, #342.

On February 4, 1994, black & red on yellow jar with low out-turned rim, ca. 1950s, parrot designs (6 x 7.5"), est. $800-1,200, sold for $1,050, at Munn, #1185.

On June 3, 1994, unusual oval redware stew bowl, interior band of Sikyatki designs, ca. 1940 (3.5 x 8 x 11"), est. $500-1,000, sold for $500 at Munn, #1097.

On February 5, 1993, black & red on yellow jar, ca. 1940, clouds, feathers designs (5 x 12"), est. $600-1,200, sold for $600 at Munn, #1050.

On June 5, 1992, signed, black & red on yellow seed jar, migration design, ca. 1982 (4 x 5"), est. $150-300, sold for $250 at Munn, #667.

On June 5, 1992, signed, polychrome pot, geometric design, ca. 1950 (4 x 5"), est. $300-600, sold for $275 at Munn, #997.

On June 5, 1992, signed, pair of black & red on yellow lamps, bird design, ca. 1950 (9" h.), est. $450-900, sold for $650 at Munn, #999A.

On May 17, 1991, signed Frog Hallmark, polychrome vase, parrot design, ca. 1960 (6 x 4"), sold for $175 at Munn, #349.

September 26, 1990, a black & red on yellow bowl with a migration design, signed Frog Hallmark (14 9/16" dia), est, $700-1,000, sold for $660 at Sotheby's, sale #6061, #480.

May 22, 1989, a black & red on yellow seed jar with a Zuni style scroll design, signed Frog Hallmark (15" dia), est. $2,500-3,500, did not reach reserve minimum at Sotheby's, sale #5858, #49.

On October 14, 1988, black & red on white bowl, parrot design, ca. 1950 (4 x 11".), sold for $600 at Munn, #803.

May 27, 1987, a black & red on yellow bowl with water and prayer feather design, signed Frog Hallmark (11 1/2" dia), est. $1,000-1,500, sold for $1,100 at Sotheby's, sale #5583, #420.

On March 23, 1984, signed, black & red on yellow oval bowl, parrot tail feather and moving cloud design, ca. 1940 (6 x 11"), sold for $125 at Allard, #135.

In 1981, signed, a black on white plate/plaque, Thunderbird design, ca. 1940 (7.5" dia), was offered for sale at $250 by T.N. Luther, "American Indian Art," catalog #A2-1981, item #P39, p. 86.

On March 17, 1978, a polychrome vase, wing feathers & cloud designs, ca. 1950, sold for $350, at Allard, #497.

PUBLICATIONS: Allen 1984:108, 111, 113; Barry 1984:81-88; Dillingham 1994:60-61; Hayes & Blom 1996:72-75, 175
BIOGRAPHICAL DATABASES: "Hopi-Tewa Potters," Native American Resource Collection, Heard Museum, Phoenix; "Artist Database," Museum of Indian Arts & Cultures, Santa Fe.

Paqua Naha is among the most famous and prolific Hopi-Tewa potters. Her first name means "frog," and she is known as "Frog Woman." The name has been passed down to her daughter, Joy Navasie. Paqua taught her daughter how to make pottery around 1935. She draws her frog hallmark with short toes, whereas her daughter draws her frog with web feet.

Paqua worked mostly in a style called black and red on yellow, referring to black and white designs on yellow unslipped pottery. She developed white ware pottery around 1951 or 1952. About three years later, Paqua died. Her daughter and grandchildren carried on the white ware tradition, passing it on to other family members.

In March of 1998, I showed Dextra Quotskuyva, an early olla by the original Frog Woman, Paqua Naha, with a rim that curves inward then flares outward at the top. "This is another very difficult shape to make. We see things in nature, like a flock of birds. All of a sudden they turn back, or they hear something, and all turn. Then it is recorded on the pottery."

She expressed her respect for the artist, "Paqua was a good potter. She made really hard pots to do, the ones that curve in and out. Only the best potter can make low seed jars. Paqua could do this...Paqua was a friendly person, like Nampeyo, especially toward the children."

Dextra studied the Paqua olla closely, "Paqua's pot has a lot of spirit. It does something to you. I could just remember her in my mind. We used to go to see her as children. Raymond Naha (painter), my cousin and Daisy's son, used to stay with her. We used to go up on the hill to play. She used to give us fry bread."

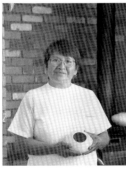

Photograph by Tom Tallant.
Courtesy of
Canyon Country Originals,
http://www.canyonart.com/

Rainy Naha
(Feather & Rainy Hallmark)
(Tewa, Spider Clan, active
1965-present: black and red
on white)
LIFESPAN: (1949-)
FAMILY: Daughter of Helen
Naha; granddaughter of Paqua
Naha; sister of Burel Naha, Sylvia
Naha Humphrey, and Rechenda
Hill. See Frog Woman-Feather
Woman Extended Family Tree Chart.
EXHIBITIONS:
 1997 Phoenix Indian Center
PUBLICATIONS: Dillingham 1994:60-61; Hayes & Blom
1996:72-75
BIOGRAPHICAL DATABASES: "Hopi-Tewa Potters,"
Native American Resource Collection, Heard
Museum, Phoenix; "Artist Database," Museum of
Indian Arts & Cultures, Santa Fe.

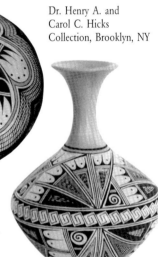

Dr. Henry A. and
Carol C. Hicks
Collection, Brooklyn, NY

Photograph by Bill Bonebrake.
Courtesy of Jill Giller,
Native American Collections, Denver, CO

Sylvia Naha or Sylvia Naha Humphrey

(Feather & S Hallmark)

(Tewa, active 1965-present: black and red on white; black on white)

LIFESPAN: (1951-)

FAMILY: Daughter of Helen Naha, grand-daughter of Paqua Naha, sister of Rainy, Burel Naha, and Rechenda Hill. See Frog Woman-Feather Woman Extended Family Tree Chart.

PUBLICATIONS: Bassman 1997:79; Dillingham 1994:60-61; Gault 1991:15; Hayes & Blom 1996:72-73

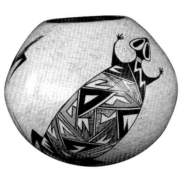
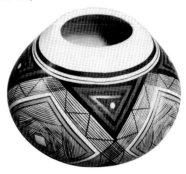

Photograph by Bill Bonebrake. Courtesy of Jill Giller, Native American Collections, Denver, CO

Richard M. Howard Collection

Virginia Cheunsey Naha

(Frog Hallmark)

(Tewa, Tewa Village, active 1930-1940: black and red on yellow bowls and jars)

COLLECTIONS: Museum of Northern Arizona, black and red on yellow bowl, #E613, 1940.

VALUES: On June 4, 1997, a black and red on yellow jar (13" dia.), est. $2,000-3,000 sold for $5,462 at Sotheby's, sale #7002, #340.

PUBLICATIONS: Allen 1984:108

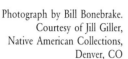

Lucy Nahee

(Hopi, Sichomovi, Fire Clan, active 1970: ladles)

FAMILY: Mother of Macus Nahee

COLLECTIONS: Museum of Northern Arizona, plainware jar, #E5096, 1970.

VALUES: On December 2, 1992, a black on red jar along with two other pots, including at least one by Mabel Dashee, est. $350-450, sold for $330 at Butterfield & Butterfield, sale #5235E, #3451

PUBLICATIONS: Allen 1984:115

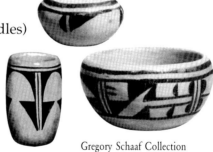

Gregory Schaaf Collection

Photograph by Angie Yan.

Verna Nahee

(Tewa, Sand Clan, Tewa Village, active 1960-1990: black on red jars & bowls)

LIFESPAN: (1940-)

FAMILY: Wife of Marcus Nahee; daughter of Ethel Youvella.

FAVORITE DESIGNS: lizards, corn, rain, cloud, feathers, parrot tail feathers, germination

COLLECTIONS: Museum of Northern Arizona, black on red bowl, #E5965, 1972.

VALUES: On February 6, 1998, black & red on yellow

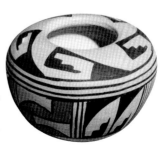

Richard M. Howard Collection

jar, ca. 1970, 3 bands of Sikyatki designs: feathers, parrot tail feathers, germination & clouds designs (6.5 x 7.5"), est. $300-450,sold for $247,50 at Munn, #389.
PUBLICATIONS: Allen 1984:116; Dillingham 1994:2-3
BIOGRAPHICAL DATABASES: "Hopi-Tewa Potters," Native American Resource Collection, Heard Museum, Phoenix; "Artist Database," Museum of Indian Arts & Cultures, Santa Fe.

Photograph by Marc Gaede
Courtesy of the Museum of
Northern Arizona.
(neg. #77. 013)

Mamie Nahoodyce

(Tewa, Kachina/Parrot Clan, Tewa Village, active 1930-1980: black and red on yellow bowls)
LIFESPAN: (ca. 1906-)
FAMILY: She made pots with her sister, Patty Maho; cousin of Sadie Adams, Beth Sakeva and Joy Navasie. See Tewa Kachina/Parrot Family Tree Chart.
VALUES: On December 2, 1992, a black and red on yellow bowl with a pair of stylized birds and central panel of feathers designs (3 1/8 x 11"), est. $300-400, sold for $467.50 at Butterfield & Butterfield, sale #5235E, #3480
PUBLICATIONS: Gaede 1977:18-21

Agnes Nahsonhoya

(Hopi, Bear Clan, Keams Canyon, active 1975-present)
FAMILY: Granddaughter of Roscoe Navasie, Agnes Navasie and Josephine Setalla; niece of Eunice Navasie and Perry Navasie; daughter of Justin and Pauline Setalla. See Frog Woman-Feather Woman Extended Family Tree Chart.
AWARDS: 1st "Hopi Show," Museum of Northern Arizona.
PUBLICATIONS: Dillingham 1994:60-61

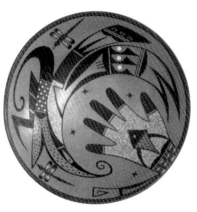

Photograph by Bill Bonebrake..
Courtesy of Jill Giller,
Native American Collections, Denver, CO

Agnes Nahsonhoya is one of the few potters at Hopi who has written her own biographical statement.

"I was born in Keams Canyon, Arizona and reared on a small ranch in Snowbird Canyon. I'm a Hopi potter and a member of the Bear Clan. My family has been working with clay for a very long time. I have always been interested in art.

"The art of pottery making was taught to me by my mother, Pauline Setalla, my aunt, Eunice Navasie, and my grandmother, Agnes Navasie. They taught me all the important steps of making clay into finished pottery. I have been making pottery for 18 years. It has always been a part of me.

"In 1992, I entered numerous pots in Northern Arizona's Hopi Show. I received my first blue ribbon for a pottery drum, a rare piece.

"My style of pottery has changed through the years, starting with the white slip on natural clay, and then moving on towards the more traditional style of using no slip. I now mainly do the traditional style, it is more beautiful, and my grandmother started with traditional.

"The clay I use is found near my home. Different colors come from clays. mustard weed for black paint which is boiled until it is like taffy, and various stones for red and white. The clay I mainly use produces a light peach or red color after firing. My coloring instru-

ments are a matchstick end, used for a dotted effect in design, and a thin yucca brush.

"To show proper respect for the clay we need to continue doing it the old way, that means digging our clay, hand-coiling, hand-burnishing, and outdoor firing." I want to continue doing pottery for as long as I live. I enjoy working with my hands and using my mind to create new and different styles. I love my work, it gives me enjoyment and pleasure to work with the clay. My teachings and heritage of pottery making continues today in the creations of my children. From the hands of my mother, to the dampness of the clay, to the smell of the smoke when the pots are fired, I am connected to the clay.

As a member of the Bear Clan, my trademark is the Bear Claw."

Provided by Tom Tallant, Canyon Country Originals, http://www.canyonart.com/

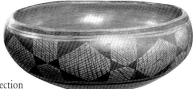

Harriet Nahsonhoya
(Tewa, Spider Clan, active 1960s)
FAMILY: Daughter of Myrtle Young

Richard M. Howard Collection

Louise Nahsonhoya
(Hopi, Sichomovi, active 1900-1930: plainware jars)
COLLECTIONS: Museum of Northern Arizona, plainware jar, #E1923, 1964.
PUBLICATIONS: Allen 1984:111

Emerson Namingha
(Hopi, active 1990)

Iva Namingha
(active 1980s)
FAMILY: Daughter of Verla Dewakuku

Photograph by Tom Tallant.
Courtesy of
Canyon Country Originals,
http://www.canyonart.com/

Les Namingha
(Tewa-Zuni, active 1990-present: black and red on yellow jars, painting)
BORN: ca. 1968
FAMILY: Grandson of Rachel Namingha Nampeyo, son of Emerson Namingha (Tewa) and a Zuni mother; nephew of Dextra Quotskuyva Nampeyo; cousin of Dan Namingha and Hisi Nampeyo; and husband of Jocelyn Quam Namingha.
EDUCATION: B.A., Design, Bringham Young University, Provo, UT.
EXHIBITIONS:
 1996 "The Nampeyo Legacy Continues
 - Santa Fe, NM with Dextra
 Quotskuyva, Steve Lucas, Hisi
 Nampeyo and Loren Ami
 Faust Gallery, Scottsdale, AZ ,with Dextra
 Quotskuyva, Steve Lucas, Hisi Nampeyo and
 Loren Ami

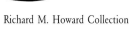

Richard M. Howard Collection

 1997 "Succeeding Generations," Faust Gallery, Scottsdale, AZ
 Phoenix Indian Center, Phoenix, AZ

"Indian Market," SWAIA, Santa Fe, NM
1998 "Heard Museum Guild 40th Annual Indian Fair & Market, Heard Museum, Phoenix
Adobe East Gallery
Summit, NJ with Loren Ami and Steve Lucas
AWARDS: Judges Choice Award, Heard Museum Guild 40th Annual Indian Fair & Market, Heard Museum, Phoenix, 1998; Best of Pottery, Challenge Award, Painting Division, "Indian Market," SWAIA, Santa Fe, NM, 1997
GALLERIES: Adobe East Gallery, Summit, NJ; Faust Gallery, Scottsdale, AZ; Gallery 10, Scottsdale and Santa Fe, AZ; Robert Nichols Gallery, Santa Fe; Southwest Trading Co., Chicago, IL.
PUBLICATIONS: Dillingham 1994:14-14; Brown 1998:53.
BIOGRAPHICAL DATABASES: "Hopi-Tewa Potters," Native American Resource Collection, Heard Museum, Phoenix; "Artist Database," Museum of Indian Arts & Cultures, Santa Fe.

Photographs by
Bill Bonebrake.
Courtesy of Jill Giller,
Native American Collections,
Denver, CO

Les Namingha is an exceptional potter. His forms are well shaped. His painting is fine; his designs innovative. His final polish is smooth. He is well respected.

In the January 1998 issue of *Southwest Art Magazine*, Les Namingha was profiled in an article entitled, "Artists to Watch: Introducing six young artists on the rise." The article illustrates a Zuni style of pottery developed by the artist. Namingha explained: "My mother is Zuni and my father is Tewa Hopi, so I'm interested in the art of both cultures." The style is characterized as "vertical white slip." This means the outer surface is wiped or painted with a white clay paint. On top of the white clay slip, Namingha has painted black and red designs. This combination has been used by some Hopi-Tewa potters, including Helen Naha and Joy Navasie inspired by Paqua Naha, the original Frog Woman.

What makes Namingha's pottery "Zuni style" is form and design. He created an olla shape with a high shoulder and short neck popular at Zuni. His design on the olla illustrated in *Southwest Art Magazine* has been popular at Zuni for over a century. In the late 19th century, researcher Alexander Stephen recorded the main design element as symbolizing, "water flowing in a series of eddies." (Stephen 1890:31; 1994:240, ill. 60)

A long history records an intimate relationship between Hopi and Zuni, connected directly through clan lines. For example, in 1779, some Hopis moved to Zuni during a time of drought. (Sando 1992:41; Schaaf 1996:43-45) At Zuni, intermarriages occurred, while arts and crafts techniques, forms and designs were shared. When the Asa, Wild Mustard, and other clan members returned to Hopi, they brought with them Zuni-style pottery. One design that continued through the end of the 19th century in Polacca polychrome was the Zuni "water flowing in a series of eddies" design found on some of Les Namingha's pottery.

Fine line, diagonal hatching represents another design element used by both Zuni and Hopi historically, and employed by Namingha today. The broad areas of bold designs are filled with diagonal lines. These lines symbolize rain falling. Both the Zuni and Hopi share their prayers for gentle rains, the lifeblood of the desert Southwest.

Ruth James Namingha

(Tewa, Corn Clan, active 1940-1960)
LIFESPAN: (1926-post 1960)
FAMILY: Fourth generation descendant of Nampeyo, the Tewa potter who revived Sityatki style pottery on First Mesa at Hopi. Granddaughter of Annie and Willie Healing, daughter of Rachel and Emerson Namingha; sister of Priscilla Nampeyo, Dextra Quotskuyva; Eleanor Lucas Nampeyo, Lillian Gonzales and Emerson Namingha; mother of Darlene Vigil Nampeyo.
PUBLICATIONS: Dillingham 1994:14-15
BIOGRAPHICAL DATABASES: "Hopi-Tewa Potters," Native American Resource Collection, Heard Museum, Phoenix; "Artist Database," Museum of Indian Arts & Cultures, Santa Fe.

 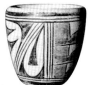

B. or Bessie Namoki

(active 1960-present: polychrome bowls)

Ed Samuels Collection

Carol Namoki

(Tewa, Spider Clan, Tewa Village, active 1960-1970: black & red on white, black on red and black on white bowls, black on red bowls, wedding vases, tiles)
FAVORITE DESIGNS: Kachinas
COLLECTIONS: Museum of Northern Arizona, tile, #E3124, 1965, black on red bowl, #E3698, 1968; black on red and black on white bowl, #E4212, 1969; wedding vase, #E5963, 1973
VALUES: On February 4, 1994, black & red on white bowl, Kachina design (3 x 11"), est. $250-500, sold for $225, at Munn, #195.
PUBLICATIONS: Allen 1984:113-114, 116; Stephen 1936:1113

Namoki means "medicine pouch." The original person named Na'moki lived in Sichomovi in the 1890's. He was the second son of To'chi and a nephew of Ha'ni. He was married to Len'mana. He succeeded Ha'ni as the chief of the Singers Society.

Florinda Namoki

(Hopi, Moencopi, Tobacco/Rabbit Clan, deep carved ware, black on buff, white on buff: active 1995-present)
BORN: December 5, 1973 at Fort Bragg, North Carolina
FAMILY: Granddaughter of Maxwell Namoki and Rosalie Kaye; daughter of Lucinda Pavinyama and Lawrence Namoki; sister of Maxine, Laurencita; wife of Eloy Talahytewa; mother of Maxwell and Eleanor Talahytewa.
POTTERY TEACHER: parents
EXHIBITIONS: "Indian Market"
FAVORITE DESIGNS: Sun, pottery sherd

Karen Namoki

(signs Karen Namoki, Bear Paw hallmark with profile of a Hopi Stone House and the date)
(Hopi, Walpi, active 1966-present: black and red on buff bowls, cups, canteens, ducks, frogs and turtles)
BORN: June 16, 1960
FAMILY: Granddaughter of Roscoe Navasie, Agnes Navasie and Josephine Setalla;

niece of Eunice Navasie and Perry Navasie; daughter of Justin and Pauline Setalla. See Frog Woman-Feather Woman Extended Family Tree Chart.
POTTERY TEACHER: Pauline Setalla
FAVORITE DESIGNS: Kachinas, Butterflies, Clouds

Karen Namoki has developed a distinctive style of pottery. Using a 14th century Sikyatki "spatter" technique, she covers many of her pots with red and black densely speckled surfaces. Her designs often are pictorial, featuring Dawa, the Sun Kachina and profiles of butterfly wings. She sometimes uses double banded friezes of designs, especially cloud symbols, painted around the rim.

Gregory Schaaf Collection

 I met Karen and her husband, Elwin, atop First Mesa. It was a cold, snowy day in February 1998. They were displaying their pots in front of the Visitor Center. They had about a dozen pots for sale, quite reasonably priced. I enjoyed our friendly visit.

Laurencita Namoki

(Hopi, Moencopi, Tobacco/Rabbit Clan, deep carved ware, black on buff, white on buff: active 1994-present)
BORN: August 17, 1977 at Tuba City, AZ
FAMILY: Granddaughter of Maxwell Namoki and Rosalie Kaye; daughter of Lucinda Pavinyama and Lawrence Namoki; sister of Maxine & Florinda; wife of Eloy Talahytewa; mother of Maxwell and Eleanor Talahytewa.
POTTERY TEACHER: parents
EXHIBITIONS: "Indian Market"
FAVORITE DESIGNS: Long Hair Kachinas & Mudheads

Lawrence Namoki

(Hopi, Polacca/Tuba City, Flute-Deer Clan, deep carved ware, black on buff, white on buff: active 1983-present)
BORN: August 25, 1949 at Polacca
FAMILY: Son of Maxwell Namoki and Rosalie Kaye; husband of Lucinda Pavinyama (Tobacco-Rabbit Clan); father of Florinda (b. December 5, 1973), Maxine (b. June 21, 1977), Laurencita (b. August 17, 1978); brother of Raleigh Namoki and Hyram Namoki, both Kachina doll carvers.
POTTERY TEACHER: "Nathan Youngblood (Santa Clara) has had the strongest influence on me."
EDUCATION: Phoenix Indian School
MILITARY SERVICE: Special Forces, Green Berets; Army, 82 Airborne Division
POTTERY STUDENTS: Maxine and Laurencita Namoki
DEMONSTRATIONS: Tuba City High School, Adams State College, Museum of Northern Arizona
EXHIBITIONS:

 1985 Eight Northern Pueblos Artists & Craftsmen Show, San Ildefonso Pueblo
 1997 Santa Fe Indian Market, SWAIA
AWARDS: Best of Show, Eight Northern Pueblos Artists and Craftsmen Show, San Ildefonso Pueblo, 1985; 1st Place, "Indian Market," Santa Fe, 1996

COLLECTIONS: Museum of the American Indian, Smithsonian Institution, Washing-ton, D.C.; Royal Family Collection, London; Milicent Rogers Museum, Taos, NM; William Devane ("Knots Landing") & James McDivitt (Astronaut, Apollo 17)
FAVORITE DESIGNS: "All my artwork on pottery is based on Hopi culture and myths." Kachinas, Sun, Kivas. He gives his pots titles, such as: "Hopi Mystic Entrance." One of his most famous works is entitled, "Hopi Ceremonial Calendar."
GALLERIES: Bill Faust Gallery, Scottsdale; Lovena Ohl Gallery, Scottsdale; Don Hoel Gallery, Sedona, AZ; Two Grey Hills Gallery, Scottsdale; Andrea Fisher Gallery, Santa Fe
PUBLICATIONS: Hayes & Blom 1996:74-75; Bassman 1997:79; *Arizona Highways* (1998); Jacka & Jacka 1998

Photograph by Angie Yan

While driving on the main road along the north side of Polacca, the lower village, I saw a sign, "Potteries and Kachinas for Sale." I turned my car around and drove up to the trailer house.

I was greeted by one of Lawrence Namoki's daughters, "Our parents just left for Tuba City, but we have some potteries and Kachinas. Come on in."

About a half a dozen miniature pottery seed jars and two small Kachinas were laid out on a counter. "These are all that are available now."

Lawrence's daughter proudly showed me some information on her father's artistic career: "His first attempt at Hopi art was carving Kachina dolls. He was a successful doll carver." His reputation led him to be recognized as the "Father of miniature Kachina Doll carvers."

Lawrence later called me at my home in Santa Fe. He was cordial and cooperative in helping me develop his biographical profile. He promised to send me further information, including a list of his many awards and ribbons.

Lenmana Namoki
(Flute Girl)
(Hopi, Walpi, active 1930-1940: yellow jars)
FAMILY: Mother of Gibson, Maxwell, Watspm. and Dana Namoki.
COLLECTIONS: Museum of Northern Arizona, yellow jar, #E455, 1932.
PUBLICATIONS: Allen 1984:107

L. Namoki

Lucille Namoki
(Hopi, Kykoramoci, Fire Clan)

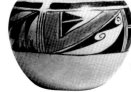
Gregory Schaaf Collection

Lucinda Namoki
(Hopi, Moencopi, Tobacco/Rabbit Clan, deep carved ware, black on buff, white on buff: active 1988-present)
BORN: January 10, 1952 at Tuba City, AZ
FAMILY: Daughter of Enos and Pauline Pavinyama; wife of Lawrence Namoki; mother of Maxine, Florinda, and Laurencita.
POTTERY TEACHER: Lawrence Namoki
EXHIBITIONS: "Indian Market"

Valerie J. Namoki-Pecos

(Hopi, active 1990: human figures, storyteller figures and kachinas)
BORN: 1964
BIOGRAPHICAL DATABASES: "Hopi-Tewa Potters," Native American Resource Collection, Heard Museum, Phoenix; "Artist Database," Museum of Indian Arts & Cultures, Santa Fe.

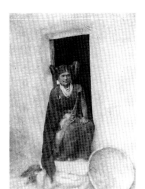

"Nampeyo at age 16," photo by William Henry Jackson. (Smithsonian Institution photo #1841-C)

Nampeyo

("Sand Snake")

(Tewa, Tewa Village, Corn Clan, active 1880-1940: jars and bowls, double jars, figurines in the following styles: black and red on yellow, black on yellow, black on red, black and white on red)
LIFESPAN: (1859-1942)
EDUCATION: Traditional family teachings.
FAMILY: Daughter of Quootsva, Snake Clan, and Kochaka, White Corn, Corn Clan (ca. 1840-?). Wife of Lesso (ca. 1860-1932). Mother of Annie Healing Nampeyo (1884-1968), William Lesso (1893-1935), Nellie Nampeyo Douma (1896-1978), Wesley Lesso (1899-1985), Fannie Polacca Nampeyo (1900-1987). Grandmother of Rachel Namingha Nampeyo (1903-1985), Fletcher, Lucy, Dewey Healing (1905-1992), Daisy Hooee (b. 1906), Beatrice Naha Nampeyo (1912-1942), Clara, Marie Nampeyo Koopee, Augusta Poocha Nampeyo, Vernon,

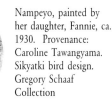

Nampeyo, painted by her daughter, Fannie, ca. 1930. Provenance: Caroline Tawangyama. Sikyatki bird design. Gregory Schaaf Collection

Zella Kooyquattewa, Lindberg, Helen, Edgar, Lynette (b. 1955), Elva Tewaguna Nampeyo (1926-1985) Leah Garcia Nampeyo, Harold Polacca Nampeyo (b. 1930), Tonita Hamilton Nampeyo (b. 1934), Tom Polacca (b. 1935), Elsworth Polacca (1940-1993), Iris Youvella Nampeyo (b. 1944). Great Grandmother of Priscilla Namingha Nampeyo (b. 1924), Lillian Gonzales, Ruth James Namingha (b. 1926), Eleanor Lucas Nampeyo, Emerson, Dextra Quotskuyva Nampeyo (b. 1928), Shirley Benn (b. 1936), Louella Naha Inote, "Whiskey", Ray Naha, Regina, Emma Lou, Rose Norris, Betsy Koopee, Judy, Marlon, Elouise, Carlene, Mary Nez, Miriam Tewaguna Nampeyo (b. 1956), Adelle Lalo Nampeyo (b. 1959), Elton Tewaguna (b. 1953), Neva Polacca Choyou Nampeyo (b. 1947), Melda Nampeyo (b. 1959), James Garcia Nampeyo (b. 1958), Rayvin Garcia (b. 1961), Clinton Polacca (b. 1958), Vernida Polacca Nampeyo (b. 1955), Diana Polacca, Clement Polacca, Harold Jr., Reva Polacca Ami, Marvin Polacca, Loren Hamilton, Gary Polacca Nampeyo, Fannie Myron, Delmar Polacca, Carla Claw, Elvira Naha, Wallace Youvella, Jr., Charlene Youvella, Nolan Youvella, Doran Youvella. Great-Great Grandmother of Foster Sahmie, Finkle Sahmie, Jean Sahmie, Randy Sahmie, Andrew Louis Sahmie, Nyla Sahmie, Rachel Sahmie, Bonnie Chapella Nampeyo, Darlene Vigil Nampeyo, Don James, Karen Lucas, Stephen Lucas, Les Namingha, Hisi (Camille) Quotskuyva Nampeyo (b. 1964), Dan Namingha, Michelle Nampeyo, Melva Nampeyo, Jenell Lalo, Chareen Lalo, Elva Lalo, Dave Lalo, Dale Lalo, David Lalo, Jr., Gleneen Choyou, Stephanie Choyou, Robert Choyou, Brian Lomavitu, Leah Navasie, Elana Navasie, Eloy Navasie, Melvin Navasie, Aaron Garcia, Chris Garcia, Robert Garcia, Keshia Garcia, Noel Garcia, Stephen Ami, Daniel Ami, Jenna Ami. Great-Great-Great Grandmother of Daryl Sahmie, Kathy Sahmie, Emerson Sahmie, Mel Sahmie, Debbie Sahmie, Donella

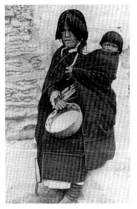

"Nampeyo and her grandchild,"
ca. 1902.

Tom, Lisa Sahmie, Randy Sahmie, Jr., Andrew Sahmie, Andrea Sahmie, Donelly Sahmie, Kenneth Lynch, Michael Collateta, Christopher Collateta, Seth Collateta Carla Talashie, Doule Sahmie, Mickie Chapella, Sahmie Chapella, Lowel Chereposy, Erica Quotskuyva and Reid Ami.

CAREER: Family of potters and other artisans.

EXHIBITIONS:

1898	Exposition, Chicago, IL, sponsored by the Santa Fe Railway
1973	Museum of Northern Arizona, Flagstaff, AZ
1974	Muckenthaler Cultural Center, Fullerton, CA
1974	American Indian and Western Relic Show, Los Angeles
1989	"Nampeyo: A Gift Remembered," Mitchell Indian Museum, Evanston, IL
1996	"The Nampeyo Legacy Continues: The Art of Five Generations of a Renowned Tewa/Hopi Family," curated by Martha Hopkins Struever, Santa Fe Indian Market, Santa Fe, NM
1996	"Drawn from Memory: James T. Bialac collection of Native American Art," Heard Museum, Phoenix, AZ
1997-1998	Recent Acquisitions, Heard Museum, Phoenix, AZ

COLLECTIONS: Field Museum of Natural History, Chicago, IL; Logan Museum of Anthropology, College of Beloit, WI; Milwaukee Public Museum, Milwaukee, WI; Southwest Museum; Los Angeles, CA; University of Colorado Museum, Boulder, CO; Dr. Gregory Schaaf Collection, Santa Fe, NM; Thomas Burke Memorial Washington State Museum, Seattle; Rick Dillingham Collection donated to Museum of Indian Arts and Culture, Santa Fe, NM.; William Hinkley Collection, Paradise Valley, AZ; Mr. and Ms. Deneb Teleki Collection; Mr. and Mrs. Theodore W. Van Zist Collection, Martha Struever Collection; Mr. and Mrs. Robert Malott Collection, Frederick C. Uhde Collection; Mr. and Mrs. Robert Vogele Collection; Mrs. Charles Preston Collection; Mrs. Hon Lanman Collection, Forrest Fenn, Santa Fe.

Museum of Northern Arizona, black and red on yellow jar, #E76, 1900-1930; black on yellow jar, #E156, 1912; black and red on yellow jar, #E215, 1920s; black on yellow jar, #E770, 1900-1921; black and white on red jar, attributed to Nampeyo, #E855, 1918; Nampeyo and Fannie Nampeyo, black and red on yellow jar, #E1411, 1934; Nampeyo and Fannie Nampeyo, black and red on yellow jar, #E2630, 1935; Nampeyo, black and red on yellow jar, #E2634, 1911; attributed to Nampeyo, black and red on yellow jar, #E7570, 1890-1915; attributed to Nampeyo, black on yellow jar, #E7571, 1904-1915; attributed to Nampeyo, black and white on red jar, #E7572, 1900-1915; attributed to Nampeyo, black and white on red jar, #E7573, 1900-1915; Nampeyo, black and red on yellow jar, #E7664, 1910-1930; Nampeyo, black and white on red jar, #E7666, 1910-1930; Nampeyo, black & red on yellow bowl, #E7678, 1910-1930; Nampeyo, black and red on yellow jar, #E7679, 1900-1930; Nampeyo, black and red on yellow jar, #E7683, 1910-1930.

Documented Nampeyo Polychrome Jar, dated 1906, authentication written on the bottom by Jesse Walter Fewkes. Photographs by Frank Kinsel.

Heard Museum, Phoenix, AZ, bowl, #3390-1, ca. 1903; bowl, #498P, 1925-1955; 7 bowls, #487P, #488P, #490P, #500P, #502P, #503P, #505P, early 1900's; pot, #489P, early 1900's; 4 water jars, #491P, #492P, #493P, #494P, early 1900's; Jar,

cooking pot, #576P, early 1900's; jar, #737P, 1920; bowl, #NA-SW-HO-A7-171, ca 1900; jar, #NA-SW-HO-A7-174, 1918-1919; jar, #NA-SW-HO-A7-32; bowl, #NA-SW-HO-A7-34; jar, #NA-SW-HO-A7-82; olla, #NA-SW-HO-A7-86; bowl, #NA-SW-HO-A7-98.

VALUES: Some of her larger pots sold in the 1990s through private sales for over $30,000.

In 1997, a black & red on yellow seed jar "probably by" Nampeyo (8 3/4" dia), est. $1,800-2,200, sold for $4,025 at Sotheby's December 4, 1997:#249.

On February 5, 1993, attributed to Nampeyo, black & red on yellow jar, ca. 1905, stars & eagle feathers designs (6 x 10"), est. $8,000-12,000, did not reach reserve minimum, at Munn, #1212.

On June 12, 1992, a black & red on yellow seed jar Nampeyo (12" dia), est. $8,000-12,000, sold for $7,700 at Sotheby's, sale #6297, #103.

On November 26, 1991, a black, white & red on yellow pictorial plate depicting a Kachina maiden, "probably" Nampeyo (9 1/4" dia), est. $6,000-9,000, sold for $6,325 at Sotheby's, sale #6245, #42.

On May 21, 1991, a black, & red on white seed jar, by Nampeyo (12 1/4" dia), est. $12,000-18,000, sold for $20,900 at Sotheby's, sale #6181, #80.

On March 15 1991, attributed to Nampeyo, old tag, polychrome jar, eagle tail design (8 x 9"), est. $2,000-4,000, sold for $2,955 at Allard, #777.

On May 22, 1989, a black & red on yellow seed jar with a winged design, "possibly" Nampeyo (10" dia), est. $2,000-3,000, sold for $4,950 at Sotheby's, sale #5858, #45.

On December 3, 1986, a black & red on yellow jar with migration design, "possibly" Nampeyo, collected pre-1910 (13" dia.), est. $1,500-3,000, sold for $2,090 at Sotheby's, sale #5522, #46.

On December 3, 1986, a black & red on yellow jar with eagle tail feather design, "possibly" Nampeyo, collected pre-1910 (12 1/2" dia.), est. $3,500-4,500, sold for $4,675 at Sotheby's, sale #5522, #47.

On March 22, 1985, attributed to Nampeyo, provenance, black on yellow jar, germination and cloud design, ca. 1928 (4 x 7"), sold for $2,300 at Allard, #1039.

On April 28, 1984, Nampeyo, black and red on yellow jar, negative stars and eagle tail feathers design (12 1/2" dia.), est. $8,000-12,000, [need sales result] at Sotheby's, sale #5171, #306.

On April 28, 1984, old label "Made by Nampeyo Hopi," black and red on yellow jar, eagle tail feathers and rain cloud designs (10 1/2" dia.), est. $1,500-2,000, [need sales result] at Sotheby's, sale #5171, #308.

On April 25, 1981, "possibly the work of Nampeyo," black and red on yellow jar, eagle wings and tail feathers design (16 3/4" dia.), est. $4,000-6,000, sold for $5,750 at Sotheby's, sale #4586Y, #109.

Photographs by
Richard M. Howard

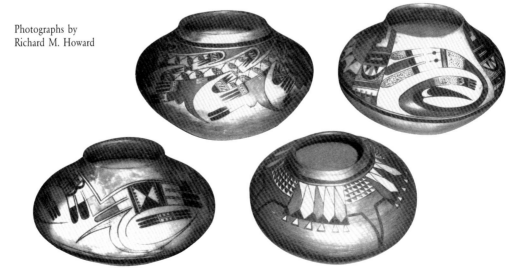

On April 25, 1981, inscribed on the base "Nampeyo," black and red on yellow jar, feathers design (6 3/4" dia.), est. $1,000-1,500, sold for $2,300 at Sotheby's, sale #4586Y, #110.

On October 26, 1979, old label "Hopi, Nampe. . .", black and red on yellow jar, bird design (13" dia.), together with a bowl, (9 7/8"), est. $1,200-1,800, sold for $2,200 at Sotheby's, sale #4391, #49.

In the 1920s, "Tom [Polacca] gets for a water jar by Nampeyo two to five dollars, depending on the size, — the five dollar size being exceptionally large for any place. A twelve inch bowl by Nampeyo, seventy-five cents. The work of other potters is cheaper. Small pieces bring from fifteen to fifty cents. Higher prices prevail on the mesas, potters realizing the extent to which they can fleece the unwary purchaser." (Bunzel 1929:5)

PUBLICATIONS: Allen 1984:106; Arizona Highways Jan. 1974:16, Jan.1975:14; Arnold 1982; Bonar 1995; Bunzel 1929; Dillingham 1978, 1994; Fewkes 1919; Frisbie 1973:231-43; Gault 1991:15; Hodge, 1942a 1942a; Hough 1915, 1917; Judd 1951; Kramer 1996; Matuz 1997:406-08; McCoy no date:100-107; Monthan & Monthan 1977; Nequatewa 1943; Schaaf 1998; Schwartz 1969; Stephen 1936; Struever 1989, 1996a, 1996b;

BIOGRAPHICAL DATABASES: "Hopi-Tewa Potters," Native American Resource Collection, Heard Museum, Phoenix; "Artist Database," Museum of Indian Arts & Cultures, Santa Fe.

Photograph by Richard M. Howard

At the beginning the of the 20th century, Nampeyo was the first Pueblo potter to gain fame beyond the American Southwest. Today, her name ranks among the most highly honored pottery artists, including Maria Martinez and Margaret Tafoya. Nampeyo and her descendants are best known for reviving and expanding a beautiful ancient style of pottery called Sikyatki.

Nampeyo's Corn Clan ancestors were Tewa speaking people from New Mexico who moved to Hopi in Arizona after the 1680 Pueblo Revolt. They settled atop First Mesa in the village of Hano. At the time of Nampeyo's birth, around 1860, Hopi pottery in the style of Polacca Polychrome was experiencing a decline in quality. Because Nampeyo was of Tewa ancestry, she was discouraged from using designs claimed by Hopi potters. Her dilemma was solved by switching to symbols found on old pottery sherds of types known as Kayenta Anasazi and Sikyatki Polychrome.

A controversy still rages over the influences on Nampeyo's pottery revival. Biographer Barbara Kramer recently challenged Dr. Jesse Walter Fewkes inference over his role in showing Nampeyo pottery sherds from his excavation of the village of Sikyatki. However, during the present generation, most First Mesa potters avidly study the paperback reprint of Fewkes' classic study, "Designs on Prehistoric Hopi Pottery." The author's opinion is that Nampeyo and her husband Lesso were drawing from designs on old pottery sherds long before the arrival of Fewkes, but the classic pottery unearthed at Sikyatki was inspiring. Whole vessels were available to Nampeyo before the arrival of Fewkes, through trader Thomas Keam. (There was no law against "pot-hunting" until 1906.) Sikyatki symbols of

parrots, butterflies, eagles and other designs appear on pottery of Nampeyo and her descendants.

Long before Picasso and Braque championed Cubism, Sikyatki style potters worked along similar artistic lines. Design elements were compressed, reduced to basic forms and abstracted. For example, a parrot design sometimes would be divided into four quadrants. The curling beak, the flowing wings and sharp-tipped tail feathers were rotated in space and then fit back together like a mosaic. The effect is sophisticated and ingenious, like a great Cubist painting.

As with her contemporaries, modern artists around the world, Nampeyo first and foremost was an innovator. Just as Picasso and Matisse drew from African masks and Tahitian carvings, Nampeyo was inspired by ancient Southwest pots and Kachinas. One measure of greatness is the test of time. Nampeyo's legacy has survived a century through six generations.

Nampeyo and Lesso's three daughters were potters. The eldest, Annie Healing, accompanied her mother to demonstrations in the Hopi House at the Grand Canyon. She was noted for Redware pots with black and sometimes white Sikyatki inspired designs. She mostly made bowls and compressed seed jars. Nellie Douma was the middle daughter who accompanied Nampeyo to the 1919 Chicago Exposition. These public events helped make Nampeyo world famous. Nellie said, "Nampeyo told me to teach my daughters how to make pottery and to keep the pottery making alive."

Nampeyo taught her great-granddaughter Priscilla, how to make pottery. Priscilla recalled that Nampeyo had two water jars glazed with piñon gum, called *chü-kau'-koz-ru* in Tewa. "Nampeyo used a tumpline to carry water from the spring at the bottom of the mesa," Priscilla recounted.

As Nampeyo's eyesight began to fail, her youngest daughter, Fannie Polacca Nampeyo, helped her mother in later years by painting on the designs. Fannie's favorite design was the fine line migration pattern featuring curling wave-like designs with parrot tail tips. She commented, "We are glad that the designs have been taken over by the family."

Among the children of Annie, Nellie and Fannie, thirteen became potters. The most noted are Rachel Namingha Nampeyo, Marie Nampeyo Koopee, Elva Tewaguna, Leah Garcia, Tonita Hamilton, Iris Youvella Tom Polacca and Ellsworth Polacca, two of the few male potters. Among Nampeyo's great-grandchildren, twenty-five became accomplished potters. Two of Rachel's daughters are

Photographs by Richard M. Howard

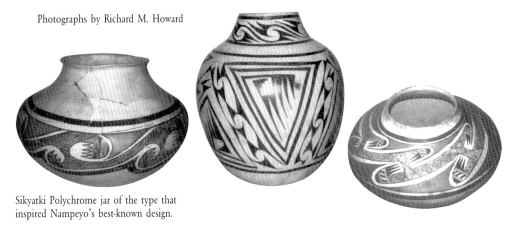

Sikyatki Polychrome jar of the type that inspired Nampeyo's best-known design.

the most highly acclaimed, Dextra Quotskuyva and Priscilla Namingha Nampeyo. Two of Leah's sons have developed respected reputations — James Garcia Nampeyo and Rayvin Garcia Nampeyo. The latter was influenced by his Aunt Fannie, noted for large seed jars and ollas with fine line migration designs.

Nine of Nampeyo's great-great grandchildren have achieved recognition as outstanding potters. Dextra's daughter, Hisi (Camille) Quotskuyva Nampeyo, has created some of the finest pottery ever made. Her large compressed seed jars are thin walled, symmetrically formed and painted to perfection with innovative designs. Her brother, Dan Namingha (q.v.), is on his way to becoming the most successful painter in Hopi history. Their cousins, Les Namingha, Karen and Stephen Lucas, are producing fine polychrome pottery with bold designs. Five of Priscilla's children have followed in the family pottery tradition — Jean, Randy, Nyla and Rachel Sahmie, as well as Bonnie Chapella Nampeyo.

As stated earlier, the Nampeyo family collectively deserve recognition and respect for reviving classic Sikyatki pottery, as well as other ancient styles. Their innovations credit them as artists of the first rank. During a recent giveaway at a Walpi dance, Nampeyo family members were seen atop a third story roof, throwing down to the people gathered in the plaza — pottery plaques tossed like Frisbees! Sometimes gusts of wind hurled the valuable gifts crashing hundreds of feet to the bottom of the mesa, where small boys scrambled to collect the pieces.

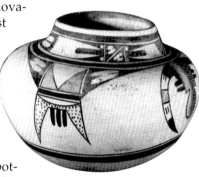

Photograph by Richard M. Howard

Adelle Lalo Nampeyo
(signs Adelle, Adelle L. Nampeyo or Adelle Lalo Nampeyo with a Corn Plant Hallmark)

(Tewa, Corn Clan, active 1970-present: black and red on yellow jars and bowls)
LIFESPAN: (1959-)
FAMILY: Daughter of Elva Tewaguna Nampeyo (1926-1985); granddaughter of Fannie Polacca Nampeyo (1900-1987); great-granddaughter of Nampeyo (1860-1942); wife of David Lalo; sister of Miriam Tewaguna Nampeyo, Elton Tewaguna, and Neva Polacca Choyou Nampeyo.
FAVORITE DESIGNS: Clown, butterfly, bird wings, feathers, migration, rain clouds, rain, 4 negative stars and eagle tail feathers, spirals, connected scroll as Muingwa-generative force of nature, parrot's beak, Sikyatki Revival
PUBLICATIONS: Dillingham 1994:14-15.
BIOGRAPHICAL DATABASES: "Hopi-Tewa Potters," Native American Resource Collection, Heard Museum, Phoenix; "Artist Database," Museum of Indian Arts & Cultures, Santa Fe.

Photograph by Angie Yan.

Adelle L. NAMPEYO

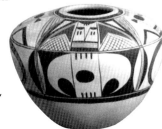

Sue Latham Collection

94

"I guess I'm so glad I learned this from my mom [Elva Tewaguna] and grandma [Fannie Polacca] and now I'm trying to teach my girls. It means a lot to me to make pots, the spiritual way means a lot...I've stayed with designs in the family — fineline and black design..." Illustrated and quoted with photograph of the potter in Rick Dillingham, *Fourteen Families in Pueblo Pottery* (Albuquerque, NM: University of New Mexico Press, 1994), pp. 14-15, 38.

Annie Healing Nampeyo
(Annie Healing, Mrs. Willie Healing, Quinchawa)
(Tewa, Tewa Village, Corn Clan, active 1900-1968: bowls and jars in the following styles: black on yellow, black and red on yellow, black on red, black and white on red, miniature jars, tile, ladles)
LIFESPAN: (1884-1968)
FAMILY: Daughter of Nampeyo and Lesso; mother of Rachel, Daisy, Dewey, Fletcher, Beatrice and Lucy; sister of Fannie Polacca Nampeyo and Nellie Douma Nampeyo
COLLECTIONS: Museum of Northern Arizona, miniature jar, #E191, 1925-1936; tile, #E1410, 1930-1950; black and red on yellow jar, #E1417, 1950; ladle, #E8388, 1979.
VALUES: On March 25, 1994, attributed?, cylinder jar, ca. 1935, bird design (12 x 6"), est. $500-1,000, sold for $330 at Allard, #945.
PUBLICATIONS: Allen 1984:106; Dillingham 1994:14-15.; Hayes & Blom 1996:68-75

Gregory Schaaf Collection

BIOGRAPHICAL DATABASES: "Hopi-Tewa Potters," Native American Resource Collection, Heard Museum, Phoenix; "Artist Database," Museum of Indian Arts & Cultures, Santa Fe.

Augusta Poocha Nampeyo
(Tewa, Corn Clan)
LIFESPAN: (- pre-1998)
PUBLICATIONS: Dillingham 1994:14-15.

Beatrice Naha Nampeyo
(Tewa, active 1930-1942)
LIFESPAN: (1912-1942)
FAMILY: Granddaughter of Nampeyo; daughter of Annie Healing; sister of Rachel Namingha Nampeyo, Fletcher Healing, Lucy, Dewey Healing (married to Juanita Healing) and Daisy Hooee Nampeyo.
PUBLICATIONS: Dillingham 1994:14-15.
BIOGRAPHICAL DATABASES: "Hopi-Tewa Potters," Native American Resource Collection, Heard Museum, Phoenix; "Artist Database," Museum of Indian Arts & Cultures, Santa Fe.

Betsy Koopee Nampeyo
(also Betsy Koopee or Betsy Nampeyo Koopee)
(Tewa, Polacca, active 1970-1980: black and red on yellow bowls)
COLLECTIONS: Museum of Northern Arizona, black and red on yellow bowl, #E6360, 1973.
PUBLICATIONS: Allen 1984:117

Bonnie Chapella Nampeyo

(also signs B. Chapella Nampeyo, Bonnie Sahmie Nampeyo)
(Tewa, Corn Clan, active 1975-present: polychrome vases, black on red bowls, tiles)
LIFESPAN: (1958-)
FAMILY: Daughter of Priscilla Namingha Nampeyo; sister of Jean, Rachel, Nyla, Randy, Finkle, & Foster Sahmie.
PUBLICATIONS: Dillingham 1994:14-15.

CARLA
NAMPEYO

"THE HARVEST"

Carla Claw Nampeyo

(also Carla Claw)
(Hopi-Tewa, Snow Clan, Shungopavy/Polacca, active 1975-present: deep carved polychrome wares and miniatures)
LIFESPAN: (1961-)
FAMILY: Daughter of Thomas Polacca (Tewa) and Gertrude (Hopi); sister of Gary Polacca; spouse of Raul Claw (Navajo).
PUBLICATIONS: Dillingham 1994:14-15; Bassman 1997:80
BIOGRAPHICAL DATABASES: "Hopi-Tewa Potters," Native American Resource Collection, Heard Museum, Phoenix; "Artist Database," Museum of Indian Arts & Cultures, Santa Fe.

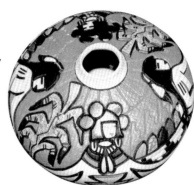

Charlotte Nampeyo

(Hopi, active 1980)

Cheryl Naha Nampeyo

(Hopi, active 1990)
BIOGRAPHICAL DATABASES: "Hopi-Tewa Potters," Native American Resource Collection, Heard Museum, Phoenix; "Artist Database," Museum of Indian Arts & Cultures, Santa Fe.

Clara Nampeyo

(Hopi, active 1990)

CLINTON
POLACCA
"NAMPEYO"

Clinton Polacca Nampeyo

(Pima/Tewa, Kachina Clan, active 1975-present: black and red on yellow jars)
LIFESPAN: (1958-)
FAMILY: Great-grandson of Nampeyo; grandson of Fannie Polacca Nampeyo; son of Harold Polacca and Alice (Pima); brother of Vernida Polacca Nampeyo, Diana Polacca, Clement Polacca, Harold Polacca, Jr., Reva Polacca Ami and Marvin Polacca.
FAVORITE DESIGNS: Migration
PUBLICATIONS: Dillingham 1994:14-15.
BIOGRAPHICAL DATABASES: "Hopi-Tewa Potters," Native American Resource Collection, Heard Museum, Phoenix; "Artist Database," Museum of Indian Arts & Cultures, Santa Fe.

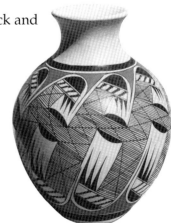

Gregory Schaaf Collection

Daisy Hooee Nampeyo

(sometimes signed Daisy Nampeyo, Nampeyo Daisy Hooee or Daisy Hooee Nampeyo)

(Tewa, Polacca, active 1920-1990: black and red on yellow jars, bowls)

LIFESPAN: (1906- pre-1998)

FAMILY: Granddaughter of Nampeyo; daughter of Annie and Willie Healing; sister of Rachel Namingha Nampeyo, Fletcher Healing, Lucy, Dewey Healing (married to Juanita Healing) and Beatrice Naha; wife of Neil Naha, Leo Poblano (Zuni), then Sidney Hooee from 1948; mother of Shirley Benn (b. 1936), Louella Naha Inote, "Whiskey" and Raymond Naha, (painter, d.)

FAVORITE DESIGNS: migration, parrot

EXHIBITIONS: 1997-98 Recent Acquisitions, Heard Museum, Phoenix

COLLECTIONS: Museum of Northern Arizona, black and red on yellow jar, #E3347, 1950; black and red on yellow jar, #E7682, 1920-1930; Heard Museum, Phoenix, AZ, jar, #3487-1, ca. 1948-1994.

VALUES: On May 10, 1996, a black and red on yellow jar, ca. 1960 (6 x 7"), faded paint, est. $150-250, sold for $82.50 at Munn, #53.

On May 10, 1996, a black and red on yellow jar, ca. 1950 (8 x 8"), faded paint, est. $150-200, sold for $220 at Munn, #302.

On October 15, 1993, black & red on yellow jar, ca. 1940, prayer feather & triangular spiral designs (8 x 6"), est. $400-800, sold for $600 at Munn, #929.

On June 5, 1992, signed Daisy Nampeyo, black & red on yellow bowl, parrot design, ca. 1930 (4 x 8"), est. $400-800, sold for $600 at Munn, #992.

On March 22, 1985, signed, polychrome bowl, ca. 1950 (2.5 x 7.5"), sold for $125 at Allard, #1037

In 1981, signed, a black & red on yellow jar, migration design, ca. 1981 (4.75 x 5.75), was offered for sale at $500 by T.N. Luther, "American Indian Art," catalog #A2-1981, item #P38, p. 84.

PUBLICATIONS: Dillingham 1994:14-15.; Hayes & Blom 1996:68-75

BIOGRAPHICAL DATABASES: "Hopi-Tewa Potters," Native American Resource Collection, Heard Museum, Phoenix; "Artist Database," Museum of Indian Arts & Cultures, Santa Fe.

In a March 1998 interview, Tewa potter Dextra Quotskuyva complimented the work of Daisy Nampeyo, "She made big pots, giant pots." She influenced a lot of potters, including the original Feather Woman, Helen Naha.

Photograph by Angie Yan

Darlene James Nampeyo

(Darlene James, Darlene Vigil Nampeyo)

(Hopi/Tewa, Corn Clan, Polacca, active 1968-present: black & red on yellow vases, figurines of maidens, tiles, plates, jars and bowls)

BORN: December 28, 1956 at Keams Canyon, AZ

FAMILY: Great-great granddaughter of Nampeyo; granddaughter of Rachel Nampeyo; daughter of Ruth James Nampeyo (b. 1926) and Dalton James; former wife of Felix Vigil; mother of James Francis Vigil and Adam Spencer Vigil.

EDUCATION: Winslow High School, 1975; Northland Pioneer College, 1977; Institute of American Indian Arts, AFA, 1979

TEACHERS: Dextra Quotsquyva, Rachel and Priscilla Nampeyo

STUDENT: Adam Vigil

AWARDS: Second, Honorable Mention, "Hopi Show," Museum of Northern Arizona, 1985; Honorable Mention, Fountain Hills Arts & Crafts Show, Fountain

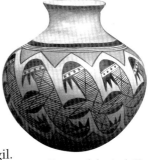

Photograph by Angie Yan

Darlene
Nampeyo

Hills, AZ, 1985; Second, Colorado Indian Market, Boulder, 1986; Fannie Nampeyo
Memorial Award, Best of Division, Scottsdale Native American Indian Cultural
Foundation Show; seven consecutive Indian Market awards.
EXHIBITIONS:

1985	Pueblo Indian Cultural Center, Albuquerque
1987-98	"Indian Market," SWAIA, Santa Fe
1990	"Life of the Clay," Wheelwright Museum, Santa Fe
1991-94	"Southwest Museum Invitational," L.A.
1992-95	"Native American Invitational, Coconino Center for the Arts, Flagstaff,
1993	"Southwest Pueblo Artists," Southwest Texas State University, San Marcos, TX
1995	"Women of the Rio Grande," Fiesta Senacu, El Paso, TX
	"Four Winds Gallery," Pittsburgh, PA
	"Ya'at'eeh '95," Sarasota, FL

Frank Kinsel Collection

FAVORITE DESIGNS: birds, cornstalks
PUBLICATIONS: Dillingham 1994:14-15; Hayes & Blom 1998:39, 61
BIOGRAPHICAL DATABASES: "Hopi-Tewa Potters," Native American Resource
Collection, Heard Museum, Phoenix; "Artist Database," Museum of Indian Arts &
Cultures, Santa Fe.

We met Darlene James at Santa Fe Indian Market. She expressed her love for her family tradition, "I feel very fortunate coming from a family of well known Hopi-Tewa potters...Each of us is unique in our own style...I draw inspirations from the landscape, songs, dances, stories and prayers. The combination of these elements goes into each pot I create. Clay is the earth and its existence is molded into beauty by the artistic talents that we possess.

Donella Tom Nampeyo
(Tewa, Corn Clan, active 1990)
LIFESPAN: (1972-)
FAMILY: Great-great-great Granddaughter of Nampeyo, Great Granddaughter of
Annie Healing, Granddaughter of Priscilla Nampeyo, Daughter of Jean Sahme

Doran Youvella Nampeyo
(see Doran Youvella)

E. LUCAS
(NAMPEYO)

Eleanor Lucas Nampeyo
(Eleanor Lucas, Eleanor Namingha)
(Tewa, Corn Clan, Gallup, NM, active 1940-84: black
on yellow jars)
LIFESPAN: (ca, 1926-)
FAMILY: Fourth generation descendant of Nampeyo, the
Tewa potter who revived Sityatki style pottery on First Mesa
at Hopi. Granddaughter of Annie and Willie Healing, daughter of Rachel and Emerson Namingha; mother of Karen Lucas,
Janelle Lucas, and Stephen Lucas; sister of Priscilla Nampeyo,
Dextra Quotskuyva; Ruth Namingha, and Emerson Namingha.
COLLECTIONS: Museum of Northern Arizona, 2 black on yellow
jars, #E6353a,b, 73.
PUBLICATIONS: Allen 1984:117; Dillingham 1994:14-15

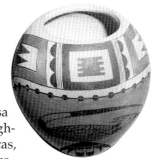

Richard M. Howard
Collection

BIOGRAPHICAL DATABASES: "Hopi-Tewa Potters," Native American Resource Collection, Heard Museum, Phoenix; "Artist Database," Museum of Indian Arts & Cultures, Santa Fe.

Ellsworth Polacca Nampeyo
(Tewa, Corn Clan, active 1970-1980: incised redware jars
LIFESPAN: (1940-1993)
FAVORITE DESIGNS: Kokopelli, water
VALUES: On October 4, 1991, signed, incised redware jar, Kokopelli & water designs, ca. 1979 (2 x 2"), est. $35-70, sold for $185 at Munn, #1002.

Elton Tewaguna Nampeyo
(see Elton Tewaguna)

ELVA NAMPEYO

Elva Tewaguna Nampeyo
(Tewa, Tewa Village/Polacca, Corn Clan, active 1940-1985: black and red on yellow bowls & jars)
LIFESPAN: (1926-1985)
FAMILY: Granddaughter of Nampeyo; daughter of Fannie Polacca Nampeyo and Vinton Polacca; mother of Miriam Tewaguna Nampeyo, Adelle Lalo Nampeyo, Elton Tewaguna and Neva Polacca Choyou Nampeyo; sister of Leah Garcia Nampeyo, Harold Polacca Nampeyo, Sr., Tonita Hamilton Nampeyo, Tom Polacca, Elsworth Polacca and Iris Youvella Nampeyo.

Gregory Schaaf Collection

COLLECTIONS: Museum of Northern Arizona, black and red on yellow bowl, #E5748, 1962-1972; black and red on yellow jar, #E7915, 1969; Heard Museum, Phoenix, AZ, jar, #3576-140, 1926-1985; bowl, #NA-SW-HO-A7-61; jar, #NA-SW-HO-A7-65.
FAVORITE DESIGNS: Migration - The fine lines represent the people. The upper scroll symbolizes clan migrations in the Northern Hemisphere. The lower scroll refers to clan migrations in the Southern Hemisphere. 4 negative stars & eagle tail feathers.
VALUES: On February 6, 1998, black & red on yellow jar, ca. 1970s, migration design (5.5 x 6.5"), est. $600-900, sold for $577.50 at Munn, #761.

October 17, 1996, a black & red on yellow jar with a migration design, signed Elva Nampeyo (7 3/4" dia.), est. $1,000-1,500, did not reach reserve minimum at Sotheby's, sale #6898, #249.

On November 30, 1995, a black and red on yellow jar (8 1/4"), est. $1,200-1,800, did not reach reserve minimum, at Sotheby's, sale #6783, #286.

On November 30, 1995, a black and red on yellow jar signed Elva Nampeyo (5 1/2" dia.), along with a smaller jar signed Fannie Nampeyo (5" dia), est. $700-1,000, sold for $1,150 at Sotheby's, sale #6783, #288.

On November 30, 1995, two black and red on yellow jars (6 7/8 & 7 5/8"), est. $1,000-1,500, did not reach reserve minimum, at Sotheby's, sale #6783, #289.

On May 19, 1995, black and red on yellow seed jar, migration design (4 x 5"), est. $125-200, sold for $90 at Munn, #960.

On October 16, 1994, black and red on yellow jar, migration design (6 x 8.5"), est. $600-1,000, sold for $425 at Munn, #937.

On October 16, 1994, black and red on yellow jar, 4 negative stars & eagle tail feather designs (3 x 6.5"), est. $500-800, sold for $400 at Munn, #1053.

On May 15, 1992, a black and red on yellow seed jar with a migration design (5 1/4 x 10 1/2"), est. $600-900 sold for $550 at Butterfield & Butterfield, sale #4865, E, #4341.

On January 31, 1992, signed, bowl, ca. 1940, Provenance: Joan Drackert Estate (5" dia.), est. $100-200, [need sales result] at Munn, #1039.

On November 26, 1991, a black & red on yellow seed jar with a migration design, signed Elva Nampeyo (8" dia.), est. $800-1,200, sold for $1,100 at Sotheby's, sale #6181, #241.

On October 4, 1991, signed, black & red on yellow seed jar, 4 wings design, ca. 1970 (3 x 5"), est. $250-500, sold for $200 at Munn, #1062.

On April 25, 1991, a black and red on yellow seed jar (3 x 6"), est. $400-600, did not reach reserve minimum, at Butterfield & Butterfield, sale #4541E, #4071.

On April 25, 1991, a black and red on yellow seed jar with four eagle tails design (4 1/2 x 6 1/2"), est. $700-1,000, sold for $770, at Butterfield & Butterfield, sale #4541E, #4099.

On April 25, 1991, a black and red on yellow seed jar with stylized bird design (3 1/4 x 6 1/2"), est. $400-600, sold for $467.50, at Butterfield & Butterfield, sale #4541E, #4125.

On March 15, 1991, signed, seed jar, batwing design, ca. 1985 (3 x 6"), est. $400-800, sold for $605 at Allard, #499.

On February 1, 1991, signed, miniature bowl, Sikyatki designs, ca. 1940 (2 x 2"), sold for $50 at Munn, #300.

On September 26, 1990, a black & red on yellow seed jar with a migration design, signed Elva Nampeyo (10 1/2" dia.), est. $2,000-3,000, sold for $1,980 at Sotheby's, sale #6061, #470.

On September 26, 1990, a black & red on yellow seed jar with a migration design, signed Elva Nampeyo (9" dia.), est. $1,000-1,500, sold for $770 at Sotheby's, sale #6061, #471.

On September 26, 1990, a black & red on yellow seed jar with a migration design, signed Elva Nampeyo (7" dia.), est. $800-1,200, sold for $550 at Sotheby's, sale #6061, #473.

September 26, 1990, a black & red on yellow seed jar with a migration design, signed Elva Nampeyo (6 1/4" dia.), est. $600-900, sold for $660 at Sotheby's, sale #6061, #475.

September 26, 1990, a black & red on yellow seed jar with a migration design, signed Elva Nampeyo (6 1/4" dia.), est. $600-900, sold for $990 at Sotheby's, sale #6061, #476.

May 22, 1989, a black & red on yellow seed jar with a 4 negative stars design, signed Elva Nampeyo (10" dia.), est. $1,500-2,000, sold for $2,310 at Sotheby's, sale #5858, #46.

On March 17, 1989, signed, polychrome jar, migration design, ca. 1950 (4 x 6"), est. $150-300, sold for $205 at Allard, #308.

On March 17, 1989, signed, polychrome jar, migration design, ca. 1950 (4 x 5"), est. $200-400, sold for $180 at Allard, #705.

On March 18, 1988, black & red on yellow seed jar, migration design (3.5 x 6"), est. $300-600, sold for $505 at Allard, #1434.

On March 18, 1988, black & red on yellow seed jar, bat wing design (4 x 6"), est. $300-600, sold for $405 at Allard, #1435.

May 27, 1987, a black & red on yellow seed jar with a migration design, signed Elva Nampeyo (8" dia.), est. $800-1,200, sold for $660 at Sotheby's, sale #5583, #422.

May 27, 1987, two black & red on yellow seed jars with a migration design, signed Elva Nampeyo (4 1/8" dia. largest), est. $700-900, sold for $990 at Sotheby's, sale #5583, #424.

May 27, 1987, a black & red on yellow seed jar with a 4 negative stars & eagle tail design, signed Elva Nampeyo (7 1/2" dia), est. $800-1,200, did not reach reserve minimum at Sotheby's, sale #5583, #425.

On December 3, 1986, a black & red on yellow jar with migration design, signed Elva Nampeyo (6 1/2" dia.), est. $800-1,200, sold for $770 at Sotheby's, sale #5522, #50.

On December 3, 1986, two black & red on yellow jar with wing designs, signed Elva Nampeyo (8" dia.), est. $800-1,200, sold for $990 at Sotheby's, sale #5522, #48.

On December 3, 1986, a black & red on yellow jar with prayer feather and water design, signed Elva Nampeyo (5 1/2" dia.), est. $600-900, sold for $550 at Sotheby's, sale #5522, #285.

On March 22, 1985, signed, polychrome jar, ca. 1955, migration design (6 x 7"), sold for $250 at Allard, #122.

On March 22, 1985, signed, polychrome jar, migration design, ca. 1965 (9 x 16"), sold for $400 at Allard, #428.

On March 23, 1984, signed, black & red on yellow seed jar, bird design, ca. 1975 (4 x 7"), sold for $175 at Allard, #481.

PUBLICATIONS: Allen 1984:116; Dillingham 1994:14-15
BIOGRAPHICAL DATABASES: "Hopi-Tewa Potters," Native American Resource Collection, Heard Museum, Phoenix; "Artist Database," Museum of Indian Arts & Cultures, Santa Fe.

Elvira Nampeyo

(Elvira Polacca Nampeyo, Elvira Polacca Naha, also signs with her husband-Marty and Elvira Nampeyo)
(Hopi, Snow Clan, Polacca, active 1980-present: carved redware)
LIFESPAN: (1968-)
FAMILY: She makes pottery with her husband, Marty Naha; daughter of Tom Polacca, sister of Gary Polacca Nampeyo and Carla Claw.
FAVORITE DESIGNS: Kachinas
PUBLICATIONS: Dillingham 1994:14-15
BIOGRAPHICAL DATABASES: "Hopi-Tewa Potters," Native American Resource Collection, Heard Museum, Phoenix; "Artist Database," Museum of Indian Arts & Cultures, Santa Fe.

Fannie Polacca Nampeyo

(signed FANNIE NAMPEYO often with Corn Clan hallmark, Fannie Polacca Nampeyo)
(Tewa, Corn Clan, Tewa Village/Polacca, active 1920-1987: jars, bowls, bird effigy bowls, cups and saucers & miniature bowls in the following styles: black and red on yellow, black on yellow)
LIFESPAN: (1904-1987)
FAMILY: daughter of Nampeyo and Lesou; wife of Vinton Polacca (Tobacco Clan from Hano); mother of Thomas, Elva, Tonita, Iris, Leah, Harold and Elsworth; sister of Annie Healing Nampeyo and Nellie Douma Nampeyo

Gregory Schaaf Collection

AWARDS: Blue first place ribbon from Museum of Northern Arizona, Flagstaff, July 1961
EXHIBITIONS:
 July 1961 "Hopi Show," Museum of Northern Arizona, Flagstaff
 1996-1997 "Fred Harvey Pottery Exhibit," Heard Museum, Phoenix
 1997-1998 Recent Acquisitions, Heard Museum, Phoenix
FAVORITE DESIGNS: migration, rain, clouds, tail feathers, star, feathers
COLLECTIONS: Museum of Northern Arizona, black and red on yellow jar, #E245, 1936; black and red on yellow jar, #E433, 1922; black and red on yellow jar, #E615, 1930-1940; black and red on yellow jar, #E700, 1930; black and red on yellow jar,

#E947, 1940-1952; Nampeyo and Fannie Nampeyo, black and red on yellow jar, #E1411, 1934; Nampeyo and Fannie Nampeyo, black and red on yellow jar, #E2630, 1935; black and red on yellow bowl, #E3522, 1930-1940; miniature bowl, #E5231, 1940-1950; black on yellow jar, #E5352, 1950; 4 black and red on yellow jar, #E5749, 5751, 5752, 5753, 1962-1972; black and red on yellow jar, #E6354, 1973; Heard Museum, Phoenix, AZ, bowl, #3361-1, 1930s; jar, #3512-3, ca. 1930s; 3 jars, #752P, #753P, #754P, mid 1900's; jar, #NA-SW-HO-A7-140.

VALUES: On February 6, 1998, black & red on yellow jar, ca. 1970s, migration designs (5.5 x 6"), est. $800-1,200, sold for $1265 at Munn, #760.

In 1997, a seed jar "possibly by" Fannie (11 3/4" dia), est. $2,500-4,500, sold for $4,312 at Sotheby's December 4, 1997:#248.

In 1997, a seed jar "probably by" Fannie (10 1/4" dia), est. $1,500-1,800, sold for $2,587 at Sotheby's December 4, 1997:#247.

In 1997, a seed jar, ca. 1940, (7 x 12"), est. $3,000-6,000, sold for $3,630, at Munn, October 1997:120, #1217; a seed jar, ca. 1950, (4.5 x 7.5"), est. $600-900, sold for $907.50 at Munn, October 1997:70, #684.

On May 21, 1996, an unsigned black and red on yellow jar (12" dia.), along with a smaller jar signed Fannie Nampeyo (5 3/4" dia), est. $2,000-3,000, sold for $1725 at Sotheby's, sale #6853, #280.

Gregory Schaaf Collection

On November 30, 1995, a black and red on yellow jar signed Fannie Nampeyo (11" dia), est. $2,000-3,000, sold for $1,840 at Sotheby's, sale #6783, #287.

On November 30, 1995, a black and red on yellow jar signed Elva Nampeyo (5 1/2" dia.), along with a smaller jar signed Fannie Nampeyo (5" dia), est. $700-1,000, sold for $1,150 at Sotheby's, sale #6783, #288.

On August 13, 1995, a polychrome 3" cup and 6" saucer, ca. 1945, est. $600-1200 sold for $495, at Allard, #80C.

On May 19, 1995, a black and red on yellow bowl, prayer feather & rain designs, ca. 1960 (2.5 x 4"), est. $300-500, sold for $412.50 at Munn, #732.

On May 19, 1995, a black and red on yellow seed jar, migration design (4 x 5"), est. $450-750, sold for $467.50 at Munn, #956.

On May 19, 1995, a black and red on yellow cup & saucer (6 x 2.5"), est. $450-600, sold for $440 at Munn, #1105.

On March 24, 1995, a terraced seed jar, signed Fannie Nampeyo (3 x 3"), ca. 1985, est. $125-250, sold for $275, at Allard, #782.

On June 3, 1994, black & red on yellow bowl, stars, eagle tail feathers, cloud designs, ca. 1930 (4 x 6"), est. $500-1,000, sold for $800 at Munn, #1096.

On May 24, 1994, a black and red on yellow jar (12 1/2" dia.), est. $4,500-5,500, sold for $6,900 at Sotheby's, sale #6567, #43.

On February 4, 1994, a miniature black & red on yellow seed jar, ca. 1970, 4 bird wings designs (2 x 2"), est. $200-400, sold for $175, at Munn, #688.

On February 4, 1994, black & red on yellow bowl, ca. 1970, (4 x 6"), est. $300-500, sold for $495, at Munn, #1096.

On October 15, 1993, a miniature black & red on yellow jar, ca. 1960, migration design (2 x 2.5"), est. $125-250, sold for $190 at Munn, #927A.

On March 26, 1993, signed, bird effigy bowl, ca. 1960 (4.5 x 5.5"), est. $250-500, sold for $275 at Allard, #600E.

On March 26, 1993, signed, seed jar, migration design, ca. 1970 (3 x 7"), est. $400-800, sold for $495 at Allard, #857.

On February 5, 1993, black & red on yellow jar, ca. 1940, clouds, feathers designs (2 x 4"), est. $100-200, sold for $350 at Munn, #538.

On February 5, 1993, black & red on yellow jar, ca. 1940, cloud designs (4 x 4"),

est. $600-1,200, sold for $875 at Munn, #1202.

On December 2, 1992, a black and red on yellow jar with cloud design (4 x 4″), est. $600-800, sold for $550 at Butterfield & Butterfield, sale #5235E, #3458.

On December 2, 1992, a black and red on yellow seed jar [no neck] with a migration design (4 3/4 x 10″), est. $3,000-4,000 sold for $3,025 at Butterfield & Butterfield, sale #5235E, #3484.

On December 2, 1992, a black and red on yellow seed jar [tall waisted neck] with a migration design (7 1/4 x 9 1/4″), est. $2,000-3,000 sold for $2,200 at Butterfield & Butterfield, sale #5235E, #3498.

On November 12, 1992, a black and red on yellow jar with a migration design (6 3/4″ dia.), est. $2,000-3,000, did not reach reserve minimum at Sotheby's, sale #6361, #84.

On October 16, 1992, a bird effigy bowl, prayer feather design (2 x 5″), est. $175-350, sold for $275 at Munn, #584.

On May 15, 1992, a black and red on yellow seed jar [no neck] with a migration design (4 x 7 1/4″), est. $800-1,200 sold for $935 at Butterfield & Butterfield, sale #5235E, #4342.

On May 15, 1992, a black and red on yellow seed jar [upturned neck] with a migration design (5 1/4 x 7 1/4″), est. $1,500-2,000 sold for $2,090 at Butterfield & Butterfield, sale #5235E, #4346.

On November 26, 1991, a black & red on yellow seed jar with migration design, signed Fannie Nampeyo (9″ dia), est. $1,500-2,000, sold for $1,540 at Sotheby's, sale #6181, #240.

On October 4, 1991, attributed to Fannie Nampeyo, polychrome jar, migration design, ca. 1940 (4 x 4″), est. $200-400, sold for $150 at Munn, #389.

On October 4, 1991, signed Fannie Nampeyo, polychrome jar, prayer feather design, hairline crack, ca. 1950 (3 x 4″), est. $150-300, sold for $100 at Munn, #630.

On October 4, 1991, signed Fannie Nampeyo, polychrome bowl, stars & eagle feather designs, ca. 1950 (4 x 6″), est. $350-700, sold for $550 at Munn, #1196.

On August 1, 1991, a black and red on yellow jar, with migration design, signed Fannie Nampeyo together with a blue first place ribbon from Museum of Northern Arizona, Flagstaff, July 1961 (8 x 13″), est. $3,000-4,000 [need sales result], at Butterfield & Butterfield, sale #4582E, #2622.

On May 17, 1991, miniature bowl, germination design, ca. 1976 (1 x 1″), sold for $245 at Munn, #1065.

On April 25, 1991, a black and red on yellow seed jar with migration design (5 x 9 3/4″), est. $1,500-2,000, sold for $2,200, at Butterfield & Butterfield, sale #4541E, #4088.

On April 25, 1991, a black and red on yellow seed jar with 4 curved wings design (4 1/4 x 8″), est. $1,500-2,000, sold for $1,320, at Butterfield & Butterfield, sale #4541E, #4089.

On April 25, 1991, a black and red on yellow seed jar with migration design (8 x 11 1/2″), est. $2,500-3,500, sold for $3,300, at Butterfield & Butterfield, sale #4541E, #4098.

On April 25, 1991, a black and red on yellow seed jar with 4 wings design (4 x 6″), est. $300-500, sold for $385, at Butterfield & Butterfield, sale #4541E, #4108.

On April 25, 1991, a small black and red on yellow bowl signed Fannie Nampeyo (2 1/2 x 5 1/2″), together with two smaller bowls signed Nellie Nampeyo, est. $500-700, sold for $357.50, at Butterfield & Butterfield, sale #4541E, #4126.

On February 1, 1991, signed, seed jar, cloud designs, ca. 1950 (3 x 5″), sold for $300 at Munn, #137.

September 26, 1990, a black & red on yellow seed jar (6 7/8″ dia), est. $700-1,000, sold for $660 at Sotheby's, sale #6061, #474.

On March 16, 1990, signed, polychrome jar, migration design, ca. 1940 (4 x 6″), est. $400-800, sold for $603.75 at Allard, #693.

November 28, 1989, a black & red on yellow seed jar with 4 negative stars design, signed Fannie Nampeyo (7" dia), est. $1,200-1,800, sold for $2,200 at Sotheby's, sale #5939, #347.

On March 18, 1988, jar, migration design (4.5 x 5.5"), est. $250-500, sold for $355 at Allard, #316.

On March 18, 1988, bowl, (2 x 3"), est. $100-200, at Allard, #1331.

On May 13, 1987, a black & red on yellow seed jar with migration design, signed Fannie Nampeyo (5 3/4 x 8"), est. $1,000-1,500, [need sales result] at Butterfield & Butterfield, sale #3927E, #2249.

On December 3, 1986, a black & red on yellow jar with migration design, signed Fannie Nampeyo with Corn Clan Hallmark (8" dia.), est. $1,200-1,800, sold for $1,650 at Sotheby's, sale #5522, #48.

On December 3, 1986, a black & red on yellow jar with migration design, signed Fannie Nampeyo with Corn Clan Hallmark (8 1/4" dia.), est. $1,200-1,800, sold for $1,430 at Sotheby's, sale #5522, #51.

On May 30, 1986, a black & red on yellow jar with migration design, signed Fannie Nampeyo (11" dia.), est. $1,800-2,200, [need sale results] at Sotheby's, sale #5465, #49.

On June 22, 1986, a black & red on yellow jar with rain cloud design, signed Fannie Nampeyo (6 1/2" dia.), est. $500-700, [need sale results] at Sotheby's, sale #5354, #370.

On March 22, 1985, signed, polychrome jar, migration design, ca. 1964 (3 x 7"), sold for $350 at Allard, #699.

On April 3, 1981, signed, a polychrome seed jar, migration design, ca. 1970 (2.25 x 2.5), sold for $550, at Allard, #780G.

PUBLICATIONS: Allen 1984:107, 113-115; Dillingham 1994:14-15; Bassman 1997:77
BIOGRAPHICAL DATABASES: "Hopi-Tewa Potters," Native American Resource Collection, Heard Museum, Phoenix; "Artist Database," Museum of Indian Arts & Cultures, Santa Fe.

Gary Polacca Nampeyo
(Hopi-Tewa, Snow Clan, active 1975-present)
LIFESPAN: (1955-)
FAMILY: Grandson of Fannie Polacca Nampeyo; Son of Thomas Polacca (Tewa) and Gertrude (Hopi); Brother of Carla Claw and Elvira Naha Nampeyo.
PUBLICATIONS: Dillingham 1994:14-15; Bassman 1997:78
BIOGRAPHICAL DATABASES: "Hopi-Tewa Potters," Native American Resource Collection, Heard Museum, Phoenix; "Artist Database," Museum of Indian Arts & Cultures, Santa Fe.

Harold Polacca Nampeyo, Sr.
(Tewa, Corn Clan, active 1950-present)
LIFESPAN: (1930- pre-1998)
FAMILY: Grandson of Nampeyo; son of Fannie Polacca Nampeyo and Vinton Polacca; brother of Elva Tewaguna Nampeyo, Leah Garcia Nampeyo, Tonita Hamilton Nampeyo, Tom Polacca, Elsworth Polacca and Iris Youvella Nampeyo; husband of Alice (Pima); father of Vernida Polacca Nampeyo (b. 1955), Clinton Polacca Nampeyo (b. 1958), Reva Polacca Ami (b. 1964), Diana Polacca, Clement Polacca (d.), Harold Polacca Nampeyo, Jr., Marvin Polacca
PUBLICATIONS: Dillingham 1994:14-15
BIOGRAPHICAL DATABASES: "Hopi-Tewa Potters," Native American Resource Collection, Heard Museum, Phoenix; "Artist Database," Museum of Indian Arts & Cultures, Santa Fe.

Photograph by Tom Tallant.
Courtesy of
Canyon Country Originals,
http://www.canyonart.com/

Hisi
Nampeyo

Hisi Nampeyo or Camille Quotskuyva

(Tewa, Corn Clan, Polacca, active 1973-present: black
and red on yellow and black on yellow jars)
LIFESPAN: (1964-)
FAMILY: Great-great granddaughter of
Nampeyo; great-granddaughter of Annie
and Willie Healing, granddaughter of
Rachel Nampeyo and Emerson Namingha,
daughter of Edwin and Dextra
Quotskuyva: sister of Dan Namingha;
mother of Lowel Chereposy, Erica
Quotskuyva and Reid Ami.
EXHIBITIONS:

Gregory Schaaf Collection

1989	Roy Boyd Gallery, Chicago, Illinois with Dextra and Loren Ami
1992	Hopi Show, Museum of Northern AZ (Ribbons: 1st Place and Best of Category)
1993	New Generations Exhibition, Lithfield Park, AZ
1994	Indian Market, Santa Fe, NM (Ribbons: 3rd Place)
1995	Gallup Ceremonial, Gallup, NM (Ribbons: 2nd Place)
1995	"The Nampeyo Legacy," Santa Fe, NM with Dextra, Steve Lucas and Les Namingha
	Lovena Ohl Gallery, Scottsdale, AZ with Dextra, Steve, Loren, Steve and Les
1996	Gallup Ceremonial, Gallup, NM (Ribbons: 2nd Place)
	"The Nampeyo Legacy Continues - Santa Fe, NM with Dextra, Steve Lucas, Les Namingha and Loren Ami
	Bill Foust Gallery - Scottsdale, AZ with Dextra, Steve, Les, and Loren
1997	Adobe East Gallery - Summit, NJ with Loren Ami
1997	"Succeeding Generations," Faust Gallery, Scottsdale, AZ
1998	Adobe East Gallery - Summit, NJ with Loren Ami, Steve Lucas, Les Namingha
	Indian Market, Portland Oregon

DEMONSTRATIONS: 1998 - Heard Museum, Phoenix
COLLECTIONS: Museum of Northern Arizona, black on yellow jar, #E6365, 1973;
Heard Museum, Phoenix, AZ, jar, 1991, #3307-1.
PUBLICATIONS: Dillingham 1994:14-15.
BIOGRAPHICAL DATABASES: "Hopi-Tewa Potters," Native American Resource
Collection, Heard Museum, Phoenix; "Artist Database," Museum of Indian Arts &
Cultures, Santa Fe.

I first met Hisi in 1996, when the Director of Southwest Learning
Centers, Seth Roffman, and I stopped to visit with her and her
family in Polacca. She arranged for a group of Hopi youth dancers
to appear at the Santa Fe Indian Market concert, "Rattles, Rhythms &
Drums," at the Santa Fe Indian School. The event was beautiful, a
showcase for American Indian performing artists.

I saw Hisi again in 1997 in Santa Fe, when one of her eight
inch jars sold at auction. I visited her again in February 1998 at her
home in Polacca. She was friendly, helpful and supportive, charac-
teristics of her good nature.

Hisi has written a brief autobiography entitled, "Hisi* Nampeyo - Traditional Hopi/Tewa Potter" (1997). She gave me a copy and permission to use it in this book.

"Since I was a youngster growing up in the Seventies, I subconsciously learned the basics of pottery making. I watched my grandmother and mother as they worked on their creations and would play with the clay creating my own toys. It was fun and I slowly learned the processes of molding, sanding, polishing, painting and observed them as they fired the pottery. I was always anxious to see how the pots would come out. I learned patience and how to accept the disappointments that are qualities one must possess to master this art. It has been a long road to get to where I am today. As a child my vision of my future was to be a veterinarian or a teacher, never a potter. The idea of having a job was more appealing. Things didn't turn out as I had envisioned, but it is all for the better. My only regret is that I wish that I could have been able to show my grandmother what I am doing now.

Photograph by Bill Bonebrake. Courtesy of Jill Giller, Native American Collections, Denver, CO

"My mother has been and still is a major influence in my life. Her patience with me has been astounding for I am one who likes to experience despite her advice. She has taught me everything about pottery and how to perfect my work and the highest compliment I have gotten was when someone said my work resembles my mother's pottery. I also credit my brother, Dan Namingha, who himself is an accomplished artist, as another great influence in my life. He encourages me in my work and advises me in decisions that I need to make for myself and my business.

"My style of work is traditional using Nampeyo family designs, but I also have my own unique style and designs. I have obtained from several museums a collection of designs that are from historical Hopi excavations such as Mesa Verde, Sikyatki and other popular ruins. My grandmother always stressed to use the traditional designs to continue the legacy of Nampeyo. I remember this and honor this tradition and aspire to pass this down to my children and future grandchildren.

"I am only halfway in my career and look forward to creating more and more. I would like to experiment in other forms. There are endless ideas that are in my head waiting to be expressed. When I get discouraged I only need to look to my mother who seems to never get deterred by anything. She is my inspiration when I am distracted by everyday life. Her dreams and visions are a window to the future and should always be heeded when advised. This is conveyed in her creations. She is very special to me and the rest of my family. Whatever the future holds for myself I only dream that I would be as creative and ambitious as Dextra and continue the Nampeyo family heritage.

"*My signature name HISI is my Hopi name given to me when

I was a baby during the Hopi naming ceremony by my paternal aunts. It is the name family and friends call me, I have no preference to either name, I will answer to both.

In a March 1998 interview with Dextra Quotskuyva, Hisi's mother spoke with pride of her daughter's development as a fine potter, carrying on the family tradition: "Camille [Hisi Nampeyo] and the younger ones have been doing real good. I'm proud of them." Dextra stressed the importance of giving young artists the freedom to be creative: "Let them decide on their own. They have their own ideas. Freedom inspires them. I tell them, 'Don't give up. If you're enjoying this, do it!'"

Iris Youvella Nampeyo

(Tewa, Corn Clan, active 1960-present: appliquéed buffware jars, black & red on yellow jars, and miniatures)
LIFESPAN: (1944-)
FAMILY: Granddaughter of Nampeyo; daughter of Fannie Polacca Nampeyo and Vinton Polacca; sister of Leah Garcia Nampeyo, Harold Polacca Nampeyo, Sr., Tonita Hamilton Nampeyo, Tom Polacca, Elsworth Polacca and Elva Tewaguna Nampeyo; wife of Wallace Youvella, Sr.; mother of Wallace, Jr., Nolan Youvella, Charlene Youvella and Doran Youvella.
COLLECTIONS: Heard Museum, Phoenix, AZ, jar, #3368-3.
FAVORITE DESIGNS: appliquéed corn cobs with leaves, corn stalks with corn cobs and leaves, migration
PUBLICATIONS: Strickland 1986:288; Dillingham 1994:14-15; Hayes & Blom 1996:74-75; Bassman 1997:77
BIOGRAPHICAL DATABASES: "Hopi-Tewa Potters," Native American Resource Collection, Heard Museum, Phoenix; "Artist Database," Museum of Indian Arts & Cultures, Santa Fe.

Photograph by Bill Bonebrake.
Courtesy of Jill Giller,
Native American Collections,
Denver, CO

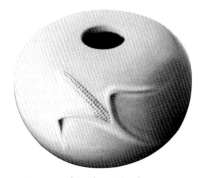

Courtesy of Southwest Auctioneers

In February of 1998, I visited Iris and her husband, Wallace Youvella, Sr., at their home on the east side of Polacca. I took my muddy boots off at the door and entered their home which was immaculately well kept. Her clothes, hair and everything around her were neat and clean, like her pottery. I found Iris to be intelligent, soft spoken and thoughtful.

Her husband, Wallace, Sr., soon returned from firing a group of pots. Iris said, "It is important to fire the pots traditionally and not use a kiln."

Wallace was especially helpful in guiding me through Hopi political protocol. He sits on the Cultural Preservation Board for the Hopi Tribe. Their office reviewed and approved my previous book, *Ancient Ancestors of the Southwest.*

Rennard Strickland in his 1986 article illustrated her appliquéed buffware jar on which he commented, "...[Iris] Nampeyo has perfected the sculptural approach to ceramics first introduced by Elizabeth White and later developed by her nephew, Al Colton [Qöyawayma]. As important to the vessel's design as its meticulously polished surface is the delicately modeled appliqué cornstalk." (Strickland 1986:288)

My visit with Iris and Wallace was pleasurable. They were kind and helpful toward me.

James Garcia Nampeyo
(James Garcia)
(Tewa/Laguna, Corn Clan, active 1975-present)
BORN: 1958
FAMILY: Great-grandson of Nampeyo, grandson of Fannie Nampeyo, son of Leah Garcia Nampeyo and Lewis Garcia (Laguna, 1928-1974), brother of Melda Nampeyo and Rayvin Garcia Nampeyo, husband of the second Fawn Navasie
FAVORITE DESIGNS: Thunderbirds, eagle tails, clowns, feathers
PUBLICATIONS: Bassman 1997:77; Dillingham 1994:14-15
BIOGRAPHICAL DATABASES: "Hopi-Tewa Potters," Native American Resource Collection, Heard Museum, Phoenix; "Artist Database," Museum of Indian Arts & Cultures, Santa Fe.

Jean Youvella Nampeyo
(see Jean Sahme)

Leah Garcia Nampeyo
(Tewa, Polacca, active 1945-1974: black and red on yellow seed jars)
LIFESPAN: (1928-1974)
FAMILY: Granddaughter of Nampeyo; daughter of Fannie Polacca Nampeyo and Vinton Polacca; sister of Elva Tewaguna Nampeyo, Harold Polacca Nampeyo, Sr., Tonita Hamilton Nampeyo, Tom Polacca, Elsworth Polacca and Iris Youvella Nampeyo, wife of Lewis Garcia (Laguna, 1928-1974); mother of Melda Nampeyo, James Garcia Nampeyo and Rayvin Garcia.
COLLECTIONS: Museum of Northern Arizona, black and red on yellow jar, #E5750, 1961-1972; black and red on yellow jar, #E7918, 1969; Heard Museum, Phoenix, AZ, bowl, #3309-377A, pre-1973; Heard Museum, Phoenix, AZ, sherd, #3309-377B, pre-1973; Heard Museum, Phoenix, AZ, sherd, #3309-377C, pre-1973; Dr. Gregory Schaaf Collections, Santa Fe.
FAVORITE DESIGNS: migration, eagle tail

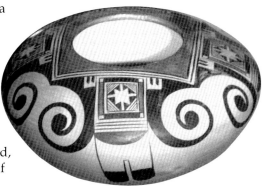

Gregory Schaaf Collection

VALUES: On February 6, 1998, black & red on yellow bowl, ca. 1970s, migration & eagle tail feather designs (4.5 x 8.5"), est. $800-1,200, sold for $1155 at Munn, #758.

On March 26, 1993, signed, seed jar, migration design, ca. 1970 (2.5 x 4"), est. $400-800, sold for $478.50 at Allard, #57.

On November 12, 1992, a black and red on yellow jar with a migration design (9" h.), est. $2,000-3,000, did not reach reserve minimum at Sotheby's, sale #6361, #230.

On October 15, 1993, black & red on yellow jar, ca. 1950, migration designs (4 x 7"), est. $200-400, sold for $375 at Munn, #926A.

On December 3, 1986, a black & red on yellow jar with migration design, signed Leah Nampeyo (7 3/4" h.), est. $1,200-1,800, sold for $990 at Sotheby's, sale #5522, #49.
PUBLICATIONS: Allen 1984:116; Dillingham 1994:14-15.
BIOGRAPHICAL DATABASES: "Hopi-Tewa Potters," Native American Resource Collection, Heard Museum, Phoenix; "Artist Database," Museum of Indian Arts & Cultures, Santa Fe.

Lillian Gonzales Nampeyo

(also signed Lee Gonzales and Lillian Namingha)
(Tewa, Corn Clan, active 1940-present)
BORN: ca. 1920s
FAMILY: Fourth generation descendant of Nampeyo; Granddaughter of Annie and Willie Healing, daughter of Rachel and Emerson Namingha; sister of Priscilla Nampeyo, Dextra Quotskuyva; Ruth Namingha, Eleanor Lucas Namingha Nampeyo and Emerson Namingha.
PUBLICATIONS: Dillingham 1994:14-15

Loren D. Hamilton Nampeyo

(see Loren Hamilton)

Marie Nampeyo Koopee

(see Marie Koopee)

Photograph by Angie Yan

Marlinda Kooyaquaptewa Nampeyo

(Tewa, Corn Clan, active 1975-present: polychrome clown figurines on bowls, ladles)
BORN: February 9, 1962 at Keams Canyon
FAMILY: Daughter of Warren Kooyaquaptewa & Zella Douma Nampeyo; wife of Manuel Chavarria; mother of Lavonna Velasco, Sonta Velasco, Fred Kooyaquaptewa
TEACHER: Rainy Naha
STUDENTS: Lavonna Velasco, Sonta Velasco, Fred Kooyaquaptewa
DEMONSTRATIONS: Elder Hostel, two years
FAVORITE DESIGNS: Clowns

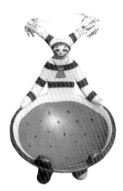

Photograph by Angie Yan

Marty Naha Nampeyo

(Marty Naha, now signs as a team with his wife - Marty and Elvira Nampeyo)
(active 1990-present: carved redware)
LIFESPAN: (1970-)
FAVORITE DESIGNS: Kachinas
PUBLICATIONS: Dillingham 1994:14-15

Melda Nampeyo

(Melda Garcia, Melda Garcia Navasie)
(Tewa, Corn Clan, active 1975-present: polychrome jars)
LIFESPAN: (1959-)
FAMILY: Great-granddaughter of Nampeyo, granddaughter of Fannie Nampeyo, daughter of Leah Garcia Nampeyo and Lewis Garcia (Laguna, 1928-1974), sister of James Garcia Nampeyo and Rayvin Garcia Nampeyo
FAVORITE DESIGNS: migration
PUBLICATIONS: Dillingham 1994:14-15; Bassman 1997:81
BIOGRAPHICAL DATABASES: "Hopi-Tewa Potters," Native American Resource Collection, Heard Museum, Phoenix; "Artist Database," Museum of Indian Arts & Cultures, Santa Fe.

Miriam Tewaguna Nampeyo

(Tewa, Corn Clan, active 1970-1980)
LIFESPAN: (1956-)
FAMILY: Daughter of Elva Tewaguna Nampeyo
FAVORITE DESIGNS: 4 eagle wings
PUBLICATIONS: Dillingham 1994:14-15

Nellie Nampeyo

(Nellie Douma, Ta-way, "Sweet Corn Meal for Bread")
(Tewa, Polacca, Corn Clan, active 1910-1978: black and red on yellow jars, canteens, ash trays)
LIFESPAN: (1896-1978)
FAMILY: Daughter of Nampeyo and Lesso; mother of Marie, Clara, Vernon, Lindberg, Augusta, Zella, Helen and Edgar; sister of Annie Healing Nampeyo, Fannie Polacca Nampeyo, William Lesso, and Wesley Lesso.
COLLECTIONS: Museum of Northern Arizona, 2 black and red on yellow jar, #E6355, 6359, 1973; black and red on yellow jar, #E7659, 1910-1930; black and red on yellow jar, #E7661, 1910-1930; Heard Museum, Phoenix, AZ, ash tray, #3604-2.
VALUES: On March 13, 1998, a polychrome jar, cloud design (4 x 4.5"), ca. 1970, est. $125-250, sold for $182.50, at Allard, #35.

On March 25, 1994, a polychrome bowl (3 x 4"), ca. 1945, est. $200-400, sold for $220, at Allard, #413.

On March 26, 1993, signed, high necked jar, migration design, ca. 1965 (6 x 5"), est. $300-600, sold for $550 at Allard, #332.

On October 16, 1992, signed Nellie Nampeyo, black & red on yellow canteen (modified into a bank with coin slot), bird wings design, ca. 1940 (8 x 7"), est. $400-800, sold for $400 at Munn, #1097.

Gregory Schaaf Collection

On June 5, 1992, signed Nellie Nampeyo, polychrome jar, ca. 1960 (2 x 3"), est. $75-150, sold for $90 at Munn, #338.

On October 4, 1991, signed, bowl, prayer feather designs, ca. 1950 (3 x 3"), est. $75-150, sold for $110 at Munn, #175.

On April 25, 1991, a small black and red on yellow bowl signed Fannie Nampeyo (2 1/2 x 5 1/2"), together with two smaller bowls signed Nellie Nampeyo, est. $500-700, sold for $357.50, at Butterfield & Butterfield, sale #4541E, #4126.

On February 1, 1991, black & red on yellow jar, migration designs, ca. 1960 (6" h.), sold for $400 at Munn, #1129.
PUBLICATIONS: Allen 1984:117, 119; Dillingham 1994:14-15; Hayes & Blom 1996:68-75; Kramer 1996:194.

Neva Polacca Choyou Nampeyo

(Tewa, Corn Clan, active 1965-present: black and red on yellow seed jars; and miniatures)
LIFESPAN: (1947-)
FAMILY: Daughter of Elva Tewayuna Nampeyo; sister of Elton Tewaguna, Adelle Lalo Nampeyo and Miriam Tewaguna Nampeyo.
COLLECTIONS: Heard Museum, Phoenix, AZ, seed jar, 1989, #3205-9; jar, #3368-4, 1991.
FAVORITE DESIGNS: migration

VALUES: On May 19, 1995, black and red on yellow seed jar, migration design (4 x 5"), est. $125-200, sold for $90 at Munn, #587.
PUBLICATIONS: Dillingham 1994:14-15
BIOGRAPHICAL DATABASES: "Hopi-Tewa Potters," Native American Resource Collection, Heard Museum, Phoenix; "Artist Database," Museum of Indian Arts & Cultures, Santa Fe.

Nyla Sahmie Nampeyo
(see Nyla Sahmie)

Priscilla Namingha Nampeyo
(Own-ya-kwa-vi, "Display of Clouds")
(Tewa, Corn Clan, Polacca, active 1931-present: black and red on yellow jars, bowls, wedding vases, piki bowls, and miniatures)
BORN: December 23, 1924
FAMILY: Third generation descendant of Nampeyo, the Tewa potter who revived Sityatki style pottery on First Mesa at Hopi. Granddaughter of Annie and Willie Healing,

Gregory Schaaf Collection

daughter of Rachel Namingha Nampeyo and Emerson Namingha; grandmother of Denella Tom; mother of Bonnie Chapella Nampeyo, Rachel Sahmie, Nyla Sahmie, Randy Sahmie, and Jean Sahmie; sister of Dextra Quotskuyva, Lilian Gonzales, Ruth Namingha, Eleanor Lucas Namingha Nampeyo and Emerson Namingha
POTTERY TEACHER: Nampeyo, her great-grandmother, began teaching Priscilla when she was only seven years old.
STUDENTS: Rachel Sahmie, Jean Sahmie, Nyla, Bonnie, Finkle Sahmie, Randall Sahmie, Andrew Sahmie, Donella, Carla, Kenneth, Michael, Christopher, Seth.
COLLECTIONS: Museum of Northern Arizona, black and red on yellow bowl, #E6356, 1973; black and red on yellow bowl, #E8039, 1977; Heard Museum, Phoenix, AZ, jar, #3372-1, 1992; miniature bowl, #3576-250; jar, #NA-SW-HO-A7-134; Hopi Cultural Center Museum, Second Mesa, AZ; Dr. Gregory Schaaf Collection, Santa Fe; Frank Kinsel Collection, San Francisco.
FAVORITE DESIGNS: migration, eagle tails, stars, parrots, birds, feathers, dragon-flies, clouds
PUBLICATIONS: Allen 1984:117; Dillingham 1994:14-15; Hayes & Blom 1996:68-75
BIOGRAPHICAL DATABASES: "Hopi-Tewa Potters," Native American Resource Collection, Heard Museum, Phoenix; "Artist Database," Museum of Indian Arts & Cultures, Santa Fe.

In February of 1998, I visited Priscilla Namingha Nampeyo at her home in Polacca. I turned off the main road and started up the hill toward First Mesa. Priscilla's home is the second house on the right, displaying a sign, "Pottery for Sale - Open." She greeted me warmly and invited me in out of the cold.

Pottery for sale by her children and grandchildren were attractively displayed in a long glass cabinet. The largest pottery was a 12" plate by one of her daughters, Rachel Sahmie. To the right were displayed pots not for sale. Priscilla proudly pointed out, "These are the first potteries made by my children and grandchildren. These aren't for sale." She proudly looked them over, some cracked and broken, yet each one representing the priceless passing of tradition from one generation to the next.

"Where are your pots?" I asked.

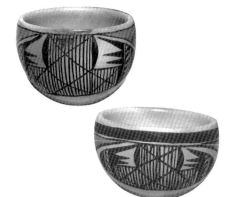

Gregory Schaaf Collection

"Oh, people come from all over to get them about as fast as I make them."

We sat down next to a table where she was working on her pots. Upon a stone palette were natural paints and yucca brushes. "I teach my children and grandchildren to make the potteries in the traditional way, the same way my great-grandmother, Nampeyo, taught me."

"How old were you when you made your first pots?" I asked.

"I grew up with my great-grandmother [Nampeyo]. When I was a kid, I made pots, then Nampeyo fired them for me. She was real kind and nice. She took the pots up to the Sand Hill, where Willie Healing raised sheep. We use the sheep dung to fire the pots."

"How do you make your pots?" I inquired.

"I try to do it the old way. I am still using my great-grandmother's designs. This is a thing that was given to us by the Great Man. We work real hard and make our living from it."

"What do you tell your children and grandchildren, when teaching them how to make pots?"

"Do it the old way. Make the coils by hand. Don't use a potter's wheel. Use our traditional paints. Don't use acrylics or store bought paints. Fire the potteries with sheep manure. Don't use a kiln." Priscilla's voice was strong and firm.

"What else did your Great-grandmother Nampeyo teach you?" I asked.

"Nampeyo told me about the future. She told me about the coming of electricity, pavement and other things."

"Did your grandmother, Annie Healing [Nampeyo's eldest daughter], also encourage your pottery making?"

"Yes, this house was my grandmother's. My grandfather [Willie Healing] was a stone mason. My grandfather's brother-in-law, Tom Pavatea, had a trading post here," Priscilla continued talking as she guided me into the kitchen.

"See this old iron stove? This was my grandmother's stove. She and my mother [Rachel Namingha Nampeyo] warmed their potteries in this stove."

"Do you mean the pots I have by your grandmother and mother were warmed in this stove?" I asked.

"Yes. We warm the pots before firing them with sheep's dung, that way they don't crack so often," Priscilla explained.

"Could you tell me about your mother, Rachel?"

"I have her last pot. She said, 'I can't see any more. This last one is for you.'"

Priscilla and I visited throughout the afternoon and enjoyed a wonderful time together. She managed to find five of her small pots to trade, some being used as candy dishes and soup bowls, each one unique and beautiful. I also acquired a perfect miniature seed jar by her daughter, Rachel Sahmie. My visit with Priscilla was warm and encouraging. I gave her a draft copy of the manuscript.

When I got back to the Hopi Cultural Center Motel, the red light was flashing on my phone, a message to call Priscilla Nampeyo. She answered the phone when I called, "Yes, this is Priscilla. I was wondering if you could come back tomorrow for another visit? I would like you to meet my daughters, Rachel and Jean."

The next day I arrived with a group of my friends: Peter Goodwin, who once got smudged with me at a Bean Dance by the "Black Soot Boys," Laurie Forbes, a healing arts practitioner, John

Kimmy, a former teacher at Hotevilla Day School and Ringi, a Mauori tribal woman and singer from New Zealand. There were just enough chairs for us to cluster together in Priscilla's living room.

We sat there and watched, as Priscilla's daughters, Rachel and Jean, proceeded to sell all their pots to the owners of a Santa Fe gallery, who had arrived just before us. Business was good. We were happy for them.

I sat next to Priscilla and pointed out to her, "In all my research, I have never seen a list of all the different types of Hopi-Tewa pottery with the Tewa names for each type. Have you ever seen a list of Tewa translations for pottery types, clays, traditional pigments?"

"No, I've never seen such a list," Priscilla said, as she scanned down my list. One-by-one, Priscilla began translating the names into the Tewa language. (See Appendix 3: "The Language of Hopi-Tewa Pottery: In English, Hopi and Tewa") She patiently and clearly stated each word, giving me time to record the vowels, long or short. The language sounds beautiful, melodic. That day we recorded a unique contribution, the language of the Tewa potters.

After their customers departed, daughters Jean and Rachel joined in our discussion of Tewa pottery terms. Rachel said that she had some big pots at her home, so we soon departed, saying our good byes to Priscilla. (See Rachel Sahmie biography for a continuation of the story.)

Rachel Namingha Nampeyo
(signs Rachel Nampeyo, Du-y-hi-yu, "Boss Girl")
(Tewa, Corn Clan, Polacca/Keams Canyon, active 1920-1985: black and red on yellow jars and bowls, effigy bowls with maiden head handles, miniature bowls, wind chimes)
LIFESPAN: (1903-1985)
FAMILY: Granddaughter Nampeyo and Lesso; daughter of Annie and Willie Healing; wife of Emerson Namingha; mother of Priscilla Nampey Dextra Quotskuyva, Lillian Gonzales, Ruth Namingha, Eleanor Lucas Namingha Nampeyo an Emerson Namingha.
EXHIBITIONS: 1994 George Gustave Heye Center, National Museum of the American Indian, Smithsonian Institution, New York, NY. Announcement: *Smithsonian Runner* (September-October 1994), p. 1, ill. "This bowl, made by the famed Hopi/Tewa potter Rachel Nampeyo, was on view in "Creation's Journey: Masterworks of Native American Identity and Belief."

COLLECTIONS: Museum of Northern Arizona, black and red on yellow bowl, #E1003, 1950; black and red on yellow jar, #E1029, 1951; wind chimes, #E1247, 1940-1950; miniature bowl, #E5230, 1960-1970; miniature jar, #E6351, 1973; black and red on yellow jar, #E6361, 1973; miniature bowl, #E7672, 1910-1930; Heard Museum, Phoenix, AZ, miniature jar, #3309-427, pre-1973; miniature bowl, #3377-10, ca. 1959-1980; miniature bowl, #3377-6, ca. 1959-1980; miniature bowl, #3377-7, ca. 1959-1980;

miniature bowl, #3377-8, ca. 1959-1980; miniature bowl, #3377-9, ca. 1959-1980; miniature bowl, #3576-164; jar, #NA-SW-HO-A7-102; olla, Rachel Nampeyo and Daisy Nampeyo Hoee, #NA-SW-HO-A7-31, 1930-1939.
FAVORITE DESIGNS: Clowns, birds, feathers, clouds, lightning, migration, eagle tail
VALUES: On February 6, 1998, black & red on yellow seed jar, ca. 1950s, migration design (4 x 8.5"), est. $500-850, sold for $962,50 at Munn, #598.

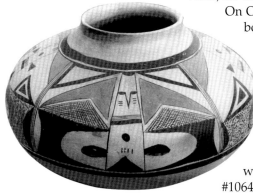

Gregory Schaaf Collection

On February 6, 1998, black & red on yellow seed jar, ca. 1960s, feathers & wing designs (4.5 x 7"), est. $500-750, sold for $550 at Munn, #756.

In 1997, a large seed jar "attributed" to Rachel (16 1/4" dia), est. $8,000-10,000, sold for $7,475 at Sotheby's December 4, 1997:#247.

On May 19, 1995, two miniature pots: 1 signed Priscilla Nampeyo, 1 signed R.N. [Rachel Nampeyo] ca. 1940 (1 x 1"), est. $75-125, sold for $85 at Munn, #426.

On March 25, 1994, a polychrome bowl (2 x 3"), ca. 1965, est. $150-300, sold for $165, at Allard, #412.

On February 4, 1994, black & red on yellow seed jar, ca. 1960, migration designs (3 x 5"), est. $500-750, sold for $250, at Munn, #687.

On February 4, 1994, miniature black & red on yellow bowl, ca. 1940, geometric designs (1 x 1"), est. $75-150, sold for $55, at Munn, #766.

On October 15, 1993, miniature black on yellow bowl, ca. 1940, cloud designs (1 x 1.5"), est. $75-150, at Munn, #442.

On March 26, 1993, signed, bowl, lightning design, ca. 1940 (3 x 6"), est. $250-500, sold for $302.50 at Allard, #722.

On March 26, 1993, signed, large seed jar, feather design, ca. 1970 (7 x 15"), repaired, est. $500-1,000, sold for $660 at Allard, #935.

On October 16, 1992, signed R. N., two miniature pots: 1 geometric, 1 tadpole designs (1 x 1"), est. $50-100, sold for $20 at Munn, #505.

On October 16, 1992, signed R. N., two miniature pots: 1 redware, 1 yellow ware (1 x 1"), est. $50-100, sold for $35 at Munn, #708.

On June 5, 1992, signed, black & red on yellow seed jar, parrot design, ca. 1940 (4 x 6"), est. $200-400, sold for $350 at Munn, #912.

On March 20, 1992, signed, bowl, feather design, ca. 1950 (3 x 8"), est. $300-600, sold for $275 at Allard, #662.

On January 31, 1992, signed R.N., 2 miniature black & red on yellow seed pots, ca. 1940, Provenance: Joan Drackett Estate (1 x 1"), est. $40-80, [need sales result] at Munn, #18.

On January 31, 1992, signed, seed jar, migration design, ca. 1930, Provenance: Joan Drackert Estate (6 x 10"), est. $1,800-2,500, [need sales result] at Munn, #947.

On October 4, 1991, signed R.N., two miniature bowls: 1 yellow ware, 1 redware, ca. 1940 (1 x 1"), est. $50-100, sold for $35 at Munn, #95.

On October 4, 1991, signed R.N., two miniature redware bowls, 1 bird print designs, ca. 1980 (1 x 1"), est. $50-100, sold for $40 at Munn, #394.

On October 4, 1991, signed R.N., two miniature redware bowls, 1 tadpole designs, ca. 1950 (.5 x .5"), est. $40-80, sold for $20 at Munn, #724.

On May 17, 1991, signed R.N., 2 miniature polychrome pots, 1 yellow ware & 1 redware, ca. 1950 (1 x 1"), sold for $75 at Munn, #776.

On May 17, 1991, two miniature pots: 1 yellow ware, 1 redware ca. 1960 (1 x 1"), sold for $65 at Munn, #1064.

Gregory Schaaf Collection

On February 1, 1991, 3 miniature bowls, geometric designs, ca.

1950 (1 x 1"), sold for $30 at Munn, #49.

On February 1, 1991, effigy bowl with maiden-head handle, ca. 1940 (3" dia.), sold for $85 at Munn, #464.

On February 1, 1991, polychrome seed jar, prayer feather designs, ca. 1950 (3 x 6"), sold for $150 at Munn, #678.

On February 1, 1991, signed R.N. 2 miniature bowls, ca. 1950 (1 x 1"), sold for $35 at Munn, #986.

May 22, 1989, a black & red on yellow seed jar with 8 Kachina faces design, "probably" Rachel Nampeyo, signed Nampeyo (14 1/2" dia), est. $2,000-2,500, sold for $4,400 at Sotheby's, sale #5858, #48.

On March 18, 1988, black & red on yellow jar, parrot tail and cloud design (8 x 16"), est. $350-700, sold for $380 at Allard, #258.

On June 22, 1985, a black & red on yellow jar with migration design, signed Rachel Nampeyo (10 1/2" dia.), est. $1,500-2,000, [need sale result] at Sotheby's, sale #5354, #281.

On March 26, 1982, signed, polychrome jar, ca. 1960 (5 x 9"), sold for $200 at Allard, #1040.

PUBLICATIONS: Allen 1984:cover ill., 110, 115; Dillingham 1994:14-15; Hayes & Blom 1996:68-75; Smithsonian Runner (September-October 1994), p. 1, ill.; W. Richard Hill, Jr., ed., *All Roads Are Good: Native Voices on Life & Custom* (Washington, D.C.: Smithsonian Institution Press & National Museum of the American Indian, 1994)

BIOGRAPHICAL DATABASES: "Hopi-Tewa Potters," Native American Resource Collection, Heard Museum, Phoenix; "Artist Database," Museum of Indian Arts & Cultures, Santa Fe.

I n a March 1998 interview, master potter Dextra Quotskuyva expressed her respect for her mother, Rachel Nampeyo, "My mom was a really good artist. She also made really nice dresses for us. She created many of her own designs without looking at anything. She would just sit down and design. I admired her. She had a lot of patience."

Rayvin Garcia Nampeyo

(Coosh)

(Tewa/Laguna, Corn Clan, active 1975-present: black and red on yellow jars)

LIFESPAN: (1961-)

FAMILY: Great-grandson of Nampeyo, grandson of Fannie Nampeyo, son of Leah Garcia Nampeyo and Lewis Garcia (Laguna, 1928-1974), brother of Melda Nampeyo and James Garcia Nampeyo; husband of Jody Garcia.

EDUCATION: He was taught pottery making by his Aunt Fannie Nampeyo.

COLLECTIONS: Heard Museum, Phoenix, AZ, jar, #3368-2, 1991.

FAVORITE DESIGNS: migration

PUBLICATIONS: Bassman 1997:81; Dillingham 1994:14-15; Hayes & Blom 1996:68-75

BIOGRAPHICAL DATABASES: "Hopi-Tewa Potters," Native American Resource Collection, Heard Museum, Phoenix; "Artist Database," Museum of Indian Arts & Cultures, Santa Fe.

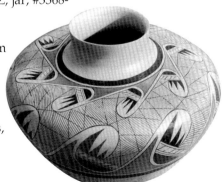

Gregory Schaaf Collection

Reva Polacca Nampeyo
(see Reva Polacca Ami)

Shirley Benn Nampeyo
(Shirley Benn)
(Tewa, active 1950-80: pottery, also jewelry, necklaces, and pins)
LIFESPAN: (1936-)
FAMILY: Great-granddaughter of Nampeyo; granddaughter of Annie Healing;
niece of Rachel Namingha Nampeyo, Fletcher Healing, Lucy, Dewey Healing (married to Juanita Healing) and Daughter of Daisy Hooee and Neil Naha, sister of
Louella Naha Inote, "Whiskey" and Raymond Naha (painter, d.); wife of Virgil
Benn.
PUBLICATIONS: Baxter 1996:40; Dillingham 1994:15, 42; Hayes & Blom 1996:68-75;
Schiffer 1990:181.
EXHIBITIONS:
 1982 Gallery 10, Scottsdale, AZ
 1982 Inter-tribal Indian Ceremonial,, Gallup, NM
 1987 Inter-tribal Indian Ceremonial,, Gallup, NM
 1988 Inter-tribal Indian Ceremonial,, Gallup, NM
BIOGRAPHICAL DATABASES: "Hopi-Tewa Potters," Native American Resource
Collection, Heard Museum, Phoenix.

She is Hopi-Tewa, but works at Zuni. She was at Zuni in 1955.

Thomas Nampeyo
(see Thomas Polacca)

Tonita Hamilton Nampeyo
(Tewa, Corn Clan, Tewa Village, active 1950-present: black and red on yellow
jars)
LIFESPAN: (1934-)
FAMILY: Granddaughter of Nampeyo; daughter of Fannie Polacca Nampeyo and
Vinton Polacca; wife of Eugene Hamilton; mother of Loren Hamilton; sister of Elva
Tewaguna Nampeyo, Leah Garcia Nampeyo, Harold Polacca Nampeyo, Sr., Tom
Polacca, Elsworth Polacca and Iris Youvella Nampeyo.
FAVORITE DESIGNS: migration, rain, clouds
EXHIBITIONS: 1984 Indian Market, SWAIA, Santa Fe, NM
AWARDS: "Best Traditional Hopi Pottery," 1984 Indian Market, SWAIA, Santa Fe, NM
COLLECTIONS: Museum of Northern Arizona, black and red on yellow bowl,
#E6352, 1973.
PUBLICATIONS: Allen, 1984, 117; Dillingham 1994:14-15
BIOGRAPHICAL DATABASES: "Hopi-Tewa Potters," Native American Resource
Collection, Heard Museum, Phoenix; "Artist Database," Museum of Indian Arts &
Cultures, Santa Fe.

 "Daughter of Fannie Nampeyo. Tonita continues to use the methods and designs learned from both her mother and grandmother. She also continually receives awards for excellence in tradition, form, and design." Sotheby's, December 4, 1997, sale #7066, back pages.

Photograph by Angie Yan

Vernida Polacca Nampeyo

(also signs V. Polacca Nampeyo, Vernida Polacca)
(Tewa/Hopi, Kachina Clan, active 1979-present: seed jars in black & red on yellow and black & red on white)
BORN: February 19, 1955
FAMILY: Great-granddaughter of Nampeyo, granddaughter of Fannie Polacca Nampeyo, daughter of Harold Polacca and Alice Polacca; mother of Heidi, Michael, and Jeremy; sister of Clinton Polacca, Diana Polacca, Clement Polacca, Harold Polacca, Jr., Reva Polacca Ami and Marvin Polacca.
TEACHERS: Fannie Nampeyo and Harold Polacca, Sr.
STUDENTS: Heidi, Michael, and Jeremy
FAVORITE DESIGNS: migration, negative stars, eagle tail feathers
PUBLICATIONS: Dillingham 1994:14-15

"To do my pottery, it relaxes me and I enjoy painting and making intricate lines. I enjoy pottery making and having an opportunity to meet people at various shows."

Veronica Nampeyo

(Tewa, active 1985-present: black & red on yellow seed jars)

Zella Douma Nampeyo

(Zella Ray, Zella Kooyquattewa)
(Tewa, Corn Clan, active 1980-1990)
FAMILY: Wife of Warren Kooyaquaptewa; mother of Marlinda Kooyaquaptewa.
VALUES: On August 1, 1991, one item among seven sold as one lot, est. $250-350, [need sale result], at Butterfield & Butterfield, sale #4582A, #2623.
PUBLICATIONS: Dillingham 1994:14-15

Edith Nash

(active 1940-1970s: black & red on yellow jars, bowls and vases)
VALUES: On December 4, 1993, five black and red on yellow pots including a small jar, shallow plate, seed jar and shallow bowl (4 1/2 - 9 7/8" dia.), est. $1,000-1,500, did not reach reserve minimum at Sotheby's, sale #6510, #343.
On June 5, 1992, signed, seed jar, ca. 1940 (2 x 3"), est. $75-150, sold for $60 at Munn, #455.

Nasimosi

(Hopi)
PUBLICATIONS: Allen 1984

Navaganni

(active 1930)
VALUES: On September 27, 1985, signed, ca. 1930 (8 X 10"), est. $450-750, sold for $600 at Allard, #670L.

Hattie Navajo

(Hopi, Sichomovi, active 1970-1980: black on yellow bowls)
COLLECTIONS: Museum of Northern Arizona, black on yellow bowl, #E7424, 1976.
PUBLICATIONS: Allen 1984:119.

Betty Navakuku
(signs B. Navakuku)
(active 1970: vases)
PUBLICATIONS: SWAIA Quarterly, v. 8, n. 3 (Fall 1973), p. 3

Agnes Navasie
(Poli Ini - "when butterflies sit to rest")
(active 1940-1960)
FAMILY: Wife of Roscoe Navasie; mother of Josephine Navasie Setalla, Perry,
Eunice "Fawn," Nathanial, and Harrington Navasie.
STUDENTS: Teacher of Pauline Setalla, She began teaching Pauline around 1954.

Bill Navasie
(Hopi, Sun Clan, Walpi, active 1985-present)
LIFESPAN: (1969-)
FAMILY: Great-grandson of Paqua Naha/1st Frog Woman; grandson of Joy
Navasie/2nd Frog Woman; Son of Maynard and Veronica Navasie; brother of Roy
PUBLICATIONS: Dillingham 1994:60-61

Charles Navasie
(also Charles Navasie Martin)
(Tewa, Kachina/Parrot Clan, active 1980-present)
LIFESPAN: (1965-)
FAMILY: Great-grandson of Paqua Naha; grandson of Joy Navasie; son of Loretta
Navasie; brother of John Biggs, Lana Yvonne David, Christopher Perry and Wayne
Joseph Koshiway
PUBLICATIONS: Dillingham 1994:60-61

Photograph by Angie Yan

Dawn Navasie
(Hopi, Water Clan, Walpi, active 1978-present:
seed jars, wedding vases, bowls)
BORN: July 1, 1961 at Toreva (Second Mesa)
FAMILY: Daughter of Eunice Navasie (Fawn)
& Joel Nahsonhoya; sister of Dolly "White
Swann," Joe Navasie, Fawn (formerly "Little
Fawn") Navasie, Darrell Navasie. & Gregory
Navasie; niece of Justin & Pauline Setalla, and
Perry & Joy Navasie (2nd Frog Woman); mother of
Julian John Mahkewa & Starlie Mahkewa
TEACHER: Eunice "Fawn" Navasie
AWARDS: Best of Division, "Hopi Show," Museum of
Northern Arizona
EXHIBITIONS: Southwest Indian Den, Coronado Islands
FAVORITE DESIGNS: Rainbirds, rain,
clouds
PUBLICATIONS: Bassman
1997:81; Dillingham 1994:60-6;
Arizona Highways 1996
BIOGRAPHICAL DATABASES:
"Hopi-Tewa Potters," Native
American Resource Collection,
Heard Museum, Phoenix; "Artist
Database," Museum of Indian Arts
& Cultures, Santa Fe.

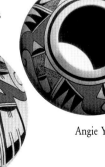

Photograph by Angie Yan

Angie Yan Collection

Gregory Schaaf Collection

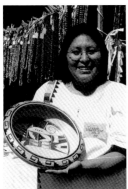

Photograph by Angie Yan

Dolly Joe Navasie
(White Swann)
(Hopi, Water Clan, active 1970-present)
BORN: July 9, 1964.
FAMILY: Daughter of Eunice Navasie (Fawn),
sister of Dawn Navasie, Fawn (formerly "Little
Fawn") Navasie, Darrell Navasie and Gregory
Navasie; mother of Josh "Honhoya" Navasie,
Marlaina "Snow" Joe, Chantel "Popovi" Joe, Cheri
"Iyuh-Iya" Joe; niece of Justin & Pauline Setalla,
and Perry & Joy Navasie (2nd Frog Woman)
HONORS/AWARDS: San Bernadino Art Show, 1984,
Third Place; Museum of Northern Arizona, "Hopi Show," 1984 -
First Place, 1994 - Third Place, 1995 - Third Place, 1998 - Best
Booth & Third Place; Lawrence Indian Art Show, 1994 - Honorable Mention; Festival
of American Indian Arts, Coconino Center, Flagstaff, AZ, 1994 - Honorable Mention,
1995 - Juror 's Award; Hopi Tu-tsootsvolla, Sedona, AZ, 1994 - Third Place, 1995 -
Third Place, 1997 - Best Traditional Pottery, First & Second Place; Pasadena Original
American Indian & Relics Show, 1995 - Best of Show, First, 1996 - Best of Show
PUBLICATIONS: Dillingham 1994:60-61; *American Indian Art Magazine,* Spring 1996;
Jacka & Jacka 1998

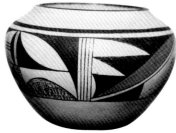

Photograph by Angie Yan

D olly White Swann Joe is from the Hopi Reservation and
resides in Snowbird Canyon. At age six she learned to work
with clay from her maternal grandmother, Poli-Ini, who was
losing her eyesight at the time. White Swann still uses the tradition-
al coil method and the pigments are all natural. River rocks are used
to polish the pottery. Sheep dung is used for firing outdoors on the
ground.

 At age seventeen, White Swann learned to paint pottery with
much patience from her late mother, Fawn, who was well-known for
her artwork.

 "I enjoy creating artwork, because it is a way of life. I'm
proud of my ancestors and the unique style they have passed down.
I enjoy working clay with my children and am proud to say they too
love the work of their ancestors. I enjoy showing my talent. I'm a
people person."

Eunice Navasie
(first Fawn)
(Hopi, active 1940-1990)
LIFESPAN: (ca. 1920-1992)
FAMILY: Sister of Perry Navasie, (husband of Joy
Navasie, the 2nd Frog Woman,) sister of Justin (hus-
band of Pauline Setalla.) Also sister of Nathanial &
Harrington Navasie. Mother of Dolly "White Swann"
Joe, Dawn Navasie, Fawn (formerly "Little Fawn")
Navasie (b. 1959), Darrell Navasie & Gregory Navasie.
AWARDS: First Prize, Gallup Ceremonial, 1969
EXHIBITIONS:
 1969 Gallup Ceremonial, Gallup, NM
VALUES: On February 6, 1998, black & red on white wedding vase, ca. 1970, feath-
ers & clouds designs (9.5 x 6"), est. $250-400, sold for $247.50 at Munn, #46.

 On February 6, 1998, unusual black on white with plainware red top wedding

Photograph by Steve Elmore

vase, ca. 1970s, triangular & clouds designs (11 x 7"), est. $350-500, sold for $187.50 at Munn, #353.

On March 22, 1985, signed, black and red on buff jar, Rainbird design (5 x 8"), sold for $75 at Allard, #64

In 1981, signed, a black & red on yellow seed jar, parrot design, (6.75 x 11.5"), was offered for sale at $400 by T.N. Luther, "American Indian Art," catalog #A2-1981, item #P45, p. 86.

On March 22, 1985, signed, wedding vase, ca. 1969 (12 x 6.5"), together with a First Prize ribbon from Gallup Ceremonial - 1969, sold for $200 at Allard, #692.
PUBLICATIONS: Dillingham 1994:60-61

Fawn Garcia Navasie, formerly "Little Fawn"
(signs Fawn or Fawn hallmark)
(Hopi, active 1975-present: black & red on white jars, bowls, wedding vases; black & red on buff/yellow jars)
BORN: 1959
FAMILY: Granddaughter of Roscoe and Agnes Navasie; daughter of Eunice (Fawn) Navasie; sister of Dolly "White Swann" Joe, Dawn Navasie, Darrel Navasie & Gregory Navasie; niece of Justin & Pauline Setalla, and Perry & Joy Navasie (2nd Frog Woman); wife of James Garcia Nampeyo.
FAVORITE DESIGNS: Rainbirds, parrots, feathers, clouds
PUBLICATIONS: Dillingham 1994:60-61

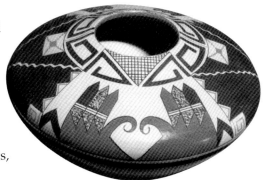

Richard M. Howard Collection

Fawn's early work is white ware that she did mostly with her mother, Eunice Navasie. Her later work is buff or yellow ware that she does with her husband, James Garcia Nampeyo. She claims the white ware is more difficult to make, especially the polishing. Fawn is known for her beautiful polychrome jars that are somewhat egg-shaped with a graceful neck.

Grace Navasie
(Grace Navasie-Lomahquahu)
(Tewa, Kachina Clan, active 1980-present)
BORN: 1953
FAMILY: Daughter of Joy Navasie.
Career: She makes some pots that are painted by Joy Navasie.
PUBLICATIONS: Bassman 1997:77

Joy Navasie
(second Frog Woman, Yellow Flower)
(Tewa, Kachina Clan, Tewa Village, active 1935-1995: jars, bowls, wedding vases, vase lamps, bird effigy bowls, lidded sugar jars & creamers in the following styles: black and red on white, black and yellow on white, black and red on yellow, black on cream)
BORN: 1919
FAMILY: Daughter of Paqua Naha/Frog Woman; wife of Perry Navasie; mother of Marianne, Leona Navasie, Natelle Lee, Maynard, Loretta Navasie Koshiway and

Grace Lomahquahu; grandmother of Charles Navasie Martin
TEACHER: Paqua Naha. Joy started making pottery around 1935 or 1936.
STUDENTS: Marianne, Leona Navasie, Natelle Lee, Maynard, Loretta Navasie Koshiway , Grace Lomahquahu, Charles Navasie, John Biggs
FAVORITE DESIGNS: rain, cloud, parrot, feathers
COLLECTIONS: Museum of Northern Arizona, black and red on yellow jar, #E521, 1939; by Paqua or Joy Navasie black and red on yellow bowl, #E6982, 1950s; Heard Museum, Phoenix, AZ, wedding vase, #3576-175, ca. 1970; jar, #3576-251, ca. 1970.jar by Joy Navasie & Paqua Naha, #NA-SW-HO-A7-126; vase, #NA-SW-HO-A7-139; wedding vase, #NA-SW-HO-A7-141; bowl, #NA-SW-HO-A7-145; jar, #NA-SW-HO-A7-47; bowl, #NA-Sw-HO-A7-70; jar, #NA-SW-HO-A7-78.
VALUES: On February 6, 1998, black & red on white wedding vase, ca. 1990, parrot & eagle tail feather designs (7 x 4″), est. $200-300, sold for $440 at Munn, #126.

On February 6, 1998, black & red on white wedding vase, ca. 1970s, parrot design, repaired handle (14 x 7″), est. $600-800, sold for $302.50 at Munn, #676.

Richard M. Howard Collection

On February 6, 1998, black & red on white vase, ca. 1970s, eagle tail feather designs (12.5 x 7″), est. $2,500-3,500, sold for $1,980 at Munn, #766.

In 1997, a jar (6 x 4″), est. $1,000-1,500, sold for $660 at Munn October 1997:120, #1217A.

On January 31, 1997, a tall black and red on white flaring jar as lamp base, parrot design (14″ h.), est. $2,200-3,200, did not reach reserve at Munn, #921.

On May 10, 1996, a black and red on white bowl, parrot & prayer feather designs, ca. 1960 (3.5 x 5″), est. $300-500, sold for $176 at Munn, #808

In 1996, a seed jar (4.5 x 4.5″), est. $450-650, sold for $385 at Munn February 1996:58, #597.

On March 24, 1995, a polychrome jar with cloud and feather designs (4 x 4″), ca. 1975, est. $350-500, sold for $137.50, at Allard, #872.

On March 24, 1995, a polychrome jar with cloud and feather designs (4.5 x 5.5″), ca. 1975, est. $375-750, sold for $302.50, at Allard, #873.

On March 24, 1995, a polychrome jar with cloud and feather designs (4.75 x 6″), ca. 1970, est. $400-800, sold for $385, at Allard, #979.

On March 24, 1995, a polychrome jar with bird designs (8 x 6″), ca. 1970, est. $200-400, sold for $440, at Allard, #1273.

On October 14, 1994, pottery ashtray, ca. 1950 (2 x 4.5″), est. $40-75, sold for $49.50 at Munn, #70A.

On October 16, 1994, black and yellow on white jar, parrot design, with several prize ribbons, (7.5 x 13″), est. $3,500-4,500, sold for $2,250 at Munn, #939.

On August 14, 1994, a pair of polychrome pottery lamps with parrot designs and hand painted shades (20 x 6″), ca. 1950, est. $500-1000, sold for $605, at Allard, #116.

On March 25, 1994, a polychrome wedding vase with bird designs (10.5 x 9″), ca. 1960, est. $450-900, sold for $495, at Allard, #371.

On March 25, 1994, signed, jar, bird design, ca. 1990 (4 x 6″), est. $300-600, sold for $330 at Allard, #1025.

On March 25, 1994, signed, bird effigy bowl (duck or swan) ca. 1955 (3 x 6″), est. $150-300, sold for $220 at Allard, #1378.

On March 26, 1993, signed, cylinder jar, parrot design, ca. 1980 (9 x 6″), est. $400-800, sold for $712.50 at Allard, #8.

On March 26, 1993, signed, black and red on white wedding vase, bird design, ca. 1970 (7.5 x 5″), est. $300-600, sold for $385 at Allard, #1096.

On December 2, 1992, a black and red on white jar with prayer feather and rain cloud designs (10 3/4 x 9 1/2″), est. $800-1,200, sold for $1,045 at Butterfield & Butterfield, sale #5235E, #3483

On March 20, 1992, signed, seed jar, feather and cloud design, ca. 1960 (4 x 5.5″),

est. $300-600, sold for $577.50 at Allard, #661.

On January 31, 1992, signed, polychrome jar, ca. 1987, Provenance: Joan Drackert Estate (4 x 10"), est. $400-800, [need sales result] at Munn, #976.

On October 4, 1991, signed, polychrome jar, prayer feather & clouds designs, ca. 1980 (4 x 4"), est. $150-300, sold for $275 at Munn, #470.

On August 1, 1991, two black and red on white wedding vases (7 1/2 x 6"), est. $700-900, [need sale result], at Butterfield & Butterfield, sale #4582A, #2659.

On May 17, 1991, signed, miniature polychrome pot, ca. 1980 (1 x 1"), sold for $125 at Munn, #771.

On May 17, 1991, signed, miniature polychrome bowl, eagle wing & tail feather designs, ca. 1985 (2 x 2"), sold for $130 at Munn, #953.

On March 16, 1990, signed, polychrome wedding vase, bird design, ca. 1975 (12 x 6.5"), est. $500-1,000, sold for $577.50 at Allard, #396.

On March 18, 1988, signed, polychrome jar, feather and cloud design, ca. 1950 (7.5 x 7.5"), est. $250-500, sold for $455 at Allard, #233.

On March 20, 1987, signed, polychrome wedding vase, bird design, ca. 1975 (17 x 9.5"), est. $700-1,500, sold for $1100 at Allard, #156.

On March 20, 1987, signed, polychrome wedding vase, ca. 1975 (13 x 7"), est. $200-300, sold for $290 at Allard, #1165.

On March 22, 1985, signed, polychrome jar, ca. 1944 (5 x 7"), sold for $150 at Allard, #96.

On March 22, 1985, signed, polychrome vase, ca. 1944, bird design (8 x 5"), sold for $200 at Allard, #107.

On March 22, 1985, signed, black on cream bowl, c. 1944(2 x 9"), sold for $100 at Allard, #478.

On March 22, 1985, signed, black and red on white wedding vase, bird design, ca. 1945 (6.5 x 4.5"), sold for $85 at Allard, #490.

On March 26, 1982, signed, polychrome jar, bird and cloud design, ca. 1970, sold for $500 at Allard, #1000B.

PUBLICATIONS: Allen 1984:108; Bassman 1997:79; Dillingham 1994:60-61; Gault 1991:15

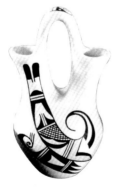

Joy Navasie is among the most famous and prolific Hopi-Tewa potters. She is known as "Frog Woman," the name being passed down from her mother, Paqua Naha. Her mother taught her how to make pottery, her career beginning around 1935. She began signing her pots with a Frog Hallmark around 1939. She draws her frog with web feet, while her mother drew the frog with short toes.

Joy works mostly in a style called black and red on white, referring to black and white designs on white slipped pottery. She credits her mother, Paqua Naha, with developing white ware pottery around 1951 or 1952. About three years later, Paqua died. Joy carried on the white ware tradition, passing it on to her daughters and other family members.

Richard M. Howard Collection

Leona Navasie
(Frog & LN hallmark)
(Tewa, Kachina Clan, active 1960-present: black and red on white vases)
LIFESPAN: (1939-)
FAMILY: Granddaughter of Paqua Naha/1st Frog Woman; daughter of Joy Navasie/2nd Frog Woman
FAVORITE DESIGNS: feathers, eagle tail feathers, parrot tail feathers, clouds and tadpoles
PUBLICATIONS: Dillingham 1994:60-61

Loretta Navasie
(Loretta navasie Martin, Loretta Navasie Koshiway, Frog & L hall-mark)
(active 1965-present)
LIFESPAN: (1948-)
FAMILY: Granddaughter of Paqua Naha/1st Frog Woman; daughter of Joy Navasie/2nd Frog Woman; mother of John Biggs, Charles Navasie, Lana Yvonne David, Christopher Perry and Wayne Joseph Koshiway
PUBLICATIONS: Dillingham 1994:60-61

Marianne Navasie
(Maryann Navasie, Marianne Navasie Jim, signs with Frog and Tadpole symbol; earlier, Frog & M hallmark)
(Tewa, Kachina Clan, active 1970-present: black and red on yellow, black and red on white)
LIFESPAN: (1951-)
FAMILY: Granddaughter of Paqua Naha/1st Frog Woman; daughter of Joy Navasie/2nd Frog Woman; wife of Harrison Jim
PUBLICATIONS: Dillingham 1994:60-61; Hayes & Blom 1996:72-75

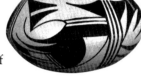

Challis & Arch Thiessen
Collection

Richard M. Howard
Collection

Maynard Navasie
(Frog and M.N. & V.N. hallmark, collaboration with Veronica Navasie)
(Tewa, Kachina/Parrot Clan, active 1960-present: black and red on white jars)
BORN: 1945
FAMILY: Grandson of Paqua Naha/1st Frog Woman; son of Joy Navasie/2nd Frog Woman; husband of Veronica Navasie. They make pots as a husband and wife team. Father of Bill Navasie.
FAVORITE DESIGNS: parrots, feathers
PUBLICATIONS: Dillingham 1994:60-61; Hayes & Blom 1996:68-75

Melda Garcia Navasie
(see Melda Nampeyo)

Natelle Lee Navasie
(Tewa, Tewa Village, Kachina Clan, active 1980-90: black and red on white jars)
FAMILY: Granddaughter of Paqua Naha/1st Frog Woman; daughter of Joy Navasie/2nd Frog Woman
COLLECTIONS: Museum of Northern Arizona, black and red on white jar, #E8757, 1983
PUBLICATIONS: Allen 1984:122

Ray Navasie
(Tewa, active 1990-present)
LIFESPAN: (1970-)
PUBLICATIONS: Dillingham 1994:60-61

Ronnie Navasie

(see Veronica Navasie)

Veronica Preston Navasie

(Ronnie Navasie, Frog and MN & VN hallmark, collaboration with Maynard Navasie)
(Hopi, Sun Clan, Walpi, active 1960-present: black and red on white jars)
BORN: ca. 1945
FAMILY: Daughter of Woodrow Preston and Laura Preston; wife of Maynard Navasie (Tewa); mother of Roy Navasie and Bill Navasie.
FAVORITE DESIGNS: parrots, feathers
PUBLICATIONS: Hayes & Blom 1996:72-75

Nawisoi

(Hopi)
PUBLICATIONS: Allen 1984

Nawisumy

(Hopi, Oraibi, active 1920-1930: stew bowls, piki bowls)
COLLECTIONS: Museum of Northern Arizona, stew bowl, #OC1008, 1923; piki bowl, #OC1056. 1926; piki bowl, #OC1083, 1923.
PUBLICATIONS: Allen 1984:103-104

Nüma'ata

(Corn Grinding Girl)
(Hopi, Walpi, Sand Clan, active 1880-1900)
FAMILY: Kwa'chakwa's Wife. They had two sons: Ka'kapti and Sikyaboy'tuima.
PUBLICATIONS: Stephen 1936:1020, 1056, 1107

> *"...Numa'ata is the best potter in Walpi, or at least the best pottery decorator, the best painter [in the 1890s]."* Alexander Stephen

Vivian Numzewia

(see Vivian Mumzewa)

Nuvangeumuma

(Hopi, Shungopavi, active 1880-1900: piki bowls, unfired bowls and jars)
COLLECTIONS: Museum of Northern Arizona, stew bowl, #OC1011, 1897; unfired bowl, #OC1065, 1899; unfired jar, #OC1067, 1889; unfired jar, #OC1067a, 1900; unfired bowl, #OC1068a, 1889.
PUBLICATIONS: Allen 1984:103-104

Nuvangienima

(Hopi)
PUBLICATIONS: Allen 1984

Kim Obrzut

(active 1990-present)
PUBLICATIONS: Hayes & Blom 1996:74-75

Photograph by Bill Bonebrake..
Courtesy of Jill Giller,
Native American Collections,
Denver, CO

124

Lula Oso

(Lula Pahona)

(Hopi, Coyote Clan, Walpi, active 1940-1960: black on red bowls)
VALUES: On October 4, 1991, signed, bowl, parrot design, Hubbell's Trading Post label, ca. 1940 (3 x 5"), est. $30-60, sold for $175 at Munn, #683.
On February 5, 1993, black on red bowl, ca. 1950, Zuni style scroll design (4 x 11"), est. $275-550, sold for $175 at Munn, #367.

Andrea Ouguh

(see Andrea Auguh)

Pahongsi

(see Barbara Fredericks)

Lula Pahona

(see Lula Oso)

Charlotte Pala

(Tewa, Tewa Village, active 1920-1940: plainware jars, piki bowls)
piki bowl, #E1931, 1931; piki bowl, #E2944, 1930.
PUBLICATIONS: Allen 1984:107

Ruth Panella

(see Ruth Paymella)

Paqua

(see Paqua Naha)

A. P.

(see Alice Puhuhevaya)

Garnet Pavatea

(Flower Girl)

Photograph by Marc Gaede
Courtesy of the Museum of
Northern Arizona.
(neg. #77.0132)

GARNET
PAVATEA

(Tewa, Spider Clan, Tewa Village, active 1940-1981: jars and bowls in the following styles: black on red, black and white on red, carved red, redware, black on yellow bowls; black and red on yellow bowls; stew bowls, piki bowls, cylinder vases, tiles, ladles, artificial pot sherds, miniatures)
FAMILY: Her father was Dewakuku or Tuwakuku, Hopi, Mustard Clan, Sichomovi, (1865-1956). Her mother was Tewa, Spider Clan. Sister of Myrtle Young and George Dewakuku; wife of Womak Pavatea; mother of Wilma Rose Pavatea; aunt of Kathleen, Georgia, Delores, and Lucinda Dewakuku.

Gregory Schaaf Collection

DEMONSTRATIONS: Museum of Northern Arizona
EXHIBITIONS: Museum of Northern Arizona;
1995-1997 "Following the Sun and Moon - Hopi Katsina Dolls," Heard Museum
COLLECTIONS: Museum of Northern Arizona, black on red jar, #E1315, 1956; black on red bowl, #E1316, 1956; black and white on red jar, #1465, 1958; black and white on red bowl, #1466, 1958; black on red jar, #1503, 1959; black on red jar, #E2208, 1960;

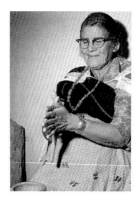

black on yellow bowl, #E2219, 1961; artificial pot sherd, #E3508, 1967; redware bowl, #E3849, 1968; ladle, #E3850, 1968; redware bowl, #E4224a, 1969; ladle, #4224b, 1969; miniature jar, #E5095, 1970; black and red on yellow bowl, #E5225, 1954; 2 ladles, #7881, 7882, 1960-1969; black and white on red bowl, #7885, 1977; stew bowl, #E8010, 1950; pik bowl, #E424, 1978; stew bowl, #E8791, 1981; red ware bowl, #E8782, 1980-1981, redware bowl, #E8783, 1980-1981; Heard Museum, Phoenix, AZ, ladle, bowl, spoon, fork, #763P; bowl, #NA-SW-HO-A1-12; pot, #NA-SW-HO-A1-45; ladle, #NA-SW-HO-A1-46; seed bowl, #NA-SW-HO-A12-12; bird effigy bowl, #NA-SW-HO-A3-4; ladle, #NA-SW-HO-A3-5; ladle, #NA-SW-HO-A6-15; 2 canteens, #NA-SW-HO-A7-147, #NA-SW-HO-A7-148; wedding vase, #NA-SW-HO-A7-149; bowl, #NA-SW-HO-A7-150; seed jar, #NA-SW-HO-A7-151; bowl, #NA-SW-HO-A7-90.

Gregory Schaaf Collection

Attrib. to Garnet Pavatea

VALUES: On February 6, 1998, a highly polished plain redware bowl, ca. 1970, (4 x 11"), est. $200-300, sold for $357.50 at Munn, #88.

On February 6, 1998, black & red on yellow jar, ca. 1950s, migration design (4 x 5.5"), hairline crack, est. $250-400, sold for $302.50 at Munn, #390.

On February 6, 1998, redware bowl with 4 incised "pie crust" bands beneath rim, ca. 1960, (4 x 9"), est. $300-500, sold for $467.50 at Munn, #674.

On February 3, 1995, a polychrome jar, parrot design (9.5 x 10"), est. $600-900, sold for $880 at Munn, #944.

On October 14, 1994, piki bowl (6 x 12"), est. $150-250, sold for $300 at Munn, #387.

On October 14, 1994, black and red on yellow cylinder vase, calendryl design (9 x 4.5"), est. $275-350, sold for $175 at Munn, #523.

On March 25, 1994, a polychrome bowl (2.25 x 6"), ca. 1950, est. $200-400, sold for $187.50, at Allard, #400J.

On March 25, 1994, signed, jar, ca. 1960, fingernail design (6.5 x 7"), est. $200-400, sold for $115.50 at Allard, #800F.

On March 25, 1994, signed, ash tray, ca. 1955, redware (2 x 5.5"), est. $50-100, sold for $38.50 at Allard, #800G.

On October 15, 1993, black & red on yellow canteen, ca. 1950, cloud, parrot, prayer feather designs (9 x 9"), est. $400-800, sold for $200 at Munn, #1091.

On October 16, 1992, signed, redware bowl, incised bands beneath rim, ca. 1960 (3 x 8"), est. $200-400, sold for $200 at Munn, #969.

On January 31, 1992, signed, tile, parrot design, ca. 1950, Provenance: Joan Drackert Estate (4 x 10"), est. $150-300, [need sales result] at Munn, #662.

On August 1, 1991, a black and red on white globular jar with split feather design (9 3/4 x 7 1/2"), est. $600-800, [need sale result], at Butterfield & Butterfield, sale #4582A, #2715.

On March 15, 1991, signed, black and white on red dough bowl, ca. 1960 (7 x 14.5"), est. $600-1,200, sold for $705 at Allard, #700A.

On March 15, 1991, signed, bowl, fingernail design, ca. 1960 (6.5 x 6.5"), est. $200-400, sold for $80 at Allard, #700B.

On February 1, 1991, redware jar, incised designs, ca. 1950 (5" h.), sold for $175 at Munn, #465.

On February 1, 1991, black & red on yellow jar, migration design, (8" dia.), sold

for $400 at Munn, #1071.

On September 27, 1985, signed, stew bowl and ladle (5 X 12"), est. $50-100, sold for $35 at Allard, #260.

PUBLICATIONS: Allen 1984:111-112, 114-115, 121-122; Barry 1984:81-88; Bassman 1997:77; Gaede 1977:18-21;

BIOGRAPHICAL DATABASES: "Hopi-Tewa Potters," Native American Resource Collection, Heard Museum, Phoenix; "Artist Database," Museum of Indian Arts & Cultures, Santa Fe.

Photograph by Richard M. Howard

Geneva Pavatea
(Tewa, Tewa Village, Spider Clan, active 1960-1980+: black on red bowls)
COLLECTIONS: Museum of Northern Arizona, black on red bowl, #E8664, 1969

Grace Pavatea
(active 1965-1975: black & red on yellow jars)
VALUES: In 1981, signed, a black & red on yellow jar, ca. 1965-1975 (3.25 x 4.25"), was offered for sale at $85 by T.N. Luther, "American Indian Art," catalog #A2-1981, item #P36, p. 84.

In 1981, signed, a black & red on yellow jar, ca. 1965-1975 (2.75 x 4"), was offered for sale at $75 by T.N. Luther, "American Indian Art," catalog #A2-1981, item #P37, p. 84.

Michael Pavatea
(Tewa/Navajo)

Wilma Rose Pavatea
(Tewa, Spider Clan, Tewa Village, active 1950-1960: miniature jars)
FAMILY: Daughter of Garnet Pavatea.
COLLECTIONS: Museum of Northern Arizona, miniature jar, #E5229, 1957.
PUBLICATIONS: Allen 1984:115

Ruth Paymella
(signed Ruth Paymella Polacca)
(Tewa, Kachina/Parrot Clan, Tewa Village, active 1940-1980: redware bowls, plates)
LIFESPAN: (ca. 1920-after 1980)
FAMILY: See Tewa Kachina/Parrot Clan - Extended Family Tree Chart.
FAVORITE DESIGNS: prayer sticks, clouds, parrots, parrot tail feathers, germination
VALUES: On March 13, 1998, signed, redware bowl, germination & parrot tail feathers design, ca. 1965 (6 x 9"), est. $150-300, sold for $187.50 at Allard, #1455.

On October 4, 1991, signed, plate, prayer stick, clouds & parrot design, ca. 1940 (1 x 13"), est. $200-400, sold for $250 at Munn, #721A.

Clara Peesha
(Hopi, Sichomovi, active 1960-present: black and red on yellow jars, redware bowls, miniatures)
FAVORITE DESIGNS: feathers
EXHIBITIONS: "Hopi Show," Museum of Northern Arizona
COLLECTIONS: Museum of Northern Arizona, redware bowl, #E3314, 1966; miniature jar, #E8384. 1979; Steve Gershenberg Collection, Los Angeles.
PUBLICATIONS: Allen 1984:113, 1921

Peheuminima

(Hopi, Hotevilla, active 1940-1960: plainware jars)
COLLECTIONS: Museum of Northern Arizona, plainware jar, #E1095, 1953; plainware jar, #E1225, 1940; plainware jar, #E1226, 1940; plainware jar, #E1227, 1940.
PUBLICATIONS: Allen 1984:110

Helena George Phillips

(Hellie)

(Hopi, Moencopi, Reed Clan, active 1998-present: bowls)
BORN: March 24, 1951
FAMILY: Daughter of Verna Tachawena Jackson and Ros George, Sr.; wife of Loren Phillips, Mother of Corwin Phillips (b. October 1, 1971)
EDUCATION: Mt. Eldon Elementary, East Flagstaff Jr. High, Tuba City High
POTTERY TEACHER: Tim Cordero (Cochiti), grandson of Helen Cordero

///I really wanted to make pottery. I've just started. I just want to make it in the old, traditional way."

Photograph by Marc Gaede
Courtesy of the Museum of Northern Arizona.
(neg. #77.0281)

Anita Polacca

(Hopi, Sichomovi, active 1940-1985+: black and red on yellow bowls, some with lids, cylinder vases)
FAMILY: Daughter of Violet Huma
COLLECTIONS: Museum of Northern Arizona, black and red on yellow bowl with lid, #E6307a,b, 1973; .
VALUES: On July 8, 1994, a black & red on yellow bowl, Sikyatki designs, ca. 1950 (3 x 5.5"), est. $75-150, sold for $55 at Munn, #23.
On June 3, 1994, black & red on yellow bowl, Sikyatki designs (3 x 5.5"), est. $100-200, sold for $88, at Munn, #488.
On June 3, 1994, black & red on yellow bowl, bird design (2 x 6"), est. $50-100, sold for $44, at Munn, #755.
On February 4, 1994, black & red on yellow seed jar, ca. 1950, rain & prayer feather designs (2 x 4"), est. $50-100, sold for $55, at Munn, #58.
On February 4, 1994, black & red on yellow cylinder vase, parrot design (6 x 3"), est. $100-200, sold for $75, at Munn, #64.
On February 4, 1994, black & red on yellow seed jar, ca. 1960 (4 x 3"), est. $50-100, sold for $65, at Munn, #267.
On February 4, 1994, black & red on yellow bowl, ca. 1960, 4 bird designs (4 x 9"), est. $250-375, sold for $200, at Munn, #1097.
On October 15, 1993, black & red on yellow bowl, ca. 1940s, prayer feather designs (4 x 6"), est. $75-150, sold for $120, at Munn, #351.
On October 15, 1993, black & red on yellow bowl, ca. 1940, parrot & prayer feather designs (4 x 4"), est. $40-80, at Munn, #441.
On October 15, 1993, black & red on yellow bowl, ca. 1960, clouds & prayer feather designs (2 x 7"), est. $75-150, sold for $75 at Munn, #628.
On November 10, 1989, signed polychrome bowl, bird hanging from the sky band design, ca. 1973 (3 x 10"), est. $100-200, sold for $285 at Allard, #145.
PUBLICATIONS: Allen 1984:117; Gaede 1977:18-21

Barbara Polacca

(also signs B. Polacca, Barbara Mara Polacca, Barbara Nampeyo)

(Tewa, Spider Clan, active 1970-present: black & red on yellow seed jars, cylinder vases, effigies on lidded jars, bowls, tiles, black on orange canteens)
FAVORITE DESIGNS: cotyledon sprouting plants, feathers, Sun Spirit Dawa, parrots, clouds, germination, wings, eagle tail feathers

Clinton Polacca
(see Clinton Polacca Nampeyo)

Delmar Polacca
(Hopi/Tewa, Snow Clan, Polacca, active 1993-present: deep-carved polychrome jars, seed jars, egg-shaped forms)
BORN: October 25, 1959
FAMILY: Son of Thomas and Gertrude Polacca; husband of Patricia Polacca; father of Anastasia, Micheal. Titian, Danielle, and Danisha.
AWARDS: 3rd, "Hopi Show," Museum of Northern Arizona, Flagstaff; 3rd, Mesa Verde Show; Honorable Mention, "Invitational," Lawrence, KA.
PUBLICATIONS: Jacka & Jacka, 1998

Fannie L. Polacca
(Fannie Myron)
(Tewa)
FAMILY: Great-granddaughter of Nampeyo; granddaughter of Fannie Polacca Nampeyo and Vinton Polacca; niece of Elva Tewaguna Nampeyo, Leah Garcia Nampeyo, Harold Polacca Nampeyo, Sr., Tonita Hamilton Nampeyo, Elsworth Polacca and Iris Youvella Nampeyo; daughter of Tom Polacca and Gertrude; wife of Elson Seckiestewa.
PUBLICATIONS: Dillingham 1994:14-15

Harold Polacca
(see Harold Polacca Nampeyo, Sr.)

Leona Polacca
(Tewa, Tewa Village, active 1900-1930: black on yellow bowls, black and red on yellow jars)
COLLECTIONS: Museum of Northern Arizona, black on yellow bowl, #E18, 1900-1930; black and red on yellow jar, #E466, 1900-1930.
PUBLICATIONS: Allen 1984:105, 108

Reva Polacca
(see Reva Polacca Ami)

Tom Polacca
(Thomas Polacca, Tom Polacca Nampeyo, Thomas Nampeyo)
(Tewa, active 1955-present: deep carved polychrome jars)
BORN: 1935
FAMILY: Grandson of Nampeyo; son of Fannie Polacca Nampeyo and Vinton Polacca; brother of Elva Tewaguna Nampeyo, Leah Garcia Nampeyo, Harold Polacca Nampeyo, Sr., Tonita Hamilton Nampeyo, Elsworth Polacca and Iris Youvella Nampeyo; husband of Gertrude; father of Gary Polacca Nampeyo (b. 1955), Fannie Myron, Delmar Polacca, Carla Claw (b. 1961), and Elvira Naha (b. 1968)
COLLECTIONS: Heard Museum, Phoenix, AZ, miniature jar, #3576-155, 1977; jar, #3576-176, ca. 1982; jar, #3576-196, ca. 1976.
FAVORITE DESIGNS: Kachinas, Mudheads

Photograph by Bill Bonebrake.
Courtesy of Jill Giller,
Native American Collections, Denver, CO

PUBLICATIONS: Dillingham 1994:14-15; Bassman 1997:80
BIOGRAPHICAL DATABASES: "Hopi-Tewa Potters," Native
American Resource Collection, Heard Museum, Phoenix;
"Artist Database," Museum of Indian Arts & Cultures,
Santa Fe.

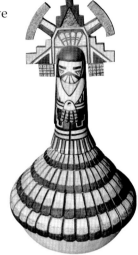

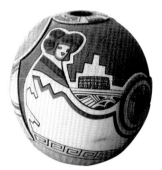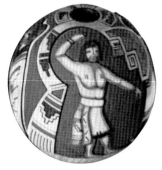

Courtesy of Southwest Auctioneers

Gregory Schaaf Collection

Vernida Polacca
(see Vernida Polacca Nampeyo)

Veronica Polacca
(Tewa)
VALUES: On December 5, 1991, 4 Hopi pots by Veronica Polacca, A. Gasper, Nyla
Sahmie, Colleen Poleahla, including two wedding vases, each with painted stylized
birds; a jar with migration design, and a small black on red jar, the largest (9 1/4 x
6"), est. $250-350 sold for $220 at Butterfield & Butterfield, sale #4664E, #869.

Carla Poleahla

Christine
Poleahla

Christine Poleahla
(black on orange cylinder vases)
FAMILY: wife of John Poleahla; sister-in-law of Colleen Poleahla
FAVORITE DESIGNS: parrot
COLLECTIONS: Ken Owens Collection, Fayetteville, Ark.

Gregory Schaaf Collection

COLLEEN POLEAHLA
HOPI
FIRE / COYOTE

Colleen Poleahla
(Hopi, Fire/Coyote Clan, Sichomovi, active
1977-present: rare black and white on yellow
jars, black & red on yellow and black on red
seed jars, wedding vases, cylinder vases,
ladles and rattles)
BORN: February 10, 1961
FAMILY: Daughter of Bert Poleahla and Freida
Warze Poleahla; mother of Justin (17), Collin (15),
James (13) and Donavan (10) in 1998.
EDUCATION: Polacca Day School, Keams Canyon,
Sherman Institute

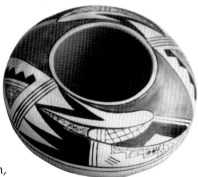

Gregory Schaaf Collection

TEACHER: Freida Warze Poleahla
STUDENTS: John, Orlinda, Rudeford, Dean, Edward, Larry, Florine Allison, Delia, Carla and Nadine Nicholas.
AWARDS: 3rd, Polychrome vase, Hopi Marketplace
EXHIBITIONS: 1997 Hopi Show," Museum of Northern Arizona, Flagstaff
FAVORITE DESIGNS: Sun, stars, clouds, Thunderbirds. Her compositions are designed in four quadrants.
PUBLICATIONS: L.S. Scala, "Colleen Poleahla: A Hopi Potter," *Hopi-Navajo Observer* (September 17, 1997), p. 3.

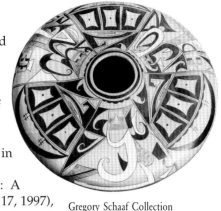

Gregory Schaaf Collection

Gregory Schaaf Collection

I met Colleen in February 1998, while she was displaying some of her pottery at the First Mesa Visitors Center. She told me, "My pots are my children. They talk to me when I work with the clay. They are my life. I work in the old traditional way, with a yucca brush and sheep dung firing."

I later visited in her home, a cinder block house next to a peach colored trailer on the east side of Polacca. She lives just north of Lawrence Namoki, noted Kachina carver and potter. She has four children.

Colleen proudly showed me her big pottery jar, illustrated in a feature article about her work in the *Hopi-Navajo Observer*. This pot is a rare example of one that is painted black and white on yellow, rather than black and red on yellow.

Colleen's style of painting also is unique — strong, bold brush strokes with an expressionistic flair. She pointed out to me how she divides her designs into four or six quadrants, compositions favored by Nampeyo, the matriarch of Sikyatki revival pottery.

Colleen also develops unique variants of form, such as teardrop shaped seed jars. Colleen Poleahla is an innovator. She shares an intimate relationship with her pottery. A potter, she explained, needs to express good thoughts and prayers. She talks to her pots in a good way.

Although she has yet to be widely exhibited, the quality of her work is exceptional.

Gregory Schaaf Collection

Charles and Suzanne Brown Collection

Elaine Poleahla
(Hopi, active 1970)

Freida Warze Poleahla

(Hopi, Fire/Coyote Clan, Sichomovi, active 1955-1990: polychrome bowls)
LIFESPAN: (- 1995)
FAMILY: Wife of Bert Poleahla, mother of Colleen Poleahla and John Poleahla
VALUES: On March 25, 1994, a polychrome tile (8 x 6″), ca. 1958, est. $150-300, sold for $148.50, at Allard, #379.

On March 25, 1994, a polychrome tile (8 x 6″), ca. 1958, est. $150-300, sold for $137.50, at Allard, #380.

On February 4, 1994, a polychrome bowl, ca. 1960s (4 x 5″), est. $50-100, sold for $45, at Munn, #319.

John Poleahla

(Hopi, Fire/Coyote Clan, Sichomovi, active 1970-1980: pottery barrettes)
FAMILY: Grandson of Rose and John Poleahla (elder); son of Bert Poleahla and Freida Warze Poleahla
COLLECTIONS: Museum of Northern Arizona, 2 pottery barrettes, #E6925a,b, 1974.

Kathleen Poleahla

(active 1980s)

Loretta Poleahla

(sometimes misspelled Poheahia)
(active 1987-present: polychrome jars)
FAVORITE DESIGNS: bands of Sikyatki designs, spirals, rain clouds, feathers

Rose Poleahla

(Hopi, Pacab/Bamboo-Reed Clan, Sichomovi, active pre-1920-1969: black and red on yellow ware.)
LIFESPAN: (pre-1900-1969)
FAMILY: Wife of John Poleahla, Sr.; mother of Bert Poleahla and Evans Poleahla.

Polevanka

(Hopi, Sichomovi, active 1920-1935: miniature jars, piki bowls)
COLLECTIONS: Museum of Northern Arizona, miniature jar, #E94, 1920-1935; miniature jar, #E95, 1920-1935; piki bowl, #E429, 1934.
PUBLICATIONS: Allen 1984:106, 107

Sylvia Poley or Poleyestewa

(also signs S. Poley)
(active 1980-present: polychrome jars, vases, canteens, red & black on cream tiles)
FAVORITE DESIGNS: Full bodied Kachinas, Hunter Kachina, Whipper Kachina parrot tail feathers, parrot wings, clouds

Sylvia Poley makes attractive polychrome tiles. Her designs are well developed; her corners nicely rounded.

Poli

(Hopi, active 1930)

Polivenka

(Hopi, Sichomovi, active 1890-1900: red jars)
COLLECTIONS: Museum of Northern Arizona, red jar, #E214, 1900.
PUBLICATIONS: Allen 1984:106

Evelyn Poolheco

(also Pootheco or Poothico)

(Tewa, Spider, Tewa Village, active 1960-1980: black on red jars, wedding vases)
COLLECTIONS: Museum of Northern Arizona, black on red jar, #E7802, 1977.
VALUES: On October 14, 1994, black and red on yellow shallow bowl, parrot
design (2.5 x 7"), est. $50-75, sold for $55 at Munn, #657.

On March 26, 1982, signed, wedding vase, ca. 1960 (9 x 7"), sold for $75 at
Allard, #134.
PUBLICATIONS: Allen 1984:121

Helen Poolheco

(active 1970-present)
PUBLICATIONS: Barry 1984:81-88

Poolie, Poolsie or Poolisie

(Hopi, Sichomovi, active 1930-1950: black and red on yellow jars, black on yel-
low, black on red jars and bowls, piki bowls, unfired jars and bowls, ladles)
DEMONSTRATIONS: "Hopi Show," Museum of Northern Arizona, annually for
many years.
EXHIBITIONS: 1937 "Hopi Show," Museum of Northern Arizona
COLLECTIONS: Museum of Northern Arizona, unfired bowl, #OC2735b, 1940-1950;
unfired jar, #OC2735c, 1940-1950; unfired jar, #OC2735e, 1940-1950; unfired jar,
#OC2735h, 1940-1950; unfired jar, #OC2735m, 1940-1950; black on yellow jar,
#OC2735n, 1940-1950; 3 black on red bowls, #E233a-c, 1937; black on red bowl, E413,
1938; piki bowl, E432, 1934; 3 unfired bowls, E444-446. 1938; piki bowl, #E454, 1938;
piki bowl, #E652, 1941; 2 ladles, #E847a,b, 1941; black and red on yellow jar, #E2940,
1935; black and red on yellow jar, #E2943, 1933; 3 black on yellow bowls, #E5408, 5411,
5412, 1937; 3 black on yellow bowls, #E5413, 5414, 5415; unfired bowl, #E5416, 1938;
black and red on yellow bowl, #E5417, 1941; black on yellow bowl, #E5418, 1941.
PUBLICATIONS: Allen 1984:105, 107-109, 116; Harold S. Colton 1939.

In 1937 at the village of Sichomovi, Poolie's pottery firing tech-
niques were recorded. They were published two years later, in
1939, by Harold S. Colton of the Museum of Northern Arizona in
Flagstaff. The largest known collection of her pottery is preserved at
this fine institution.

Vera Nevahoioma Pooyouma

(Pooyema, Posyevma)

(Hopi, Hotevilla, active 1950-1981: black on yellow bowls, plainware jars,
piki bowls, canteens, ladles, mortars & pestles, miniature jars; also master
piki maker)
DEMONSTRATIONS: Hopi Show, Museum of Northern Arizona
EXHIBITIONS: Hopi Show, Museum of Northern Arizona
COLLECTIONS: Museum of Northern Arizona, ladle, #E1250, 1954; plainware jar,
#E3315, 1966; ladle, #E4161, 1969; plainware bowl, #E5470, 1971; canteen, #E6199,
1973; plainware jar, #E6387, 1973; black on yellow bowl, #E7606, 1976; miniature jar,
#E8154, 1978; mortar & pestle, #E8571a,b, 1981; ladle, #E8572, 1981; ladle, #E8667, 77.
PUBLICATIONS: Allen 1984:110, 113-14, 116, 119, 122

Potsung
(Tewa, Tewa Village, active 1930-1940: piki bowls)
COLLECTIONS: Museum of Northern Arizona, piki bowl, #E610, 1940.
PUBLICATIONS: Allen 1984:108

Poui
(Tewa, Bear Clan, Tewa Village, active ca. 1870-1900+)
FAMILY: See Tewa Bear, Sand and Spider Clan Family Tree Chart.

Laura Preston
(active 1960: plates, shallow bowls, ladles)
FAMILY: Mother of Veronica Preston Navasie
FAVORITE DESIGNS: rain, clouds
VALUES: In 1997, a plate (1.5 x 10″), est. $250-350, sold for $137.50 at Munn,
October 1997:70, #684.
 On June 3, 1994, black on yellow ladle , cloud designs (3 x 7″), est. $40-80, sold
for $16.50, at Munn, #757.
PUBLICATIONS: Bassman 1997:81

Pü'che
(Pü'chi, Pi'chi)
(Hopi, Walpi Horn/Deer Clan, active 1870-1900: clay figurines for ceremonies)
FAMILY: brother of Siwi'ñaiya; sister's son of H'hawi
PUBLICATIONS: Stephen 1936:1118

Pü'che was a respected priest of the Two Horns, an ancient hunting society. He was considered for the highest spiritual position, Kikmongwi, after the death of Si'mo.
 On the evening of December 22, 1891 — winter solstice — he and Ka'chi were in the Goat Kiva at Walpi, making clay effigies of oxen. They attached feathers to their necks and set them on the alter in the Goat Kiva. (Stephen 1936:12)

Jofern Silas Puffer
(Tewa/Laguna, Kachina Clan, active 1990-present: polychrome seed jars)
FAMILY: Daughter of Roberta Silas; sister of Louann Silas and Antoinette Silas

Alice Puhuhefvaya
(signs A.P.)
(Polacca)
FAMILY: Wife of Fernando Puhuhefvaya; mother of Ira, Clauson and Malcomb
Puhuhefvaya.
GALLERIES: Secakuku Trading Post, Second Mesa, AZ

Clauson Puhuhefvaya
(Polacca)
FAMILY: Son of Alice and Fernando Puhuhefvaya
GALLERIES: Secakuku Trading Post, Second Mesa, AZ

Ira Puhuhefvaya
(Polacca)
FAMILY: Son of Alice and Fernando Puhuhefvaya
GALLERIES: Secakuku Trading Post, Second Mesa, AZ

Malcomb Puhuhefvaya

(Polacca)
FAMILY: Son of Alice and Fernando Puhuhefvaya
GALLERIES: Secakuku Trading Post, Second Mesa, AZ

Qomahoinimam's grandmother

(Hopi, Shungopavi, active 1875-1900: white jars)
COLLECTIONS: Museum of Northern Arizona, white jar, #OC1085, 1875-1900.
PUBLICATIONS: Allen 1984:104

Qomanquiamka

(Hopi, Shungopavi, active 1890-1900: piki bowls)
COLLECTIONS: Museum of Northern Arizona, piki bowl, #OC1088, 1897
PUBLICATIONS: Allen 1984:104

Al Qöyawayma

(also known as Al Colton)

(Hopi, Scottsdale, AZ, active 1970-present: carved and appliquéed buffware and redware seed jars, Anasazi style ollas, wedding vases, clay and bronze sculptures and figurines)
FAMILY: Nephew of Elizabeth White
CAREER: He has been represented by Gallery 10 in Santa Fe and Scottsdale.
TECHNIQUES: Finely modeled buffware with figures in relief or appliquéd. Often with a highly polished micaceaus cream slip.
COLLECTIONS: Museum of Northern Arizona, redware jar, #E8398, 1978
FAVORITE SYMBOLS: Kokopelli, pueblo ruins, kivas, human and spiritual figures, corn, clouds, rain
PUBLICATIONS: Jacka and Jacka 1988:94-95; Ron McCoy, "Sculptural Perfection, The Pottery of Al Qöyawayma'," *Southwest Profile Magazine,* Aug/Sept/Oct, 1993:22-25; Bassman 1997:81

"Al Qöyawayma's pottery, embellished with his finely sculpted clay figures, stands alone as clay artistry of the highest degree." Jacka and Jacka 1988:94-95.

"Al Qöyawayma's pottery is legendary. Connoisseurs and critics speak of its sculptural perfection, pristine elegance, profound, synchronous relationships, and sublime, fluid forms. For the potter himself, the meaning is simple and clear. It is 'evidence of the spiritual influence on all men.'" Ron McCoy, "Sculptural Perfection, The Pottery of Al Qöyawayma'," *Southwest Profile Magazine,* Aug/Sept/Oct, 1993:22-25

"...He attributes his style to his aunt, noted artist Elizabeth White. Much of the ornamentation of Qöyawayma's work is figurative and embodies a bas relief of repoussé technique, based on traditional Hopi designs. He has won numerous awards and has been featured in numerous articles, books and in museum collections." Sotheby's, December 4, 1997, sale #7066, back pages.

Courtesy of Gallery 10
Scottsdale and Santa Fe

Polingaysi Qöyawayma

(see Elizabeth White)

Lorna Quamahongnewa

(Hopi, Hotevilla, active 1990-present: ceramic jars, bowls, stew bowls, sugar bowls, creamers, salt & pepper shakers, necklace pendants, napkin rings)
CAREER: Teacher, Hopi High School, Day School
FAMILY: Wife of Radford Quamahongnewa
FAVORITE DESIGNS: Kokopelli, bears, butterflies, clouds, Twin War Gods' footprints, Kachina cape designs

Gregory Schaaf Collection

Qumanquimka

(Hopi, Shungopavi, active 1890-1900: plainware jars)
COLLECTIONS: Museum of Northern Arizona, plainware jars, #OC1078, 1895
PUBLICATIONS: Allen 1984:104

Quinchawa

(see Annie Healing Nampeyo)

Quioyanginima

(Hopi, Sichomovi, active 1930-1940: white jars, plainware jars)
COLLECTIONS: Museum of Northern Arizona, plainware jar, #OC2780, 1931; plainware jar, #E158, 1934; plainware jar, #E194, 1931; plainware jar, #E305, 1937; white jar, #E558, 1939; plainware jar, #1415, 1935.
PUBLICATIONS: Allen 1984:105-106, 108, 111

Camille Quotskuyva

(see Hisi Nampeyo)

Dextra Quotskuyva

(Dextra Nampeyo)
(Tewa, Corn Clan, Polacca/north of Kykotsmovi, active 1940-present: bowls, jars, wedding vases, miniatures in black and red on yellow, black on redware)
BORN: September 7, 1928, at Polacca, AZ.
EDUCATION: Polacca Day School, Phoenix Indian School, Oraibi High School.
FAMILY: Third generation descendant of Nampeyo, the Tewa potter who revived Sityatki style pottery on First Mesa at Hopi. Great-Granddaughter of Nampeyo; Granddaughter of Annie and Willie Healing; daughter of Rachel and Emerson Namingha; sister of Priscilla Nampeyo, Lilian Gonzales, Ruth Namingha, Eleanor Lucas Namingha Nampeyo and Emerson Namingha; wife of Edwin Quotskuyva;

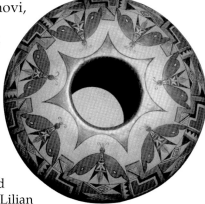

Richard M. Howard Collection

mother of Hisi (Camille) Nampeyo and Dan Namingha; grandmother of Lowel Chereposy, Erica Quotskuyva and Reid Ami.

CAREER: Began making pottery in 1967.

HONORS: First Place, 1974 American Indian and Western Relic Show, Los Angeles; 1995, proclaimed "Arizona Living Treasure."

EXHIBITIONS:

1973	Museum of Northern Arizona, Flagstaff, AZ
1974	Muckenthaler Cultural Center, Fullerton, CA
1974	American Indian and Western Relic Show, L.A.
1989	Mitchell Indian Museum, Evanston, IL
1993 - 95	"Rain," Heard Museum, Phoenix
1996	"The Nampeyo Legacy Continues: The Art of Five Generations of a Renowned Tewa/Hopi Family," curated by Martha Hopkins Struever, Santa Fe Indian Market, Santa Fe, NM
1997	"Succeeding Generations," Faust Gallery, Scottsdale

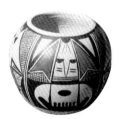

Richard M. Howard
Collection

COLLECTIONS: Rick Dillingham Collection, donated to Museum of Indian Arts and Culture, Santa Fe, NM.; William Hinkley Collection, Paradise Valley, AZ; Richard M. Howard Collection, Santa Fe, NM; Mr. and Ms. Deneb Teleki Collection; Mr. and Mrs. Theodore W. Van Zist Collection, Martha Struever Collection; Mr. and Mrs. Robert Malott Collection; Frederick C. Uhde Collection; Mr. and Mrs. Robert Vogele Collection; Mrs. Charles Preston Collection; Mrs. Hon Lanman Collection. Museum of Northern Arizona, black and red on yellow jar, #E6363, 1973; redware bowl, #E6364, 1973; miniature bowl, #E8212, 1972; miniature jar, #E8574, 1981; Heard Museum, Phoenix, AZ, jar, #3585-1, ca. 1985-1992; bowl, #NA-SW-HO-A7-158; jar, #NA-SW-HO-A7-157; 1969; seed jar, #NA-SW-HO-A7-159; jar, #NA-SW-HO-A7-160; jar, #NA-SW-HO-A7-162; bowl, #NA-SW-HO-A7-163.

PUBLICATIONS: *Arizona Highways* 1974:16; Arnold 1982; Bonar 1995; Dillingham 1974, 1978, 1994; Gault 1991:15; Jacka & Jacka 1988:57; Matuz 1997:477-78; Monthan 1977; Struever 1989, 1996a, 1996b; *The Indian Trader* 1987:27.

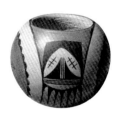

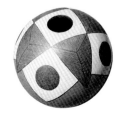

Richard M. Howard Collection

Following in the heritage of Nampeyo, her Tewa great-grandmother, Dextra honors her ancestors while expanding the artistic tradition. She is an innovator, a unique artist among a family of fine potters from First Mesa at Hopi. Her work features thin walled coiling and near perfect symmetry. Her traditional and contemporary forms display delicate design that seem ancient, yet modern at the same time.

Dextra told Rick Dillingham for the classic *Seven Families in Pueblo Pottery*, "I started my pottery work around 1967 and have been working on it constantly ever since. My mother, Rachel, watched and supervised me. I would help my mother with the firing but began to fire on my own. I have experimented with the use of shells and turquoise on my pottery like some of the potters at San Ildefonso. My mother isn't happy about the break from tradition. I am always working on new experiments. I want to keep my pottery unique."

Dextra began "working seriously" in 1972 and was recognized in 1977 as a "master" by Guy and Doris Monthan, in their article "Dextra Quotskuyva Nampeyo," *American Indian Art Magazine.* "The graceful shapes bear a rich complexity of designs and the craftsmanship is flawless."

In 1982, Dextra was featured with four photographs and a detailed description of her pottery making by David L. Arnold, "Pueblo Pottery: 2000 Years of Artistry," *National Geographic Magazine* (November 1982). Dextra recounted her early beginnings, " One day I

asked my mother to let me paint pots. She gave me a cracked one to start with, but when she saw how I could paint, she was sorry she had given me the cracked one. It came easily."

The late Rick Dillingham, author of *Fourteen Families in Pueblo Pottery*, recorded Dextra's commitment to pottery, "I think the pottery took over me and I can't get away from it. That's for sure. Clay is in my system. It's all the time, and you're happy with your pots."

Martha Hopkins Struever, in her exhibit catalog "The Nampeyo Legacy Continues," presents an updated biography of the artist: "Growing up on the Hopi reservation, in a family of famous potters, Dextra and her sisters were introduced at an early age to the many steps in the process of creating traditional Hopi pottery. Later, when she began working with clay as a serious potter, she was encouraged by her mother Rachel, a fine potter in her own right. Dextra was surprised to discover how readily she learned to produce finely crafted vessels."

Dextra recalled, "My mother would tell me, 'I think you are going to be a real good potter."

"And I would say, 'Me, you think so?'

"Then she would say, 'Yes, look at your hands.' So she asked me to just fill up the solid places on her pots. Then one day she told me that it was about time that I should mold. So I started making tiny pots. Then she told me it was about time to do the bigger ones. That scared me, but she said just keep coiling and stretching them and they will get bigger. During that time I was making the flat ones. My mom thought that those flat ones were too hard to make and said, 'Why don't you try to make some round ones?' I finally got around to the round ones, and they were easier. I also found out that it is easier to design larger pots than small ones.

"But before all of that happened I had a dream. . .of being at Sand Hills where all the trees were in the midst of the sand dunes. It was so beautiful...We used to play there all the time, rolling down those big hills. In this dream I was sitting on the hill by myself. I kept smoothing the sand and then I felt something round. I went, 'What is this?' I kept digging on the right hand side, and finally I saw a pot. I dug it out, and it was really pretty with beautiful designs on it. I kept picking up pots, all with those beautiful designs. There were so many of them! After that, I thought the dream was wiped away, but when I was firing, it came back. Then it dawned on me that some of those designs were on one of the pots that I had designed..."

Regarding her creative process, Dextra explained, "Most of the time you already have the idea of the design that needs to be on the pot. Other times, it's very difficult to design for some reason. You

138

can't seem to picture that design on this pot. You wonder why that's happening...That's when you really get smothered, and you're fighting your mind. Most of the time I'm listening to what the pot is telling me to do. I'm just a maker. You are just there to guide it the way it wants..."

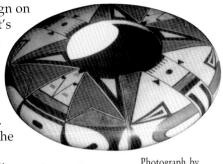

Speaking of the healing nature of pottery, Dextra said, "Sometimes I put my designs on the pot just thinking about people. Not just people within this area. I think of people being sick, and that this pot might do something for someone."

Sharing a sense of optimism and good faith, the artist relates, "Sometimes, we think for ourselves that there's no way out, but there is always some way out. I think that it has something to do with faith. You have to believe in what you are doing. It's so personal. There is so much you want to say. Most of the time these designs are just right there. You wonder why it is that I am so full of these designs? You just put them down, and they are loose and free."

Conceding the sacrifices an artist must make, Dextra expressed to her children and young relatives, "I tell them it's not easy to be a potter. There are a lot of things you sacrifice. You need to almost surrender yourself to what you're doing. You're talking to clay all the time. It's just like talking to another person. Once clay gets hold of you, you drop everything. The clay has a lot of energy...the clay wants you home. It's got that energy to pull you back...I'm just in my own world. Once you start feeling that way, the clay wants to work along with you, and let you make this beautiful pot. These are things that you feel, but I never really felt I was an artist."

In the Summer 1996 issue of Indian Artist Magazine, Struever recorded these conversations with Dextra, making an original contribution to the history of pottery in the Southwest. Struever correctly acknowledges the constant demand for Dextra's pottery, "Recognition of her talents came quickly to collectors, and from that day to this, Dextra's pottery is among the most difficult to obtain. The demand for her work is such that most pieces are sold as quickly as they become available."

During a 1997 interview in her new home north of Kykotsmovi village, Dextra expressed the importance of passing on traditional culture: "Our old ways have a lot of value. At some time, your culture will help you. It's important that you know about it. You should pass it on to your kids."

Dextra spoke with pride of her daughter's development as a fine potter, carrying on the family tradition: "Camille [Hisi Nampeyo] and the younger ones have been doing real good. I'm proud of them." Dextra stressed the importance of giving young artists the freedom to be creative: "Let them decide on their own. They have their own ideas. Freedom inspires them. I tell them, 'Don't give up. If you're enjoying this, do it!'"

In February and March of 1998, I visited Dextra twice. She talked about her long desire to

experiment in creating unique types of pottery, as well as reviving old forms and designs. "I stayed up late at night, trying different things."

One style Dextra pursued was a low shouldered seed jar with a flat top. "My mother, Rachel, use to say, "My daughter, do those pots that come up and have bellies...I don't know why you're doing those flat ones. They're so hard to do."

Dextra explained, "Those flat ones are harder to do. You have to change the size of the coils, making the top thinner and lighter, so the weight of the clay will not collapse inward."

I showed Dextra an early olla by the original Frog Woman, Paqua Naha, with a rim that curves inward then flares outward at the top. "This is another very difficult shape to make. We see things in nature, like a flock of birds. All of a sudden they turn back, or they hear something, and all turn. Then it is recorded on the pottery."

She continued expressing her respect for early potters, "Paqua was a good potter. She made really hard pots to do, the ones that curve in and out. Only the best potter can make low seed jars. Paqua could no this. . .Paqua was a friendly person, like Nampeyo, especially toward the children."

Dextra studied the Paqua olla closely, "Paqua's pot has a lot of spirit. It does something to you. I could just remember her in my mind. We use to go to see her as children. Raymond Naha (painter), my cousin and Daisy's son, use to stay with her. We use to go up on the hill to play. She use to give us fry bread."

Dextra complimented the work of Daisy Nampeyo, "She made big pots, giant pots." She influenced a lot of potters, including the original Feather Woman, Helen Naha.

Dextra also admired the work of Sadie Adams, who signed her pots with a flower hallmark, "Sadie was a really good potter. She did those ones with the flaring rim and flat ones. They're the hardest."

Dextra, expressed her respect for her own mother, Rachel Nampeyo, "My mom was a really good artist. She also made really nice dresses for us. She created many of her own designs without looking at anything. She would just sit down and design. I admired her. She had a lot of patience.

Finally, Dextra expressed her opinion of this biographical directory of Hopi-Tewa potters. She said to me in a complementary tone of voice, "The potters and their families will have something to feel proud of, looking back at these people and their work. It gives a lot of credit to them."

Photographs by
Richard M. Howard

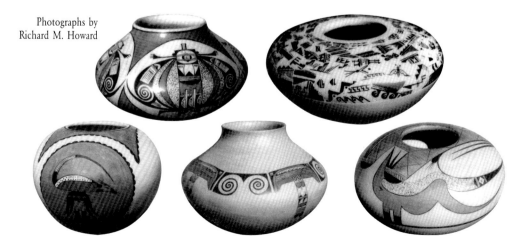

Rabbit (Running) hallmark
(black and red on buff jars, active 1970-80)
VALUES: On March 16, 1990, signed polychrome jar, feather & tadpole design, ca. 1975 (7 x 10"), est. $400-800, sold for $420 at Allard, #989.

Rain Cloud hallmark
(active 1940-1950: black & red on yellow jars)
VALUES: On January 31, 1997, a black and red on yellow bowl, crescent moon and rain cloud designs (7 x 8.5), est. 450-650, sold for $175 at Munn, #208.

Flora Ray
(Tewa, Bear Clan, Tewa Village, active 1930-1960: effigy bowls, black and red on yellow bowls and jars, black on yellow bowls, redware bowls, scoops)
LIFESPAN: (- after 1960)
COLLECTIONS: Museum of Northern Arizona, redware bowl, #E1312, 1956; black and red on yellow bowl, #E5403, 1936; black on yellow bowl, #E5404; black and red on yellow jar, #E5405, 1936; scoop, #E5406, 1936; effigy bowl, #E8561, 1940-1960.
PUBLICATIONS: Allen 1984:111

Zella Ray
(see Zella Nampeyo)

Marcia Rickey
(Flying Ant hallmark, Ant Woman, Marcia Fritz, Marcia Rickey)
(Hopi, Walpi, active 1950-1990?: black and white on red bowls, black on white black and red on yellow jars, cookie jars)
COLLECTIONS: Museum of Northern Arizona, black and white on red bowl, #E1311, 1956; black and red on yellow jar, #E1476, 1958; black on red and black on white bowl, #E3311, 1966.
FAVORITE DESIGNS: feathers
VALUES: On March 25, 1994, a polychrome bowl with geometric designs (3.75 x 9"), ca. 1960, est. $200-400, sold for $225.50, at Allard, #78.

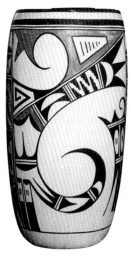

Richard M. Howard Collection

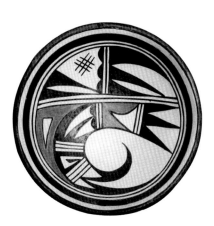

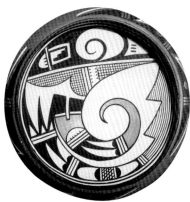

PUBLICATIONS: Allen 1984:111; Barry 1984:81-88; Coe 1986:218-219' Gault 1991:15.

In 1984, Indian art historian Ralph Coe acquired one of her black and white on red bowls. Coe recognized that her style of pottery is similar to "St. Johns polychrome pottery, a White Mountain, Arizona, red ware that was once (1175-1300) widely distributed through the Southwest." Coe concluded, "Mrs. Rickey represents the solid comfortable continuance of Hopi style. . .Mrs. Rickey retains a conservative matte paint surface. " (Coe 1986:218-219)

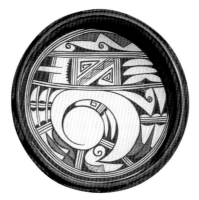
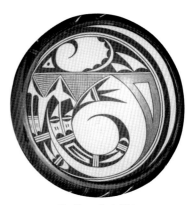

Attrib. by Richard M. Howard
Gregory Schaaf Collection

Challis & Arch Thiessen
Collection

Donna Navasie Robertson
(Frog, Tadpole & D.R. hallmark)
(Tewa/Hopi, active 1990-present: black and red on white wedding vases)
LIFESPAN: (1972-)
FAMILY: Granddaughter of Joy Navasie; and daughter of Marianne Navasie. See Frog Woman-Feather Woman Extended Family Tree Chart.
FAVORITE DESIGNS: feathers, tadpoles, rain clouds, eagles
PUBLICATIONS: Dillingham 1994:60-61
BIOGRAPHICAL DATABASES: "Hopi-Tewa Potters," Native American Resource Collection, Heard Museum, Phoenix; "Artist Database," Museum of Indian Arts & Cultures, Santa Fe.

Gregory Schaaf Collection

Gail Navasie Robertson
(Frog & GNL hallmark)
(Tewa/Hopi, active 1990-present: black and red on white)
FAMILY: See Frog Woman-Feather Woman Extended Family Tree Chart.
PUBLICATIONS: Hayes & Blom 1996:72-75

Rose
(Hopi, Shungopavi, active 1900-1928: ladles)
LIFESPAN: (-1928)
COLLECTIONS: Museum of Northern Arizona, ladle, #OC1048, 1900-1928
PUBLICATIONS: Allen 1984:103

Marlene R. Roseta or Rosetta
(Hopi, active 1990-present)

Ross's Mother
(Hopi, Oraibi, active 1830-1850: plainware jars)
COLLECTIONS: Museum of Northern Arizona, plainware jar, #OC1152, 1830-1850
PUBLICATIONS: Allen 1984:105

MS
(see Marietta Sulu)

Andrew Louie Sahmie
(Tewa, Corn Clan, active 1980-present)
LIFESPAN: (b. ca. 1952)
FAMILY: Son of Priscilla Namingha Nampeyo, brother of Rachel Sahmie, Jean Sahme, Bonnie Chapella Nampeyo, Nyla Sahmie, Finkle Sahmie, Foster Sahmie, and Randy Sahmie; husband of Ida Sahmie

Photograph by Marc Gaede. Courtesy of the Museum of Northern Arizona. (neg. #77.0259)

Clarice Sahmie
(Hopi, Sichomovi, active 1960-present: black on yellow jars)
FAMILY: Aunt of Jean, Rachel, Nyla, Bonnie, Randy, Finkle, Foster, Andrew Louie
COLLECTIONS: Museum of Northern Arizona, black on yellow jar, #E7874, 1977
PUBLICATIONS: Gaede 1977:18-21; Allen 1984:121

Finkle Sahmie
(Tewa, Corn Clan, active 1990-present)
LIFESPAN: (b. ca. 1946)
FAMILY: Son of Priscilla Namingha Nampeyo, brother of Rachel Sahmie, Jean Sahme, Bonnie Chapella Nampeyo, Nyla Sahmie, Foster Sahmie, Randy Sahmie & Andrew Louie Sahmie

Foster Sahmie
(Tewa, Corn Clan, active 1990)
LIFESPAN: (ca. 1944-ca. 1991)
FAMILY: Son of Priscilla Namingha Nampeyo, brother of Rachel Sahmie, Jean Sahme, Bonnie Chapella Nampeyo, Nyla Sahmie, Finkle Sahmie, Randy Sahmie & Andrew Louie Sahmie

Ida Sahmie
(Navajo, active 1990-present: polychrome bowls)
FAMILY: Wife of Andrew Louie Sahmie; daughter-in-law of Priscilla Namingha Nampeyo
LIFESPAN: (b. May 27, 1960)
FAVORITE DESIGNS: Yei-like figures
PUBLICATIONS: Gault 1991:16

Ida Sahmie is a Navajo woman who is married into a Tewa family. She has learned how to make pots in the technique and style of Hopi-Tewa potters. However, she prefers to use Navajo designs, especially Navajo Yeis, spiritual "Holy People."

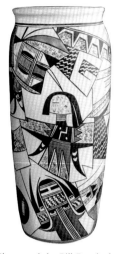

Jean Sahme
(Jean Sahmie Nampeyo)
(Tewa, Corn Clan, Polacca, active 1965-present: black &
red on yellow jars, wedding vases, cylinder vases)
LIFESPAN: (1948-)
FAMILY: Daughter of Priscilla Namingha Nampeyo; mother of
Donella Tom; sister of Nyla Sahmie, Rachel Sahmie, Bonnie
Chapella Nampeyo, Randy Sahmie, Andrew Louie Sahmie,
Foster Sahmie and Finkle Sahmie.
FAVORITE DESIGNS: Migration, butterflies, rain, clouds
PUBLICATIONS: Dillingham 1994:14-15; Gault 1991:15, 26
BIOGRAPHICAL DATABASES: "Hopi-Tewa Potters," Native
American Resource Collection, Heard Museum, Phoenix; "Artist
Database," Museum of Indian Arts & Cultures, Santa Fe.

Photograph by Bill Bonebrake.
Courtesy of Jill Giller,
Native American Collections,
Denver, CO

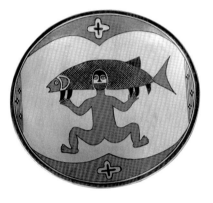 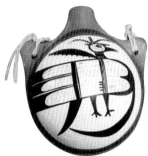

Richard M. Howard
Collection

Louie Sahmie
(see Andrew Sahmie)

Nyla Sahmie
(also Nyla Nampeyo, Nyla Sahmie)
(Tewa, Corn Clan, active 1970-present: black
and red on yellow seed jars, vases; black and
red on white wedding vases)
LIFESPAN: (1954-)
FAMILY: Daughter of Priscilla Namingha
Nampeyo; mother of Kenneth Lynch (b. 1974),
Michael (b. 1981), Christopher, & Seth (b. 1985)
Collateta; sister of Bonnie Chapella Nampeyo,
Finkle Sahmie, Rachel Sahmie, Randy Sahmie, Jean
Sahme, Andrew Louie Sahmie, and Foster Sahmie.
FAVORITE DESIGNS: migrations, double humming-
birds, flowers
PUBLICATIONS: Dillingham 1994:14-15
BIOGRAPHICAL DATABASES: "Hopi-
Tewa Potters," Native American Resource
Collection, Heard Museum, Phoenix;
"Artist Database," Museum of Indian Arts
& Cultures, Santa Fe.

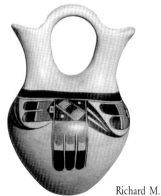

Richard M.
Howard Collection

Frank Kinsel
Collection

Rachel Sahmie
(Rachel Sahmie Nampeyo, Rachel Sahmie Talashie)
(Tewa, Corn Clan, Polacca/Keams Canyon, active 1970-present: black & red on yellow and black & red on white seed jars, cylinder vases)
LIFESPAN: (1956-)
FAMILY: Daughter of Priscilla Namingha Nampeyo; sister of Nyla Sahmie, Jean Sahme, Bonnie Chapella Nampeyo, Randy Sahmie, Andrew Louie Sahmie, Foster Sahmie & Finkle Sahmie.
FAVORITE DESIGNS: migration, 4 stars, eagle wings & tail feathers, rain, feathers, butterflies, Kachina, Hummingbirds
PUBLICATIONS: Dillingham 1994:14-15

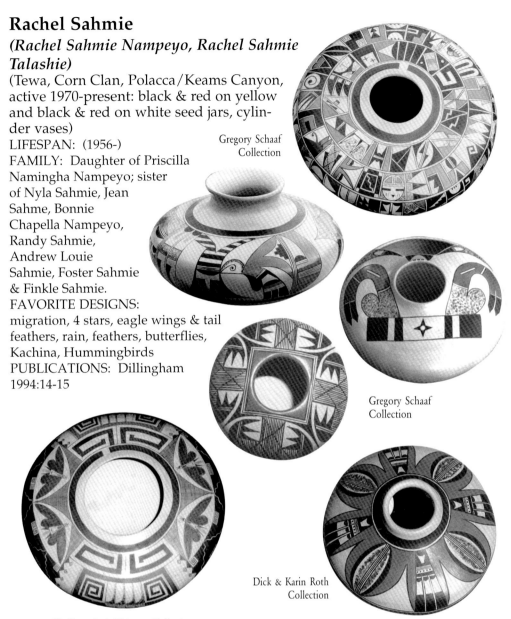

Gregory Schaaf
Collection

Gregory Schaaf
Collection

Dick & Karin Roth
Collection

Challis & Arch Thiessen Collection

Randy Sahmie
(Randall Sahmie)
(Tewa, Corn Clan, Tewa Village, active 1970-present)
LIFESPAN: (1950-)
FAMILY: Son of Priscilla Namingha Nampeyo; brother of Nyla Sahmie, Rachel Sahmie, Jean Sahme, Bonnie Chapella Nampeyo, Andrew Louie Sahmie, Foster Sahmie and Finkle Sahmie
PUBLICATIONS: Dillingham 1994:14-15

Madeline Sahneyah
(Yellow Spider)
(Tewa, Tobacco Clan, Tewa Village, active 1970-present: seed jars, piki bowls)

BORN: 1956
FAMILY: Daughter of Herman Sahneyah and Ernestine
Chaca; mother of Lynn, Ivy and Richie.
TEACHER: Ivy Youwyha (Spider Clan)

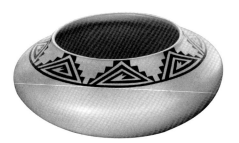

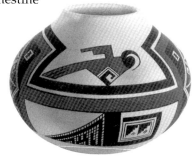

Richard M. Howard Collection

Photograph by Bill Bonebrake.
Courtesy of Jill Giller,
Native American Collections, Denver, CO

Jeanette Sahu
(Hopi, Walpi, active 1960-1970: jars, ladles)
FAVORITE DESIGNS: rain, clouds, arrow points, parrot, feathers
VALUES: On February 4, 1994, black & red on yellow seed jar with square neck,
diagonal bands of Sikyatki designs: rain clouds, falling rain, arrow points (3.5 x 5"),
est. $175-250, sold for $60, at Munn, #116.

On October 15, 1993, black & red on yellow jar, ca. 1960, cloud, parrot, prayer
feather designs, also three incised "pie crust" bands beneath the rim (7 x 6"), est.
$150-300, sold for $70 at Munn, #926A.

Norma Sakenima
(Hopi, active 1990-present)

Alfonso Sakeva
(Tewa, Kachina/Parrot Clan, Tewa Village, active 1970-present)
BORN: January 20, 1952
FAMILY: Husband of Vernida Sakeva; son of Beth Sakeva

Photograph by Marc Gaede
Courtesy of the Museum of
Northern Arizona.
(neg. #77.0279)

Beth Sakeva
(Tewa, Kachina/Parrot Clan, Tewa Village, active 1940-
1975: black on red bowls; and plates)
LIFESPAN: (1926-1994)
FAMILY: Grandmother of Claudia Grover; mother of
Alfonso Sakeva. See Tewa Kachina-Parrot Clan Extended
Family Tree Chart.
EXHIBITIONS:
 1997 "Recent Acquisitions from the Herman and
 Claire Bloom Collection," Heard Museum, Phoenix

Richard M. Howard Collection

COLLECTIONS: Museum of Northern Arizona, black on red bowl, #E6130, 1973;
Heard Museum, Phoenix, AZ, bowl, #3576-203; bowl, #NA-SW-HO-A7-166, ca 1980.
VALUES: On October 15, 1993, black on red bowl, ca. 1940, prayer feather designs
(4 x 6"), est. $75-150, sold for $125, at Munn, #352.
PUBLICATIONS: Allen 1984:116; Gaede 1977:18-21; Bassman 1997:78
BIOGRAPHICAL DATABASES: "Hopi-Tewa Potters," Native American Resource
Collection, Heard Museum, Phoenix; "Artist Database," Museum of Indian Arts &
Cultures, Santa Fe.

Vernita Sakeva

(Hopi, Sichomovi)
FAMILY: Wife of Alfonso Sakeva;
daughter-in-law of Beth Sakeva. See
Tewa Kachina-Parrot Clan Extended
Family Tree Chart.

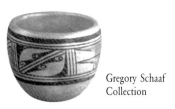

Gregory Schaaf
Collection

Alice Sakiestewa

(Hopi, Kykotsmovi, active 1900-1930: plainware bowls)
COLLECTIONS: Museum of Northern Arizona, plainware bowl, #E2206, 1960.
PUBLICATIONS: Allen 1984:112

Se-Kya-Chee

(Hopi)

Ethel Salyah

(signed Ethel or Salyah)
(Tewa, active 1920-1930: black & red on yellow jars; black on red jars, tulip
vases, cylinder jars)
FAMILY: Wife of Wilfred Salyah; mother of Vivian (b. 1932)
FAVORITE DESIGNS: Parrots, rain
PUBLICATIONS: Walker & Wyckoff 1983:107, 113, 118-119

Parts of Ethel Salyah's biography are recorded in Walker & Wyckoff's *Hopis, Tewas and the American Road*. The book was inspired by the Hopi-Tewa pottery collected by Mrs. Carey Melville in the 1920s and 1930s.

Ethel was a member of the First Mesa Baptist Church at Polacca. She was joined by four other potters: Lucy, Ethel Ruth Takala and Sellie.

Ethel and Wilfred wrote letters in the 1890s to collector Mrs. Carey Mellville and Mrs. Alfred S. Arnold. In a letter to the latter in August 1934, Ethel wrote of her family and the drought they were suffering. Mrs. Mellville and Ethel often exchanged gifts and photographs. A photograph of Ethel appears on page 25 in Walker & Wyckoff. She is dressed in a cloth dress with a long calico blouse. She holds two redware cylinder vases. Her hair is done in old Hopi-style side curls.

Alice Seabiyestewa

(Hopi, Kykotsmovi, active 1960-1970: black and red on yellow bowls)
COLLECTIONS: Museum of Northern Arizona, black and red on yellow bowl,
#E2220, 1961.
PUBLICATIONS: Allen 1984:112

Janey Seechoma

(Hopi, Roadrunner, Sichomovi, active 1940-1960: ladles)
VALUES: On June 5, 1992, signed Janey Seechoma, ladle, parrot design, ca. 1950 (8 x
4"), est. $60-125, sold for $70 at Munn, #383.

Kate Seeni

(Hopi, Walpi, active 1920-60: black on red jars, black and red on yellow jars, black on yellow bowls, plainware jars, unfired jars)
COLLECTIONS: Museum of Northern Arizona, unfired jar, #OC400, 1931; plainware jar, #E443, 1930; plainware jar, #E443, 1930; black and red on yellow jar, #E519, 1939; black on red jar, #E972, 1948; black on yellow bowl, #E5419, 1955.
PUBLICATIONS: Allen 1984:102, 107, 116

Sekayumka

(Hopi, Moencopi, active 1800-1850: plainware jars)
COLLECTIONS: Museum of Northern Arizona, plainware jar, #E5369, 1800-1850.
PUBLICATIONS: Allen 1984:115

Sekayuma is the oldest known Hopi potter found in my research. In the Museum of Northern Arizona, this is the only potter represented from Moencopi, a community connected to Old Oraibi, their "Mother Village."

Selly

(also Sully)
(active 1920-1930)
PUBLICATIONS: Walker & Wyckoff 1983:128, 132, 134

Edna Sequi

(Tewa, Polacca, active 1960-1970: black jars)
COLLECTIONS: Museum of Northern Arizona, black jar, #E3180, 1964.
PUBLICATIONS: Allen 1984:113

Mrs. Sequoptewa

(Hopi, Hotevilla, active 1930-1940: plainware bowls, ladles)
COLLECTIONS: Museum of Northern Arizona, plainware bowl, #E200a, 1936; plainware bowl, #200b, 1936; plainware bowl, #200c, 1936; 3 ladles, #200d,e,f, 1933.
PUBLICATIONS: Allen 1984:106

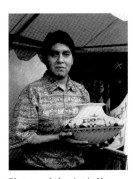

Photograph by Angie Yan

Dee Johnson Setalla

(Hopi, Bear Clan Mishongnovi, active 1970-present)
BORN: July 17, 1963
FAMILY: Son of Justin and Pauline Setalla. See Frog Woman-Feather Woman Family Tree Chart.
TEACHERS: Pauline Setalla (mother) and Eunice "Fawn" Navasie (father's sister)
AWARDS: 1st Place, Traditional Hopi Pottery Jar, "Indian Market," (August 1997), Santa Fe, NM; Merit Award, "Rez Art Show" (February 1998), Scottsdale Community College, Scottsdale, AZ; 3rd Place & Honorable Mention, "Hopi Show" (1998), Museum of Northern Arizona, Flagstaff, AZ; Honorable Mention, "Indian Market," (August 1998), Santa Fe.
EXHIBITIONS:
　　1993　"All Potters Show," Arizona State University, Tuscon, AZ

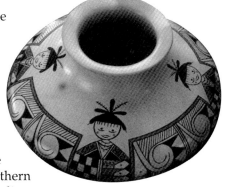

Photograph by Angie Yan

"Hopi Arts and Crafts Show," (September 10), Second Mesa, AZ
1994 Coconino Center for the Arts (July), Flagstaff, AZ
1995 "Festival of Native American Arts," (November 25-26), Flagstaff, AZ
1996 "Santo Domingo Pueblo Indian Arts & Crafts Market," (Aug 31-Sept. 2)
 "Pueblo Grande Show," (December), Phoenix, AZ
1997 "Indian Market," (August), Santa Fe, NM
 "Southwest Indian Arts Festival," SWAIA (October 25-26), Albuquerque
 "Pueblo Grande Invitational Indian Market," (December 12-14), Phoenix
1998 "Sixth Annual Native American Festival," (Jan. 17-18), Litchfield Park, AZ
 "Indian Market," (August), Santa Fe, NM

FAVORITE DESIGNS: Birds, moths, butterflies, bear claws, clouds, rain (from father's Water Clan)
PUBLICATIONS: Dillingham 1994:60-61

"I pray each morning with corn meal," Dee Johnson Setalla began explaining his spiritual approach to pottery making. "You must be very grateful for the clay and pottery....When we dig clay, we leave food there. You can't be greedy and not leave anything."

We met Dee at the 1998 Santa Fe "Indian Market," clustered under his awning, as a summer rain shower faded. He spoke kindly about his nine other brothers and sisters, praising their mother, Pauline Setalla, and his father's sister, Aunt Eunice "Fawn" Navasie. He shared their philosophy, "When working with the clay, it's like you're bringing it to life. You must treat it with respect. You treat it like you are raising a child, and guide it through the growing stages. It's not just steps out of tradition, but a personal nurturing as well."

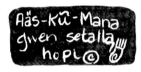

Gwen Sharon Setalla

(Aäs-Ku-Mana, "Mustard Juice Girl," Heck-Pah-Tahwee, "Blue Spruce Song," Bear Paw hallmark)
(Hopi, Bear Clan, Mishongnovi, active 1985-present: seed jars, plates, canteens)
BORN: November 17, 1964
FAMILY: Granddaughter of Roscoe Navasie, Agnes Navasie and Josephine Setalla; niece of Eunice Navasie and Perry Navasie; daughter of Justin and Pauline Setalla. See Frog Woman-Feather Woman Family Tree Chart.
EDUCATION: 1971-1979, Keams Canyon Boarding School, Kindergarten-8th (Valedictorian); 1980-1983, Sherman Indian High School, Riverside, California (Valedictorian); 1985-1987, Southwestern Indian Polytechnic Institute (SIPI), Albuquerque, New Mexico. Majored in data processing, earning certification.
TEACHER: Pauline Setalla, mother
STUDENTS: Garreth Polingyumptewa and Michael Miller
PUBLICATIONS: Dillingham 1994:60-61

Gwen Setalla is a master potter. She makes some of the thinnest pottery at Hopi, along with Nona Naha. Her painting is very fine. Her polishing is smooth. Her finished pots are exceptional in quality and design. She also is among a small group of Hopi-Tewa potters who wrote a personal autobiographical statement:

"I was BORN to Justin and Pauline Setalla in the early winter morning of November 17, 1964. There are 10 children in the family, I was the 9th child. My father was BORN at Polacca, Arizona, in the village of Sichomovi...my mother at Second Mesa, Arizona in the village of Mishongnovi. Dad was raised on a ranch and farm in

Snowbird Canyon, which is approximately 3 miles from Keams Canyon, Arizona. Mom spent most of her childhood life at Mishongnovi.

"When they married, mom moved to the ranch in Snowbird. They lived in a traditional Hopi adobe home that was built by my grandfather, Roscoe Navasie, and my father. The home has no modern conveniences of today. A kerosene and Coleman lantern are used for light and a wood and coal stove for heating. They haul their drinking water from the family water well. My dad is a rancher, farmer, carpenter, laborer and a traditional doll carver, my mother a homemaker, gardener, Christian, and a potter.

"Most of my childhood life was spent on the ranch/farm. My chores included: helping in the kitchen, hauling drinking water from the water well (with buckets and jugs), helping with the ranch work and the farm work, and helping with other outdoor chores.

"I was taught the art of pottery by my mother, Pauline. She had learned how to make pottery by watching my paternal grandmothers, Agnes Navasie and Josephine Setalla, and Aunt Eunice Navasie. (All are now deceased.) I also had the opportunity to watch them work before they passed on.

"At the age of 5, I took interest in pottery. I would sit with my mother, as she was molding, and play with a little ball of clay. My first bowls were done by forming a ball of clay and pushing it up against my elbows or my knees. My mom would then shape them for me and complete the process for me. I continued to do pottery from that age.

"I gradually improved and progressed as the years went by, learning how to shape, sand and polish the pottery. I also had learned where to find the clay and how to make it. When I was 16 I began to paint my designs on my pottery and fire them myself. To do the whole process on my own was a real challenge - digging and making the clay, creating the pottery, shaping, sanding, polishing and painting my pottery.

"My first designs were basic. Most of my designs were just simple shapes. My painting was unsteady from the beginning, but as I practiced and painted more, I began to improve.

"I began to take my work seriously at 21, always wanting to experiment with new techniques and shapes of pottery. During the earlier part of 1993, I begin experimenting with engraving and protruding figures (side profile). I find these techniques to be enjoyable but they require a lot of patience. I continue to create different styles and shapes of pottery.

"When I am working with clay, I am always reminded of what my parents taught me as a child, 'When you create a pot (as with any kind of art), you bring it to life and breath life into it. Always treat it with respect, as you would your own child, and always be thankful for the wonderful talent and knowledge that the Heavenly Father, the Great Spirit, has blessed you with. Never take your work for granted and never abuse it or use in a greedy manner.'

"As I am creating my pottery, I say a silent prayer, giving thanks for my talent and also blessing the pottery, praying that it brings happiness to the person that purchases it or to whom it is given. I also pray that they find appreciation in it, just as I did in creating it.

Today, most of my designs consist of the Eagle, rain and water symbols (clouds, rain drops, snow flurries), the corn symbols,

and the Kokopelli. The Eagle is used to represent the breath of life and well-being. The feathers of an eagle are used in Hopi traditional practices.

"To the Hopi, corn is not only the traditional staff of life but also the symbol of spiritual food and welfare. The colors of the corn are significant: Yellow corn represents the North, Blue the West, Red the South and White the East.

"In addition, the Hopis also recognize two other points; the Sky and the Underworld represented by the Deep Purple and Grey Sweet corn. The Kokopelli is used to represent fertility and he was known to carry a sack of songs on his back along with various seeds that he distributed as he traveled on his journey throughout the Native Lands.

"I use the face of the Hopi Sun Kachina to represent the Sun, who we consider to be our Father. The rain and water symbols are used to represent the moisture and nourishment that we need in order to make plants and life grow. All my designs have some significant meaning.

"I sign my pottery with my Hopi name Aas-Ku-Mana, my English name, my tribal affiliation, and a Bear Paw with a water wave within the paw.

"I am very thankful that my grandparents and relatives had the patience to let me observe and learn from them. Most of all I am grateful for my parents constant guidance and encouragement. They are always encouraging me to improve and make my artwork better. To my mother, Pauline Setalla, I am most thankful. She has taught me the art of Hopi Traditional Pottery and will always remain to be "MY GREATEST TEACHER."

"Those who have given me the opportunity to observe and learn from them include: my Godmother Rainy Naha, children of Eunice Navasie (Fawn Navasie-Garcia, Dolly "White Swann Navasie-Joe) and children and grandchildren of the famous potter Joy "Frog Woman" Navasie. (Frog Woman is married to my father's older brother Perry Navasie.)

"[My favorite past-times include: cross-country running (1978-1983). I participated in many 1OK foot races (1984-1992). During the winter months I participated in the Hopi Basket Dance races. These races consisted of running approximately 5-6 miles, running up the village on trails to where the dance was taking place. (My father was also a runner when he was a young boy.) Basketball (1978-1983), volleyball (1979-1983), and making pottery are also some of my favorite pastimes.

"Most of my leisure time is spent with my two children, Garreth Polingyumptewa and Michael Miller. I am also teaching them the art of traditional Hopi pottery."

151

Karen Setalla

(Hopi, Bear Clan, Mishongnovi, active 1975-present)
PUBLICATIONS: Dillingham 1994:60-61

Pauline Navasie Setalla

(Bear Paw & Hopi Stone House with Ladder Hallmark)

(First Mesa, active 1954-present: black & red on white, jars, wedding vases, black & red on yellow canteens)
FAMILY: Daughter of Amelia Talasyousie. See Frog Woman-Feather Woman Family Tree Chart.
FAVORITE DESIGNS: Parrot wing and tail feathers, feathers, bird tracks, spiral Water Clan, clouds

Pauline Setalla pots are noted for strong, bold designs, excellent painting quality, stippled shading and a beautiful clay that fires in warm shades from yellow to orange. Her forms are well balanced, elegant in shape. The symmetry of her pots reflect technical skill and confidence.

Courtesy of
Susan Latham Collection

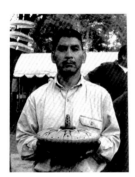

Photograph by Angie Yan

Stetson Setalla

(Hopi, Bear Clan, Mishongnovi, active 1980-present)
BORN: 1962
FAMILY: Grandson of Roscoe Navasie, Agnes Navasie and Josephine Setalla; nephew of Eunice Navasie and Perry Navasie; son of Justin and Pauline Setalla; brother of Gwen Setalla, Agnes Nahsonhoya, Dee Setalla, Justina Setalla and Karen Namoki.
PUBLICATIONS: Dillingham 1994:60-61
BIOGRAPHICAL DATABASES: "Hopi-Tewa Potters," Native American Resource Collection, Heard Museum, Phoenix; "Artist Database," Museum of Indian Arts & Cultures, Santa Fe.

Stetson Setalla is one of the few Hopi potters from Second Mesa. He wrote his own biographical statement.

"My name is Stetson M. Setalla, I am 36 years old and enrolled with the Village of Sichomovi, which is one of the three villages known as First Mesa (Polacca). My father, Justin Setalla, is from Sichomovi village and my mother, Pauline Setalla, is from Mishongnovi Village (Second Mesa), however, my parents raised myself and nine siblings in the Keams Canyon area known as Snowbird Canyon.

I was only 19 years old when I began the art of pottery which was right after I graduated from high school. My mother was my mentor and she did an excellent job because without her patience, guidance and love, I would not be where I am today. I have now been in the pottery business for the past 16 years and although it started out as a hobby, I find it has

Photograph by Angie Yan

152

become my main source of income, but most important, it gives me a sense of serenity, self-worth, pride and inner peace with my soul. I also work as a seasonal fire fighter with the Coconino Forest Service which keeps me busy during the summer months, but I enjoy the hard work that goes with the job and when I return home, I am anxious to sit down with my clay to be within myself once again.

As I work on my pots, I clear my mind of all bad thoughts by concentrating and praying to my clay. Good thoughts and a good heart are essential in working with your clay because you are creating yourself in each pot as you coil and when you are ready to paint the pot, a clear mind and good heart is crucial in assisting you with your painting because the designs flow through your mind into your hand and onto your pot without difficulty.

My pottery making is mentioned in Rick Dillingham's book, *Fourteen Families in Pueblo Pottery."*

Courtesy of Tom Tallant, Canyon Country Originals, http://www.canyonart.com/

Mary Seymour
(active 1990-present)

Ethelyn Sahmea
(Navajo, Lower Polacca, active 1990)
FAMILY: Wife of Harold Sahmea

Lorraine Shula
(Hopi, Eagle Clan, Walpi/Tewa Village, active 1960-1970: ladles, wall sconce, miniature animals)
COLLECTIONS: Museum of Northern Arizona, ladle, #E2488, 1962; 2 miniature animals, #E5112a,b, 1970.
PUBLICATIONS: Allen 1984:112, 115; Hayes & Blom 1996:68-75

Vivian Shula
(see Vivian Muchua)

Hazel Shupla
(Feather hallmark)
(Tewa, Kachina/Parrot Clan, active 1980)
FAMILY: See Tewa Kachina/Parrot Clan - Extended Family Tree Chart.

Irene Gilbert Shupla
(Flower- Peach hallmark)
(Tewa, Kachina/Parrot Clan, active 1930-1980: black and red on yellow jars)
COLLECTIONS: Museum of Northern Arizona, black and red on yellow jar, #E518, 1938.
FAMILY: See Tewa Kachina/Parrot Clan - Extended Family Tree Chart.
VALUES: On February 1, 1991, signed Irene Shupla, polychrome jar, double parrot & rain designs, ca. 1965 (9 x 8"), sold for $275 at Munn, #864A.

On March 22, 1985, signed, polychrome jar, bird design, ca. 1954 (5 x 7"), sold for $100 at Allard, #403.
PUBLICATIONS: Allen 1984:108

Siayowsi
(First Mesa, active 1920-1930: black and red on yellow jars)
COLLECTIONS: Museum of Northern Arizona, black and red on yellow jar, #E434, 1922.
PUBLICATIONS: Allen 1984:107

Annetta Silas
(Anetta Silas)
(Hopi, Wild Mustard Clan, Sichomovi, active 1930-1990: black on yellow and black on red bowls, jars, ladles)
LIFESPAN: (ca. 1915-1990)
FAMILY: Wife of Tom Silas; mother of Matthew Silas, Sr., Gertrude Adams, Albert Silas, Rudene Silas, Zora Polinyama, Burke Silas and Hattie Navajo
FAVORITE DESIGNS: Thunderbirds
VALUES: On June 3, 1994, black on red bowl (3 x 5"), est. $40-80, sold for $27.50, at Munn, #586.
On March 26, 1993, signed, bowl, migration design, ca. 1950 (3 x 8"), est. $175-350, sold for $137.50 at Allard, #327.
On October 4, 1991, signed, redware ladle, geometric designs, ca. 1980 (6"), est. $35-70, sold for $35 at Munn, #794.

Antoinette Silas
(Tewa/Laguna, Kachina Clan, Polacca, active 1990-present: wedding vases)
FAMILY: Daughter of Roberta Silas; sister of Louann Silas, Venora Silas and Jofern Silas Puffer
FAVORITE DESIGNS: complex compositions of parrot tail feather, prayer feather, scroll, parrot's beak, rain clouds, kiva steps
PUBLICATIONS: Hayes & Blom 1996:74-75

Charlotte Silas
(Hopi, Hotevilla, active 1970: miniature canteens)
COLLECTIONS: Museum of Northern Arizona, miniature canteen, #E5093, 1970.
PUBLICATIONS: Allen 1984:115

Hattie Silas
(Hopi, active 1990-present)

Joy Silas
(Hopi, Polacca)

Gregory Schaaf
Collection

Jofern Silas
(see Jofern Silas Puffer)

Louann Silas
(Tewa/Laguna, Kachina Clan, Polacca, active 1990-present: polychrome miniatures)
FAMILY: Daughter of Roberta Silas; sister of Antoinette Silas, Venora Silas, and Jofern Silas Puffer

ROBERTA YOUVELLA SILAS LAGUNA TEWA *(handwritten)*

Roberta Silas

(Tewa/Laguna, Kachina Clan, Polacca, active 1960-1981+: black & red on yellow cylinder vases, black on red bowls, jars, piki bowls)

FAMILY: Mother of Antoinette Silas, Venora Silas, and Louann Silas and Jofern Silas Puffer

FAVORITE DESIGNS: Bands of Sikyatki designs: parrots, lightning, clouds, feathers,

VALUES: On July 8, 1994, a polychrome cylinder vase, ca. 1960 (5 x 4"), est. $100-200, sold for $60.50 at Munn, #W2.

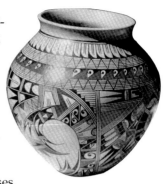

Challis & Arch Thiessen
Collection

On June 3, 1994, black & red on yellow cylinder vases, cloud & prayer feather designs (5.5 x 4.5"), est. $150-300, sold for $55, at Munn, #355.

On February 4, 1994, black on red bowl (3 x 6"), est. $75-150, sold for $80, at Munn, #219.

On January 31, 1992, signed, black on red jar, ca. 1960, Provenance: Joan Drackert Estate (7 x 6"), est. $100-200, [need sales result] at Munn, #18.

On March 20, 1987, signed, jar, ca. 1975 (3 x 3.5"), est. $20-40, sold for $15 at Allard, #559.

Venora Silas

(Tewa/Laguna, Kachina Clan, Polacca, active 1990-present: black & red on white jars)

FAMILY: Daughter of Roberta Silas; sister of Louann Silas, Antoinette Silas and Jofern Silas Puffer

Sinimpka

(Hopi, Hotevilla, active 1930-1950: plainware jars)

COLLECTIONS: Museum of Northern Arizona, plainware jar, #E559, 1939; plainware jar, #E699, 1942.

PUBLICATIONS: Allen 1984:108

Siwirinepnina

(Hopi, Hotevilla, active 1930-1940: piki bowls)

COLLECTIONS: Museum of Northern Arizona, piki bowl, #E555, 1939.

PUBLICATIONS: Allen 1984:108

Marjorie Smiley

(active 1970: bowls)

VALUES: On March 13, 1998, a polychrome bowl (2 x 5"), ca. 1970, est. $35-70, sold for $38.50, at Allard, #1223.

Snake hallmark

(active 1950: bird effigy bowls)

VALUES: On March 26, 1982, signed, polychrome bird effigy bowl, ca. 1950 (3 x 9.5"), sold for $100 at Allard, #657.

Mrs. Solo

(Tewa, Tewa Village, active 1930-1940: black and red on yellow jars)

COLLECTIONS: Museum of Northern Arizona, black and red on yellow jar, #E515, 1939.

PUBLICATIONS: Allen 1984:108

Annette Suha

(active 1960-1970)
VALUES: In 1995, a seed jar (2.5 x 4.5" dia.), est. $25-45, sold for $35 at Munn October 1995:19, #180.

Marian Sulu

(see Marian Sulu Tewaginema)

Marietta Sulu

(signs MS)
(active 1970)

Rebecca Sulu

(Tewa, Tewa Village, active 1940-1950: plainware jars)
COLLECTIONS: Museum of Northern Arizona, plainware jar, #E1004, 1950.
PUBLICATIONS: Allen 1984:110

R. (or P.) Sumatzkuhu

(active 1990-present: polychrome vases)
FAVORITE DESIGNS: beautifully painted Kachinas

Sun Clan hallmark

(active 1970: canteens)
VALUES: On June 5, 1992, signed, canteen with cloud designs, ca. 1970 (4 x 5"), est. $75-150, sold for $35 at Munn, #513

Frank Kinsel Collection

Sunflower hallmark

(Black and red on yellow vases)
FAVORITE DESIGNS: Thunderbirds

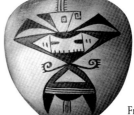

Frank Kinsel Collection

Susie's Mother

(Hopi, Oraibi, active 1900-1910: scoops)
COLLECTIONS: Museum of Northern Arizona, scoop, #OC1109, 1900-1910
PUBLICATIONS: Allen 1984:104

Susie's Grandmother

(Hopi, Oraibi, active 1880: plainware bowls)
COLLECTIONS: Museum of Northern Arizona, plainware bowl, #OC1159, 1880.
PUBLICATIONS: Allen 1984:105

M.T.

(active 1950: large storage pots)
VALUES: On March 26, 1982, signed, large storage pot, ca. 1950, sold for $75 at Allard, #189.

Tadpole hallmark
(see Lana David)

Emma Tayamana
(Tagsmana)
(Hopi, Walpi, active 1930-1940: ladles)
COLLECTIONS: Museum of Northern Arizona, ladle, #E517, 1939.
PUBLICATIONS: Allen 1984:108

Alma Chapella Tahbo
(Tewa, Bear Clan, active 1930-1993)
LIFESPAN: (1915-1993)
FAMILY: Grandmother of Mark Tahbo; daughter of Grace Chapella and Tom Pavatea; wife of Olson Tahbo; mother of Deanna Tahbo. See Tewa Bear, Sand and Spider Clan Family Tree Chart.
VALUES: On June 3, 1994, black & red on yellow jar, butterfly, parrot, rectangular spirals designs (3.5 x 3"), est. $125-250, sold for $110, at Munn, #637.
PUBLICATIONS: Dillingham 1994:2-3
BIOGRAPHICAL DATABASES: "Hopi-Tewa Potters," Native American Resource Collection, Heard Museum, Phoenix; "Artist Database," Museum of Indian Arts & Cultures, Santa Fe.

Deanna Tahbo
(Deanna Lomahquahu-Sakiestewa)
(Tewa, Bear Clan, active 1960-present)
BORN: 1941
FAMILY: Granddaughter of Grace Chapella, daughter of Alma Tahbo; mother of Olson Lomaquahu, Colleen Lomaquahu and Althea Lomaquahu; aunt of Dianna Tahbo and Mark Tahbo. See Tewa Bear, Sand and Spider Clan Family Tree Chart.
BIOGRAPHICAL DATABASES: "Hopi-Tewa Potters," Native American Resource Collection, Heard Museum, Phoenix; "Artist Database," Museum of Indian Arts & Cultures, Santa Fe.

Photograph by Tom Tallant.
Courtesy of
Canyon Country Originals,
http://www.canyonart.com/

Dianna Tahbo
(also Diane Tahbo)
(Tewa, Spider Clan, Tewa Village/Polacca, active 1980-present: polychrome plates, jars, bowls)
BORN: (1941-)
FAMILY: Great-granddaughter of Grace Chapella, granddaughter of Alma Tahbo, daughter of Ramon Tahbo; sister of Mark Tahbo. See Tewa Bear, Sand and Spider Clan Family Tree Chart.
FAVORITE DESIGNS: Butterflies
PUBLICATIONS: Dillingham 1994:2-3; Hayes & Blom 1996:74-75

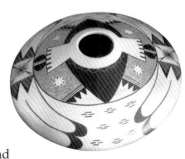

Photograph by Bill Bonebrake.
Courtesy of Jill Giller,
Native American Collections,
Denver, CO

Richard M. Howard Collection

157

Photograph by Tom Tallant.
Courtesy of
Canyon Country Originals,
http://www.canyonart.com/

Mark Tahbo

(Tewa, Spider Clan, active 1978-present: black and
red on yellow jars)
LIFESPAN: (1958-)
FAMILY: Great-grandson of Grace Chapella; grand-
son of Alma Tahbo; son of Ramon Tahbo; brother of
Dianna Tahbo-Howato. See Tewa Bear, Sand and Spider
Clan Family Tree Chart.
FAVORITE DESIGNS: Double headed birds, Nachwach-
clan handshake, rain clouds, moths, flowers
COLLECTIONS: Heard Museum, Phoenix, AZ, jar, #NA-
SW-HO-A7-179, 1991.
EXHIBITIONS:
 1998 "Heard Museum Guild 40th Annual Indian Fair
 & Market," Heard Museum, Phoenix
AWARDS: First Place and Overall Prize, SWAIA,
Indian Market, Santa Fe, NM., 1991; Best of
Division, "34th Annual Heard Museum Guild
Indian Fair and market, Heard Museum,
Phoenix, 1992; Third Place, SWAIA,
Indian Market, Santa Fe, NM., 1992; First
and Third Place, SWAIA, Indian Market,
Santa Fe, NM., 1993; Best of Division, Judge's
Choice Award, "Heard Museum guild 40th Annual Indian
Fair & Market," Heard Museum
PUBLICATIONS: Dillingham 1994:14-15; Hayes & Blom 1996:74-75
 BIOGRAPHICAL DATABASES: "Hopi-Tewa Potters," Native American
Resource Collection, Heard Museum, Phoenix; "Artist Database," Museum of Indian
Arts & Cultures, Santa Fe.

Photograph by Bill Bonebrake.
Courtesy of Jill Giller,
Native American Collections,
Denver, CO

Photograph by
Richard M. Howard

Richard M. Howard
Collection

Ruth Takala

(active 1920-1930: black & red on yellow jars; black & white on red cylinder
jars; black on white ware bowls and jars)
FAMILY: Daughter of Judge Hooker (Hongavi) and Sehepmana; wife of Takala
COLLECTIONS: Carey Melville
PUBLICATIONS: Walker & Wyckoff 1983:107, 117, 131

Parts of Ruth Takala's biography are recorded in Walker &
Wyckoff's *Hopis, Tewas and the American Road*. The book was
inspired by the Hopi-Tewa pottery collected by Mrs. Carey
Melville in the 1920s and 1930s.
 Ruth was a member of the First Mesa Baptist Church at
Polacca. She was joined by four other potters: Lucy, Ethel Salyah and
Sellie. Ruth's husband, Takala, was a deacon of the church. He
encouraged Ruth to join.

Nannie Talahongva

(N. Talahongva)
(Tewa, Tewa Village, active 1965-1990: black on red cylinder jars, tiles)
COLLECTIONS: Museum of Northern Arizona, black on red jar, #E8765, 1980
FAVORITE DESIGNS: eagles, parrots, snakes, rain clouds, tadpoles, prayer feathers
VALUES: On March 17, 1978, a round tile, bird design, ca. 1965, did not reach
reserve, at Allard, #476.
PUBLICATIONS: Allen 1984:122

Caroline Talas
(Hopi)

Ella Mae Talashie
(Hopi, Walpi, active 1970-present: black on red bowls)
COLLECTIONS: Museum of Northern Arizona, black and red on yellow bowl, #E5778, 1972; black on red bowl, #E5964, 1973.
PUBLICATIONS: Allen 1984:116

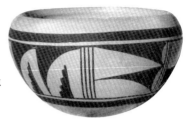

Gregory Schaaf Collection

Rachel Sahmie Talashie
(See Rachel Sahmie)

Talashoynum
(Hopi, Oraibi, active 1850-1860: plainware jars)
COLLECTIONS: Museum of Northern Arizona, plainware jar, #OC1149, 1855; plainware jar, #OC1150, 1854.
PUBLICATIONS: Allen 1984:104-105,

Rosalie, Rosie Talasie or Talashie
(Hopi, Sichomovi Village, active 1930-1970: black on yellow bowls)
COLLECTIONS: Museum of Northern Arizona, black on yellow bowl, #E3458, 1967.
PUBLICATIONS: Allen 1984:114

Caroline Talayumptewa or Talyemtewa
(Polacca, active 1959-1981+: turtle effigies)
COLLECTIONS: Museum of Northern Arizona, 2 turtles, #E3853a,b, 1968.
PUBLICATIONS: Allen 1984:114

Laura Tamosie
(see Laura Chapella Tomosie)

Irma Tawyesva
(Hopi, Roadrunner Clan, Sichomovi, active 1970-1980: miniature canteens)
LIFESPAN: (- before 1998)
COLLECTIONS: Museum of Northern Arizona, miniature canteen, #E7803, 1977.
PUBLICATIONS: Allen 1984:121

Mabel Tcosytiwa's mother
(Hopi, Hotevilla, active 1920-1930: redware bowls)
COLLECTIONS: Museum of Northern Arizona, redware bowl, #OC1108, 1928.
PUBLICATIONS: Allen 1984:104

Chakop Tewa
(Believed to be a non-Indian producing replicas of large Sikyatki style jars.)

Rondina Tewa
(see Rondina Huma)

Marian Sulu Tewaginema
(Hopi, Sichomovi Village, active 1960-1980: effigy bowls, teapots with lids, cups and saucers)
COLLECTIONS: Museum of Northern Arizona, effigy bowl, #E4159, 1969; teapot with lid, #E6196a,b, 1973; cup and saucer, #E6197a,b, 1973.
PUBLICATIONS: Allen 1984:114, 116

Elton Tewayguna
(Tewa/Hopi, Corn Clan, active 1970-present)
BORN: 1953
FAMILY: Son of Richard and Elva Tewaguna Nampeyo; brother of Adelle Lalo Nampeyo, Miriam Tewaguna Nampeyo and Neva Polacca Choyou Nampeyo
PUBLICATIONS: Dillingham 1994:14-15

Marjorie Tewayguna
(active 1940: shallow oval bowls)
VALUES: On March 22, 1996, signed, shallow oval bowl, ca. 1940 (2. x 6"), est. $50-100, sold for $55 at Allard, #793.

Tewanginema
(Hopi, Sichomovi, active 1900-1940: bowls and jars in the following styles: black on red, black and white on red, black on yellow, black and red on yellow, double jars, piki bowls)
COLLECTIONS: Museum of Northern Arizona, black on red bowl, #E199, 1933; double jar, #E304, 1937; black and red on yellow bowl, #E427, 1938; black on yellow bowl, #E450, 1938; black on yellow bowl, #E522, 1939; black on yellow bowl, #E553, 1939; black and white on red bowl, #E1412, 1900-1933; piki bowl, #1414, 1933.
PUBLICATIONS: Allen 1984:106-108, 111

Tewavensi
(Hopi, Hotevilla, active 1930-1940: yellow jars, plainware jars, canteens)
COLLECTIONS: Museum of Northern Arizona, plainware jar, #E29, 1938; yellow jar, #E456, 1932; canteen, #E481, 1935; canteen, #E483, 1935; canteen, #E484, 1933.
PUBLICATIONS: Allen 1984:108

Doris Tewayqua
(active 1970-1980: canteens)
VALUES: On January 31, 1992, signed, canteen, parrot design, ca. 1980, Provenance: Joan Drackert Estate (8 x 9"), est. $300-500, [need sales result] at Munn, #1037.

Laura N. Timi
(active 1940-1950: polychrome bowls)
VALUES: On February 5, 1993, polychrome bowl, ca. 1940, center-bachelor or bird blanket checkerboard, four directions, Zuni-style spiral designs (6 x 14"), est. $500-1,000, sold for $550 at Munn, #641.

Laura Timothy
(Tewa, Tewa Village, active 1930-1940: black and red on yellow jars)
COLLECTIONS: Museum of Northern Arizona, black and red on yellow jar, #E437, 1936.
PUBLICATIONS: Allen 1984:107

Ella Tiwa
(Tewa, Sichomovi Village, active 1930-1955: black and red on yellow bowls, stew bowls)
COLLECTIONS: Museum of Northern Arizona, stew bowl, #E439, 1935; 3 black and red on yellow bowls, #E5223, 2227, 2228, 1954.
PUBLICATIONS: Allen 1984:107, 115

New Tobacco
(active 1940: black and red on yellow vases)
FAVORITE DESIGNS: parrots
VALUES: On May 19, 1995, black and red on yellow vase, parrot design, ca. 1940 (6.5 x 6"), est. $250-350, sold for $275 at Munn, #300A.

Donella Tom
(Tewa, Corn Clan, Polacca, active 1990-present)
LIFESPAN: (1972-)
FAMILY: Great-great-great granddaughter of Nampeyo, great-great granddaughter of Annie Healing, great-granddaughter of Rachel Nampeyo, granddaughter of Priscilla Nampeyo, daughter of Jean Sahme
PUBLICATIONS: Dillingham 1994:14-15
BIOGRAPHICAL DATABASES: "Hopi-Tewa Potters," Native American Resource Collection, Heard Museum, Phoenix; "Artist Database," Museum of Indian Arts & Cultures, Santa Fe.

Laura Chapella Tomosie
(also signs L. Tomosie, Laura Tomasi, Laura Tomosi)
(Tewa, Bear Clan, Tewa Village, active 1930-1968: black and red on yellow jars and bowls, redware bowls, bowls with handles, tiles, ladles, miniature bowls)
LIFESPAN: (- ca. 1981)
FAMILY: Daughter of Poui & Toby White; sister of Mihpi Toby, Grace Chapella, Dalee & Bert Youvella; wife of Timothy Tomosie; adopted Edgar Tomosie. See Tewa Bear, Sand and Spider Clan Family Tree Chart.
FAVORITE DESIGNS: Thunderbirds, honey bees, clouds

Frank Kinsel Collection

COLLECTIONS: Museum of Northern Arizona, 6 tiles, #E1915-1921, 1964, tile, #E2493, 1962; black and red on yellow bowl, #E2642, 1963; black and red on yellow jar, #E3357, 1967; black and red on yellow bowl, #E3696, 1968; ladle, #E4158, 1969; tile, #E4164, 1969; miniature bowl, #E5099, 1970; redware bowls, #E7873, 1970; black and red on yellow jar with lid, #E78008a,b, 1959-1961; Heard Museum, Phoenix, AZ, jar, #NA-SW-HO-A7-89.

VALUES: On February 1, 1991, bowl with handle, ca. 1950 (7" h.), sold for $50 at Munn, #50.

On February 1, 1991, polychrome seed jar, thunderbird & honey bee designs, (4 x 7"), sold for $225 at Munn, #559.

PHOTOGRAPHS: Portrait (1960), neg. # 3083, Museum of Northern Arizona, Flagstaff

PUBLICATIONS: Allen 1984:111-114, 121.

BIOGRAPHICAL DATABASES: "Hopi-Tewa Potters," Native American Resource Collection, Heard Museum, Phoenix; "Artist Database," Museum of Indian Arts & Cultures, Santa Fe.

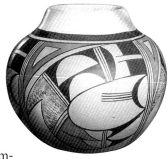

Richard M. Howard Collection

Laura Tomosie did not speak English. When collector Dick Howard used to buy pottery from her, they communicated by raising a number of fingers to determine the price.

Olive Toney
(Hopi, Walpi, Eagle Clan Mother: active 1940-present)
LIFESPAN: (1915?-present)
CAREER: She ran the Keams Canyon Motel for 20 years.
COLLECTIONS: Steve Gershenberg Collection, Los Angeles

Nellie Toopkema
(Hopi, Bacavi, active 1930-1960: plainware bowls)
COLLECTIONS: Museum of Northern Arizona, plainware bowl, #E2209, 1930-1960.
PUBLICATIONS: Allen 1984:111-112

Elizabeth Tootsie
(active 1970s)

Elmer Tootsie
(Hopi, active 1980s to present)

Jean Tootsie
(see Jean Sahme)

Fay Tray-wa
(Tewa, Tewa Village, active 1930-1940: stew bowls)
COLLECTIONS: Museum of Northern Arizona, stew bowl, #E461, 1930.
PUBLICATIONS: Allen 1984:108

Bertha Tungovia
(Tewa, Bear Clan)
LIFESPAN: (- before 1998)

Lena Turley
(Hopi, active 1980)

Tyvewynka

(Hopi, Shungopavi, active 1875-1900: stew bowls, plainware jars)
COLLECTIONS: Museum of Northern Arizona, stew bowl, #OC1015, 1895; plainware jar, #OC1061, 1892-1895; plainware jar, #OC1079, 1887-1890; plainware jar, #OC1114, 1875-1880.
PUBLICATIONS: Allen 1984:103-105

Marjorie S. Valdo

(Hopi/Acoma, active 1990-present)

Ergil Vallo

(Dalewepi)
(Hopi/Acoma, active 1990-present: unusual carved and engraved blackware with bright polychrome paint in the lines and carved areas)
FAVORITE DESIGNS: Mudheads, Kiva Steps, Terraced Clouds
PUBLICATIONS: Hayes & Blom 1996:172-173

Bertha Wadsworth

(Hopi, active 1970-present: pottery, also baskets,)

Elizabeth White

(Polingaysi Qöyawayma)
(Hopi, Kykotsmovi, active 1954-80: jars, clay sculptures, figurines, canteens, plainware, white bowls, wind chimes, mostly in white clay)
LIFESPAN: (1892-1990)
POTTERY TEACHER: Charles Loloma, who taught classes at Flagstaff and Sedona, after he came back from Alfred University.
COLLECTIONS: Museum of Northern Arizona, black and white on red bowl, #E1311, 1956; plainware bowl, #E1505, 1959; wind chime, #E3017, 1965; wind chime, #E4163, 1969; white jar, #E4166, 1969; 3 figurines, #E5048a,b,c, 1969; wind chime, #E5100, 1970; canteen, #E5234, 1961; wind chime, #E7472, 1968-1969; plainware bowl, #E8422, 1979; white bowl, #E8591, 1966.
VALUES: In 1997, a cream clay sculpture made as a wind chime (12.5 " height), acquired in 1978, est. $2,000-3,000, sold for $2,875 at Sotheby's December 4, 1997:#256.
PUBLICATIONS: Monthan 1975:176-185; Walker & Wyckoff 1983; Allen 1984:111; Trimble 1987:99; Bassman 1997:77

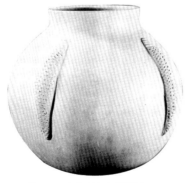

Photograph by Mark Middelton.
Courtesy of the Museum of Northern Arizona.
(neg. #77.0333)

"Elizabeth White, as an individual, is as impressive and singular as the beautiful pottery she creates. Her accomplishments and contributions to her people are heroic in their depth and diversity."
Monthan 1975:176-185

"Began her career as a potter when she retired from her first very successful career as a teacher in 1954. Ten years later she won an award for excellence from the United States Department of Interior. In searching for a style and technique she found a uniquely colored clay, which combined with her elegant and simple forms, contrasting color and texture became her hallmark. Elizabeth is now credited as being an inspiration to her nephew, Al Qöyawayma."
Sotheby's, December 4, 1997, Sale #7066, back pages.

White Corn
(Tewa, Tewa Village/Walpi, Corn Clan, active 1850-1909: seed jars, cooking pots, large storage bowls, water jars, piki bowls, cups and ladles)
LIFESPAN: (ca. 1830-1909)
FAMILY: Wife of Quootsva (ca. 1830-1899), mother of Tom Polacca (1849-1911), Kano (1854-), Patuntupi or Squash (1858-), and Nampeyo (1860-1942); grandmother of Dewey Healing, Annie Healing, Nellie Douma, Fannie Nampeyo, & Wesley Lesso. See Nampeyo Extended Family Tree Chart.
PUBLICATIONS: Yava 1978:132; Kramer 1996:7-11.

Tewa historian Albert Yava credits White Corn with helping to revive pottery making at First Mesa in the latter 19th century. Yava stated: "The fact is that pottery making tapered off to almost nothing here on First Mesa at one time, then it revived again...White Corn, a Tewa woman, was still making pottery when a lot of Hopi women had given it up."

White Swann
(see Dolly Joe Navasie)

Matilda Williams
(Sichomovi, active 1930-1940: black and red on yellow bowls)
COLLECTIONS: Museum of Northern Arizona, black and red on yellow bowl, #E612, 1940.
PUBLICATIONS: Allen 1984:108

Ada Yayetwea
(active 1970-present)
PUBLICATIONS: Barry 1984:81-88

Loretta Yeetewa
(active 1970: bowls)
VALUES: On November 10, 1989, signed, small bowl, ca. 1970 (2 x 3.5"), est. $30-60, sold for $30 at Allard, #1503.

Eve Yellow Bird
(Eva Yellow Bird)
(active 1940-1950: black and red on yellow vases)
FAVORITE DESIGNS: parrots, flowering plants, eagle tails, clouds
VALUES: On March 26, 1993, signed, large vase, parrot design, ca. 1950 (13 x 9"), est. $500-1,000, sold for $550 at Allard, #1162.
 On March 22, 1985, signed, black and red on yellow vase (sometimes called "umbrella stand,") flowering plant, eagle tail and cloud design, ca. 1945 (13 x 9"), sold for $350 at Allard, #751.

Yellow Flower
(see Joy Navasie)

Yellow Spider
(see Madeline Sahneyah)

Myrtle Luke Young
(Tewa/Hopi, Spider Clan, Tewa Village, active 1930-1980: black and red on yellow bowls, piki bowls)
LIFESPAN: (-February 1984)
FAMILY: Sister of Garnet Pavatea; mother of Harriet Nahsonhoya
EXHIBITIONS:
> 1997 "Recent Acquisitions from the Herman and Claire Bloom Collection," Heard Museum, Phoenix

COLLECTIONS: Museum of Northern Arizona, piki bowl, #E453, 1938; piki bowl, #E556, 1939, black and red on yellow, #1413, 1930-1957; piki bowl, #E6311, 1973; Heard Museum, Phoenix, AZ, bowl, #3576-143; piki bowl, #NA-SW-HO-A1-29. Photographs: Portrait (1960), neg. # 3078, Museum of Northern Arizona, Flagstaff
VALUES: On March 16, 1990, signed, polychrome stew bowl, cloud & rain design, ca. 1970 (5 X 14"), est. $450-900, sold for $735 at Allard, #181.
PUBLICATIONS: Allen 1984:107-108, 117; Barry 1984:81-88; Gault 1991:15
BIOGRAPHICAL DATABASES: "Hopi-Tewa Potters," Native American Resource Collection, Heard Museum, Phoenix; "Artist Database," Museum of Indian Arts & Cultures, Santa Fe.

Younga
(Hopi, Walpi, active 1930-1940: ladles)
COLLECTIONS: Museum of Northern Arizona, ladle, #E449, 1931.
PUBLICATIONS: Allen 1984:107

Charlene Youvella
(Charlene Clark)
(Tewa, Corn Clan, active 1985-present: appliquéed buffware jars)
LIFESPAN: (1969-)
FAMILY: Great-granddaughter of Nampeyo; Granddaughter of Fannie Nampeyo; daughter of Wallace Youvella Sr. and Iris Youvella Nampeyo; sister of Wallace Youvella, Jr., Nolan Youvella and Doran Youvella
PUBLICATIONS: Dillingham 1994:14-15
BIOGRAPHICAL DATABASES: "Hopi-Tewa Potters," Native American Resource Collection, Heard Museum, Phoenix; "Artist Database," Museum of Indian Arts & Cultures, Santa Fe.

Doran Youvella
(Doran Youvella Nampeyo)
(Tewa, Corn Clan, active 1990-present: appliquéed buffware jars)
BORN: 1982
FAMILY: Great-grandson of Nampeyo; Grandson of Fannie Nampeyo; son of Wallace Youvella Sr. and Iris Youvella Nampeyo; brother of Wallace Youvella, Jr., Nolan Youvella, and Charlene.
COLLECTIONS: Heard Museum, Phoenix, AZ, miniature jar, #3603-7, ca. 1996
PUBLICATIONS: Dillingham 1994:14-15
BIOGRAPHICAL DATABASES: "Hopi-Tewa Potters," Native American Resource Collection, Heard Museum, Phoenix; "Artist Database," Museum of Indian Arts & Cultures, Santa Fe.

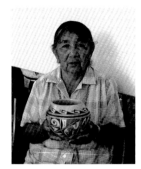

Ethel Youvella Tewa Polacca Ariz

Ethel Youvella

(Tewa, Sand Clan, Tewa Village/Polacca, active 1930-present: black and red on yellow jars, black on red bowls, black on yellow cylinder vases, also tiles, plates, turtles, bird effigy ash trays)
BORN: 1919
FAMILY: Granddaughter of Lela Augah and Preston Talavensi and "Poui" and Toby White, daughter of Bert Youvella and Belle Augah Humeunse; niece of Mihpi Toby, Laura Tomosie, Grace Chapella, "Dalee" Da Tse; sister of Roy Youvella, Charlie Youvella, Harry Youvella and Mildred Youvella (b. 1922); mother of Toby Grover, Verna (Grover) Nahee (b. 1940), Lee Grover, Crucita and Melford Youvella. See Tewa Bear, Sand & Spider Clan Family Tree Chart.
TEACHER: Lela Talavensi
STUDENTS: Verna Nahee, Neomi (Nahee) Laban.
AWARDS: NA-SW-HO-A6-11 winner: 3rd Premium, Indian Dept. Arizona State Fair class 168-233, 1968.
EXHIBITIONS: "Hopi Show," Museum of Northern Arizona
FAVORITE DESIGNS: clouds, feathers, Nachwach-clan handshake
COLLECTIONS: Museum of Northern Arizona, black on red bowl, #E3313, 1966; black and red on yellow jar, #E8788, 1972; Heard Museum, Phoenix, AZ, jar, #NA-SW-HO-A6-11.
PUBLICATIONS: Dillingham 1994:2-3; Bassman 1997:77
BIOGRAPHICAL DATABASES: "Hopi-Tewa Potters," Native American Resource Collection, Heard Museum, Phoenix; "Artist Database," Museum of Indian Arts & Cultures, Santa Fe.

Gregory Schaaf Collection

In March of 1998, I arrived atop First Mesa and was greeted by a young woman near the Visitor's Center. Along a stone window sill, she displayed Kachinas made by her husband and a single pot made by Ethel Youvella. She kindly guided me to Ethel's home.

I knocked on the door and was greeted by Ethel Youvella, a respected grandmother in her seventies. She invited me into her home where we sat down at the kitchen table. We visited for about an hour, having a pleasant conversation about her family relationships. She explained how she learned pottery making from her mother's mother, Lela Augahi. This grandmother helped her form her first little pots. Grace Chapella taught her how to make redware pottery. She enjoyed the company of her aunts, Grace and Laura Tomosie. They made pottery together.

Ethel explained the symbols on the black and red on yellow pottery jar that I acquired from her. "This is the eye of a bird [a dot inside a circle]. These are clouds [terraced], and this is a moving cloud [three horizontal lines attached to spiral]. The zig-zag lines are lightning. This is an eagle tail feather.

Ethel then opened up an unplugged refrigerator where she stores her pottery. "This one I have to re-fire. See the paint here," she said pointing to a tiny, almost invisible imperfection. "I have to go over it." Ethel Youvella is a perfectionist. I felt honored to meet this remarkable woman who has made pottery for almost seventy years with great care.

Iris Youvella
(see Iris Youvella Nampeyo)

Jean Youvella
(see Jean Sahme)

Mildred Youvella
(Tewa, Sand Clan, Tewa Village, active 1940-70: black & red on yellow bowls)
LIFESPAN: (1922-October 3, 1971)
FAMILY: Granddaughter of Lela Augah Preston Talavensi and "Poui" & Toby White, daughter of Bert Youvella and Belle Augah Humeunse; niece of Mihpi Toby, Laura Tomosie, Grace Chapella, "Dalee" Da Tse; sister of Roy Youvella, Charlie Youvella, Harry Youvella and Ethel Youvella; wife of Peter Nuvansa, Jr.; mother of Rethema Youvella. See Tewa Bear, Sand and Spider Clan Family Tree Chart.
TEACHER: Lela Talavensi
STUDENTS: Rethema Youvella
COLLECTIONS: Museum of Northern Arizona, black and red on yellow bowl, #E1003, 1950.
PUBLICATIONS: Allen 1984:110; Dillingham 1994:2-3

Nolan Youvella
(Tewa, Corn Clan, active 1985-present: appliquéed buffware jars)
LIFESPAN: (1970-)
FAMILY: Great grandson of Nampeyo; grandson of Fannie Nampeyo; son of Wallace Youvella Sr. and Iris Youvella Nampeyo; brother of Wallace Youvella, Jr., Charlene Youvella and Doran Youvella
PUBLICATIONS: Dillingham 1994:14-15; Hayes & Blom 1996:74-75
BIOGRAPHICAL DATABASES: "Hopi-Tewa Potters," Native American Resource Collection, Heard Museum, Phoenix; "Artist Database," Museum of Indian Arts & Cultures, Santa Fe.

Rethema Youvella
(Tewa/Hopi, Sand Clan, Tewa Village, active 1988-present: redware, buffware, polychrome tiles)
BORN: January 8, 1950 at Keams Canyon
FAMILY: Great-granddaughter of Lela Augah and Preston Talavensi and "Poui" and Toby White, granddaughter of Bert Youvella and Belle Augah Humeunse; great-niece of Mihpi Toby, Laura Tomosie, Grace Chapella, "Dalee" Da Tse; niece of Roy Youvella, Charlie Youvella, Harry Youvella and Ethel Youvella; daughter of Peter Navamsa, Jr. and Mildred Youvella; mother of Cynthia, Eugeneia, Melissa, Teresa. See Tewa Bear, Sand and Spider Clan Family Tree Chart.
EDUCATION: Hopi High School, Haskell College
TEACHER: Mildred Youvella
STUDENTS: Melissa
EXHIBITION: Museum of Northern Arizona
GALLERIES: Iskasokpu Gallery, Second Mesa, AZ

Rethema explains that she enjoys creating artworks, because it "clears my mind of day-to-day events. Molding pots takes you into deep thinking. Before you realize it, a unique shape has been formed...It makes time pass smoothly and quickly."

Rethema was especially helpful in editing the text of this book. She devoted over two hours to correcting tribal and clan identifications. Thank you.

Susie Maha Youvella

(Hopi, Kachina Clan, Sichomovi, active 1960-1990: polychrome wedding vases)
LIFESPAN: (-before 1998)
FAMILY: Mother of Wallace Youvella, mother-in-law of Iris Youvella Nampeyo
VALUES: On June 3, 1994, polychrome wedding vase, parrot wing designs (5 x 3"), est. $100-200, sold for $88, at Munn, #425.
　　On February 5, 1993, polychrome wedding vase, ca. 1990, parrot & Zuni-style water in the eddies designs (9 x 4"), est. $175-350, sold for $175 at Munn, #840.
PUBLICATIONS: Gaede 1977:18-21

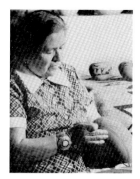

Photograph by Marc Gaede
Courtesy of the Museum of
Northern Arizona.
(neg. #77.0262)

Wallace Youvella, Jr.

(Tewa/Hopi, Corn Clan, active 1975-present: black & white on red jars, appliquéed and carved buffware jars)
LIFESPAN: (ca. 1960s)
FAMILY: Great grandson of Nampeyo; grandson of Fannie Nampeyo; son of Wallace Youvella Sr. and Iris Youvella Nampeyo; brother of Nolan Youvella, Charlene Youvella and Doran Youvella
FAVORITE DESIGNS: Kokopelli
PUBLICATIONS: Dillingham 1994:14-15; Gaede 1977:18-21

Courtesy of Southwest Auctioneers

BIOGRAPHICAL DATABASES: "Hopi-Tewa Potters," Native American Resource Collection, Heard Museum, Phoenix; "Artist Database," Museum of Indian Arts & Cultures, Santa Fe.

Photograph by Marc Gaede
Courtesy of the Museum of
Northern Arizona.
(neg. #77.0230)

Wallace Youvella, Sr.

(Hopi, Kachina Clan, Polacca, active 1976-present: buffware pottery and lithographs)
BORN: July 28, 1947
FAMILY: Son of Charlie Youvella and Susie Maha Youvella; husband of Iris Youvella Nampeyo; father of Wallace Youvella, Jr., Charlene Youvella, Nolan Youvella and Doren Youvella
EDUCATION: Polacca Day School, Hopi Day School, Phoenix Indian School
TEACHERS: He learned by watching his wife, Iris, as well as Susie Maha and Fannie Nampeyo.
STUDENTS: Wallace, Jr. and Nolan Youvella
PUBLICATIONS: Dillingham 1994:14-15

Ivy Youwyha

(Tewa, Tewa Village, Spider Clan, active 1925-1955: plainware bowls, piki bowls)
LIFESPAN: (ca. 1900-1955)
FAMILY: Daughter of Youwyha; mother of Harvey Sidney (b. 1925), Paul Sidney (b. 1927) and Herman Sidney (b. May 12, 1929); grandmother of Madeline Sahneyah; great-grandmother of Lynn, Ivy and Richie Sahneyah. Also related to Myrtle Young and Grace Chapella, both Spider Clan members.
STUDENTS: Madeline Sahneyah "Yellow Spider" (Tobacco Clan)

Jelma Zeena

(active 1960-1970: red & black on yellow stew bowls)
FAVORITE DESIGNS: parrots
VALUES: On June 3, 1994, black & red on yellow stew bowl, parrot designs (2 x 8"),
est. $75-150, sold for $71.50, at Munn, #420.

Josephine Zeena

(Sichomovi, active 1960-present)
BORN: ca. 1935
FAMILY: Wife of Ned Zeena

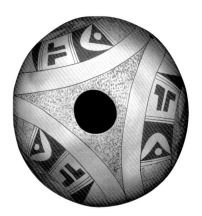

Colleen Poleahla, Polychrome Seed Jar
Dr. Neil and Dawna Chapman Collection

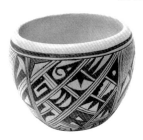

Ella Mae Talashie, Mosaic Design
Dr. Neil and Dawna Chapman Collection

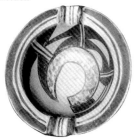

Cloud Design, Ashtray
Gregory Schaaf Collection

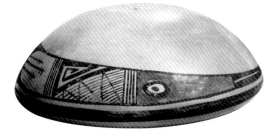

Sityakti Bird Design
Gregory Schaaf Collection

Appendix 1 _____

Chronology of Some Pottery Types found at Hopiland

1. Black Mesa Black-on-white (ca. 875-1130)

2. Tusayan Polychrome (ca. 1100-1300)

3. Tusayan Black-on-white (ca. 1125-1300)

4. Jeddito Black-on-yellow (ca. 1300-1625)

5. Sikyatki Polychrome (ca. 1375-1625)

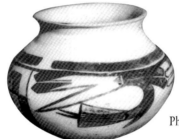

Photograph by Richard M. Howard

6. San Bernardo Polychrome (ca. 1625-1680)

7. Payapki Polychrome (ca. 1680-1780)

8. Polacca Polychrome (ca. 1780-1900)
 Style A (ca. 1780-1820)
 Style B (ca. 1820-1860)
 Style C (ca. 1860-1890)
 Style D (ca. 1890-1900)

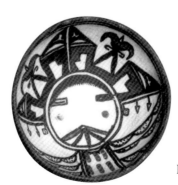 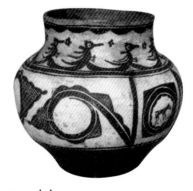

Photograph by
Richard M. Howard

9. Walpi Polychrome

10. Hano Polychrome/Sikyatki Revival Ware (c. 1890-present)
Black & Red on Yellow Ware (or Orange Ware)

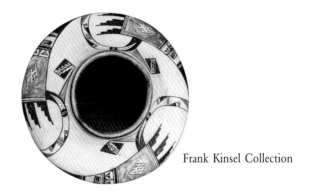

Frank Kinsel Collection

Nampeyo's Five Periods (see Kramer 1996:177188)
Period 1 (pre-1900) - generalized style
Period 2 (ca. 1900-1910) - improvising, more varied work
Period 3 (ca. 1910-1917) - fine workmanship, less improvising
Period 4 (ca. 1917-1930) - variations in shapes & surfaces
Period 5 (ca. 1930-1942) - large, flat-shouldered jars

11. Sichomovi Red Ware (ca. 1900-present)

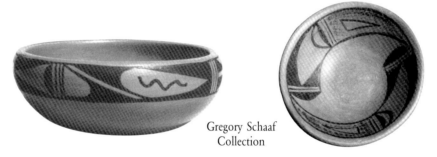

Gregory Schaaf
Collection

12. Sichomovi Polychrome (ca. 1900 -present)

13. Black on White Revival Ware (ca. 1925-present)

14. Black & Red on White Revival Ware (1925-present)

15. Buffware (ca. ?-present)

Appendix 2

DESIGNS IN HOPI-TEWA Pottery:
In English, Hopi and Tewa

(Recorded in the 1890's by Alexander Stephen...Gregory Schaaf, Field Notes, 1981-1998)

For Stephen's study explaining Hopi designs in detail, see Alex Patterson, *Hopi Pottery Symbols* (Johnson Books: Boulder, CO, 1994)

Top 100 Hopi Symbols: *(*-most popular)*

Anklets & Wristlets
Arrow (*Ho-hu* H.)
Arrow, Double Headed
Aspergill or Sprinkler
Bat Wing
Bear Claws
Bird - California Quail
Bird - Rain (*Tci-zur* H.)
Bird - Roadrunner or Chaparral Cock
Bison Mask
Breath or Life Gate
*Butterfly
Calendar
Clan - Badger
Clan - Bats
Clan - Cactus
Clan - Tobacco
Clan - Water
Clan Handshake
*Cloud (*Naktci* H., *Oh-mow* H.)
Cloud Spirit (*Omau* H.)
*Clowns or Men of the Mud (*Tcu-ku wympka* H.)
Corn Cob
Corn Plant
Corn Spirit (*Salyko* H.)
Crook (*Gneu-gneu-pi* H.)
Dragonfly (*Batolatci* H.)
Eagle (*Kwa'hu or Gwa'hu* H.)
*Eagle Tail (*Gwa-su* T.)
*Eagle Wing
*Feather- Prayer Feather (*Baho or Paho* H.)
*Feather - Eagle Feather

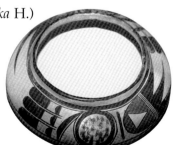

Left: eagle tail feathers
Right: parrot tail feathers
Steve Elmore Collection

172

*Feather - Parrot Feather
Feather - Turkey Feather
*Feather Ornament - Kirtle or Feathered Skirt
Game (*Tugh-ti-wiki* H.)
Gardens or Cultivated Fields
*Germination Spirit (*Aloseka* H.)
*Germination Spirit (*Muingwa* H.)
*Germative Emblems
*Girdle - Feathered Skirt
Gnome or Wizard (*Sumy-kolis* H.)
Gourd (*Da-we-a* H.)
Hail
Hairdo - Maiden's Whorls (*Na-somp* H.)
Hairdo - Man's Hair Wrap (*Hem-somp* H.)
Hand
Headband or Fillet
Headdress - One Horn Society Gourd
Katcina Hairdo
Katcina House
Katcina - Humis or Hemis, Terraced Cloud Tableta
Katcina - Hunting
Katcina - Snow
Kokopelli
Kilt
Ladder, Lightning
Ladder, One Pole (*Ha-wi-wa* H., *Sa-ka* T.)
Lightning (*Diel-weep-dah or diel-we-be* H.)
Love Locks
Maiden or Virgin (*Mana* H.)
Meander - Dance of the linked finger
*Migration
Mountain Lion (*To-hoash* H.)
*Parrot
*Parrot Beak
*Parrot Tail
*Parrot Wing
Phratry House, Confederated
*Prayer Stick (*Baho or Paho* H.)
Rabbit (*Dah-vo* H.)
Rabbit Stick (*Putc-ko-nu or Dup-go-ho or Mak-go-ho* H.)
*Rain or Rain Cloud
Rainbird
Rainbow
Rattles - Antelope
Sky Band
Sky Spirit's Arrow - the Sky Spirit (*So-tuk-nang or Co-tuk-inunwa* H.)
Sky Spirit's Eye - the bright star, believed to be Aldebaran, in Taurus
Sky Spirit's Window

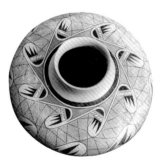

Migration Design
Gregory Schaaf Collection

Snow Cloud
Squash Bud
*Star (*So-du* H.)
Sun (*Dawa or Tawa* H.)
Sunlight (*Titksi* H.)
Sunflower
Tadpole
*Thunderbird
Thunder Spirit (*Um-tok-ina* H.)
Tobacco Flower
Transformation Spirit (*Massau* H.), Spirit of Earth, Death
Turkey
Turkey Feather Skirt
Warriors - One Horn Society Headdress (*Kaw-kwantya* H.)
Water, Cross-lined Square
*Water, in Eddies
Water, Meandering
Water, Penetrating
Water, Running
Water, Still
Water Spirit (*Baho-li-konga* H.)
Water Spirit's House
*Whirlwind or Breath Spirit (*Ho-bo-bo* H.)
Woman (*Wu-de, Woo-di or Wu-u-de* H. (Third Mesa))

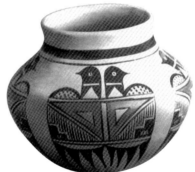

Thunderbirds Design
Charles & Patricia Collection

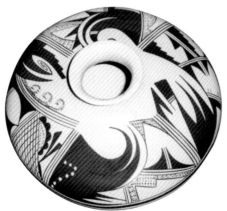

Parrot, Germination and Cloud Design
Challis & Arch Thiessen Collection

174

Appendix 3

THE LANGUAGE OF HOPI-TEWA POTTERY:
In English, Hopi and Tewa

(Recorded in the 1890's by Alexander Stephen...Gregory Schaaf, "Field Notes: Loren and Helena Phillips (Hopi), Priscilla Nampeyo (Tewa) and others," 1981-1998)

BOWLS

pottery, a bowl or dish wider than tall, food basin [large bowl] =
 cha-ka'-pta (1st Mesa) *or ca-qá-pta* (3rd Mesa)
 dto-wa-se-e-we or se-e-we (Tewa)

technically excellent pottery, bowl or dish wider than tall =
 qa-hín-ca-qa-pta

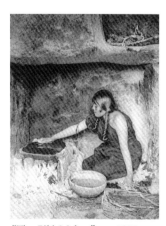

Angie Yan
Collection

ceremonial vessel [crenelated bowl] = *ña'kü-yi-pi* (1st Mesa)

sacred medicine bowl or dish = *na-hi-ca-qap-ta* (3rd Mesa);
 ko-lo-ke-le si-em or *ko-lo-ke-le se-e-we* (Tewa)

small food basin [small bowl] = *cha-kap'-hoy-a* (1st Mesa) *or ca-qáp-hoy-a*
 (3rd Mesa)

plainware cooking bowls = *si'-bvu* (Tewa)

large bowl = *wí-ko-ca-qap-ta* (3rd Mesa)

stew bowl, corn & meat stew bowl =
 nöq-kwi-scaq-qap-ta (3rd Mesa)
 doo-sen-se-e-we (Tewa)

serving bowl, low walled container =
 o-yâ-pi or ó-yo-pi (3rd Mesa)

piki bowl, for mixing blue corn batter =
 pa-qwi-sca-qap-ta (3rd Mesa)
 mo-wa-o-whi-e (Tewa)

"The Piki Maker," ca. 1922, by Edward Curtis. Courtesy of Rainbow Man, Bob and Marianne Kapoun.

large bowl, for mixing batter =
 wí-ko-pa-qwi-sca-qap=ta (3rd Mesa)

175

cup or bowl with handles or lugs =
> *ho-mí ca-qap-ap-hoy-a* (3rd Mesa); *ke-de* (Tewa)

bird or duck effigy bowl = *pá-wikw-o-caq-ap-ta* (3rd Mesa)

small mixing bowl (9-12″) = *pa-va-ca-qu-pta* (Tewa)
> Used in making blue corn balls called "blue marbles."

JARS

seed jar, decorated meal jar = *ñü-ma'-ñiñ-pi* (1st Mesa); *te-do-me-le* (Tewa)

seed jar, seed corn jar = *po-shím-si-vi or po-shím-i-si-vi* (3rd Mesa)

technically excellent jar or pot, usually wider than tall =
> *qa-hí-n-si-vi* (3rd Mesa)

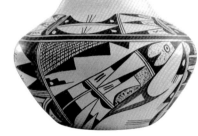

jar or pot, usually taller than wide =
> *sí-vi* (3rd Mesa); *po-me-le* (Tewa)

small jar or pot = *sí-vi ho-ya* (3rd Mesa)

large jar or water cask = *kü'-yi-pi* (1st Mesa)
> These pots are up to 20″ high and
> 17″ in diameter with a 12″ mouth.
> In early times, these huge pots were
> made up to 36″ in diameter.

Gregory Schaaf Collection

large jar, pot or olla = *wí-ko-si-vi*
> (3rd Mesa)

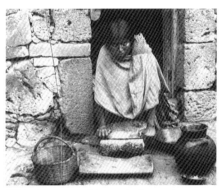

water jar = *kü'-yi si'-bvu* (1st Mesa);
> *po-ku-lu-me-le* (Tewa)

water jars glazed with piñon gum =
> *chü-kau'-koz-ru* (Tewa)

"Grinding corn with parched corn jar on the lower right." Bureau of American Ethnology, Smithsonian Institution.

parched corn jars = *ki-tik-si-vi* (3rd Mesa)

COOKING POTS

cooking vessels, pots, caldrons = *si'-bvu or shi'bvu* (1st Mesa); *too-se-le-me-le*
> (Tewa)

largest cooking pots = *Nak'si-bvu* (1st Mesa) meaning "hot sand pot or
> "hot pot"
> These are large greyware pots with wide mouths. They often have a
> fillet around the rim. There is no coat or slip. They are undecorated

plainware. The Hopi call them "hot pots" because they are heated very hot for popping corn.

CANTEENS, LADLES, FIGURINES, ETC.

decorated water bottle [canteen] = *chü-kau'-ko-zru añ'-pen-ta* (1st Mesa); *se-pe-ge* (Tewa)

canteen, bottle or olla = *wi-kó-ro* (3rd Mesa)

clay figurines = *chü-ka' ti'-hu-ta* (1st Mesa)

clay smoking pipe with a reed stem = *Có-ngo* (3rd Mesa); *sa-ku* (Tewa)

"Canteens," ca. 19th Century, by Edward Curtis. Courtesy of Rainbow Man, Bob and Marianne

pottery basin in which the bride & groom wash their hair = *Lö'-lo-qin-si-vi* (3rd Mesa)

ladles and spoons = *a'-kü* (1st Mesa), *ki-yá-pi* (3rd Mesa); *na-po-ke-de* (Tewa)

Ancestral Puebloan Ladle, ca. 1200. Robert and Dixie Fisher Collection

General Pottery Terms

rim, mouth of a vessel = *mó-a* (3rd Mesa); *se-boo* (Tewa)

base of a vessel = *kí-kri or kwákw-spi* (3rd Mesa);

body or stomach of a vessel = *pó-no* (3rd Mesa)

pie crust rim = *mi-a-ke-ve* (Tewa)

corrugated surface made from fingernail impressions = push in

*Alexander Stephen, *Journals* (1891-1893, 1936), p. 1021, 1189-1190

Appendix 4 ————————————————————————

Hopi Pottery Paint Pigments and Clays

Paint Pigments

black iron ore for black = *kwü-ma'-pto'-hoo* (1st Mesa)

black/dark brown vegetal pigment = *A'sa* (tansy mustard) (1st Mesa),
 A-we (Tewa), also known as wild mustard, wild spinach or bee weed,
 is boiled down into a thick liquid. When hardened it may be ground
 down, then water is added to the right consistency. For a deep black,
 the vegetal paint is steeped in cold water with black iron ore,
 hematite. In Tewa, wild mustard also is called *Gu-won-ve-e-ka*, mean-
 ing "You paint the designs with it." (Priscilla Nampeyo)

black vegetal pigment from bee weed = *tí-mi* (3rd Mesa)

red ochre for red = *pa-la'-to-ho* (1st Mesa)

white slip of kaolin clay = *kü-cha'-ch-ka* (1st Mesa); *tí-ma* (3rd Mesa);
 tse-e (Tewa)

yellow clay that fires red = *na-po-tse-ee* (Tewa)or *sikyatho* (Nampeyo: Hough
 1915)

Clays

Awatovi clay = *a-wát-pi-cö-qa* (3rd Mesa)

Sikyatki clays = white clay - *hisat chuoka* (Tewa) (Nampeyo: Hough 1915);

grey clay = *ma-si'-ch-ka* (1st Mesa); *ma-sí-cö-qa* (3rd Mesa); chaka-butska
 (Tewa) (Nampeyo: Hough 1915)

red clay = *siwu chuoka*, also from Sikyatki, iron-stained clay, (Tewa)
 (Nampeyo: Hough 1915)

white clay = *kutsatsuka* or *hopi chuoka*, (Tewa) burns white. (Nampeyo:
 Hough 1915)

white clay slip = *choku chuoka* (Tewa)
 This clay comes from about 10 miles southeast of Walpi (Nampeyo:
 Hough 1915); also below 3rd Mesa.

yellow ochre for yellow = *sik-ya'-to-ho* (1st Mesa)

yellow indurated clay for yellow = *cha-ka'pta sik-ya'-ch-ka* (1st Mesa)
This clay is used for making cooking pots and canteens.

yellow clay that fires brownish red for Redware = *pa-lá-cö-qa* (3rd Mesa);
na-po-tse-ee (Tewa)

yellowish clay from Howell Mesa that fires red for Redware = *Sik-ác-ö-qa*
(3rd Mesa)

Other Pottery Terms

paint brushes = *mohu,* (Tewa) two strips of yucca fiber, one for each color
(Nampeyo: Hough 1915)

polishing stone = *koo-i-a-we* "shining rock" (Tewa)

concave dish = *tabipi,* (Tewa), used as a form to begin a pottery, "nearest
approach of the Pueblos to the potter's wheel." (Nampeyo: Hough
1915)

gourd smoothers = *tuhupbi,* (Tewa), used to close up the coiling grooves, and
were always backed from the outside or inside by the fingers.
(Nampeyo: Hough 1915)

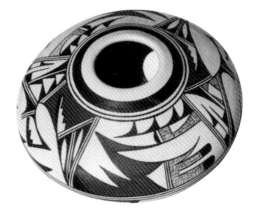

Seed Jar with Eagle Tail,
Rain and Cloud Designs.
Challis & Arch Thiessen Collection

Appendix 5 _____

Unsigned Hopi Pottery

Most pre-1940 Hopi-Tewa pottery is unsigned. Some grand-
mothers still do not sign, as a matter of personal choice. Nampeyo
only signed a few pots. Dick Howard has seen a few with her name
on the side of the pot, rather than on the bottom. However, hundreds
of pots have Nampeyo's name — with various misspellings —
scrawled on the bottom. Who signed these pots?

Some early collectors wrote names on the bottoms of pots to
remember who made them. Some early
traders wrote Nampeyo's name on the
bottom of pots in hopes of selling the
pot more quickly and for more
money. Specialists are not convinced
a pot is really by Nampeyo simply
because her name is written on the
bottom. Convincing evidence
might include photographs, collec-
tion documentation, including histo-
ry of past ownership. The ideal evi-
dence would be a photograph of
Nampeyo making the pot, a collection num-
ber on the bottom, along with an original
document recording the purchase from
Nampeyo. Few "ideal" pots exist.

"Mythic Bird on Sky Band," ca. 1920.
Gregory Schaaf Collection

In contrast with objective data, we also rely upon subjective
opinion. Top collectors and dealers respect the expert opinions of a
handful of pottery experts. See our acknowledgement section.

Assigning attributions to unsigned Hopi-Tewa pottery is very
difficult, but a fascinating intellectual challenge. We encourage our
readers to join us in this pursuit of knowledge. We propose that you
send us your opinions regarding unique and identifiable characteris-
tics that you propose to assign to individual potters. We will print
these observations in upcoming editions. By carefully examining
groups of pottery documented as being by each artist, we can compile
lists of unique characteristics. Consider how particular designs are
owned by particular artists, families, clans or group of clans. This
information is to be documented in the section "Favorite Designs."

By developing our computerized database, we hope to main-
tain a scholarly approach to attributions. For example, considering a
Hopi-Tewa bowl that is black on red on the outside and black and red
on white on the inside, we can produce a short list of artists who

made or continue to make this type of pottery. In this case, the short list would include "Flying Ant Woman" Marcia Fritz Rickey and Emogene Lomakema. Then by comparing design elements, we could make a possible attribution.

Regarding the value of unsigned pottery, attributions can enhance the value of a particular pot when the evidence is supportive and acceptable. In the field of American Indian basketry, Marvin Cohodas pioneered the attribution of unsigned Washo basketry. Craig Bates followed with attributions of unsigned Miwuk and other Sierra California tribes.

The value of the mass of Hopi-Tewa pottery — unsigned and unattributed — is determined by certain variables: condition, size, quality of construction, the fineness of the painted design and overall attractiveness, and age.

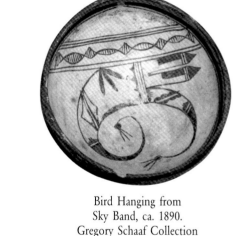

Flying Ant Woman,
attributed by Richard M. Howard.
Gregory Schaaf Collection

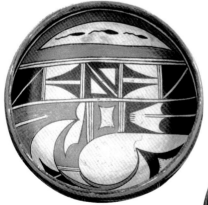

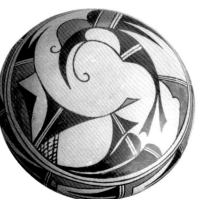

Bird Hanging from
Sky Band, ca. 1890.
Gregory Schaaf Collection

Courtesy of
Victor and Tommy Ochoa

181

Hopi-Tewa Hallmarks & Signatures

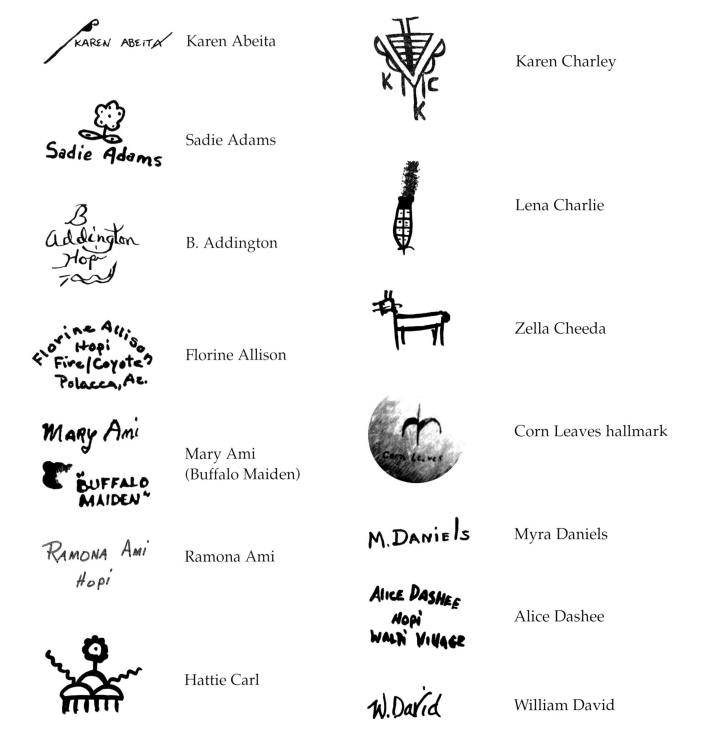

Karen Abeita

Sadie Adams

B. Addington

Florine Allison

Mary Ami
(Buffalo Maiden)

Ramona Ami

Hattie Carl

Karen Charley

Lena Charlie

Zella Cheeda

Corn Leaves hallmark

Myra Daniels

Alice Dashee

William David

Verla Dewakuku (signature)	Verla Dewakuku
(figure)	Preston Duwyenie
(figure)	Agnes Honie
Patricia HONIE	Patricia Honie
RONDINA HUMA TEWA VILLAGE POLACCA, ARIZ.	Rondina Huma
ROSetTA HUMA HOPI	Rosetta Huma
PO\VEE STELLA HUMA	Stella Huma
VioLET HUMA	Violet Huma
Marcella Kahe Hopi	Marcella Kahe
(figure) Koopee	Jake or Jacob Koopee
RENA LESLIE (figure)	Rena Leslie
CLAUDINA LOMAKEMA	Claudina Lomakema
Emogene Lomekema	Emogene Lomakema
KAREN LUCAS	Karen Lucas
B. Monongye Old Oraibi Ariz (figure)	Bessie Monongye
Vivian Muchmo Polacca, Ariz. Tewa	Vivian Muchmo
(figure)	Burel Naha
EMMA NAHA 1st Mesa Polacca, AZ	Emma Naha

183

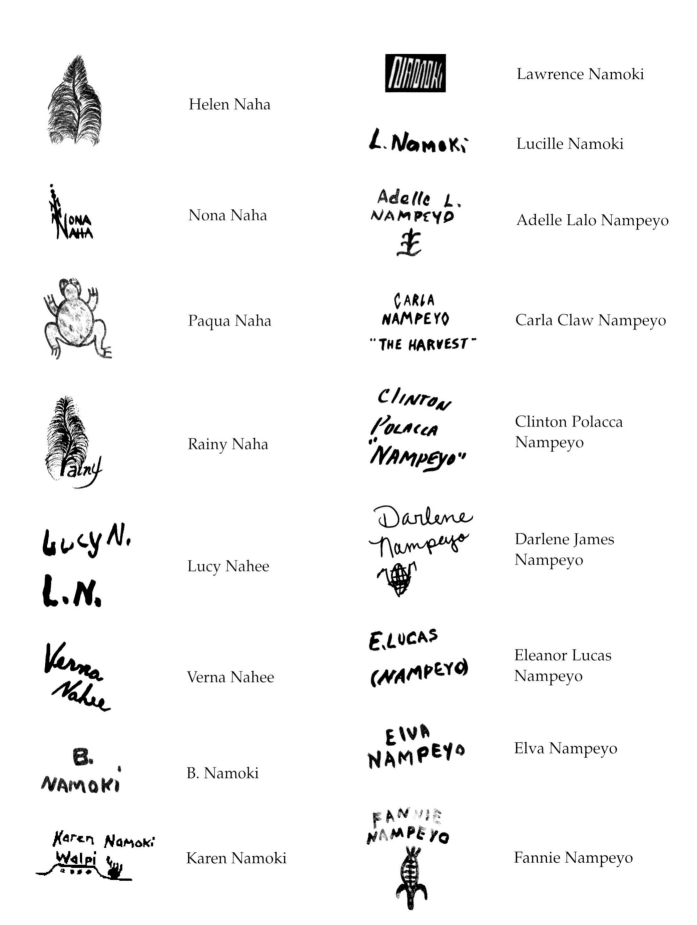

Helen Naha

Lawrence Namoki

Lucille Namoki

Nona Naha

Adelle Lalo Nampeyo

Paqua Naha

Carla Claw Nampeyo

Rainy Naha

Clinton Polacca
Nampeyo

Lucy Nahee

Darlene James
Nampeyo

Verna Nahee

Eleanor Lucas
Nampeyo

B. Namoki

Elva Nampeyo

Karen Namoki

Fannie Nampeyo

184

Hisi Nampeyo

Leah Nampeyo

Nellie Nampeyo

Priscilla Namingha Nampeyo

Rachel Namingha Nampeyo

Rayvin Nampeyo

Dawn Navasie

Dolly Joe Navasie (White Swann)

Eunice Navasie

Fawn Garcia Navasie

Joe Navasie

Marianne Navasie

Garnet Pavatea

Tom Polacca

Christine Poleahla

COLLEEN PALEAHLA HOPI FIRE / COYOTE	Colleen Paleahla
LQ HOPI	Lorna Quamahongnewa
Dextra (corn motif) Dextra (corn motif in circle)	Dextra Quotskuyva
(ant motif in circle)	Marcia Rickey (Ant Woman)
DONNA.R HOPi-TEWA	Donna Navasie Robertson
(frog motif) GAIL GRANDMA	Gail Navasie Robertson
IDA SAHMIE	Ida Sahmie
JEAN SAHME	Jean Sahme
nxahmie nampeyo	Nyla Sahmie
B (in circle)	Rachel Sahmie
Vernita Sakeva	Vernita Sakeva
Aäs-Kü-Mana gwen setalla hopi©	Gwen Setalla
PAULINE SETALLA HOPi	Pauline Setalla
JOY SILAS Polacca Az HOPi	Joy Silas

186

ROBERTA
YOUVELLA
SILAS
LAGUNA
TEWA

Roberta Youvella

Sun Clan hallmark

Sunflower hallmark

DIANNA
TAHBO
TEWA HOPI

Dianna Tahbo

M. TAHBO Mark Tahbo

Ella Mae Talashie

Laura Tomosie

Ethel
Youvella
Tewa
Polacca Ariz

Ethel Youvella

NAMPEYO EXTENDED FAMILY

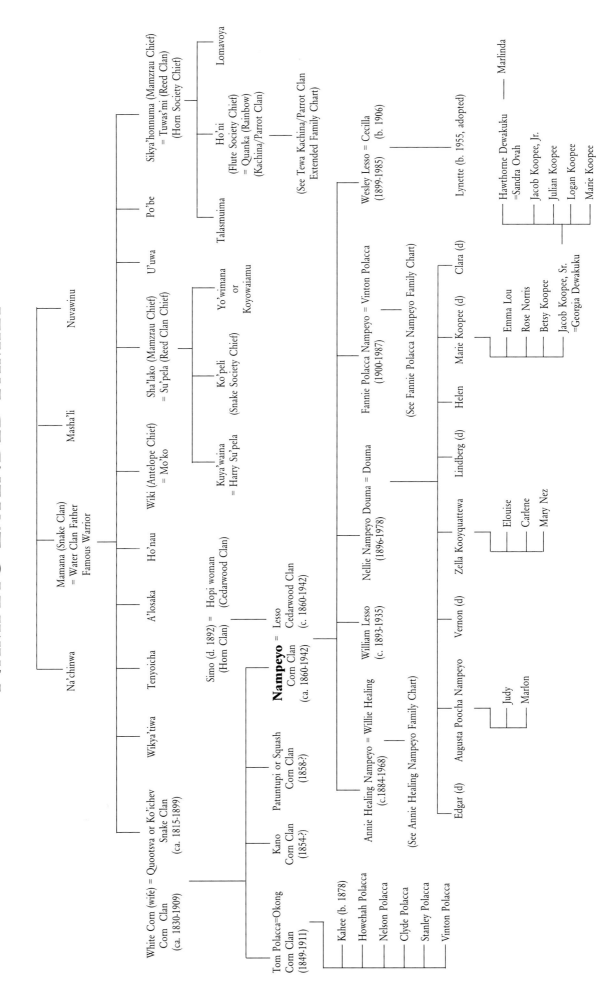

ANNIE HEALING NAMPEYO FAMILY

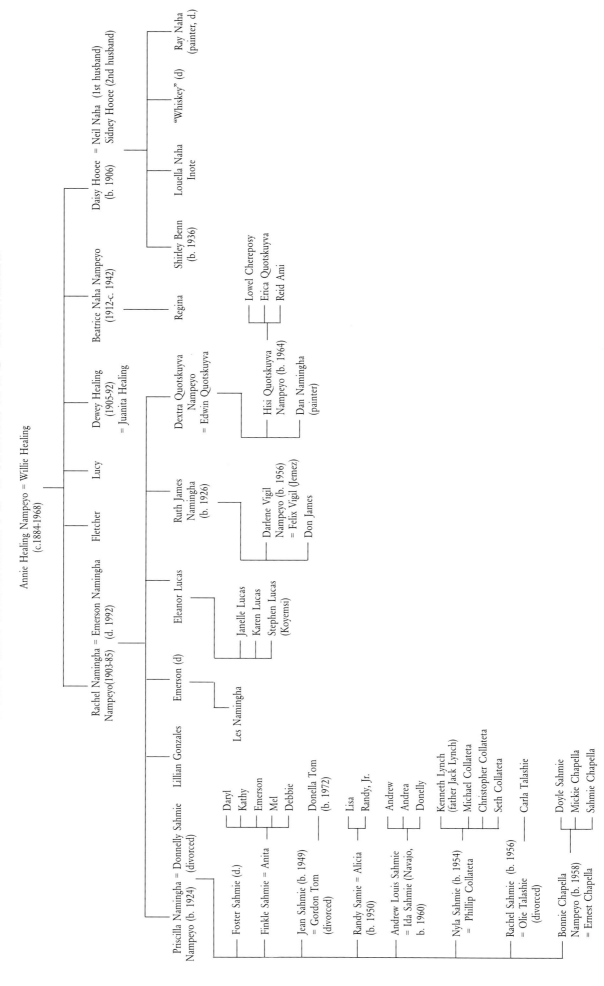

Annie Healing Nampeyo = Willie Healing
(c.1884-1968)

Rachel Namingha = Emerson Namingha
Nampeyo(1903-85) (d. 1992)

Priscilla Namingha = Donnelly Sahmie Lillian Gonzales Emerson (d) Eleanor Lucas Ruth James Lucy Dewey Healing Beatrice Naha Nampeyo Daisy Hooee = Neil Naha (1st husband)
Nampeyo (b. 1924) (divorced) Namingha (1905-92) (1912-c. 1942) (b. 1906) Sidney Hooee (2nd husband)
 (b. 1926) = Juanita Healing

Les Namingha

Dextra Quotskuyva Shirley Benn Louella Naha "Whiskey" (d) Ray Naha
Nampeyo (b. 1936) Inote (painter, d.)
= Edwin Quotskuyva

Regina

Foster Sahmie (d.)
Daryl
Kathy
Emerson
Mel
Debbie

Finkle Sahmie = Anita

Jean Sahmie (b. 1949)
= Gordon Tom
(divorced)
Donella Tom
(b. 1972)

Randy Samie = Alicia
(b. 1950)
Lisa
Randy, Jr.

Andrew Louis Sahmie
= Ida Sahmie (Navajo,
b. 1960)
Andrew
Andrea
Donelly

Nyla Sahmie (b. 1954)
= Phillip Collateta
Kenneth Lynch
(father Jack Lynch)
Michael Collateta
Christopher Collateta
Seth Collateta

Rachel Sahmie (b. 1956)
= Olie Talashie
(divorced)
Carla Talashie

Bonnie Chapella
Nampeyo (b. 1958)
= Ernest Chapella
Doyle Sahmie
Mickie Chapella
Sahmie Chapella

Janelle Lucas
Karen Lucas
Stephen Lucas
(Koyemsi)

Darlene Vigil
Nampeyo (b. 1956)
= Felix Vigil (Jemez)
Don James

Hisi Quotskuyva
Nampeyo (b. 1964)
Dan Namingha
(painter)

Lowel Chereposy
Erica Quotskuyva
Reid Ami

FANNIE POLACCA NAMPEYO FAMILY

Fannie Polacca Nampeyo = Vinton Polacca
(1900-1987)

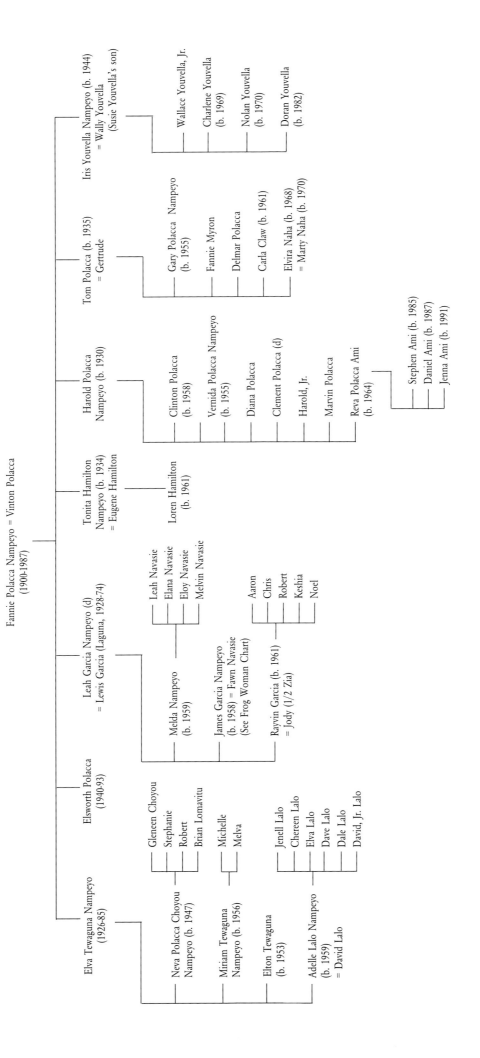

Elva Tewaguna Nampeyo
(1926-85)

- Neva Polacca Choyou Nampeyo (b. 1947)
 - Gleneen Choyou
 - Stephanie
 - Robert
 - Brian Lomavitu
- Miriam Tewaguna Nampeyo (b. 1956)
 - Michelle
 - Melva
- Elton Tewaguna (b. 1953)
- Adelle Lalo Nampeyo (b. 1959)
 = David Lalo
 - Jenell Lalo
 - Chereen Lalo
 - Elva Lalo
 - Dave Lalo
 - Dale Lalo
 - David, Jr. Lalo

Elsworth Polacca
(1940-93)

Leah Garcia Nampeyo (d)
= Lewis Garcia (Laguna, 1928-74)

- Melda Nampeyo (b. 1959)
 - Leah Navasie
 - Elana Navasie
 - Eloy Navasie
 - Melvin Navasie
- James Garcia Nampeyo (b. 1958) = Fawn Navasie (See Frog Woman Chart)
- Rayvin Garcia (b. 1961) = Jody (1/2 Zia)
 - Aaron
 - Chris
 - Robert
 - Keshia
 - Noel

Tonita Hamilton Nampeyo (b. 1934)
= Eugene Hamilton

- Loren Hamilton (b. 1961)

Harold Polacca Nampeyo (b. 1930)

- Clinton Polacca (b. 1958)
- Vernida Polacca Nampeyo (b. 1955)
- Diana Polacca
- Clement Polacca (d)
- Harold, Jr.
- Marvin Polacca
- Reva Polacca Ami (b. 1964)
 - Stephen Ami (b. 1985)
 - Daniel Ami (b. 1987)
 - Jenna Ami (b. 1991)

Tom Polacca (b. 1935)
= Gertrude

- Gary Polacca Nampeyo (b. 1955)
- Fannie Myron
- Delmar Polacca
- Carla Claw (b. 1961)
- Elvira Naha (b. 1968) = Marty Naha (b. 1970)

Iris Youvella Nampeyo (b. 1944)
= Wally Youvella
(Susie Youvella's son)

- Wallace Youvella, Jr.
- Charlene Youvella (b. 1969)
- Nolan Youvella (b. 1970)
- Doran Youvella (b. 1982)

TEWA KACHINA/PARROT CLAN-EXTENDED FAMILY

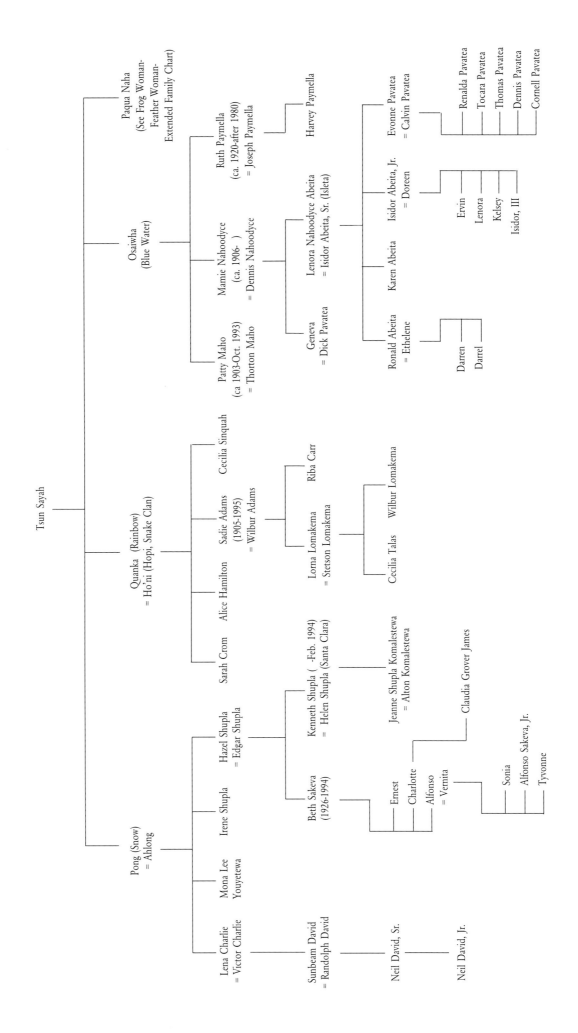

TEWA BEAR, SAND AND SPIDER CLAN

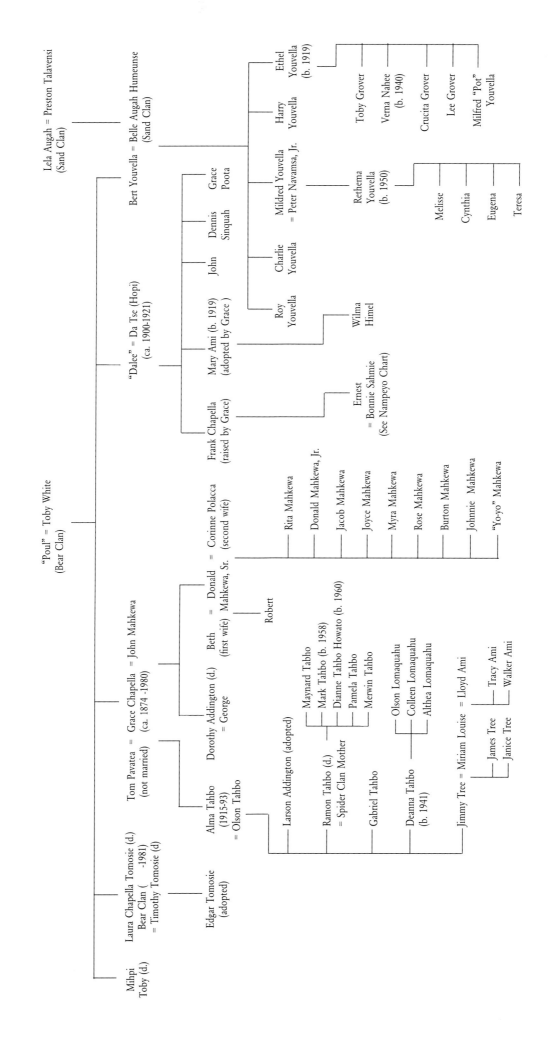

FROG WOMAN–FEATHER WOMAN–EXTENDED FAMILY

Roscoe & Agnes Navasie

Amelia Talasyousie

Hugh Sequi (Spider Clan)

Paqua Naha (First Frog Woman) (Kachina/Parrot Clan) (ca. 1890-1950)

Archie Naha = Helen Naha (1st Feather Woman) (Kachina/Parrot Clan) (Spider Clan) (d. 1993) (1922-1993)

Cynthia Sequi Komalestewa (b. 1954)
Hubert Sequi
Merrill Sequi
Milburne Sequi
Leon Dallas (adopted)
Miltona Naha (b. 1962)

Burel Naha (b. 1944)
Rechenda Hill
Rainy Naha (b. 1949)
Sylvia Naha Humphrey (b. 1951)

Pauline Setalla = Justin Navasie/Setalla (Bear Clan) (b. 1930)

Josephine Setalla (Water Clan)

Eunice Navasie (Water Clan) (ca. 1920-1992)

Perry Navasie = Joy Navasie (2nd Frog Woman) (Kachina/Parrot Clan) (b. 1919)

Grace Lomahquahu (b. 1953)

Loretta Navasie Koshiway (b. 1948)

Rusty Navasie
Dusty (Reginald) Navasie
Ambrose Navasie

John Biggs (adopted) (b. 1970)
Charles Navasie (b. 1965)
Lana Yvonne David (b. 1971)
Christopher Perry
Wayne Joseph Koshiwya

Jacob David
Rachel David
Lloyd David

Maynard (b. 1945) =Veronica Navasie (b. 1945)

Natelle Lee (b. 1941)

Bill Navasie (b. 1969)
Ray Navasie (b. 1970)

Bobbie Curtis
Natalie Curtis
Fern Curtis
Donald Curtis

Marianne (b. 1951) =Harrison Jim

Leona Navasie (b. 1939)

Linda Addington =Dietrich Lovato
Laurie Addington
Louella Addington

Pamela Navasie
Donna Navasie Robertson (b. 1972)
Gail Navasie Robertson =D. Robertson
Harrison Jim, Jr.
Amber Snow Star

Gary Setalla

Dolly Joe
Dawn Navasie
Fawn Garcia Navasie (b. 1959)=James Garcia
Darrell Navasie

Christine Victor

Antoinette Tewahaftewa

Stetson Setalla (b. 1962) —— Shea Margue Setalla

Wilner Setalla

Derek
Nichole
Miriah

Agnes Nahsonhoya

Dee Setalla (b. 1963)

Justin Stone
Brandon Stone
Chelsey Stone

Justina Setalla

Karen Namoki (b. 1960) —— Macadio Kayla Linoel

Gwen Setalla (b. 1964) —— Garreth Polingyumptewa
Michael Miller

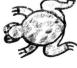

Bibliography

ALLEN, LAURA GRAVES
 1984 *Contemporary Hopi Pottery.* Flagstaff, Museum of Northern Arizona [Features an inventory of Hopi pottery in the Museum of Northern Arizona Collection.]

ARNOLD, DAVID L.
 1982 "Pueblo Pottery: 2000 Years of Artistry," *National Geographic Magazine* (November). [Features a photo essay on Hopi pottery techniques

BARBER, EDWIN ATLEE
 1876 "The Ancient Pottery of Colorado, Utah, Arizona, and New Mexico," *American Naturalist.* (August), 10(8):449-464, ill. [Features the oldest references to Hopi pottery making techniques.]

BARTLETT, KATHERINE
 1936 "How to Appreciate Hopi Handicrafts," *Museum Notes.* Flagstaff, AZ (July)

BASSMAN, THEDA
 1997 *Treasures of the Hopi.* Flagstaff, *Northland Publishing*

BAUM, PETER
 1959 "Die Malerei Der Hopi-Keramik" [The Designs of Hopi Pottery], *Das Kunstwork [The Artwork],* (January), 12(7):26-28.

BONAR, EULALIE H.
 1995 in Tom Hill and Richard W. Hill, Sr., eds., *Creation's Journey: Native American Identity and Belief.* Washington, D.C.: Smithsonian Institution Press and National Museum of the American Indian.

BREED, WILLIAM J.
 1972 "Hopi Bowls Collected by John Wesley Powell," *Plateau* (Summer), 44-46, ill.

BREW, JOHN OTIS
 1949 "The History of Awatovi," *Peabody Museum of Archaeology and Ethnology, Papers 36.* Cambridge: Harvard University Press.
 1949 "The Excavation of Franciscan Awatovi," *Peabody Museum of Archaeology and Ethnolgy, Papers 36.* Cambridge: Harvard University Press.

BRODY, J.J.
 1971 *Indian Painters and White Patrons.* Albuquerque, NM: University of New Mexico Press, ill., bibliography, index, 238 pp.

BUNZEL, RUTH
 1929 *The Pueblo Potter: A Study of Creative Imagination in Primitive Art.* New York: Columbia University Press, ill., bibliography 134 pp. (Columbia University Contributions to Anthropology, v. 8).

CHAPMAN, KENNETH, M.
 1927 "A Feather Symbol of the Ancient Pueblos," *El Palacio* (November 26), 23(21):526-540.

CHAPMAN, KENNETH M. & BRUCE T. ELLIS
 1951 "The Line Break: Problem Child of Pueblo Pottery," *El Palacio* (September), 58(9):251-289.

COE, RALPH T.
 1976 *Sacred Circles: Two Thousand Years of North American Indian Art.* Kansas City: Nelson Gallery.
 1986 *Lost and Found Traditions: Native American Art, 1965-1985.* Seattle: University of Washington, Press.

COLLINS, JOHN E., foreword by Barton Wright
 1974 *Nampeyo, Hopi Potter: Her Artistry and Her Legacy.* Fullerton, CA: Muckenthaler Cultural Center. 50 p. illus. (part col.) 27 cm. Exhibition held at the Muckenthaler

Cultural Center Apr. 19-May 26,1974. Bibliography:49-50.

1974 "Nampeyo: Prestigious Exhibition Honors Five Generations of World Famous Hopi Potters," *Arizona Highways* (May), 50(5):16-21.

COLTON, HAROLD SELLERS

1939 "The Reducing Atmosphere and Oxidizing Atmosphere in Prehistoric Southwestern Ceramics," *American Antiquity* (January), 4(3):224-231.

"Primitive Pottery Firing Methods," *Museum Notes* [Museum of Northern Arizona} (April), 11(10):63-66. [Features Hopi potter Poolie's firing techniques.]

1951 "Hopi Pottery Firing Temperatures," *Plateau* (October), 24(2):73-76.

1952 "Primitive Pottery Making: The Ceramic Methods of a Hopi Indian Potter," *Faenza,* 38(6):135-138.

1953 *Potsherds: An Introduction to the Study of Prehistoric Southwestern Ceramics and Their Use in Historic Reconstruction.* Flagstaff, AZ: Northern Arizona Society of Science and Art. ill., bibliography, index, 86 pp. (Museum of Northern Arizona, Bulletin, n. 25).

COLTON, HAROLD SELLERS and COLTON, MARY-RUSSELL FARRELL

1938 "The Arts and Crafts of the Hopi Indians: Their Historic Background, Processes and Methods of Manufacture and the Work of the Museum for the Maintenance of Hopi Art," *Museum Notes* [Museum of Northern Arizona] (July), 11(1):1-24; reprinted in volume 3 of the Reprint Series of the Museum of Northern Arizona, Flagstaff, 1951.

1943 "An Appreciation of the Art of Nampeyo and Her Influence on Hopi Pottery," *Plateau* (January), 15(3):43-45; reprinted in volume 3 of the Reprint Series of the Museum of Northern Arizona, Flagstaff, 1951.

COLTON, MARY-RUSSELL FARRELL

1930 "The Hopi Craftsman," *Museum Notes* [Museum of Northern Arizona] (July), 3(1):1-4. [Features a list of contemporary Hopi arts & crafts.]

"The Hopi Craftsman," Museum Notes [Museum of Northern Arizona] (August), 21(8):469-470.

"Wanted—A Market for Indian Art," *Southern California Business* (October), 9(10):24.

1931 "Technique of the Major Hopi Crafts," Museum Notes [Museum of Northern Arizona] (June), 3(812):1-7.

1938 "The Hopi Indians, Craftsmen of the Southwest," *School Arts Magazine* (October), 39-43, ill.

"The Arts and Crafts of the Hopi Indians: Their Historic Background, Processes and Methods of Manufacture and the Work of the Museum for the Maintenance of Hopi Art," *Museum Notes* [Museum of Northern Arizona] (July), 11(1):1-24, ill., bibliography.

1939 "Primitive Pottery Firing Methods," [Museum of Northern Arizona] Notes (April), 11(10):63-66.

"The Reducing Atmosphere and Oxidizing Atmosphere in Prehistoric Southwestern Ceramics," *American Antiquity* (January), 4(3):224-231.

1952 "Primitive Pottery Making: The Ceramic Methos of a Hopi Indian Potter," *Faenza.* 38(6):135-138.

CORTWRIGHT, BARBARA

1974 "The Beauty Collectors," *Arizona Highways* (May), 13-15., ill.

CURTIS, EDWARD S.

1907-1930 *The Hopi, The North American Indian.* Norwood: Plimpton Press, v. 12.

DEDERA, DON

1985 *Artistry in Clay.* Flagstaff, Northland Press

DILLINGHAM, RICK

1994 *Fourteen Families in Pueblo Pottery.* Albuquerque, NM: University of New Mexico Press.

DOUGLAS, FREDERIC HUNTINGTON

1933 *Hopi Pottery.* Pasadena, CA: Esto Publishing Co.,ill. 15 pp. (Enjoy Your Museum, Series N.3A)

Modern Pueblo Pottery Types. Denver: Denver Art Museum. ill., 8 pp. (Leaflet n. 53-54).

1935 *Pottery of the Southwestern Tribes* . Denver: Denver Art Museum. ill., 8 pp. (Leaflet n. 69-70).

1941 *Indian Art of the United States.* New York: Museum of Modern Art, Ill, bibliography, 219 pp.

1954 "Influences on Indian Art," *Philadelphia Anthropological Society Bulletin* (January), 7(2):10-11; reprinted in Smoke Signals (May 1955), n. 15:5-8.

DOZIER, EDWARD

1966 *Hano: A Tewa Community in Arizona.* New York, Hold, Rinehart and Winston.

FEWKES, JESSE WALTER

1895 "Preliminary Account of an Expedition to the Cliff Villages of the Red Rock Country, and the Tusayan Ruins of Sikyatki and Awatobi, Arizona, in 1895," *Smithsonian Institution Annual Report.* Washington, D.C..: U.S. Government Printing Office, 557-588.

1896 "Preliminary Account of an Expedition to the Pueblo Ruins near Winslow, Arizona, in 1896," *Smithsonian Institution Annual Report.* Washington, D.C..: U.S. Government Printing Office, 517-540.

1898 "Archaeological Expedition to Arizona in 1895," *Seventeenth Annual Report of the Bureau of American Ethnology.* Washington, D.C..: U. S. Government Printing Office, 17(2):519-742.

1919 "Designs on Prehistoric Hopi Pottery," *Bureau of American Ethnology 33rd Annual Report 1911-1912.* Washington, D.C.: U.S. Government Printing Office, 74(6):207-284.

FIELD, CLARK

1963 *Indian Pottery of the Southwest: Post Spanish Period.* Tulsa, OK: Philbrook Art Center, ill. 65pp.

FORBES, JACK

1991 "Pueblo Pottery in the San Fernando Valley," *Masterkey* (Jan.-Mar.), 35-38.

FRANK, LARRY & FRANCIS HARLOW

1974 *Historic Pottery of the Pueblo Indians.* Greenwich, CT, New York Graphic Society, ill.; reprinted West Chester, PA: Schiffer Publishing, Ltd., 160 pp.

GAEDE, MARC

1977 "The Makers," *Plateau* Winter, 18-21.

GAULT, RAMONA

1991, 1995 *Artistry in Clay: A Buyer's Guide to Southwestern Indian Pottery.* Santa Fe, Southwestern Association for Indian Arts, Inc.

GÉRARD-LANDRY, CHANTAL

1995 *Hopi: peuple de paix et d'harmonie.* Paris : A. Michel, 244 p.: maps; 23 cm. Includes bibliographical references (p. 235-[242]).

GODDARD, PLINY EARLE

1931 *Pottery of the Southwestern Indians.* New York: American Museum of Natural History, ill., bibliography, 30 pp. (Guide Leaflet Series, n. 73)

GOLDWEISER, ALEXANDER A.

1937 *Anthropology: An Introduction to Primitive Culture..* New York: F.S. Crofts, ill., bibliography, index, 550 pp.

GRATZ, KATHLEEN E.

1977 "Making Hopi Pottery: Techniques and Materials, *Plateau.* Flagstaff, AZ: Museum of Northern Arizona (Winter), 49(3):14-17.

GRANZBERG, GARY ROBERT

1973 "Influences of the Western Economy on Hopi Pottery Making," *California Anthropologist* (Fall), v. 3:47-51, bibliography.

GREENBERG, LAURA J.

1975 "Art as a Structural System: A Study of Hopi Pottery Designs," *Studies in the Anthropology of Visual Communications,* (Spring), 2(1):33-50, ill., bibliography.

HAMMOND, HARMONY AND JANE QUICK-TO-SEE SMITH

1985 *Women of Sweetgrass, Cedar & Sage.* New York: American Indian Community House Gallery (AICH)

HARLOW, FRANCIS H. & JOHN V. YOUNG

1965 *Contemporary Pueblo Indian Pottery.* Santa Fe, NM: Museum of New Mexico Press, ill., 23 pp. (*Popular Series Handbook, n. 9.*)

1967 *Historic Pueblo Indian Pottery: Painted Jars and Bowls of the period 1600-1900.* Santa Fe, NM: Museum of New Mexico Press, ill. 49pp.

HARRINGTON, MARK RAYMOND

1945 "Hopi Effigy Canteen," *Masterkey.* (January), 19(1):31. Abstracted in the *American Journal of Archaeology* (1945), 49:376

HARVEY, BYRON, III

1965 *New Dimensions in Indian Art.* Scottsdale, AZ: Scottsdale National Indian Arts Council, 40 pp.

HAYES, ALLAN AND JOHN BLOM

1996 *Southwestern Pottery: Anasazi to Zuni.* Flagstaff: Northland Publishing.

HODGE, FREDERICK W.

1904 "Hopi Pottery Fired with Coal," *American Anthropologist* (July-September), 6(4):581-582.

1942 "Death of Nampeyo," *Masterkey,* 16(5).

1942 "The Age of Nampeyo The Potter," *Masterkey,* 16(6).

HOUGH, WALTER

1915 *The Hopi Indians: Mesa Folks of Hopiland.* Cedar Rapids, Iowa: The Torch Press. [One of the first books on the Hopi.]

1917 "A Revival of the Ancient Hopi Pottery," *American Anthropologist,* 19(2):322-323.

1918 *The Hopi Indian Collection in the United States National Museum,* Proceedings. Washington, D.C.: United States National Museum, v. 54, n. 2235.

HOULIHAN, PATRICK T.

1974 "Southwest Pottery Today," *Arizona Highways.* 50 (5):2-7.

HOWARD, RICHARD M.

1975 "Contemporary Pueblo Indian Pottery," *Ray Manley's Southwestern Indian Arts & Crafts.* Tuscon, AZ, ill., 96pp.

HUBERT, VIRGIL

1937 "An Introduction to Hopi Pottery Design," *Museum Notes* [Museum of Northern Arizona], 10(1):1-4.

JACKA, JERRY AND SPENCER GILL

1976 *Pottery Treasures.* Portland, OR: Graphic Arts Center.

JACKA, JERRY AND LOIS

1988 *Beyond Tradition: Contemporary Indian Art and Its Evolution.* Flagstaff: Northland Publishing Co..

JAMES, GEORGE WHARTON

1901 "Indian Pottery," *House Beautiful.* (April), 9(5):235-243.

1901 "Indian Pottery," *Outing.* (November), 39(2):154-161.

JUDD, NEIL

1951 "Nampeyo, An Additional Note," *Plateau,* 24(2).

KENNARD, EDWARD

1979 "Hopi Economy and Subsistence," *Handbook of North American Indians, Southwest,* 9:554-562.

KOENIG, SEYMOUR AND HARRIET

1976 *Hopi Clay, Hopi Ceremony: An Exhibition of Hopi Art.* Katonah, N.Y.: Katonah Gallery, 116 p. : ill. ; 21 x 26 cm.;Bibliography: pp. 69-71.

KRAMER, BARBARA

1996 *Nampeyo and Her Pottery.* Albuquerque, NM: University of New Mexico Press.

LESTER, PATRICK D..

1995 *The Biographical Dictionary of Native American Painters.* Tulsa, OK: Sir Publications.

LINNE, SIGVALD

1946 "Prehistoric and Modern Hopi Pottery," *Ethnos.* (January-June), 11(1-2):89-98.

LIPPARD, LUCY R.

1985 "Double Vision, "*Women of Sweetgrass, Cedar & Sage.* New York: AICH Gallery

MANLEY, RAY

 1975 *Ray Manley's Southwestern Indian Arts & Crafts.* Tuscon, AZ, ill., 96pp.

McCHENSEY, LEA S. (with the assistance of Barbara W. McCue)

 1982 *A Reference Manual for Historic Hopi Ceramics.* Peabody Museum of Archaeology and Ethnology, Cambridge: Harvard University.

McCOY, AL RON

 1993 "Sculptural Perfection, The Pottery of Al Qöyawayma," *Southwest Profile Magazine,* Aug/Sept/Oct:22-25.

MONTHAN, GUY AND DORIS

 1975 *Art and Indian Individuals: The Art of Seventeen Contemporary Southwestern Artists and Craftsmen,* Northland Press, Flagstaff, Arizona, 116-125

 1977 "Dextra Quotskuyva Nampeyo," *American Indian Art Magazine,* (Autumn), v. 2, n. 4.

NEQUATEWA, EDMUND

 1936 *Truth of a Hopi.* Flagstaff: Northland Press.

 1943 "Nampeyo, Famous Hopi Potter," *Plateau,* 15(3).

PABANALE, IRVING

 1935 "Hopi Pottery," *Indians at Work.* (August 1), 2(24):21.

PATTERSON, ALEX

 1994 *Hopi Pottery Symbols: Based on work by Alexander M. Stephen.* Boulder, Johnson Books.

RENO, DAWN

 1995 *Contemporary Native American Artists.* Brooklyn, NY, Alliance Publishing, Inc.

SAUNDERS, CHARLES FRANCES

 1910 "The Ceramic Art of the Pueblo Indians," *International Studio.* (September), 41(163):xvi-xxi.

SCHAAF, GREGORY, et. al.

 1996 *Ancient Ancestors of the Southwest.* Portland, OR: Graphic Arts Center Publishing Co.

 1997a "Otielle Loloma," "Dextra Nampeyo," "Nampeyo Family" in *Native North American Artists,* edited by Roger Matuez. Detroit: St. James Press

 1997b *Honoring the Weavers.* Santa Fe, NM: Kiva Press

 1997c "Weaving Traditions: The Richness of Puebloan, Navajo, and Rio Grande Textiles," *Indian Artist.* (Summer), 3(3):34-41.

 1998a *Hopi-Tewa Pottery: 500 Artist Biographies.* Santa Fe, NM: Center for Indigenous Arts & Cultures Press

 1998b "Top Ten Points to Values in Indian Art," *Indian Market Magazine.* Santa Fe, NM: Southwestern Association for Indian Arts

SCHWARTZ, STEPHEN

 1969 "Nampeyo and the Origins of Modern Hopi Pottery," *Lore,* 19(4).

SIKORSKI, KATHRYN A.

 1968 *Modern Hopi Pottery.* Logan, UT: Utah State University Press, ill., bibliography, 92 pp. (Utah State University Mongraph Series, 15(2)).

SNODGRASS, JEANNE O.

 1968. *American Indian Painters: A Biographical Directory.* New York: Museum of the American Indian

STAFF

 1933 "Hopi Pottery," *Field Museum News.* (September), 4(9(2.

STAFF

 1974 "In the End...Fire Determines," *Arizona Highways* (May), 50(5):8-9/ [Features the firing techniques of Helen Naha, also known as "Feather Woman."]

STAFF [photography, Mark Middleton]

 1978 *An Introduction to Hopi Pottery.* Flagstaff, AZ: Museum of Northern Arizona Press, 28 p.: ill. (some col.); 23 cm.; Bibliography: pp. 24-25.

STAPPERT, GISELA

 1992 *Kunst und Ästhetik der Hopi-Indianer: Eine Geschlechtsspezifische Betrachtung.* Bonn, Germany: Holos, vi, 501 p. :ill., maps; 21 cm. Summary in English. Originally presented as the author's thesis (doctoral)—Johann Wolfgang Goethe-Universität zu Frankfurt am Main. Includes bibliographical references (pp. 431-501).

STEPHEN, ALEXANDER
 1936 *Hopi Journal of Alexander M. Stephen.* New York: Columbia University Press.
STILES, HELEN E.
 1939 POTTERY OF THE AMERICAN INDIANS. New York: E. P. Dutton, ill., bibliography, index, 169 pp.
STRICKLAND, RENNARD
 1986 "Tall Visitor at the Indian Gallery; or, The Future of Native American Art," Edwin Wade, ed., *The Arts of the North American Indian: Native Traditions in Evolution.* New York: Hudson Hills Press, pp. 283-306.
STRUEVER, MARTHA HOPKINS (Martha Lanman Cusick, Martha Struever)
 1989 *Nampeyo: A Gift Remembered.* Evanston, IL.
 1996 "Potter Dextra Quotskuyva," *Indian Artist Magazine.* (Summer).
 1996 "The Nampeyo Legacy Continues," Santa Fe, NM.
TANNER, CLARA LEE
 1968 *Southwest Indian Craft Arts.* Tuscon: University of Arizona Press.
WADE, EDWIN
 1976 *The History of the Southwest Indian Art Market.* Ph.D. dissertation in Anthropology, University of Washington, University Microfilms, Ann Arbor.
 1980 "The Thomas Keam Collection of Hopi Pottery: A New Typology," *American Indian Art Magazine,* 5(3).
 1986 ed., *The Arts of the North American Indian: Native Traditions in Evolution.* New York: Hudson Hills Press.
WADE, EDWIN AND LEA S. McCHESNEY
 1980 *America's Great Lost Expedition: The Thomas Keam Collection of Hopi Pottery from the Second Hemenway Expedition, 1890-1894.* The Heard Museum, Phoenix.
 1981 *Historic Hopi Ceramics.* Cambridge: Peabody Museum.
WELPLEY, CHARLES
 1933 *Pottery Decorations among the Indians of the Southwestern United States.* M.A. Thesis, George Washington University, ill., bibliography, 28 pp.
WILSON, OLIVE
 1920 "The Survival of an Ancient Art," *Art and Architecture* (January), 9(1):24-29.
WORMINGTON, H. MARIE AND ARMINTA NEAL
 1951 *The Story of Pueblo Pottery.* Denver: Denver Museum of Natural History, ill., bibiography, 60 pp. (Museum Pictorial, n. 2.)
WRIGHT, BARTON
 1979 *Hopi Material Culture.* Phoenix: The Heard Museum.
 1989 *Hallmarks of the Southwest.* West Chester, PA: Schiffer Publishing Ltd.
WRIGHT, MARGARET N.
 1972, 1989 *Hopi Silver.* Flagstaff, AZ: Northland Publishing
WYCKOFF, LYDIA
 1983 The Sikyatki Revival. In *Hopis, Tewas and the American Road.* Middletown, CT: Wesleyan University.
 1990 *Designs and Factions: Politics, Religion and Ceramics on the Hopi Third Mesa.* Albuquerque: University of New Mexico Press.
YAVA, ALBERT
 1982 *Big Falling Snow: A Tewa-Hopi Indian's Life and Times and the History and Tradition of His People.* Albuquerque: University of New Mexico Press.
YOUNGER, ERIN
 1978 *Loloma, A Retrospective View,* prepared in coordination with an exhibition by the Heard Museum, November 11, 1978-January 12, 1979; foreword by Edward Jacobson; Phoenix, AZ: The Heard Museum, 48 p.: ill. (some col.); 27 cm.; Bibliography: pp. 47-48.
 1985 "My Mother's Daughter: A History of Native American Women in Art,: (Interview) *Women of Sweetgrass, Cedar & Sage. New York: AICH Gallery*